Prospects for the Nation

Studies in British Art 4

Prospects for the Nation: Recent Essays in British Landscape, 1750–1880

Edited by Michael Rosenthal,
Christiana Payne, and Scott Wilcox

Published for
The Paul Mellon Centre for Studies in British Art
The Yale Center for British Art

Yale University Press, New Haven & London

Designed and set in Adobe Garamond by Julie Lavorgna
Printed in Great Britain by BAS Printers Limited, Over Wallop, Hampshire

Library of Congress Catalog Card Number 97-60730
ISBN 0-300-06383-0

A catalogue record for this book is available from the British Library.

Contents

Introduction

Michael Rosenthal

EVERYBODY KNOWS *The Hay Wain*, albeit more often in reproduction than as the original. This landscape has become so powerful an image within popular culture that, when the artist Peter Kennard wanted to press home the ghastly threat under which the installation of cruise missiles there placed East Anglia in the early 1980s, he created a photomontage where the wagon labors under the weight of these weapons. Stephen Daniels quotes Peter Fuller on how this symbolized an "absolute despair" in constrast to Constable's "aesthetic wholeness," finding the image alien and unwelcome within that famous pictorial rendering of "our green and pleasant land."[1] The extent to which Constable's imagery is formative in this myth was reinforced by an exhibition based around *The Cornfield* held at the National Gallery in London in 1996. This highlights two significant issues: that landscape painting has been of dominating importance in forming ideas of the nature of the British School of art, and that it is characteristic to figure the United Kingdom in terms of the landscapes of the southern parts of England. Scholarship of the past thirty years or so has gone a long way to demonstrate how we should be sceptical, not take any of this on trust, and these essays confirm that landscape painting, aesthetics, and politics in Britain are not only indissolubly linked but also demanding of scrupulous and sophisticated analysis.

To attempt any comprehensive summary of that literature would be to double the length of this book. But, and this will apply to the historical study of British art in general, we can say that before the 1960s relatively little was published, that there was then an increase in activity, leading to a peak around the early 1980s, and that, since then, publications have leveled out at a fairly high rate, although landscape is no longer so dominating an interest.

To get a more complete picture it is necessary to be less restrictive in focus. Before the 1960s British art had hardly been an issue. Valuable and lasting books had been written before World War II, including W. T. Whitley's painstakingly researched and still invaluable volumes on the eighteenth- and early-nineteenth-century artworld, and on Thomas Gainsborough. Christopher Hussey's *The Picturesque* remains essential, and in the 1930s refugee scholars like Edgar Wind made notable contributions (with some of which we are only now catching up) to the study of the history of British art. After the war came volumes like Kenneth Clark's *Landscape into Art* (1949), a fairly short and chronologically ambitious survey of landscape from a broadly formalist and modernist viewpoint, and there was E. K. Waterhouse's volume on British painting for the Pelican History of Art series, as well as his monographs on Reynolds and Gainsborough. But, as

far as landscape went, apart from R. B. Beckett's unparalleled edition of Constable's *Correspondence*, and Graham Reynolds's catalogue of the Constable collection in the Victoria and Albert Museum, published in 1960 and for many years remaining the *only* compendious and useful catalogue of that artist, quiescence seemed to reign.

Then, in 1969, John Gage published *Colour in Turner* and curated the groundbreaking exhibition, *A Decade of English Naturalism, 1810–1820*, which showed both in Norwich and London. The former was arguably the first study of a British landscapist that did more than, as it were, simply skim over the surface. Knitting Turner's practices into intellectual trends and developments, understanding formal connections between his and the work of old masters like Titian, potentially to be possessed of meaning, this accommodated the history of British art within a discipline that had seldom dealt with it so seriously. The exhibition, a demonstration that genius resides in recognizing what is staring you in the face, disclosed that, instead of being in some queer way an anticipation of Impressionism, quite a large number of artists were painting oil sketches from nature in the 1810s, and that this was an exercise within a laid-down procedure for painting landscapes, one originating in French practice. This, together with other, smaller shows (notably an exhibition of the studies of Thomas Jones at Cardiff in 1970) showed that British landscape painting was rich in potential and waiting to be investigated. John Barrell's publication of *The Idea of Landscape and the Sense of Place* in 1972 expanded the numbers of ways in which one might contemplate so doing. Consolidating the impact of Gage's work, this study of the poetry of John Clare analyzed connections between pictorial and literary configurations in terms of comparative structures — syntax organizing language as composition the parts of a picture — and proposed a methodology which allowed more telling connections to be made between art and literature than those possible from surmising that each had a simlar "feel." In addition, the grounding of Clare's and others' responses to developments in the countryside, actual histories, notably parliamentary enclosure, showed those of us who were students at the time that creativity, cultural production, is not insulated from the circumstances of its times. In the meantime, in 1971 at the Tate, Conal Shields and Leslie Parris mounted a small but momentous exhibition, *Constable: The Art of Nature,* which began to do something parallel to this.

Activity became intense. The exhibition, *Landscape in Britain, 1750–1850*, again organized by Shields and Parris and again at the Tate, in 1973 (in which year Allen Staley published *The Pre-Raphaelite Landscape*), was a landmark show. By assembling an enticing variety of works by numerous artists, so that it allowed one to survey something of the very great variety and disparity in landscape practice over the period, to contemplate examples of estate design alongside paintings by Wright, Wilson, or Gainsborough, to inspect the literature of landscape or Pre-Raphaelite landscapes, to look at both some of the optical aids the artists

used and at what they produced by using them. The exhibition invited the visitor to notice disconnections, to make connections; and the affordable and portable catalogue was scrupulously designed to encourage the process retrospectively with, for instance, a color plate of De Loutherbourg's *Coalbrookdale by Night* opposite a page of picturesque images, thus encouraging one to ponder if they might be related and, if so, how.[2] The same year Luke Herrmann published *British Landscape Painting of the Eighteenth Century* which further added to the stock of knowledge. Then, in 1975 and 1976, there were the great retrospectives in London of Turner and of Constable. Works were brought together. For the first time it became possible to witness the ways in which the oeuvres of two of the foremost British landscape painters developed, to gauge their variety, range, changes in direction.

Histories of art were being reinstated into other—literary, political, aesthetic—histories. Scholarship was positive and experimental, asking questions, looking at things in new ways. The opening of the Yale Center for British Art in 1977 gave public access to a major permanent collection in which landscape was prominent. Indeed, its major 1977 exhibition, *English Landscape, 1630–1850*, assembled an extensive collection of works on paper, prints, and books, and in the Preface which Andrew Wilton contributed to the catalogue, maintained that, in comparison with portraiture and genre painting, "landscape...in England offers a subtler commentary on the philosophical development of the culture that produced it," as well as reminding readers of its quintessential "Englishness."[3] In 1982 the Center would follow this up with *Presences of Nature*, in which exhibition Louis Hawes arranged landscapes according to various topographical categories. By now John Barrell had published his hugely influential *The Dark Side of the Landscape: The Rural Poor in English Painting, 1730–1840*. Highlighting the fact that no figure within a landscape painting can ever be neutral, and understanding the roles of the social classes as historically defined, the book exposed unnoticed aspects of the contents of landscape paintings, showed that contemporary worries about the management of the poor were manifest in fine art too. In paintings George Morland's peasants might scowl. By the time they reappeared in the mezzotints by which his work was brought to the attention of a wider public, their faces wore complacent smiles. David Solkin elaborated and expanded upon this approach in his substantial catalogue for the exhibition *Richard Wilson: The Landscape of Reaction*, which he curated for the Tate Gallery in 1982. Here, Wilson's imagery and the artistic languages in which he articulated it, were placed within a particular patrician culture, refining understanding of the kinds of nostalgia his classical landscapes would evoke, revealing the beauties of the bucolic pastoral of Wilson's classicizing English landscapes (the Welsh ones are subtly different) to have been tailored to the tastes of patrons who preferred to think of themselves, in their role of landlords, as the spreaders of beneficence over domains in which the gulf between wealth and poverty was

indescribable and potential social tension managed by draconian laws.

Since then there have been further major publications (some by contributors to this volume) and exhibitions of British landscape in all its manifestations. Indeed, most of the essays which follow this Introduction originated in papers delivered at conferences arranged around three exhibitions: *The Great Age of British Watercolours, 1750–1880* at the Royal Academy of Arts, London, and then at the National Gallery of Art, Washington DC in 1993; and *Toil and Plenty: Images of the Agricultural Landscape in England, 1780–1890* (which had shown first at the University Art Gallery, Nottingham) at the Yale Center for British Art in 1993–94), and *Glorious Nature: British Landscape Painting, 1750–1850* at the Denver Art Museum in 1994. Together they supply a perspective over current scholarship. British landscape is now an international and, increasingly, a multi-disciplinary concern. *Prospects for the Nation* includes writing by British, German, Canadian, and American scholars from both university and museum backgrounds, among whom are art historians, historians, geographers, and literary scholars. Their concerns and methodologies are various, although there are themes which recur.

Elizabeth Helsinger opens with an examination of the way in which the United Kingdom is imaged as the particular landscape of the English South. By covering a wide historical span, she shows how the eighteenth-century convention of conceiving British landscape in terms of property was gradually abandoned, so that at the turn of the nineteenth century the picturesque came to offer a more general way for any viewer or traveler to experience scenery (painted or not) as *patria;* while, in response to socioeconomic developments, writers like Wordsworth or Scott were having to move this ideal to the margins: respectively the Lake District (which as Alun Howkins shows was a terrain unspoiled by progress only to some) or the Highlands of Scotland. By 1815 Helsinger detects a further shift, as the focus homes in on the rural: rustic figures going about their business in a countryside that looks enough like anywhere to supply those who had been recently displaced from the country into rapidly-expanding towns with a sustaining image of nation; for, as Constable — quintessentially taken to be the English painter — stated, such pictures could supplant actual fields as "real property to my children." Certain of the themes explored here — the notion of landscape as nation, as property, the politics of the picturesque, the changes in the social constitution of those who created and those who assumed to themselves an interest in landscape — are picked up elsewhere in the book, where essays are set in broadly thematic groupings.

Thus, this opening chapter is followed by three focusing on figures in the landscape. My own proposes that Thomas Gainsborough was persistent in picturing the countryside of the forest commoners and, in so doing, was articulating a reacton against those capitalist economic developments most commonly realized in the first great wave of parliamentary enclosures. I argue that his land-

scapes thus contribute to a more general dialectic concerning what was the proper management of land, and to what ends. By 1800 or so it would appear that the improvers had won the battle, and individuals like W. H. Pyne in his *Microcosm of the Arts* was concerned to display a selection of rural figures suitable for insertion into watercolor (or oil) landscapes. Christiana Payne, in her exploration of the phenomenon, analyzes how a group of artists associated with the Water-Colour Society was concerned to maintain authenticity when studying from rustic figures in the life, although this ethos had to be extremely qualified when it came to reconciling this rustic imagery against the new technologies and rural unrest which were rendering any benign myths of country people increasingly unsustainable. She writes of the extent to which historical forces strained the credibility of these rural figures in paintings, even though torn clothes and elements of portraiture went towards proclaiming them ostensibly to be documentary. Sam Smiles explores further the complex politics of the relationship of the representation to the thing represented, pointing out the extent to which aesthetic protocols determine what, at any one time, it is permissible to display as art. I have already mentioned how Morland's figures stop scowling once they are exposed to the public gaze, and the people shown in Westall's *Storm in Harvest* or Cristall's *Hop-Picking* bear little resemblance to the unkempt and unwelcoming mien of such a figure as James Ward's *Swineherd*. Smiles argues that among the strategies used to maintain aesthetic decorum was that of naturalism — rendering subjects which might otherwise appear threatening or improper in such a way as to suggest they embody real truths — while at the same time defusing any disruptive potential they might have.

From here the focus moves to the actual histories of landscapes, to reminding us that a match between art and any reality is going to be extremely partial, because what is seen depends on the ways available for seeing and which of these are brought into play. Alun Howkins illustrates how localized regional economies and societies were, and how the kind of small-scale landholder Wordsworth celebrated in Cumberland would, when attempting to eke out a comparable living in the Kentish Weald, still under Forest Law, become a symbol of backwardness and immorality: these people were, in their independence, seen as hindrances to the effective implementation of new agricultural technology. Whether any of these histories were represented in landscape imagery depends on whether the artist had an outsider's or, as in the case of Constable, an insider's view. Cumberland was one of the peripheries to which the true England was understood to be retreating from the depredations of modernity, and Maxine Berg confirms the extent to which the urban explosion attendant upon industrialization also fostered in some a horror of towns. Since Raymond Williams's publication in 1973 of *The Country and the City* we have had a sharpened awareness of the ideological impulses which led to there being a new urgency in the old antithesis; but Berg, while describing anti-urbanism, goes on to show how Adam

Smith, by positing an essential interrelation between the agricultural and urban economies, allowed for a more integrated view, exemplified in particular in some of the pictures of J. M. W. Turner.

Of course, by the 1800s, most landscapes were being painted for metropolitan exhibition to urban spectators, and new strategies were evolving to allow those with no direct connection with the country to develop an aesthetic relationship with it, a phenomenon intimately bound up with the increase in leisure and the rage for touring which, until the end of the Napoleonic Wars, was largely confined to the British Isles. It is here that the example of the Reverend William Gilpin is of particular significance, and Stephen Copley concerns himself with the various ways in which Gilpin's *Observations on the River Wye* of 1782 went towards confirming both the region in general and particular sites along the river as places essential for the would-be cultivated tourist to visit. Copley analyzes the ways in which Gilpin's text was itself adaptable, particularly in its re-use in Fosbrooke's 1818 *Gilpin on the Wye*, with Gilpin's descriptions allowing for the visual accommodation of what had the potential to disgust—the signs of industry for example—into the touristic view, to create the "positively superficial." Gilpin's complicated strategies of viewing and describing are devoted to recreating the experiences of a series of places he had passed through but once (and the anachronism of his text has to be taken account of here). When Stephen Daniels, Susanne Seymour, and Charles Watkins turn their attention to verbal and pictorial representations of the upper reaches of the Wye, then they are confronting figures like Uvedale Price, whose aesthetic was formed by his long-lived experience of his ancestral estate, Foxley, as much as it was by his political sentiments, which led him to prefer a landscape of settled paternalism and interdependence, where ancient oaks and deep tracks confirm the reassuring longevity of these arrangements. The authors describe the various Herefords then understood to be mutually coexisting—the picturesque of the Wye opening into the georgic Siluria around Hereford itself, this region given historical cachet through being the site of Caractacus's last stand, before further upstream the visitor enters the realm of wild landscape and, eventually, Wales. We learn further of what Alun Howkins has pointed out of the extreme complexities of regional identities, and of how certain associations would be available to some but not to other visitors, so that Humphry Repton, landscaping various estates around Foxley, was not only opposed to attempting this according to aesthetic principles learned from the study of pictures alone, but oblivious to some of the complex historical associations embodied in those places.

Moving into the North of England, Andrew Hemingway unravels precisely those associations which would have been made available to John Sell Cotman when, in 1803, 1804, and 1805 he made successive visits to Brandsby near York, seat of the Cholmeley family. The volume as a whole is concerned to be scrupulous in recognizing the very problematic aspect of concepts like "genius," or "nat-

uralism," which have occasionally been used uncritically, and which have an obvious attraction when writing of Cotman. Hemingway unravels the kinds of networking which Cotman exploited in establishing patronage. This enables him then to detail the sorts of ideas about the locale which would have been mooted when he was introduced to John Morritt of Rokeby Park in Richmondshire. In their turn these clarify both the reasons behind Cotman's selection of motifs, and the apparently extremely individualistic way he represented them. In consequence, the uniqueness of his style becomes considerably less mysterious. Yorkshire was less off the beaten track than the Island of Staffa in the Hebrides. Since Sir Joseph Banks's visit in 1772, which had been published by Thomas Pennant four years later, the unique geology of Fingal's Cave, with its batteries of basalt columns, had proved of general fascination. Charlotte Klonk matches the changing ways in which the cave was treated by artists to developments both in geology and in theories of the earth's formation (themselves subjects of fierce debate). As with Payne's and Smiles's observations on the representation of rustic figures, we find that in the late 1800s the emphasis was coming to be laid on fieldwork, observation, and particularity, for it was these which the Geological Society of London (founded in 1807) aimed to uphold. In Turner's great 1832 painting, *Staffa, Fingal's Cave*, nature is represented as dynamic process, in keeping with the theories of the geologist, John MacCulloch, who furthermore maintained that the only reliable evidence was to be had from the observable. Turner, as the observing subject, plays an analagous role to the scientist, who has to abstract generalizations to explain phenomena from data.

Klonk writes how William Daniell's picture of Fingal's Cave was, in his *Interesting Selections from Animated Nature with Illustrative Scenery* (1807–11), close to that with which Moses Griffith had provided Pennant. In Volume IV of *A Voyage Round Great Britain* (1818), however, Daniell eschewed the drama for a more neutral pictorial account. Along with his uncle, Thomas, William Daniell had made his name with the aquatint view of India published as *Oriental Scenery* from 1795–1808. To notice this poses interesting questions about the relationship between the material appropriation of colonialism and the processes of scientific discovery. It also reminds us that the British gaze extended well beyond even such of the uttermost extremities of the British Isles as Staffa. Turner, with his marathon journeying on the Continent, not only proved that in his own example but, as Dian Kriz reveals in her essay on his Carthaginian pictures, was able to extend his interest to places he had not seen. Here we move from the places of experience to those of the imagination and are shown how embedded Turner's great landscapes are within contemporary preoccupations. Some of these are well known; the imagery of imperial decline and fall has for a long time been connected to the rise and fall of Napoleon in particular and, by inference, held out as a warning to Britain. By electing to analyze both the imaginary geography of place and the manner of Turner's recreation of it, Kriz reveals that there

is rather more to it. To a European mindset identifying Muslim North Africa as "Eastern"—hence Hazlitt's finding *Dido Building Carthage* "eastern" in its "characteristic splendour and confusion"—its presumed decline validated Western intervention. The historical Carthage had been subjugated by Rome. The soft beauty of Turner's recreation of the Tunisian city points up the feminization of this landscape, a gendered vision, to oppose to the hard, masculine sublimity of the earlier *Snowstorm: Hannibal and His Army Crossing the Alps*. While femininity is appropriate to the decadence normally associated with the East, here Turner's themes are knitted into current debates about slavery—including White Slavery in North Africa—thus making his ancient profoundly salient to modern history.

We know that many of his subtler allusions passed people by, and the kinds of pressures and problems associated with making a match between art and its publics are the concern of Ann Pullan. Her subject is the tensions created by the realities of having to square the creation of elevated fine-art imagery with the demands of various markets. She explores the problematic issues of the changing notions of "public" and "private," contrasting opinions from Hazlitt or Constable on what it was that artists were supposed to do. The role of journalists is revealed as increasingly important in mediating relationships, as is the degree to which Rudolf Ackermann in his *Repository of Arts* was creating an area in which a newly-developing urban bourgeoisie was able to buy into art. Here we move into the under-explored area of artistic institutions, and, in clarifying these subjects, Pullan opens up our understanding of the ways they worked. Kim Sloan, too, deals with art in the public arena, testing the cliché that the amateur artists who proliferated as the eighteenth century progressed were mainly women and mostly concerned with landscape: she supplies convincing evidence to discredit it. Before 1770 the main recipients of drawing lessons were young men who, among other things, were taught to do topographical landscapes. A small group of women amateurs, associated with Arthur Pond, was in the 1730s going through a comparable regime; copying prints, drawing figures, painting in oil, but seldom doing landscape. As society changed and leisure became a live issue, so too did the accomplishments it was thought fit for women to boast, so that it was only after the 1770s that an ability to draw landscape came to be thought of as an appropriate feminine accomplishment. Ideas of gender, media, and propriety obtain here, as does the fact that, by then, male amateurs were also focused on landscape, which was of course rising to popular prominence (some of the more prominent professional artists—Wright, Gainsborough—practiced landscape as well as other genres of art). By the early nineteenth century, nevertheless, it was appearing to dominate the British School. And Scott Wilcox takes a retrospect over this process, of how the notion of a national school of art, particularly manifested in terms of watercolor landscape painting, had become established by the 1850s, consequently going on to be authenticated by exhibitions and collections

at Manchester and South Kensington respectively. There were problems in this, but the net result was to define a particular history of art which displayed an internal historical dynamic, and where the apogee was reached in the works of J. M. W. Turner. It does to ask what kind of selectivity is necessary to ignore many other kinds of artistic production in creating this school, as well as to ponder on the pressures that led a national school to manifest itself as landscape watercolors, which were hardly an assertive public art. And here we find a resonance with that opening essay with its exploration of landscape as the figuring of nation.

This, perhaps, is the unifying theme of a collection, which, in addition, supplies a snapshot of what is interesting historians of British culture towards the end of the twentieth century. Landscape itself is no longer the subject of an unblinking gaze and has to be seen within the broader picture, contributing to, informed by other histories. There remain fresh areas to be explored. British colonial landscape in India, the West Indies, or Australia is being researched (in the case of the latter, following the pioneering work of Bernard Smith), and the imagery of voyaging and travel intrinsic to colonizing needs to be considered within terms of the domestic, as William Daniell's publication of views both in the Hebrides and India intimates. At the same time it remains, as I shall suggest, crucial, particularly for those based in the United Kingdom, to continue to take a critical interest in British landscape painting, although this volume suggests that, with the exception of some individuals—Cotman and, notably, Turner—the monographic approach has, for the moment, lost its appeal, for it is significant that Constable's art is mentioned only from time to time, even though he was the subject of a substantial retrospective exhibition at the Tate Gallery in 1991. This too was an interesting moment in the historiography of British landscape studies.

To appreciate why, it is necessary to turn back to 1982 and the reaction provoked by David Solkin's catalogue for his Wilson exhibition, mentioned earlier as providing telling insights into Wilson's art, premised on the unexceptionable and historically accurate notion that social relations were hierarchical in eighteenth-century Britain, and that landscapes meant for patrician patrons would communicate approval of what were structures of power, too. In some quarters this interpretation provoked uproar, as apparently offending against the modern status quo. There were calls for the Tate to censor its publications.[4] Such advocacy went virtually unchallenged in what likes to present itself as a modern democracy in which freeedom of speech is sacrosanct and, with subsequent exhibitions of British art, the Tate published catalogues which, while full of information and beautifully illustrated, hardly attempted any kind of interpretative history. The one produced for the Constable show was the culmination of these.

A painting like Constable's *View of Dedham* (fig. 2) of 1814, recreates something of the appearance, the lie of the land, of a particular part of the valley of the Suffolk Stour. It is historically specific. The rural economy of intensive farming which it records was driven partly by the economic imperatives created by the

Napoleonic Wars, partly by the oft-remarked entrepreneurial spirit of the East Anglian farmers, and was as characteristic of the area as it was absent elsewhere. As Ann Pullan shows, the painting, meant as a souvenir for a London-bound villager, showed an agricultural scene which would have been readily understood and appreciated by metropolitan spectators. Constable's careful, descriptive handling was arrived at as part of his artistic experimentation and development, but he was not alone at this time in seeking to handle paint in a way that suggested an unmediated representation of natural appearance. John Linnell, G. R. Lewis, and others were attempting something similar. The painting, then, represents a remote history. It also communicates autumnal appearances we would still recognize in a place we can as readily know.

So, there is a difficult relationship here, between a contemporary perception of a contemporary landscape, filtered through both general ideas of Constable's paintings, and what they are thought to stand for. The introduction to the 1991 Constable exhibition catalogue took a survey of recent scholarship in which Constable had featured. It remarked on the "variety of literary and sociological readings" (and it does here to remember the anathema sociology and the sociological can be to Middle England) by, among others, Karl Kroeber, James Heffernan, Ronald Paulson, Ann Bermingham, and John Barrell. We read, however, that "few" of these readings "have found their way into the main body of Constable scholarship."[5]

"Constable scholarship," then, was evidently not part of art history. And, from time to time, a real anxiety to preserve Constable from history spilled over into catalogue entries. One of the high points of the exhibition was to be the display of *The Wheatfield*, which had been lost to sight for decades. This prospect over the Stour Valley features a wheatfield in the foreground, with some very small figures reaping in the middle distance, two women and a child gleaning the edges. The catalogue entry ended by challenging John Barrell to qualify what he had written about the "to him—nearly invisible workers in Constable's landscapes."[6] No casual reader would have had much idea of who John Barrell was. And when *The Wheatfield* is checked against, say, G. R. Lewis's *Harvest Scene, Afternoon* (1815, Tate Gallery), the latter's men, one of whom swigs cider, dominate the foreground, where Constable's are tiny and tucked behind the wheat. Lewis's field is full of laborers; Constable's isn't.[7]

Forbidding Constable's landscape any historical specificity beyond the anecdoctal implied that its main interest lay in the striking appeal of its illusions, its communication of optical sensations that we can as readily experience today. Nature might be relatively unchanging, although evolution and environmental trends have to be taken into account, but the societies which live within that nature are hardly static. Constable's England is not ours. The essays in this collection understand this, appreciate that, among others, "literary and sociological readings" are essential if we are to attempt to understand historical landscapes.

This is of some note when we consider the extent to which the idea persists that the image of nation is the image of its landscape. In a newspaper article analyzing the deletrious effects that projected increases in greenfield housing and in motor traffic would have on the diminishing landscapes of an overpopulated island, Henry Porter prognosticated that the "hedgerows will disappear, the spinneys, wetlands, moors, bogs, and the beautiful little awkwardnesses of our landscape will simply vanish," and we shall see the "destruction of all the things that we hold dear and imagine to be the quintessence of Englishness."[8] One might point out that to write of "England" and "Englishness" is to forget that England is part of a United Kingdom which includes Scotland, Wales, and, more problematically, Ulster, and that to claim that the "quintessence of Englishness" lies in the rural, is, as was happening in the eighteenth and nineteenth centuries, to deny most British subjects any stake in the nation, for how can this accommodate a multicultural population which lives mainly in towns, estates, cities, and suburbs? Stephen Daniels and others have been regularly pointing out that not only is it odd to picture the nation as landscape—in contrast to the urban modernities of the Eiffel Tower for France or the Manhattan skyline for the USA—but that this landscape should habitually be that of the Southern heartlands is to turn a trick which leaves many stakeless, excluded.[9]

This book shows that there is nothing new about this and proposes that it remains of central importance to carry on analyzing and questioning the historical processes which go towards creating this illusion. For scholars in Britain this can seem a thankless task, for they have been working in demoralizing circumstances for a long while. Yet, it remains the case that critical intellectual inquiry is crucial in any society which wishes to claim for itself any civil character.[10] Debate is essential. Orthodoxies must be questioned. At the time of writing, the "deserving" and "undeserving" poor have been reinvented, at the same time as the voices of intolerance and nationalism are increasingly strident. It is more necessary than ever to look into as well as at the landscape of nation, to expose the very idea as something unfixed and constantly changing.

I should like to thank Christiana Payne for her speedy reading and commenting on a draft of this essay.

1 Stephen Daniels, *Fields of Vision: Landscape Imagery and National Identity in England and the United States* (Cambridge: Polity Press, 1993), 228–29.

2 Leslie Parris, *Landscape in Britain, c. 1750–1850*, exh. cat. (London: Tate Gallery, 1973), 72–73.

3 Andrew Wilton, "Preface," in Christopher White, *English Landscape, 1630–1850. Drawings, Prints and Books from the Paul Mellon Collection*, exh. cat. (New Haven: Yale Center for British Art, 1977), xi.

4 For an account of this, see Neil McWilliam and Alex Potts, "The Landscape of Reaction: Richard Wilson (1713?–1782) and the Critics," in A. L. Rees and Frances Borzello, eds., *The New Art History* (London: Camden Press, 1986), 106–9, and Michael Rosenthal, "Approaches to Landscape Painting," *Landscape Research* 9, no. 3 (1984): 2–13.

5 Leslie Parris and Ian Fleming-Williams, *Constable*, exh. cat. (London: Tate Gallery, 1991), 16. My own *Constable: The Painter and His Landscape* (1983) was the exception which proved the rule.

6 Ibid., 162.

7 For an analysis of the catalogue, see Michael Rosenthal, "Constable at the Tate: The Bright Side of the Landscape," *Apollo* 134 (1991): 77–84.

8 Henry Porter, "Heartacres," *The Guardian*, September 16, 1996, 1–2.

9 Daniels, *Fields of Vision*. Also Alex Potts, "'Constable Country' between the Wars," in Raphael Samuel, ed., *Patriotism: The Making and Unmaking of British National Identity*, vol. 3, *National Fictions* (London: Routledge, 1989) 160–88.

10 An exemplary instance is Nigel Everett, *The Tory View of Landscape* (New Haven and London: Yale University Press, 1994), which, written from the standpoint of a traditional conservative, has effectively challenged orthodoxy on the politics of aesthetic theories.

Land and National Representation in Britain

Elizabeth K. Helsinger

MY SUBJECT CAN best be thought of as particular imaginings of a general form: representations of Britain by images and narratives of, usually, *English* country. "Land" and "country" are not synonymous here with "landscape." They refer to the common space (or a very partial symbol for it) that is claimed as a common language, whose images—including but not limited to landscapes —form a crucial ground, in a double sense, of an Englishness placed at the center of a British nation.

That symbolism takes specific forms at different moments in British history, however. Critical attention, focused in recent decades on eighteenth-century landscapes of great estates, has not usually considered the relation of these landscapes to other ways of representing land whose forms, meanings, and histories may overlap with but are not identical to those of landscapes of property. We risk confusing those forms of shaped land especially important in Europe and Britain in the seventeenth and eighteenth centuries—painted, drawn, written, or built landscapes sharing many formal features and embedded in particular social and economic relations—with the general phenomenon of shaped land as signifier, what W.J.T. Mitchell suggests we think of as a medium.[1] "British landscape" generally refers to the former, more limited sense of the term, but often threatens not only to define the form and ideology of landscape in the broader sense (as if the medium were itself a peculiarly national possession), but also to absorb and obscure other forms and signifying uses of English land.

This is not to deny the value of recent work on eighteenth-century British landscapes of property for reflecting on what I would frame as a more general problem for "thinking the nation": the seductions and mystifications of land deployed as a national symbol.[2] "Country" possesses a peculiar power to give the abstract conception of "nation" a local, lived meaning. For that very reason it can dangerously misrepresent the nation (naturalizing historical transformations, obscuring social and economic relations, ignoring local differences) or limit what that nation might become (tying it to communal models of homogeneity and exclusivity).[3] British landscape was always more ambivalent in its national meanings and expansive in the range of national viewers it could seem to address than its close links with the economics and ideology of landownership might suggest. But the social and political implications of such landscapes, however sensitively read, are not in any case a reliable guide to other forms of national representation through land. It can, I believe, be useful to think of the British eighteenth-century landscape of property as a more limited term so that we may

begin to see other ways that the imagery of land has been — and might be — used to create or contest particular ideas of the nation.

What follows is a preliminary effort to think about the place of the landscape of property within a larger field of representational practices. While I review much that will be familiar to historians of British landscape, I do so to emphasize the particular contours, and hence the limits, of the landscape of property as an historical practice, and to point to several things that we might want to distinguish from it. Maps or romantic encounters with borderlands and "spots of time" offer alternative ways of figuring the nation through its land. So too do representations of distinctively rural scenes of village life and agricultural labor. My own recent work on the 1820s and '30s suggests that the rural scenes that proliferate after 1815 carry very different implications from landscapes of property and become the language through which national identity as land is debated in those years.[4] By questioning the assumption that the eighteenth-century landscape of property provides the master term for British national imagery of land, I also mean to explore the possibility that such imagery offers a greater range of affective and political meanings than we have come to associate with British landscapes.

Historically, the map precedes the landscape of property as national representation in Britain. In the late sixteenth century Elizabeth I commissioned a collection of maps of the English counties. Though these maps were initially inscribed with the royal arms, in subsequent editions her arms were replaced by those of the major landholders. This substitution points toward a new, postmedieval conception of Britain as privately owned land, constituting a bounded territory distinct from the public body of the monarch. The conception was elaborated in a number of descriptive prose and poetic works including Camden's *Britannia* and Drayton's *Poly-Olbion*. Cartography and chorography enabled and announced a significant shift in loyalties. They opened a "conceptual gap between the land and its ruler"[5] and fostered an attachment to the land itself as the symbol of nation. That attachment could later be mobilized against the monarch in the name of national interests — that is to say, of the interests of men who came to see their wealth, status, and political identity as vested not in royal favor but in ownership of land. It could also be extended beyond the borders of the political state. Maps allowed the definition of boundaries between states conceived as exclusive properties. They also accompanied and enabled European claims to "new" territories in Africa, Asia, America — or the Scottish highlands — land not acknowledged as anyone else's property. Military and commercial designs on these appropriable lands were often first inscribed through surveying and mapmaking (marked physically on the land, as well as on representations of it), activities that continued to produce new maps of Britain's internal territory in the following centuries.[6]

If maps and cataloguing verbal descriptions are among the first representa-

tions of a national British land, landscapes constitute a second. Built, drawn, painted, and written landscapes were initially produced in seventeenth-century England for the same class of landowners to provide views of and from their estates.[7] Their use as national representation may not seem immediately obvious; not all landscapes lent themselves to such readings, and only some audiences understood landscapes as national metaphors. While maps attempted to comprehend and systematize many local knowledges within larger political and geographic orders, the landscapes that emerged in Britain, drawing on Dutch and Italian examples, limited what could be seen or imagined to the view of one person from one spot at one moment. But the detail of these landscapes was organized by conventions of representation that emphasized perceived structures in the English countryside, such as the visual patterns of park and fields in framed recession from commanding country houses. These repeated structures implied the organization of power and property of which they formed a part, permitting the use of landscapes to represent abstractions like the nation-state. For the newly national subjects of seventeenth- and eighteenth-century Britain —its landowners—landscapes could suggest the national in the local.[8] They supplemented, though they did not supplant, the more obvious functions of maps for controlling land as private and national property.[9]

When the landscape stands for the nation, it brings with it a set of quite specific social relations that the map need not engage. In seventeenth- and eighteenth-century Britain, these relations included not only those visibly lived on the land, at home or abroad (which might be elided or obscured), but also those implicit in the form itself: in its address to and positioning of the subjects and objects it presented.[10] Etymologies constructed for the English term connect it both with the Old English *landscipe*, region, and the Dutch *landschap*, literally land-shape or shaped land, the name of an emerging genre of painting introduced into England about the time (at the beginning of the seventeenth century) that the English word begins to be used in its present sense.[11] Raymond Williams also suggests a connection with the Latin roots of "country" in *(terra) contra*, land spread out opposite or facing a viewer. Landscape, in its English forms and uses, combines these senses: it designates a relatively local extent of land that has been shaped and designed for someone positioned facing it. As in Holland, the word refers both to the design imposed in the process of constructing an artistic representation, as in a painting or poem, and to design worked out on the land itself (the hedges and walls of enclosed fields; plantings, earthworks, buildings; paths created for the eye). The term acknowledges the constructed character of the land produced by Dutch reclamation projects and English agricultural improvement and landscape gardening, practices that contributed importantly to the emerging market in those countries for artistic representations of the land.[12] All three ways of reshaping land—Dutch dikes, English enclosed fields and landscaped estates, pictures and poems in both countries—assert, though

often in order to disavow, an understanding of possession that conveys the right to shape the appearance of the land and control its uses: rights of private ownership that in both countries enabled the development of land as capital and were soon understood as the basis of national prosperity.

Landscapes can support the identification of land with private property because they are what Nancy Munn calls a "centered" form of topographical organization.[13] Unlike the named, bounded region that can be located by the spatial coordinates of a map, landscapes are "constituted on a principle of centering relative to a 'viewer'" observing them. When the land is represented as landscape, or when landscapes are constructed within it, "an imaginary deixis is embedded in the topography, providing the implicit rationale for imputing value and making qualitative changes." Landscapes not only indicate the presence of subjectively constituted places within a topographical space, however. As Munn argues, they also point to their observers. They project the possibility of a subject while they refer to a portion of the land. The landscape of property projects an owner.

It would be a mistake, however, to read in eighteenth-century British landscapes simply the unproblematic representation of private property, space that has been emptied out, rationalized, and controlled for profitable production. Landscapes of property proved more flexible than a strict reading of their ideology and the viewers they seem to imply might lead us to imagine. Much more than maps and chorographies, these landscapes point to appropriation as a process that was difficult to effect and produced considerable ambivalence in landowners and empire builders. They represent an idea of order continually working on local disorder, where general structures emerge in an encounter with the messily particular or the unrecognizable wilderness that may be itself an object of desire and regret.

The appropriative struggles on which georgic celebrations of a cultivated land depended became especially visible — and relished as a source of imaginative pleasure — in Gainsborough's small landscapes, or in picturesque landscapes of the later eighteenth and early nineteenth centuries. Perhaps as the memory of civil war receded, the landscaping of private estates and the views of them produced in poems and pictures began to incorporate passages of deliberately reconstructed wildness: picturesque rambles. At the same time, in prints and guides intended for internal tourists increasingly outside the landowning classes, authors and artists sought out less cultivated areas of Britain (Wales, the Lake District, gypsy-frequented hollows) on which to exercise the shaping powers of the eye and pencil.[14] It was not only the relatively domesticated character of the English countryside that led landowners and artists to find or construct picturesque disorder close to home, however. The aesthetics of landscape were severely tested, and perhaps definitively shaped, by encounters with less familiar and far more frightening "wild" places overseas. Landscapes participated in the

ordering of land for individuals and for the nation, but the waste, wild, or (what amounts to the same thing) differently-used land in Highlands or jungle or bush in turn helped shape and fix the normative representation of Englishness as cultivated land.[15]

One subject projected by the landscape in seventeenth- and eighteenth-century Britain was indeed the landowner. But the implied subject could also include others whose presences potentially extended the power of landscapes to create national consciousness. New national subjects from the middle classes could be embedded in a national topography: those who could learn the rules of taste; travel and visit estates; make and purchase pictures, poems, and prints; or otherwise imagine themselves addressed by landscape views. This was possible because the landscape form invited a rough three-way analogy between the position and powers of owner, artist, and a viewer who need not be identical with either. The owner could in theory remake the land to his own design, striving to control not only its shape and appearance but the processes of production on it and the lives of the producers. His distance and difference from both the nature and the labor that he commanded could be indicated by incorporating or alluding to works of art, or by effacing the signs of agricultural labor and its relation to the park. The artist exercised comparable powers within the medium of his representation. The viewer is invited to participate vicariously in both forms of command: to abstract and grasp the principles of design that shape the land and, similarly, to experience from the perspective of the owner the economy of production that contributed to that shaping (together with the elisions and mystifications of those structures of power that characterized the owner's views). Finally, the viewers addressed by the landscapes praised in poems like Andrew Marvell's "Upon Appleton House" or James Thomson's *The Seasons* are asked to derive a general concept from particulars, to understand the relation between the land as a local landscape, the property of individuals, what can be seen by one viewer from one spot, and that elusive abstraction, the nation.

In practice, landscapes embodied the class distinctions not only of eighteenth-century English agricultural production but of a national political life rooted in it. Those who owned and those who produced were assigned different roles by the landscape, confirming a distinction between those who exercised political citizenship in Parliament and those who did not. Commerce and non-agricultural production were seldom represented. Laborers were commonly the objects but not the subjects of the landscape gaze.[16] The single-point perspective, compositional framing, and manipulation of recession in an articulated space, conventional features of seventeenth- and eighteenth-century landscape gardens and pictures (or verbal descriptions that observed pictorial conventions), all tend to enforce a separation and a hierarchy of control between the viewing subject, invited to take the place of the owner of the land represented, and the objects of that most distancing of the senses, sight. As John Barrell has pointed out, the

mode of sight embodied in landscapes was itself initially read as an index of civic virtue.[17] The elevated views to which Thomson's readers are invited to "ascend" merge into contemplation of national power in part because they seemed so well to embody the kind of abstracting, comprehensive mental action held necessary and only possible for landed men whose education and leisure fitted them to act for the public good, that is, to be national subjects in the fullest sense. Low perspectives, dense foregrounds, and blocked distances suggested a contrasting absorption in the particular and the concrete, private interests that might ignore or conflict with a public good. Comprehensive vision, analysis, and foresight might be temporarily surrendered by public men for the private pleasures of intricacy and surprise associated with the picturesque (though always in some tension with public responsibilities), without affecting their assumed ability to reclaim the commanding point of view. And, increasingly, middle-class men whose property was not land read themselves into the commanding perspective of the landscape as vicarious investors in British scenery—what Wordsworth called "a sort of national property"—claiming private economic interests as qualification for public citizenship.[18] But women, children, the laboring classes, or the native inhabitants of the lands to which Britain was extending her empire were granted no such powers.[19] Seldom or never the subjects addressed in comprehensive prospects, their exclusion signified their unfitness for national civic life in either its traditional or its newer commercial models.

Yet the landscape as a representation of Englishness seemed to address a still broader range of viewers, long before the lower-middle and working classes began to travel or to participate in colonial administration overseas later in the nineteenth century. As Thomson's lines suggest ("Happy Britannia! where …Liberty abroad / Walks, unconfin'd"), perhaps the most salient value associated with the English landscape to British audiences has been that of "liberty": a term capacious enough to enlist the sympathies of many whom the landscape of property as a national symbol in other respects seems designed to exclude.[20] The liberty invoked in Thomson's lines is that considered to inhere in common law and to be secured by Parliament, particularly with the settlement of 1688: that is, the limitations on absolute monarchical power over the persons and property of individual subjects, enfranchised or not. English landscapes, construed as they were against the rigid symmetries of Versailles, figured a national difference in light of which differences of rank might be overlooked. The artfully composed "naturalness" of an English landscape—with its unpruned trees, its preference for studied asymmetry and curves over straight lines—was most readily perceptible by the contrast (frequently pointed out) with France, especially the constructed landscapes of the great Sun King. From the commanding prospect in Thomson's poem, the viewer, like Britannia herself, commands "the treasures of the Sun without his rage."[21] Those treasures are in the hands of unconfin'd Liberty who "scatters plenty with unsparing hand" "even to thy farthest cots."[22]

Many were not blind to the irony of the repressive measures necessary to construct this appearance of liberty on the territories of Empire or the landscaped estate (the villages displaced, the land taken out of production, the fences and, in the nineteenth century, stringent game laws and private, armed guards to keep the residents of cots from infringing the "liberties" of the estate to gather the promised plenty). Yet the conjunction, in English landscapes, of Britain with "liberty" and "nature" against the absolutism and artifice of France (or, in the 1790s, against the artifice of revolutionary rationalism) was central to the construction of a national consciousness that could appeal beyond the landed, male aristocracy.

The considerable flexibility of these landscapes of property as representations of the nation has its limits, however, as a closer look at the decades before and after 1800 should suggest. We can distinguish at least two alternatives to the landscape of property and its relative, the picturesque landscape: the romantic borderland encounter and the rural scene. These alternative representations increasingly vie with landscapes of property as important forms of imagining the nation through its land. The conjunction of Britain with liberty and nature is invoked but figured quite differently in the turn away from landscapes of property presaged in Thomas Gray's "Elegy in a Country Churchyard" and developed more fully in Romantic literature beginning with Wordsworth in the later 1790s. The village graveyard or the farm in the remote mountain vale replace the landed estate as the loci of nature and liberty. The virtues of the "mute" and "inglorious" who live and die in these rural places—rescued and articulated by the poet— become, especially for Wordsworth, the necessary supports of national greatness. His imagination is engaged by borderlands (Cumbria, Scotland, Wales) and isolated spots—pockets or enclaves of the pre-modern and pre-national.[23] There memory, "domestic tales" ("Michael"), and an occasional encounter with a solitary (the leech-gatherer, the Highland girl, the cottage girl of "We are Seven") enable the poet-wanderer to bring back stories of that simpler, plainer time and place where the shaping power of Nature is still to be found. Scott's Highlands are a yet more distant borderland. The East as imagined by Byron or Shelley serves similar purposes but is more radically disjunct: less Britain's borderland than its ahistorical other, the far side of an uncrossable divide from European time. Wordsworth's borderlands and spots of time define the temporal and physical boundaries that both separate and connect present-day England with the "elemental presences" of nature or the different chronologies of pre-modern peoples.[24] The solitary figures (Michael, Margaret) whose memory is preserved in his "domestic" or traditionary tales practice an "habitual piety, maintained / With strictness scarcely known on English ground" in their everyday lives, "pure religion breathing household laws" not to be found in more typical or representative English places, even rural ones.[25] Their marginal lives and anachronistic virtues constitute a resource to be mobilized against the initially seductive, later deeply disturbing promise of a now-revolutionary France.

English liberty, challenged increasingly at home with ideas imported from America and France, is no longer found within the picture-like landscape of Anglicized property for these poets. The shaping encounters with wilderness are beyond the possibilities of picturesque control. Wordsworth resents a "tyranny" of the eye embodied in the "rules of mimic art" that turn the experience of nature into a succession of landscapes, a "comparison of scene with scene."[26] His poetic explorations of England's borderlands use picturesque figures but imagine land and its power to create national subjectivity quite differently. Old distinctions of class and gender, rooted in a relation to land, are reinscribed on the new grounds of a national culture. The value of figures like Michael, Margaret, and Lucy—all but natural objects themselves, fixed in the settings in which the poet encounters them if not already buried in them—is inseparable from their proximity to an "English ground." But that Englishness can only be articulated by those more historically and nationally conscious than such proximity permits: the poet who can recognize their ground as England, not France; their piety as "known," if "scarcely"; their present as his past.

For later readers Wordsworth's poems will confirm that what was once habitual or traditional can only be passed on as conscious representation, aided by the medium of print—Schiller's sentimental literature forever distanced from a naive poetry. Culture, literate culture, intervenes as a mediating term (and the poet as a mediating voice) between examples of traditionary virtues and the subjects of a modern British nation. The second nature of a customary culture so valued by Burke and Wordsworth needs the poet, the orator, the historian before it can serve as a ground for national consciousness.[27] The nation is an audience to be created by these poems of a disappearing rural life. This is Wordsworth as he was read by Victorians like Tennyson or George Eliot. The importance they gave to his poetry of the borderlands for the creation of national consciousness would not have been possible, however, without the significant shift in the symbolism of land that Romantic poetry effected. When "nature" is preferred to landscapes, then the power of shaping and receiving representations—of language and knowledge, of the mental force the Romantics called imagination: the power to be both in nature and out of it—creates new grounds for national subjectivity. The cultural nation whose subjects are enfranchised by their imaginations in Romantic literature challenges claims to citizenship implicit in the landscapes of property and picturesque pleasure: owning or vicariously posssessing land shaped for viewing.

Though maps, landscapes of property or the picturesque, and romantic encounters with nature continue to be produced throughout the nineteenth century, rural scenes emerge from the later eighteenth century as an increasingly important way of representing the nation through land. Unlike English places invoked as Nature or some of those presented earlier as landscapes, rural scenery always signifies a countryside both inhabited and cultivated. Fields, footpaths,

villages, and groves that may appear obscurely or distantly in the maps and landscapes representing other conceptions of Britain are here of primary interest, and scenes of the generic activities that take place in these largely agricultural locales are as much the focus as the land itself. Moreover, unlike images of rural labor that extended the classical pastoral tradition in Renaissance England, these are scenes to be understood in a realist mode. However generalized or mythologized particular representations may be, the rural scene is conceptually located in both space and time. It represents an idea of topographical and historical specificity, a here and now that is somewhere in England in the present or relatively recent past and involves real rural inhabitants including laborers, not simply court or urban visitors in disguise.

Art historians who have traced this imagery tend to see it as a sub-genre of the landscape of property, what Michael Rosenthal refers to as "agricultural landscape" and Christiana Payne characterizes as a cross between landscape and genre painting of everyday rural life.[28] I would stress the tension that develops between rural scenes and landscapes of property in the nineteenth century and suggest that we might more usefully approach them through this tension, which will become clearer if we look at verbal as well as visual representations of the land. Interest in English versions of the "rural" (with its references to Virgilian pastoral and the *Georgics*) has a lengthy history in English literature, reaching back at least to Spenser (the "rural musicke" of *The Shepherd's Calendar*) and Milton (the "rural minstrelsie" of *Comus* and—English in form if not in name—the "rural sights and sounds" encountered by Satan on his visit to Eden in *Paradise Lost*).[29] The term has a new currency in the late eighteenth century, however, in texts like Cowper's "Retirement" (1782):

> The tide of life, swift always in its course,
> May run in cities with a brisker force,
> But no where with a current so serene,
> Or half so clear, as in the rural scene

or Wordsworth's praise of "the milder minstrelsies of rural scenes" in his emphatically English poem, *The Prelude*.[30] By the 1820s and '30s "rural scenes" resonate through middle-class literature like Mary Russell Mitford's very popular *Our Village* (1824–32), subtitled "Sketches of Rural Character and Scenery" and firmly located "in a small village in the South of England" (Preface). Fifty years later Gerard Manley Hopkins can conclude his lament for the destructive cultivation of a grove near Oxford, "Binsey Poplars" (1879), by repeating, with a cherishing, bitter tenderness, a phrase now fraught with an accumulated burden of cultural meanings:

> Rural scene, a rural scene,
> Sweet especial rural scene.

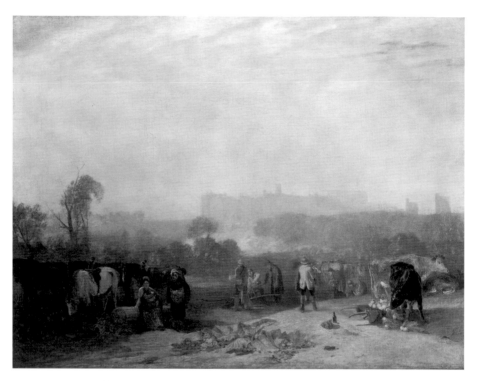

1. J. M. W. Turner, *Ploughing Up Turnips, Near Slough*, exh. 1809, oil on canvas, 102 x 130 cm. Tate Gallery, London/Art Resource, NY.

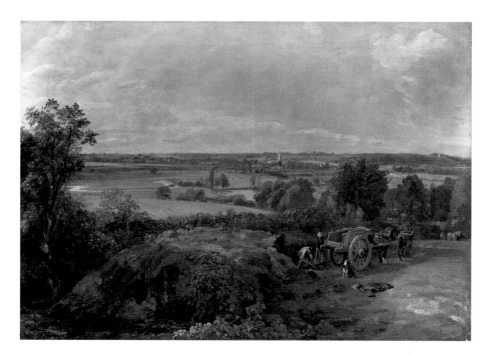

2. John Constable, *The Stour Valley and Dedham Village*, 1814, oil on canvas, 55.5 x 77.8 cm. Warren Collection, courtesy Museum of Fine Arts, Boston.

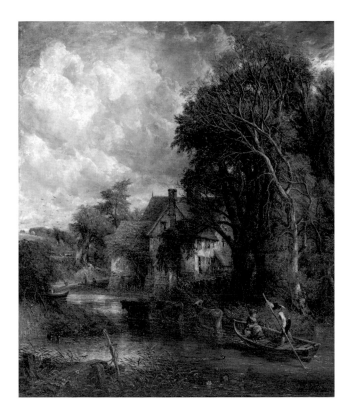

3. John Constable, *The Valley Farm*, 1835, oil on canvas, 148.6 x 125.7 cm. Tate Gallery, London / Art Resource, NY.

Rural scenes appear early in the history of English visual art as well: Michael Rosenthal finds antecedents in Roman and medieval seasonal images for eighteenth-century representations of contemporary land and labor. Yet in the early nineteenth century these scenes acquire a new primacy and a different range of meaning. They can appear georgic when they are placed in the landscapes of property celebrating an agriculturally-based British commercial power; Turner's *Ploughing up Turnips, near Slough* (exhibited 1809; fig. 1) would be a good example. As several art historians have pointed out, such agricultural landscapes, rendered with a new naturalism that attends to details of local topography and agricultural practices, were especially popular during the continental blockade that accompanied the Napoleonic Wars, when farming became a patriotic act.[31] But after 1815 rural scenes are contained with difficulty, if at all, within the conventions and assumptions of landscapes of property. They take on new argumentative functions as competing conceptions of the nation. Literary scenes are more common than pictures, perhaps because the contemporary countryside is frequently too troubling to allow the georgic assumptions of landscapes of property or the vicarious pleasures of aesthetic possession or control. But England's two greatest landscape painters, Turner and Constable, produce in the 1820s and '30s important images which either explicitly challenge the limitations of landscapes of property or substantially alter their scope and meaning by depicting English

rural scenes. Many images in Turner's *Picturesque Views in England and Wales* (1826–38) fall into the first category; the second embraces most of Constable's best-known pictures (such as the *View of Dedham* of 1814, fig. 2; the six-foot canal scenes painted between 1819 and 1825; or the first of his pictures to enter national collections and be widely disseminated in reproduction, *The Cornfield* of 1826 and *The Valley Farm* of 1835, fig. 3). Constable himself described the images assembled in his *Various Subjects of Landscape, Characteristic of English Scenery* (1830, 1833) as consisting more particularly of "the *Rural Scenery* of England" (Preface, my emphasis). Together with poetic and prose accounts of the countryside, these pictures constitute some of the most powerful and influential imaginings of Britain through land from 1815 to the middle of the century. While I cannot elaborate the argument here, I want to suggest, rather briefly and generally, how and why rural scenes after 1815 come to represent Britain differently from the landscape of property—and to represent different Britains.

First, these representations of the local do not seem to work simply as metaphors for Britain, substituting a determinedly local view for an understanding of the nation. Rather, post-war rural scenes often record rather carefully the physical links and economic, social, and political relationships that situate local places *within* a heterogeneous national entity. They register recent changes that implicate local places in national systems—the new fields and hedges of a final wave of enclosure; proliferating roads, canals, and railroads; spreading industrialization; and recurrent, disturbing social protest.

In the second place, such changes are figured (and often read) as displacement or disruption, even when the disjunction is minimized or explicitly denied. Abroad or at home, the reach of national needs into local life meant that for growing numbers of the population, displacement was a common experience—from country to city, from cottage to workhouse, from agriculture to industry or old to new professional identities, from metropole to colonial periphery or back again. "Rural England" for these displaced persons was no more than a real or invented memory; a fiction of origin for Britain and some of her subjects, regardless of the actual trajectory of their new mobilities; a place to come from, irrecoverable except in memory or representation. These displacements neither begin nor begin to be depicted for the first time in 1815. They do, however, produce two of the most interesting features of the rural scenes of the 1820s and '30s. The nostalgia we might expect from post-1870 readings of Tennyson's "English Idyls," Constable's pictures, and even William Cobbett's *Rural Rides* (collected in 1830) is not the dominant mood. Rather, these rural scenes were, at the time of their production, contestatory. They were also consciously staged.

Let me begin with the latter point. The rural scenes of these years do not acknowledge that rural life is disappearing, but they are often curiously marked as reproductions or representations, exhibiting the staged self-consciousness of

the theatrical scene.[32] The songs, stories, or pictures of rural life exchanged in Tennyson's "English Idyls" and *The Princess*, or the heavily worked, paint-encrusted surfaces of Constable's later exhibition pictures advertise the rural as cultural artifact. Constable took pride in the extra finishing of *The Valley Farm* that polished his usual "sleet" and "snow" into "silver, ivory, and a little gold."[33] His language suggests the icon rather than the window into nature. These artifacts, like the melodramas popular on the theatrical stage in this period, provoke interaction among those who consume them.[34] Such interaction—as imagined in the frames to a number of Tennyson's poems before 1850—can model the creation of a collective nation out of difference. The performance of national unity seemed particularly necessary in this period. The landscape of property (evolved during a civil war and after its settlement) assumes the existence of viewers already constituted as a nation by their shared interests and positions. Wordsworth's tales of the borderlands are presented as natural culture, a second nature that could reawaken readers to the unifying force of British origins and British virtues at a time when war with revolutionary France made loyal patriotism both necessary and popular. The audience imagined for post-war rural scenes, however, is apparently assumed to remain heterogeneous and divided unless it can be brought together around a reproduction of rural life, imagined as socially cohesive.[35] In the passages that frame Tennyson's *The Princess* (1847), a group of undergraduates and their female relatives gather at a country house where a Mechanics' Institute picnic is in progress (and a feminist aunt preaches of the rights of women) to create a poem collaboratively. The social experience of creating and consuming a cultural representation thus becomes a means of performing a national consciousness that the author suspects to be hopelessly divided. Or wishes to drastically alter: so radical journalist Cobbett's highly polemical tours attempt to re-write the country he traverses from a perspective that would unify farmers and laborers, wresting the land's meanings out of the hands of literate rulers who write grammars, construct turnpikes, and manipulate production statistics.

For many of their creators and some, at least, of their contemporaries, rural scenes like Constable's, Tennyson's, or Cobbett's reply to the deeply divisive question, focused only in part on the reform of Parliament: Who should constitute the nation? As capital transformed the economics of agriculture and began to shift to industry, conflictual class relations were replacing vertical relations—ideally of deference and responsibility—within a finely articulated system of ranks remembered as more personalized. In the aesthetic representation of Britain, "the country" becomes particularly contested ground, as Cobbett's *Rural Rides* insist and Turner's *England and Wales* views repeatedly remind us. Scenes of touristic pleasure are reread in light of the challenge to landowners by the mobile middle classes demanding a different basis for the franchise that would recognize property that was not land. Those who describe everyday life

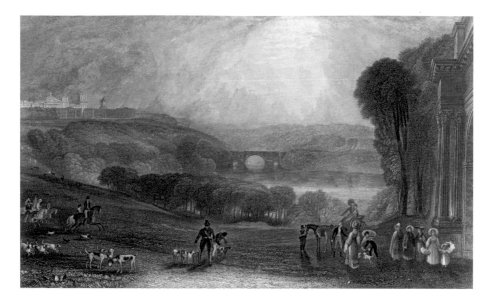

4. W. Radclyffe after J. M. W. Turner, "Blenheim, Oxfordshire," 1833, from J. M. W. Turner, *Picturesque Views in England and Wales*, vol. 2. London, 1838.

ponder its interruption by the claims of rural and urban laborers for bread and the ballot, marked on the land in recurring images of burning haystacks and marching men summoned by the mythical Captain Swing or the Chartists. In the foreground of Turner's *Blenheim, Oxfordshire* (fig. 4) a group of middle-class visitors to that popular national shrine confront a man with a gun from a mounted hunting party on the estate: the plate was published in 1833, just after the passage of the fiercely contested Reform Bill granting such visitors the voting rights hitherto reserved for the landed upper classes. In *St. Catherine's Hill, near Guildford* (fig. 5) the ominously raised arms of contestants and spectators at a back-sword fight in a country fair are picked out against the gathering dark of a storm, capturing the menace of rural popular violence. The contest to define, or redefine, the political nation is frequently so bitter and disruptive that the continued existence of any nation is sometimes in doubt. Land and its changing role in defining relations of power are at the center of the political conflict; representations of the land are increasingly used to contest or reconstitute a national symbol. The disturbed relation of country to nation forces a rethinking of the relationship between land and the nation, and becomes the occasion for presenting different visions of what "the nation" is or could be.

Constable and Tennyson figure directly the competing claims of fixed and mobile property against, for Tennyson, a frequent background of disruption — landowners who have sold up, conflagrations, Chartist pikes, and mechanics' bloody thumbs ("Walking to the Mail"). In Tennyson's "English Idyls" the country is the setting for male friendships cemented in cultural exchanges — initiated by poets or painters whose subject is itself the country ("The Gardener's Daugh-

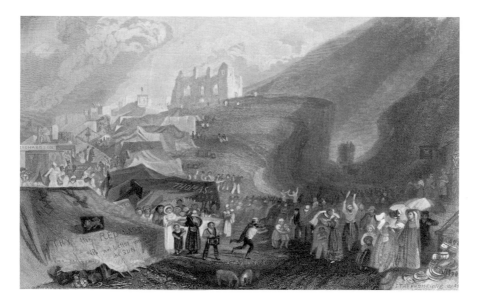

5. J. H. Dernot after J. M. W. Turner, "St. Catherine's Hill, near Guildford, Surrey," 1832, from J. M. W. Turner, *Picturesque Views in England and Wales*, vol. 2. London, 1838.

ter," "Audley Court," *The Princess*). These fellowships replace disrupted familial and social structures anchored in a relation to land. For Constable, rural scenes could become portable icons, movable household gods to accompany the displaced rural bourgeois and his family to the city (or the colonies), where they might help to reconstitute his household by blessing it with distinctively English presiding presences. This at least is the way he came to understand his own paintings, which he liked to have visibly around his new home in London. They were "real property to my children" that might take the place of a family business by *representing* the Suffolk lands of his father's corn milling and shipping. They constructed for the artist "a kingdom of my own…both fertile & populous" in which pictures of the rural places he had left enabled a newly national sense of belonging: his personal kingdom was also "my own dear England."[36] The generations of emigrants who used prints of his paintings to bring England with them to distant colonies understood them much as he did. According to an 1877 account, *The Valley Farm* (fig. 3) — with its cottage and family group glimpsed down a broad, slow-moving stream as if through the haze of glorifying memory suggested by Constable's ivory, gold, and silver lights — "has its representatives all over the world, east, west, north, and south, wherever the English tongue is spoken…Thus has English blood fructified throughout the world."[37] Constable and Tennyson attempt to reconstitute Englishness around the mobility of representations while evoking the stability of fixed property in land. Their efforts depend on our recognizing that the use and meaning of rural scenes differ from those of georgic landscapes of property.

6. W. J. Cooke after J. M. W. Turner, "Plymouth Cove, Devonshire," 1832, from J. M. W. Turner, *Picturesque Views in England and Wales*, vol. 2. London, 1838.

Turner's *England and Wales* is a less wishful account. Many of his views, in which "poetic" Turnerian landscapes are the settings for scenes of contemporary social and political activity, show a land not easily representable within older conventions of landscape. His figure scenes are too prominent, rendered in a graphic style recalling Hogarth's satiric cityscapes that both contemporary and modern critics (from Ruskin to Ronald Paulson) register as out of place, disfiguring what are otherwise aesthetically impressive landscape views, what Paulson calls "Turner's graffiti."[38] It is not simply through size or style that Turner's figures deface his landscapes, however; the Hogarthian manner accords with the matter — who these people are and what they are doing — to make these English scenes reflect ironically on the aesthetic and social order implied by landscapes of property. From the litter and license of the carousing sailors in *Plymouth Cove, Devonshire* (fig. 6) to the more literally transgressive activities of a smuggling populace in *Folkestone, Harbour and Coast to Dover, Kent* (fig. 7), Turner's landscapes are often the setting for a contemporary history in which those who inhabit the land do not observe the boundaries of taste or property that should govern a country of landed estates. Contemporaneous with Turner, Cobbett and the rural laborer-poet John Clare are more overtly critical of inherited landscape conventions. They articulate alternative understandings of lived relations to land that invoke use rather than ownership as the basis for national citizenship. Cobbett had already protested, several years before Turner drew his *Folkestone*, the bitter irony by which the round towers shown in Turner's view, once intended to

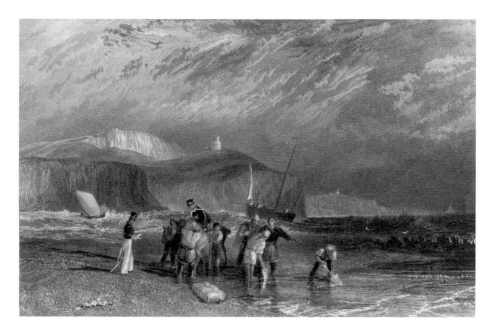

7. J. Horsburgh after J. M. W. Turner, "Folkestone, Harbour and Coast to Dover, Kent," 1831, from
J. M. W. Turner, *Picturesque Views in England and Wales*, vol. 1. London, 1838.

protect the populace against invasion from France, were now used by customs
officers to protect England from the English—the local populace who supple-
mented their meager incomes with smuggling.[39]

In the same years differently critical versions of rural England were produced
by middle-class women writers. Emily Brontë and George Eliot (writing later of
the 1830s) explore what is for the most part not problematic for their male con-
temporaries: how or whether women's different relations to the land might give
them that "living force of sentiment in common" that Eliot called "national con-
sciousness."[40] Unconvinced by either landowning or labor as grounds for Eng-
lishness, they imagine moments of identification with the alienated, wandering,
or un-English that expose deep fissures within the imagined rural community
and its metaphoric equivalent, the nation. They imagine rural places as scenes of
transitions, which do not easily support the coherent identity of persons or
nations. Quite the opposite: they are created by remembering, by wandering in
fact or imagination. The passage is painful. It retraces experiences of separation,
diffusion and dispersal, performing self and community as fissured by, and para-
doxically, constituted through, difference and incoherence.[41] Eliot's Maggie Tul-
liver and Daniel Deronda root themselves in cherished memories of provincial
childhood places only to discover difference or disinheritance at the center of the
scenes that they have taken as a sign of their Englishness, the "mother tongue of
the imagination."[42] Emily Brontë's poems and fiction continually imagine a self
that is both here and there, exiled and at home as it moves across the vividly

evoked Yorkshire moors, while it is also plural, a warring multiplicity of speaking presences. Her narratives and scenes trace the distance between privilege and deprivation as a pattern of repeated reversals in which the empowered and the disempowered sustain a common universe as they change positions. But Brontë also celebrates, through two imagined female characters, the difficult but exhilarating embrace of incoherence and absence of fixed location. Her A. G. A., the shadowy, politically ambitious, continually faithless lover-heroine of the Gondal Saga, has a restless grandeur neither contained nor comprehended by even the most loyal of her followers when he imagines her finally at rest in a rural spot, her grave. Brontë returns to the same ironic rewriting of a Wordsworthian scene at the end of *Wuthering Heights*, where the efforts of another Englishman to speak a woman's epitaph are gainsaid by signs that the elder Catherine lives on after her death as at once Catherine Earnshaw, Catherine Linton, and Catherine Heathcliff. She haunts the scene of her painfully lived separations, the moors that divide and unite the Heights and the Grange, while her more conventional daughter can only inhabit one place, and one identity—within a single patronymic household—at a time.

Brontë's and Eliot's rural scenes approach a limit beyond which representations of the land and rural life lose their power to motivate social collectivities, at least national ones. For them, as for John Clare, the land is inscribed with memories of exclusion, separation, exile, dispossession—histories that maps, liminal spots, and landscapes have often been used to obscure. These rural scenes, born of a time when both particular ideas of Britain and even the possibility of national coherence were openly contested, were for contemporaries one place where that contest was engaged. Even the apparently reassuring scenes of Tennyson or Constable are marked by signs of disturbances they are invoked to dispel. These images, despite the legacy of nostalgia in which they have been fixed since at least the 1880s, should remind us that the imagery of an English land need not always serve conservative ends. Like other forms of the imagery by which a national identity is constructed around the land—including maps, romantic spots of time, and landscapes of property—they may also be read, indeed may once have been read, to question allegiances they now appear to have installed as an unproblematic national heritage.

This essay is reprinted by permission of Princeton University Press from Elizabeth K. Helsinger, *Rural Scenes and National Representation: Britain, 1815–1850.* Copyright © 1997 by Princeton University Press.

1 W. J. T. Mitchell, "Imperial Landscape," in Mitchell, ed., *Landscape and Power* (Chicago: University of Chicago Press, 1994), 5–34.

2 The phrase is Benedict Anderson's, from *Imagined Communities: Reflections on the Origin and Spread of Nationalism* (London: Verso, 1983, rev. ed. 1991), 22. For recent scholarship critical of landscapes as an ideological form, see, for example, Raymond Williams, *The Country and the City* (New York: Oxford University Press, 1973), John

Barrell, *The Dark Side of the Landscape: The Rural Poor in English Painting, 1730–1840* (Cambridge: Cambridge University Press, 1980), and Ann Bermingham, *Landscape and Ideology: The English Rustic Tradition* (Berkeley: University of California Press, 1986).

3 On the particular uses of land in national imaginings, a good point of departure is Colin Williams and Anthony D. Smith, "The National Construction of Social Space," *Progress in Human Geography* 7 (1983): 502–18. On the problem of reifying selective versions of history by embodying them in territory, see Nicos Poulantzas, *State, Power, Socialism*, trans. Patrick Camiller (London: NLB, 1978); also Edward W. Soja, *Postmodern Geographies: The Reassertion of Space in Critical Social Theory* (London: Verso, 1989). On the homogenizing tendencies of rural, as opposed to urban, space as symbolic territory, see Iris Marion Young, *Justice and the Politics of Difference* (Princeton: Princeton University Press, 1990), esp. chap. 8; on the elision of local differences in the substitution of rural southeastern England for Britain, see Alun Howkins, *Reshaping Rural England: A Social History, 1850–1925* (London: HarperCollins Academic, 1991) and "The Discovery of Rural England," in Robert Colls and Philip Dodd, eds., *Englishness: Politics and Culture, 1880–1920* (London: Croom Helm, 1986); and Martin J. Wiener, *English Culture and the Decline of the Industrial Spirit* (Cambridge: Cambridge University Press, 1981).

4 See my *Rural Scenes and National Representation: Britain, 1815–1850* (Princeton: Princeton University Press, 1997). This essay is adapted from a section of the introduction to that book and draws on material in chapters on Constable and Turner.

5 Richard Helgerson, "The Land Speaks: Cartography, Chorography, and Subversion in Renaissance England," *Representations* 16 (Fall 1986): 56. I draw on this article and Helgerson's subsequent *Forms of Nationhood: the Elizabethan Writing of England* (Chicago: University of Chicago Press, 1992) in this section. The identification of a nation with the body of its monarch was one way that individual feudal land-holding lords had been gradually subordinated to a single king in medieval Europe.

6 Adam Anderson in 1801 formulates the concept of national territory as analogous to the private property of which it was conceived to be composed: "By dominion is to be understood property, or a right of possessing and using any thing as one's own…as particular persons…so countries and territories, like greater manors, divided each from the other by limits and borders, are the public properties of nations, which they possess exclusively of one another's"—*An Historical and Chronological Deduction of the Origin of Commerce, from the Earliest Accounts…Containing an History of the Great Commercial Interests of the British Empire* (London, 1801), 3:350. Quoted in Sudipta Sen, "The Colonial Mapping of India: A Study in the History of Cartography" (unpublished paper, University of Chicago, 1993). On the extensive remapping of England in the later eighteenth and early nineteenth centuries, see Nicholas Alfrey and Stephen Daniels, eds., *Mapping the Landscape: Essays on Art and Cartography* (Nottingham: University of Nottingham, Castle Museum, 1990), esp. Alfrey, "Landscape and the Ordnance Survey, 1795–1820," 23–27; see also J. B. Harley, "The Re-Mapping of England, 1750–1800," *Imago Mundi* 19 (1965): 56–97.

7 In addition to Williams, *Country and the City;* Barrell, *Dark Side of the Landscape;* and Bermingham, *Landscape and Ideology,* see also John Dixon Hunt's *The Figure in the Landscape: Poetry, Painting, and Gardening during the Eighteenth Century* (Baltimore: Johns Hopkins University Press, 1976); Michael Rosenthal, *British Landscape Painting* (Ithaca: Cornell University Press, 1982); and James Turner, *The Politics of Landscape: Rural Scenery and Society in English Poetry, 1630–1660* (Oxford: Oxford University Press, 1979). Few of these works, however, discuss the uses of landscape as national rep-

resentation, but see Stephen Daniels, *Fields of Vision: Landscape Imagery and National Identity in England and the United States* (Princeton: Princeton University Press, 1993) and (in passing) Andrew Hemingway, *Landscape Imagery and Urban Culture in Early Nineteenth-Century Britain* (Cambridge: Cambridge University Press, 1992).

8 Verbal and visual landscapes do not work in quite the same ways to suggest the national in the local, however. Locodescriptive verse or prose can articulate the metaphoric relations between particular and national views, between private and national properties—as, for example, when Marvell's seventeenth-century poem "Upon Appleton House" explicitly links the order of the private garden to that of the garden isle of England, recently disturbed by civil war; or when James Thomson's *The Seasons*, published in parts in the 1720s, '30s, and '40s, uses extensive prospects of private property to meditate on British liberty and prosperity. Landscape paintings and drawings (or landscaped estates) may acquire metaphoric meaning in the context of such explicit discussions. Otherwise they must suggest their Britishness by allusion or juxtaposition—by including historical ruins or figures, for example, or by insertion into series of national scope (collected views of great houses like *Britannia Illustrata*, first issued in 1707–8, of British antiquities, or, by the late eighteenth century, of picturesque scenes arranged as British tours). Toward the beginning of the nineteenth century landscape painting becomes a generic national signifier: the landscape painting of Gainsborough or Wilson or the watercolorists is claimed as a distinctively national art wedded to particularities of English atmosphere or flora or English genius; see William Vaughan, "The Englishness of British Art," *Oxford Art Journal* 13, no. 2 (1990): 11–23; also Michael Rosenthal, "Landscape as High Art," in *Glorious Nature: British Landscape Painting, 1750-1850* (New York: Hudson Hills Press and the Denver Art Museum, 1993), 13–30. Verbal landscapes are never as fully nationalized.

9 The complementarity of landscape and map is also evident in the use made of new maps of Britain by landscape artists; see Alfrey and Daniels, *Mapping the Landscape*. Steven Daniels looks in particular at Constable's and Turner's use of new maps in "Re-Visioning Britain: Mapping and Landscape Painting, 1750–1820," in *Glorious Nature*, 61–72.

10 On the occlusion of social relationships in landscapes, see (besides Williams, *Country and the City;* Barrell, *Dark Side of the Landscape;* and Bermingham, *Landscape and Ideology*) Mary Louise Pratt, *Imperial Eyes: Travel Writing and Transculturation* (London: Routledge, 1992), and the essays in several recent collections: Denis Cosgrove and Stephen Daniels, eds., *The Iconography of Landscape: Essays on the Symbolic Representation, Design, and Use of Past Environments* (Cambridge: Cambridge University Press, 1988); Simon Pugh, ed., *Reading Landscape: Country–City–Capital* (Manchester: Manchester University Press, 1990); and Mitchell, ed., *Landscape and Power*. On the politics of address implied in the form, see especially Denis E. Cosgrove, *Social Formation and Symbolic Landscape* (Totowa, NJ: Barnes and Noble, 1985) and Nancy Munn, "Creating a Heterotopia: An Analysis of the Spacetime of Olmsted's and Vaux's Central Park," unpublished paper.

11 See the *OED;* Raymond Williams, *Keywords: A Vocabulary of Culture and Society* (New York: Oxford University Press, 1985), 81; also Richard C. Trench, *Dictionary of Obsolete English* (New York: Wisdom Library, 1958, reprint from undated publication), 138.

12 On the connections between landscape and land-reclamation projects in Holland, see Ann Jensen Adams, "Competing Communities in the 'Great Bog of Europe': Identity and Seventeenth-Century Dutch Landscape Painting," in *Landscape and Power*, ed. Mitchell. On the shifting patterns of land ownership and tenure as they affect the

shaping of land in England, see Tom Williamson and Liz Bellamy, *Property and Land-scape: A Social History of Land Ownership and the English Countryside* (London: George Phillip, 1987). Landscapes themselves did not always acknowedge their constructed character. The form generally represents land as both culture and nature. Landscapes of property often emphasized some features of the land's human shaping and ordering while disguising others as completely natural.

13 Nancy Munn, "Creating a Heterotopia"; the quotations and discussion below refer to section 3.3 of her article (in manuscript form). Munn uses the term "scene" in this passage to refer to what, following the practice of recent critical work on British material, I refer to as "landscape," that is, a portion of land or a representation of it constituted through an implied viewer. While Munn's account may not hold for all the forms of shaped land Mitchell would include under landscape considered as a medium, it does describe most things designated by the vernacular use of the term, including British landscapes of property.

14 See Alan Liu, *Wordsworth: The Sense of History* (Stanford: Stanford University Press, 1989), who points out the high percentage of still unenclosed waste land in the Lake District of the late eighteenth and early nineteenth centuries, making it a favorite region for the pleasing exercise of finding (or constructing) pictures in wild places — a vicarious or visual enclosure and appropriation especially appealing to those new commercial classes who were not landowners (91–95).

15 On the relationship between domestic and colonial processes of constructing English landscapes in South Africa, for example, see John and Jean Comaroff, "Homemade Hegemony," in their *Ethnography and the Historical Imagination* (Boulder, CO: Westview Press, 1992) and *Of Revelation and Revolution: Christianity, Colonialism, and Consciousness in South Africa*, vol. 1 (Chicago: University of Chicago Press, 1991), esp. chaps. 2 and 3.

16 See Cosgrove, *Social Formation and Symbolic Landscape*, esp. chap. 1; and Barrell, *Dark Side of the Landscape*.

17 John Barrell, "The Public Prospect and the Private View: The Politics of Taste in Eighteenth-Century Britain," in Pugh, ed., *Reading Landscape*, 19–39.

18 William Wordsworth, *A Guide to the District of the Lakes in the North of England* (London, 1810; 5th ed. 1835; reprint London: Oxford University Press, 1970), 92.

19 This is not to say that middle- and upper-class wives and daughters did not look at landscapes (and even produce them, as amateur sketchers); indeed, they were expected to. But they were not the implied viewers (they are often represented as inept viewers) and certainly not the national subjects referred to by such centered views. Hemingway, *Landscape Imagery and Urban Culture*, 60–61, discusses the construction of a masculinized viewing subject by late-eighteenth-century philosophical critics.

20 James Thomson, *The Seasons*, "Summer," lines 1442–44. See Jill Franklin, "The Liberty of the Park," in Raphael Samuel, ed., *Patriotism: The Making and Unmaking of British National Identity*, vol. 3, *National Fictions* (London: Routledge, 1989), 141–59.

21 Thomson, *The Seasons*, "Summer," line 1426.

22 Ibid., lines 1445, 1444.

23 Wordsworth's borderlands function somewhat like Fernand Braudel's "neutral zones" (isolated local pockets of backwardness within a modernizing national and international economy), or Michel Foucault's "heterotopias" (real places, recognizably part of the world surrounding them yet opening onto other times, hence serving some of the critical functions of utopias). See Fernand Braudel, *The Perspective of the World: Civilization and Capitalism* (New York: Harper and Row, 1986), 3:42–45; Michel Foucault, "Of Other Spaces," *Diacritics* (1986): 22–27 (trans. Jay Miskowiec). Saree

Makdisi discusses Wordsworth's spatiotemporal spots in relation to Braudel and Foucault in "Songs of the Tyger: Nature and Empire in British Romanticism" (Ph.D. diss., Duke University, 1993; forthcoming, revised, from Cambridge University Press).

24 Makdisi argues for the structural and functional similarities between Wordsworthian nature and the alien lands and peoples shaping English romantic heroic consciousness in Scott's, Byron's, and Shelley's poetry.

25 Wordsworth, "Michael," line 22; *The Excursion*, Book 1, lines 116–17; "Written in London, September 1802," line 14.

26 Wordsworth, *The Prelude*, Book 12, lines 135, 111, 115.

27 See James Chandler, *Wordsworth's Second Nature* (Chicago: University of Chicago Press, 1984).

28 Rosenthal, *British Landscape Painting*, 28; Christiana Payne, *Toil and Plenty: Images of the Agricultural Landscape in England, 1780–1890* (New Haven: Yale University Press, 1993), 2-3.

29 Spenser, *The Shepherd's Calendar*, "January," line 64; Milton, *Comus*, line 547, and *Paradise Lost*, Book 9, lines 451ff.

30 Wordsworth, *The Prelude*, Book 12, line 200.

31 John Gage first pointed out the new naturalism of landscapes in this period in his *A Decade of English Naturalism, 1810–1820*, exh. cat. (Norwich: Norwich Castle Museum, 1969); Rosenthal, *British Landscape Painting;* Hemingway, *Landscape Imagery and Urban Culture;* and Payne, *Toil and Plenty* each develop it at greater length. Barrell, *Dark Side of the Landscape*, 20–21, suggests the pictures respond to the blockade; see also Rosenthal, 96ff.

32 Landscape painting and theatrical scene painting are linked in the careers of a number of painters, in both the eighteenth and nineteenth centuries: George Lambert, Philippe de Loutherbourg, David Cox, David Roberts, Clarkson Stanfield. The rural scenes to which I refer here, however, provide both the setting and the actions together in the same visual or literary artifact.

33 *John Constable's Correspondence*, ed. R. B. Beckett, (Ipswich: Suffolk Records Society, 1968), 4:278 (29 October 1835).

34 While some drama may produce a passive spectator not unlike the viewer of a landscape, other kinds, particularly the pantomime or the melodrama so popular on the early nineteenth-century stage, encourage a more active dialogue among spectators about what is represented on the stage. See Elaine Hadley, "The Old Price Wars: Melodramatizing the Public Sphere in Early-Nineteenth-Century England," and Kimberly W. Benston, "Introduction. Being There: Performance as Mise-en-Scene, Abscene, Obscene, and Other Scene," both in *PMLA* 107 (May 1992): 524–37 and 434–39.

35 On conflicting audiences for art and the problems of controlling the interpretation of landscapes of Britain in the early decades of the nineteenth century, see Hemingway, *Landscape Imagery and Urban Culture*, and Rosenthal, "Landscape as High Art," in *Glorious Nature*.

36 *Constable's Correspondence*, 6:116 (9 May 1823). For a more extended discussion of Constable's rural scenes, see chap. 1 of my *Rural Scenes and National Representation;* an earlier version appeared in *Critical Inquiry* 15 (Winter 1989): 253–79.

37 Olive Mount Wavertree, *Home Life in England* (London, 1877), 77. The same text appears in *The New Gallery of British Art* (New York, [1884]), 2:n.p.

38 For Ruskin's comments, see *The Complete Works of John Ruskin* (Library Edition), ed. E. T. Cook and Alexander Wedderburn (London: George Allen, 1903–12), 13:152 and

438–39. The phrase "Turner's graffiti" is the title of Paulson's chapter on Turner in *Literary Landscape: Turner and Constable* (New Haven: Yale University Press, 1982), 63–103. Paulson argues for the deliberate reference to Hogarth (21, 28). For a fuller discussion of England and Wales as scenes defacing landscapes, see chap. 5 of my *Rural Scenes and National Representation;* an earlier version can be found in Mitchell, ed., *Landscape and Power*, 103–25.

39 William Cobbett, *Rural Rides* (London, 1830; reprint Penguin Books, 1983), 194. The passage was first published in Cobbett's widely circulated *Political Register* for 1823. Turner's drawing was made c. 1829–30 and the engraving published in 1831.

40 George Eliot, "The Modern Hep! Hep! Hep!" in *Impressions of Theophrastus Such* (Leipzig, 1879), 255, 250.

41 Jacques Derrida's essay, "Freud and the Scene of Writing," in *Writing and Difference*, trans. Alan Bass (Chicago: University of Chicago Press, 1978), 196–231, is useful for thinking about this; I am grateful to Lauren Berlant for pointing me to it. See also Toni Morrison's novels of history, memory, and place, especially *Song of Solomon* and *Beloved*, and her remarks on "The Site of Memory" in Russell Ferguson, et al., eds., *Out There: Marginalization and Contemporary Cultures* (New York and Cambridge, MA: New Museum of Contemporary Art / MIT Press, 1990), 299–305.

42 George Eliot, *The Mill on the Floss* (London: J. M. Dent, 1956), 36.

The Rough and the Smooth:
Rural Subjects in Later-Eighteenth-Century Art

Michael Rosenthal

RURAL AND FARMING subjects were hardly uncommon in British art. But the impression to be had from various places—numbers of surviving pictures, the relative proportions of them displayed in Royal Academy exhibitions—is that, as Christiana Payne has shown, not until with the French Wars did they become a significant sub-category of landscape.[1] Before 1780 or so, Thomas Gainsborough was alone in painting ploughmen, but only in the 1750s and seldom, before he turned to a countryside filled with shepherds, drovers, wood-cutters, and resting figures, precisely such figures as "fill a place…or…create a little business for the Eye to be drawn from the Trees in order to return to them with more glee."[2] John Hayes considers that there is more to it. He notes the eighteenth-century "disruption of the peasants' independent, yeoman way of life as a result of 'Improvement,'" and suggests that this invested the "simplicities of a rural life, the labours of the countryman, and the concept of a sturdy independent peasantry…with a heightened sentiment…reflecting a profound feeling of disturbance at, as well as nostalgia for, what was seen to be slowly passing." This mood, "consciously or unconsciously, seems deeply to have affected the work of Gainsborough," and was sounded, too, in the writings of Cowper and Goldsmith.[3] Ann Bermingham, writing specifically of *The Watering Place* (fig. 15), recognized both that this and other paintings described "an unmediated and organic relationship between man and nature" and, in a brilliant insight, that

> The life of these country people seems to be their own, for the paintings do not suggest that they work to pay rent or to receive wages…Labor and production are organized not according to the demands of an expanding market, but according to the simple needs of the laborer.

This, moreover, is a landscape that "implicitly rejects the harsh new order as much as Goldsmith's 'Deserted Village.'"[4]

Bermingham understood this rural economy as "an idealized vision of an earlier form of enclosure." Most of the agrarian history published before K. D. M. Snell's ground-breaking *Annals of the Labouring Poor* in 1985 had made it hard to see things in any other way. That history had been concerned to counter the idea that the imposition of the money economy signaled by the first wave of enclosures from around 1750 ushered in the pauperization and proletarianization of the rural poor. The transformation of the moral into a money economy, it was maintained, created employment; and the increase in rural poverty so remarked

8. Thomas Gainsborough, *Mr. and Mrs. Andrews*, c. 1748–50, oil on canvas, 68.8 x 117.5 cm. National Gallery, London.

on in the later eighteenth century was consequent upon an increase in population.[5] That orthodoxy has been further challenged by J. M. Neeson, who argues, on the basis of extensive archival and literary research, that when "common right prospered in the eighteenth century," and when "enclosure acts extinguished common right from most of lowland England in the late eighteenth and early nineteenth centuries, its loss played a large part in turning the last of the English peasantry into a rural working class."[6]

Neeson's conclusions are backed up in much eighteenth-century writing. In 1772, for instance, a self-styled "Country Gentleman" concerned himself with what many feared must be the aftermath of the enclosures of the commons and open fields:

> the great farmer dreads an increase in rent, and being constrained to a system of agriculture which neither his inclination or experience would tempt him to; the small farmer, that his farm will be taken from him, and consolidated with the larger; the cottager not only expects to lose his commons, but the inheritable consequence of the diminution of labour, the being obliged to quit his native place in search of work; the inhabitants of larger towns, a scarcity of provisions; and the kingdom in general the loss of people.

But, as any country gentleman might, this one claimed that such widespread fears were groundless. The money economy would be good for all. Certainly small farmers would have to quit their holdings to become wage laborers; but, in his experience, "they have afterwards earned a very comfortable living, and rejoiced in the necessity which compelled them to it."[7]

9. Thomas Gainsborough, *Gainsborough's Forest*, c. 1746–48, oil on canvas, 121.9 x 154.9 cm. National Gallery, London.

It would be startling had this rural revolution not registered beyond tracts and pamphlets. And, indeed, David Solkin has spotted that, for example, Richard Wilson's *Moor Park* (1765–67) describes the building of fences to enclose fields at the height of the first phase of enclosure, to the apparent benefit of landlord and laborer alike, counterpointing the claims of the "Country Gentleman" and many others besides.[8] Yet, while it is straightforward enough to recognize enclosing, and its results, the ordered landscape of regular fields, we have tended not to keep an eye open for its antithesis, the scenery of common ground. So, to Ann Bermingham's acute recognition of Gainsborough's poor not being wage earners, we can add that this may not have been because they were enjoying the benefits of an earlier form of enclosure, but because, in fact, they were commoners.

Gainsborough seldom painted either fences or hedges: even his ploughmen usually work on patches of ground unbordered by barriers. Enclosures appear exceptionally—in portraits like *Major Dade* (Yale Center for British Art) or, quintessentially, in *Mr. and Mrs. Andrews* (fig. 8). The Andrewses parade before their partly-enclosed and agriculturally-revolutionary farmscape of folded sheep and drilled wheat stubble; but, habitually, in contemporary conversation pieces like *The Gravenor Family* (Yale Center for British Art) the corn stands rather for the fruitfulness of the union, as the crossed tree trunks point up its strength, than

10. Thomas Gainsborough, *Wooded Landscape with Peasant Boy Mounted and Two Horses, Pond with Ducks, Haymakers and Haycart*, 1755, oil on canvas, 92.1 x 102.2 cm., Woburn Abbey. By kind permission of the Marquess of Tavistock and the Trustees of the Bedford Estate.

for efficient farming and is the only agricultural component of the composition. This prompts a suspicion that there may have been plenty of patronal input when the young Gainsborough was commissioned to paint Mr. and Mrs. Andrews. Left to his own inclinations, he did not paint enclosures. In his first great landscape composition, *Gainsborough's Forest* (fig. 9) he gave, among other things, a comprehensive account of the economy of the forest commoners. There is much to which one would draw notice in this painting: the development of a composition out of Ruisdael, the brilliance of the descriptive handling of paint, the beautiful cool light cast from a sky grand with cumulus. But there is, in addition, a very real element of the matter-of-fact. Gainsborough broadcasts this through his very manner. There is nothing new in noting that his style had been learned from the study of seventeenth-century Dutch landscapists—he said so himself—and this art was understood to imitate natural appearances unfiltered through any aesthetic screen. For Horace Walpole it was "the drudging mimicry of nature's most uncomely coarseness," for Joshua Reynolds "a literal truth and a minute exactness in the detail…of Nature, modified by accident."[9] Gainsborough's picture must therefore be viewed as an illusion of the actual appearance of that part of Suffolk then known as the "Woodlands," with the perspective closed with a view to Great Cornard, to add to the authenticity.[10]

11. Thomas Gainsborough, *Wooded Landscape with a Woodcutter Courting a Milkmaid*, 1755, oil on canvas, 106.7 x 128.2 cm., Woburn Abbey. By kind permission of the Marquess of Tavistock and the Trustees of the Bedford Estate.

Varieties of pedestrians and mounted travelers pass through a forest where other figures get on with other things. The woodman, having graded his timber, binds a bundle of faggots, while his dog sleeps and the donkeys which will cart the load browse in the middle distance. The woodman alone works. A youth has paused from digging sand to court a girl—his dog's interested pose tells this—and she may own that cow. People do enough to get what they need and then enjoy leisure, their own society. The forest common supplies fuel, sand for cleaning or building, and food—the cow's milk, the ducks.[11] The oaks carry patriotic associations, and the fact that the travelers in this landscape must have come from somewhere connects the place in imagination with the larger scenery of Britain, showing it as characteristic of the beauties and therefore the virtues of the nation, and thus celebrating the economy of the forest commons. The vast majority of Gainsborough's Suffolk landscapes display this easy coexistence between nature and people—as, we may notice, does the pre-enclosure vista of Sandby's *Hackwood Park* (Yale Center for British Art). Nowhere is this more interestingly done than in the pair of canvases that he finished for Woburn Abbey in 1755 (figs. 10, 11).[12]

Designed as overmantels for chimney pieces, these paintings respectively represent haymaking and a scene with a woodcutter, milkmaid, and ploughman.

The former, painted in a cautious, delicate style appropriate to a commission from a great aristocrat, shows the grass being cut around the village pond and is colored green and gold. Of the figures, only the duo loading the wagon actually labor. Otherwise, a youth slides off his nag but with no great urgency; in the background two old women leaning on a gate inspect things; and to their left another man leans on his rake and chats to a girl who is enjoying the shade. The painting communicates a sense of heat and indolence. Haymaking was a common enough subject in English georgic poetry. In Thomson's "Summer" the entire village occupies the meadow, as an army a battlefield:

> all in a Row
> Advancing broad, or wheeling round the Field,
> They spread their breathful Harvest to the Sun,
> That throws refreshful round a rural Smell:
> Or, as they rake the green-appearing Ground,
> And drive the dusky Wave along the Mead,
> The russet Hay-cock rises thick behind,
> In order gay. While heard from Dale to Dale,
> Waking the Breeze, resounds the blended Voice
> Of happy Labour, Love, and social Glee. (lines 361–70)[13]

Gainsborough does include the "happy Labour, Love, and social Glee," albeit in a minor key. But these, unlike the earlier workers in the Dixton Manor haymaking (Cheltenham Museum and Art Gallery), are no battalions of laborers battling the earth for its fruits: even the horse idly ruminating at the haycock suggests natural abundance easily got at. The imagery of a population living symbiotically with its surroundings gains an edge alongside the *Wooded Landscape with a Woodcutter Courting a Milkmaid*.

Highlighting and scale pull the eye to the woodman asking a dish of milk from a woman, whose cow yields more than enough to spare. Behind are donkeys and a couple heading towards Ipswich (which town may be discerned in the distance). Julian Gardner first pointed out that all these characters occupy common ground separated by a fence from an enclosed field on which a solitary ploughman toils.[14] Keith Snell has added:

> The contrast of the ragged clothes of the man ploughing, with the finery of the milkmaid (with her pails full of milk), and the well-dressed woodcutter, is worth noting. In the enclosed section of the painting, the only indication of material well-being is in the horse and plough—both belonging to the farmer.[15]

While the milk fills the pail, and the common supplies the material needs of all, the enclosure benefits mainly the farmer who employs the ploughman. As the picture is both very beautifully and scrupulously worked, and sophisticated in its

imagery—for that flirtatious incident originates (perhaps ironically) in the courtly art of Watteau—it would appear to celebrate the moral common economy, which, the ancient trunk of the oak tells us, is sanctified through time, over centuries. The painting thus contributes to a debate, then in its early stages, and more normally followed through tracts, pamphlets, and other literary sources, that followed the first great wave of parliamentary enclosures.[16]

Enclosure was nothing new. In Eastern Suffolk enclosed fields had long since been created by assarting, clearing them from woodland, and before this period parishes had from time to time been enclosed by agreement. Now, however, the interested parties, the principal landowners in a parish, were increasingly resorting to parliamentary enclosure. According to Chambers and Mingay,

> Enclosure by Act made it possible to enclose the whole of the open fields, together with the commons and any suitable waste land, at one and the same time, and thus facilitated an important and rapid improvement in farming efficiency. The Act also conferred legal sanctity and finality on the new arrangements, and lastly made it possible for the owners of the greater area of land to force the hand of other proprietors in the village who might be opposed to the change.[17]

Enclosure was promoted in the name of efficiency and profit. In the case of open fields held in common by all the landholders of a village, the consolidation of holdings into individual farms would allow farmers to experiment, to try out advanced agricultural practices that might increase their profits. Common waste—heaths, woodland, moors—was under no regular system of husbandry and was, therefore, a resource hardly being exploited to its full potential for the national good. Land that might supply crops for food or export was literally going to waste. Thus, in 1776 Matthew Peters computed that, in theory at least, over 2.25 million acres of common would remain even after the New Forest and Forest of Dean were reserved for the shipyards. He proposed to put out one third of this remaining common to pasture and the remainder to "tillage, timber, and coppice wood for the use of farms." It made sound economic sense, for if the "present use of…Heaths, is to keep a few ragged sheep in the summer, or breed a poor stunted sort of cattle, scarcely fit for the clothier or the market," then better they should be converted to five-hundred-acre farms, with the Lord of the Manor, whose property common waste legally was, "paying to those who have a right of common by way of purchase, such sum as 12 men on oath may award." Rents and productivity would rise. Commoners would be rewarded with cash for their loss of right.[18]

In this view money, the principal instrument of circulation and exchange, was the prime measure of value. Traditional rights were nothing before law (here, the Enclosure Act). Common right, time-honored and customary, presumed the regulation of relationships between members of rural communities by means

other than laws designed to protect and preserve the ownership of property. Furthermore, it permitted the functioning of a rural economy geared towards ends incompatible with the maximization of productivity to the greatest profit of the enterprising individual, an economy based on barter and exchange, not money. Not only did common right allow commoners to graze animals and keep horses but, as Neeson writes:

> The fuel, food and materials taken from common waste helped to make commoners of those without land, common-right cottages, or pasture rights. Waste gave them a variety of useful products, and the raw materials to make more. It also gave them the means of exchange with other commoners and so made them part of the network of exchange from which mutuality grew. More than this, common waste supported the economies of landed and cottage commoners too.[19]

And, as commoners were not wage slaves, so, as we see in Gainsborough's landscapes, they could work or not, as they chose. Hence, for example, in the later 1750s he pictured an old peasant ruminating in precisely the pose in which Richard Wilson had portrayed a toga-clad, contemplating figure in *Ego Fui in Arcadia*.[20] This man, so quirky in profile as very possibly to be a portrait, enjoys the liberty of a cottage, the common, and time. In the Golden Age of pastoral poetry humanity had had no need to work, and Schlegel would later maintain that laziness was "the one divine fragment of a god-like existence left to man from Paradise."[21]

Idleness was anathema to an improving interest which, conscious of time being money, roundly condemned such leisure. "The poor," thundered Josiah Tucker, "being left to do whatever is right in their own Eyes, become the more desirous of Parish-Pay as a Pension to support them in Laziness, and Indolence and as a Refuge against that Want, which Vice and Extravagance have drove them to."[22] Matthew Peters bemoaned "a false, delusive idea of liberty, as having a right to work, or not, as they themselves may be disposed."[23] Hence, argued the Reverend John Howlett, a wage economy had to be approved of, for it would compel the poor to work.[24] Yet there were dangers even in this solution. Pay too well, and the laborer "will no doubt keep Saint Monday and Saint Tuesday."[25] In 1773 John Arbuthnot summed things up:

> Let not the mistaken zeal of well-disposed but ignorant people, persuade the man of sense that [enclosure] is prejudicial to the Poor…The benefit which they are supposed to reap from commons, in their present state, I know to be merely nominal; nay, indeed, what is worse, I know that, in many instances, it is an essential injury to them, by being made a plea for their idleness; for some few excepted, if you offer them work, they well tell you, they must go to look up after their sheep, cut furzes, get their cow out of the pound, or perhaps say they must take their horse to be shod, that he may carry them to a horse-race or cricket-match.[26]

He makes it plain that the natural obligation of the poor was to work for wages as that of the horse was to pull the plough.

The improving interest did not have it all its own way. In 1767 one writer accused the landlords of becoming "little better than tyrants or bashaws…who when they had less wealth were more sensible of their dependence and connections, and could feel both for the poor and the public upon every emergency." Others accused them of outright theft. It may signal what great anger was aroused that this eighteenth-century verse is still current in the Cotswolds:

> The law locks up the man or woman
> Who steals the goose from off the common,
> But lets the greater villain loose
> Who steals the common from the goose.[27]

David Solkin quotes another writer of 1767, who agreed with the "Country Gentleman" about what was happening in the countryside, but who, unlike him, could take no comfort from it:

> The great objection to inclosing is, that it depopulateth the country, in reducing the number of farms, and annihilating the cottages, by which means members of the lower class of people are not only turned out of doors, but driven to seek a living they many times have not been used to. This is a most abominable practice, spreading further and wider every day. Some are become such mighty possessors of what was dealt out in common to all [land] by the great father of all, as to exclude multitudes from their least share in it…this kind of monopoly is one of the sorest evils under the sun.[28]

Some, like William Ogilvie, thought that, as the earth had "been given to mankind in common occupancy, each individual seems to have by nature a right to possess and cultivate an equal share."[29] Others, for example Nathaniel Kent, held that

> agriculture, when it is thrown into a number of hands, becomes the life of industry, the source of plenty, and the fountain of riches to a country; but that, monopolized, and grasped into few hands, it must dishearten the bulk of mankind, who are reduced to labour for others instead of themselves; must lessen the produce, and greatly tend to general poverty.

He debunked engrossing, as being based on "ill digested calculations" and culminating in "considerable private loss, and public calamity."[30]

A reaction to developments that saw agriculture mainly for its investment potential, and labor in terms of productivity, spread into literature. In Frances Brooke's popular novel, *The History of Lady Julia Mandeville* (1763; 6th edition by 1773), Henry Mandeville writes to his patron, Lord Belmont (Lord of his own Manor), about an engrosser:

It is with infinite pain I see Lord T– pursuing a plan, which has drawn on him the curse of thousands, and made his estate a scene of desolations; his farms are in the hands of a few men, to whom the sons of the old tenants are either forced to be servants, or to leave the village to get their bread elsewhere. The village, large, and once populous, is reduced to about eight families; a dreary silence reigns over their deserted fields; the farm houses, once the seats of cheerful smiling industry, now useless are falling into ruins; his tenants are merchants and ingrossers, proud, lazy, luxurious, insolent, and spurning the hand which feeds them.

In contrast, Lord Belmont

encourages industry, and keeps up the soul of cheerfulness amongst his tenants, by maintaining as much as possible the natural equality of mankind on his estate: His farms are not large, but moderately rented; all are at ease and can provide happily for their families, none rise to exorbitant wealth. The very cottages are strangers to all that even approaches want.[31]

The contrast is between the established Lord of the Manor (who owns the common waste) and the engrosser, who amalgamates small farms, disrupts and destroys, creates the antisocial landscape of silence, and is intimately associated with commercial interests and developing capitalism. The old economy is set up against the new—a literary motif taken up to devastating effect by Oliver Goldsmith.

His enormously popular poem, *The Deserted Village* (1770), was into its seventh edition within two years. Auburn had been the "loveliest village of the plain, / Where health and plenty cheered the labouring swain"; but now, "One only master grasps the whole domain, / And half a tillage stints they smiling plain," and consequently "the sounds of population fail." The peasantry migrate, and as they go, so "the rural virtues leave the land."[32] Goldsmith wrote the poem, he claimed, from his own experience of a "little village about fifty miles from town," which had fallen into the hands of "a Merchant of immense fortune in London," who had turned out the laboring population. "I could wish that this were the only instance of such migrations," he wrote.[33] Advertisements in the press, and an essay by John Scott which emphasized the deleterious effects of new money on the living standard of the rural poor, insisted that Goldsmith's poem was documentary.[34]

Gainsborough, who had painted the moral economy of the commoners with apparent approval and affection when he had been in Ipswich, carried on after removing to Bath in 1759, although he responded to the change of scenery by making his countryside hillier and more wooded. Some paintings show shepherds and drovers. Others, like the *Wooded Landscape with Country Waggon, Milkmaid, and Drover* of 1766, reprise the Woburn *Woodcutter Courting a Milkmaid* in a transformed setting.[35] And then, towards the end of this decade, both

12. Thomas Gainsborough, *Wooded Landscape with Peasant Children, Mounted Peasants and Pack-horses, Figures by the Wayside, and Distant Cottage*, c. 1768–71, oil on canvas, 119.4 x 146.1 cm. Iveagh Bequest, Kenwood, London.

in painted and graphic works, Gainsborough began to show figures on the move, to portray an imagery of migration; and there is reason to follow John Hayes and believe that these pictures of the poor are as powerful and moralistic a response to the changes in the countryside as was Goldsmith's.

The landscape of c. 1768–71 at Kenwood (fig. 12, Hayes, no. 95) features a procession of mounted figures led by a girl and a young boy moving out of the painted space, to our right. In the left background is a cottage, at the bottom right a pair of beggars. The paint is worked delicately, the effects—the translucency of foliage against a light sky, reflections on the still surface of a pond—are breathtaking. It has to be evening, for figures lounge with their backs against the cottage wall, which is done after work, not so early in the morning as would have to be the case were this a summer's sunrise. The cottagers bask in the late sunshine, enjoying good fortune, whereas the beggars are in the shade of penury. And between them is that group of mounted figures, with a nag whose panniers are loaded with produce (carrots, turnips, cabbages), so that it might be, in the changed scheme of things, that these are now wage laborers returning from market, having had to buy what previously the common gave. The subject dis-

turbs the beauty of the painted nature. The beggars are an old woman and a younger one who is slumped by her side. The ginger-headed boy gestures towards them, but the girl responds by turning the other cheek, although their group has vegetables they could give. In the distance the cottagers remain aloof from this inversion of the Good Samaritan.[36]

This is so rare and unusual an imagery that I cannot believe that Gainsborough painted these figures simply "to fill a place…or…create a little business for the eye." The subject did have recent precedents — Hogarth's tight-fisted old maid in *Morning*, a huntsman cheerfully ignoring a cripple, drawn by Laroon — and, in the most suggestive antecedent, a *Flight into Egypt* by Joos de Mompers (Ashmolean Museum, Oxford), where Joseph elects to pass by a beggar precisely in the manner of the young girl. Hugh Belsey reckons that a contemporary Gainsborough drawing illustrates that Bible story, and Gainsborough was a believer and churchgoer whose inversion of the tale of the Good Samaritan ought to catch the eye.[37] Furthermore, we may with some assurance hypothesize that the artist would have been familiar with the writings of Laurence Sterne, including his third sermon, "Philanthropy Reconsidered," which is written around the parable of the Good Samaritan.[38] It opens: "There is something in our nature which engages us to take part in every accident to which man is subject." We cannot but be engaged with such scenes as Gainsborough pictures. So, his imagination afire, Sterne dramatizes the parable, having the Samaritan think "'Good God! what a spectacle of misery do I behold!'" before concluding "I think there needs no stronger argument to prove how universally and deeply the seeds of this virtue of compassion are planted in the heart of man, than in the pleasure we take in such representations."[39] The corollary should be that the spectacle of the withholding of compassion should provoke dismay, misery. It is more complicated than that, though, for Gainsborough invites us, the polite viewers of his paintings, to confirm our own virtuousness by responding properly and morally to the sight of the beggars, while pondering on the extent to which the poor have become so dehumanized as to refuse charity even to their destitute brethren; to abandon what Goldsmith called "the rural virtues" (line 398). This is an imagery of the moral economy's succumbing to the money one. In a Protestant society secular paintings contemplated within the privacy of the house could take on the moralizing functions religious ones in churches served for Roman Catholics and could inspire ethical reflections in their viewers. And, while here Gainsborough makes play with the theme of the Good Samaritan, it is worth briefly noticing that in a related composition (Hayes, no. 107) a woman who is begging with a couple of children is strongly reminiscent of Raphael's *Alba Madonna*.[40]

Gainsborough's response to the shock of the new is complementary to Richard Wilson's in his closely contemporary *Dinas Bran from Llangollen* (1770–71, Yale Center for British Art). This pictures part of the estate of Sir

Watkin Williams-Wynn, where, in a way analagous to Gainsborough's landscapes, figures are scattered around and flocks graze amongst the trees in the middle distance. Some figures chop timber or break branches for fuel (which the poor were legally entitled to do), others fish the river, and in the near distance is the village with its church tower. In its companion piece, *A View near Wynnstay* (1770–71, Yale Center for British Art), nature is so abundant that the peasantry choose to feed a dog from their basket.[41] The naturalness of these images confirms Williams-Wynn as a paternal landlord in the approved tradition, appropriate to his tracing his ancestry to a Welsh king of the ninth century. Although, as we have seen, he was adaptable enough to paint enclosures too, like Gainsborough, Wilson here confirms the virtues of a precapitalist system of land management; in which context it is pertinent that, according to G. E. Mingay, the great landowners like Williams-Wynn or, in Gainsborough's case, the 4th Duke of Bedford, were not agricultural improvers.[42] This directs us to a further point that must be taken into consideration. The rural economy of benign paternalism and a free peasantry, which Gainsborough in particular celebrated in his landscapes, embodied notions of social stasis at variance with the axiom that society was fluid, in a state of constant progress.

In 1771 the Scots political economist, John Millar, typically described society as evolving from hunter-gatherer, to pastoral, farming, and finally a commercial state. He claimed that the dangerous luxury inherent in "the improvement of arts and manufactures" was counteracted by the "constant attention" demanded by ever-expanding kinds of employment, and that there would inevitably be real strains between new money and old wealth in such a developing society.[43] The inevitability of progress and the stresses of modernity were precisely what occupied writers as diverse as Arbuthnot, or Nathaniel Kent, or Goldsmith, who was himself taken to task by George Crabbe in his poem, *The Village* (1783). Crabbe's aim was to paint "the real picture of the poor," because

> Fled are those times, when in harmonious strains,
> The rustic poet praised his native plains:
> No shepherds now, in smooth alternate verse,
> The country's beauty or their nymph's rehearse.

The "village life" was now "a life of pain," and the villagers themselves were brutish and exploited.[44] With this in mind, it is a noteworthy coincidence that at exactly this time, 1783, George Stubbs chose to confirm the death of the old world with the first of his two pairs of haymaking and reaping scenes, following these up with two more in 1785 (figs. 13, 14), subsequently exhibited in the 1786 Royal Academy.

Stubbs's is the agriculture of improvement. These are no free peasants but wage laborers, as we discover by the presence of the mounted farmer. The laborers themselves are kempt and smooth compared with Gainsborough's roughly

13. George Stubbs, *Haymaking*, 1785, oil on panel, 83.1 x 146.9 cm. Tate Gallery, London.

dressed figures but, despite being startlingly undirtied by what in reality is filthy work, are dressed as they would have been.[45] They are posed to itemize working procedures. In *Reaping*, looking from right to left, we have a virtually diagrammatic pictorial account in three stages of how the corn is cut. Christiana Payne has rightly observed that the stubble is too short, and that there are no swathes of unbound corn on the ground; but these would distract the eye from what Stubbs does show—a sober, industrious, obedient, and curiously grateful workforce. By omitting the mounted figure from the haymaking scene, and having the woman address the viewer directly, Stubbs forces the spectator to take that part, which suggests that he was trying to attract as buyers those who would be most sympathetic to his imagery (the farming interest) by inviting their active response. By the 1780s the arguments of the commoners appeared to have been lost, and the *Annals of Agriculture* were being published, so Stubbs might have sensed a market; and if the subsequent publication of prints after these scenes is significant, he may have sensed correctly. Although the debate about the rural poor was still raging, the artist took pains to present the agriculture of improvement as entirely natural, and therefore entirely right, by various simple means. Mature oaks show at intervals along his hedge. These trees grow slowly and thus transfer ideas of longevity to the scene of agricultural practice. In addition, they would instantly be understood as patriotic emblems.[46] His painting laborers to exactly the same format as prize cattle or champion racehorses conforms to that view of the poor which understood their function principally to be to serve their employers.

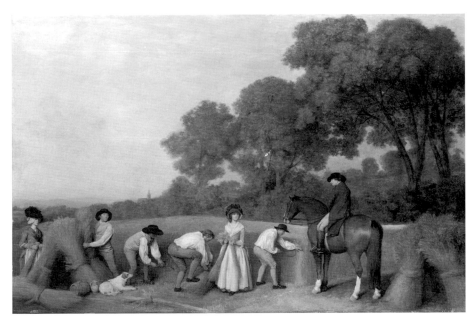

14. George Stubbs, *Reaping*, 1785, oil on panel, 88.8 x 134.7 cm. Tate Gallery, London.

Stubbs's view conforms with that of Thomas Ruggles in the essay, "Picturesque Farming," which he published in the *Annals of Agriculture* in 1788:

> Let us farmers, who immediately see in our daily walks the advantages resulting from labour, be steady friends to the poor…by incitements to honest industry, by an early attempt to fix the industrious principle in the youthful breast…by encouraging those who shew a disposition to fill the station allotted in society with the credit of a good name, and upon this foundation of honesty, industry, and sobriety, let us lead them on to an improvement of their minds proper for their station.[47]

And Stubbs's handling is so self-effacing that we are convinced by it, or by his appearing to picture even laborers as individuals, to take his pictures as representing some truth (although, of course, truth can only be in the mind of the believer).

It would be wrong, however, to presume that these paintings, as much as the progress of agrarian history, meant that the common economy lost credibility for all. Gainsborough continued to paint an imagery of idleness, independence, and sociability but developed it in particular and significant ways. An especially beautiful painting — *Rocky Wooded Landscape with Rustic Lovers, Herdsman and Cows* (Private Collection, Hayes no. 113) — in which a herdsman lazily drives three cows and a goat along a wooded track past rocks that prop up a relaxed youth who chats to a girl, was created around 1774. While the constituents of the landscape are familiar, they are now arranged to refer, both in composition and

15. Thomas Gainsborough, *The Watering Place*, 1777, oil on canvas, 147.3 x 180.3 cm. National Gallery, London.

light effects, to such of Claude's paintings as *The Herdsman* (National Gallery, Washington). Documentation is subsumed into a pictorial fiction which emphasizes the imaginative idealism of this Arcadia. This was no scene we might actually expect to encounter. Neither, in 1777, was *The Watering Place* (fig. 15), which was recognized at the time as making a comparable reference to the bucolic countryside of Rubens, and which John Hayes convincingly suggests may also connect with sixteenth-century Venetian landscape.[48] Here again figures laze in the grand tranquility of a woodland setting, and the independence of the peasantry is reaffirmed. The relation of the composition to a tradition of high art confers upon its subject a status by association, albeit a status that academic painters would argue to be incompatible with low-life subjects. This is underlined by the peasants' inhabiting a world similar to that of Gainsborough's friend, *Dr. Schomberg* (National Gallery, London), who, as we see from his portrait, we must approve of as someone with a sensibility refined enough to enjoy the simple beauties of nature, and who is shown to share the environment of the independent poor.

Gainsborough was virtually alone in maintaining the value—morally rather than monetary—of a traditional rural economy. In his *Cottage Door* scenes the very setting communicates the strength of his commitment. In the earliest of

these (fig. 16) he showed the cottage and its family as a functioning economic unit. The ebullience of the group of women and children is offset by the stooped and grimly anonymous woodcutter, accepting, in the way of a Christ carrying the cross, the burden of labor as the price of his independence. In one of the last (fig. 17) the laborer sits outside his cottage, relaxed and blowing smoke rings. The dwelling blends into the forest in a setting painted to hint at some of the landscapes of Titian. From Edward Thompson we have learned of the forest's being the last refuge of the independent peasantry; and from William Gilpin, writing specifically about the New Forest in Hampshire, we read of the irritations this could create:

> the forest is continually preyed on by the incroachments of inferior people… who build their little huts, and inclose their little gardens, and patches of ground, without leave, or ceremony of any kind. The under-keepers, who have constant orders to destroy all these enclosures, now and then assert the rights of the forest by throwing down a fence; but it requires a legal process to throw down a house of which possession has been taken.[49]

These "inferior people," moreover, were indolent, surviving on furze-cutting and poaching, not wage labor, and eventually getting parish rights. And yet, Gilpin conceded,

> in some circumstances, these little tenements (incroachments as they are, and often the nurseries of idleness) give pleasure to a benevolent heart. When we see them, as we sometimes do, the habitations of innocence, and industry, and the means of providing for a large family with ease, and comfort, we are pleased at the idea of so much utility and happiness, arising from a petty trespass on a waste, which cannot in itself be considered an injury.[50]

Gainsborough's cottage imagery, then, was charged with intimations of anarchy; but, to a "benevolent heart" censure would pale before humane sympathy. Gilpin's echoes Adam Smith's language of sensibility: "Sympathy…may now, however, without much impropriety, be made to denote our fellow-feeling with any passion whatever," and both are evidence for Janet Todd's description of "Sensibility" as a term that "has come to denote the movement discerned in philosophy, politics, and art, based on the belief in or hope of the natural goodness of humanity."[51]

Sensibility, an instinctive, natural morality, supplied a need in a rapidly changing society where ideals of civic virtue were increasingly untenable.[52] Gainsborough's reviewers responded properly to his landscapes and fancy pictures, remarking, for instance, on an imagery "well calculated to move the heart."[53] The problem was, if spectators reacted thus to artistic representations of the poor, they might extend their approval to the moral economy they represented. To some eyes, figures like the ones relaxing in *The Watering Place* were

16. Thomas Gainsborough, *The Cottage Door*, c. 1778, oil on canvas, 122.5 x 149.2 cm.
Cincinnati Art Museum. Given in honor of Mr. and Mrs. Charles F. Williams
by their children.

17. Thomas Gainsborough, *Cottage Door with Peasant Smoking*, 1788, oil on canvas,
195.6 x 157 cm. University of California, Los Angeles, gift of Mrs. James Kennedy.

vagrants, a parasitic threat to the poor rates and laws of settlement, and whom Josiah Tucker for one wanted to deal with by temporary incarceration in solitary confinement and by hard labor.[54] It is pertinent here that an alternative to Gainsborough's sentimental landscapes was developing simultaneously. In Thomas Hearne's *Palemon and Lavinia* or *Autumn* of 1783–84, we are invited to direct our sympathy at a proper target—the young girl of elevated birth, recognized for such and rescued from the harvest field by the aristocrat, whose presence keeps the actual poor firmly at a proper arm's length. In her comic opera, *Rosina* (1783), Frances Brooke explained that she had adapted her story from the Book of Ruth, "a fable equally simple, moral, and interesting," and which had "already furnished a subject for the beautiful episode of Palemon and Lavinia in Thomson's *Seasons*."[55] (This further suggests that subjects like these were serving a Protestant society as religious ones did a Roman Catholic one.) The imperative of maintaining a proper gap between the classes was underlined by Brooke's hero, Belville: "Unveil your heart to me, Rosina. The graces of your form, the native dignity of your mind which breaks through the lovely simplicity of your deportment, a thousand circumstances concur to convince me you were not born a villager."[56]

In a similar opera, *The Reapers* (1770), the proprieties are confirmed by the laborers' speaking a parodic rustic dialect. The same maneuver is effected in a different way by Francis Wheatley, who displays poor who deserve our sympathy because they live according to the norms articulated by their superiors. Each tactic displaces the poor as subject from the direct consideration we must bestow upon them in Gainsborough's landscapes, and it may be because our approval has to be directed at an unambiguously independent peasantry—something that was hardly uncontentious—that these later paintings were not particularly popular. Beechey recalled unsold ones stacked in the corridor of his London house. In addition, as J. H. Pott recognized, in these paintings Gainsborough "seems to have aimed at something more elevated."[57] This was apparent from his artistic cross-referencing—to Rubens, Claude, Titian, the semiology of his technique—and it raised the status and pretensions of his subjects, much as his style and presentation were meant to disabuse us of the illusion that these were such scenes as we might see in common nature.[58] His endowing them with high moral and cultural value was subversive enough to be countered by the efforts of Hearne, Wheatley, and others to bring rural subjects under control, to take them down to size.

It would be fatuous, finally, to conclude from a survey of an amazingly complex subject that painters like Wheatley and, particularly, Stubbs represented the capital economy which was wrecking the moral economy in the countryside, and Goldsmith and Gainsborough the opposite. All of them lived in the real world. Despite his famously declaring himself to be "sick of Portraits" and wishing "very much to take my Viol da Gamba and walk off to some sweet Village

when I can paint Landskips and enjoy the fag End of Life in quietness and ease," Gainsborough displayed no indication of doing anything of the sort.[59] The great advantage with the sentimental landscape was that to respond properly to it confirmed the spectator's exemplary morality in just the way that Charity Sermons explained away the uneven distribution of wordly goods: "the unequal condition of Mankind in general allows due scope to the benevolent affections" and hence was ordained by God.[60] The world that emerged in the later eighteenth century was the agrarian capitalist one detailed by George Stubbs; but the landscapes of commoners, such as Gainsborough's, must serve to remind us that alternatives to that world can exist. Stubbs's landscape of agrarian triumphalism is carefully managed, and we should not be deluded by its illusion of matter-of-fact verisimilitude into believing it to represent the only way of looking at things.[61]

This is a slightly revised version of an essay first published in *Eighteenth-Century Life* 18, n.s., 2 (May 1994): 36–58. While working on it I received invaluable assistance from Alan Godson, Betty Styring, Geoff Quilley, and Sam Smiles. In the longer term I should like to express my gratitude for the conversation of Paul Hills.

1 Christiana Payne, *Toil and Plenty: Images of the Agricultural Landscape in England, 1780–1890* (New Haven: Yale University Press, 1993). Catalogue to the exhibition held at Nottingham University Art Gallery, October 7–November 14, 1993, and the Yale Center for British Art, January 15–March 13, 1994.

2 *The Letters of Thomas Gainsborough*, ed. Mary Woodall, rev. ed. (Greenwich, Connecticut: New York Graphic Society, 1963), 99.

3 John T. Hayes, *The Landscape Paintings of Thomas Gainsborough: A Critical Text and Catalogue Raisonné* (Ithaca: Cornell University Press, 1982), 1:8–9. See also John Barrell, *The Dark Side of the Landscape: The Rural Poor in English Painting, 1730–1840* (Cambridge: Cambridge University Press, 1980), 35–88.

4 Ann Bermingham, *Landscape and Ideology: The English Rustic Tradition, 1740–1860* (Berkeley: University of California Press, 1986), 41, 42, 40.

5 J. D. Chambers and G. E. Mingay, *The Agricultural Revolution, 1750–1880* (London: Batsford, 1966), 96–97. For a survey of the debate, see J. M. Neeson, *Commoners: Common Right, Enclosure and Social Change in Common-Field England, 1700–1820* (New York: Cambridge University Press, 1993), Introduction, particularly 6–8, and Paul Langford, *A Polite and Commercial People: England, 1727–1783* (Oxford: Clarendon Press, 1989), 432–42.

6 Neeson, 12.

7 *The Advantages and Disadvantages of Inclosing Waste Lands and Open Fields, Impartially Stated and Considered by a Country Gentleman* (London, 1772), 7–8, 36.

8 David H. Solkin, *Richard Wilson: The Landscape of Reaction*, exh. cat. (London: Tate Gallery, 1982), 126–27, 232–33.

9 *Letters*, 91. See also Hayes, passim. Walpole is quoted in Thomas Martyn, *The English Connoisseur* (London, 1766), 1:iii, Joshua Reynolds, *The Idler* 79 (20 October 1759) as reprinted in *The Works of Sir Joshua Reynolds*, ed. Edmond Malone (London, 1797), 1:353–56.

10 John Kirby, *The Suffolk Traveller*, 2nd ed. (London, 1764), 1–2. Norman Scarfe, *The Suffolk Landscape* (London: Hodder and Stoughton, 1972), 29.

11 See Neeson, chap. 6, "The Uses of Waste."

12 Hayes, 2:283–86, cat. nos. 51, 50. Hayes considers it very probable that the paintings were for Woburn rather than the Duke of Bedford's London house, and Thomas Pennant, *The Journey from Chester to London* (London, 1782), 351–52, found in the Green Drawing Room at Woburn "A Landscape by Mr. Gainsborough; containing cattle, figures, and an ancient tree: a piece that would do credit to the best masters," which confirms what Hayes infers from the canvases' conformity of measurements and from an overmantel at Woburn.

13 James Thomson, *The Seasons*, ed. James Sambrook (Oxford: Oxford University Press, 1981), 78.

14 The suggestion was originally made during a research seminar at the University of Warwick, sometime around 1980.

15 K. D. M. Snell, *Annals of the Labouring Poor: Social Change and Agrarian England, 1660–1900* (Cambridge: Cambridge University Press, 1985), 172n51.

16 For Gainsborough's iconography see Hayes, 1:77–78; for enclosure, Neeson, chap. 1 and passim.

17 Chambers and Mingay, 78.

18 Matthew Peters, *Agricultura; or, The Good Husbandman...* (London, 1776), 36, 31; see Neeson, 96.

19 Neeson, 158–59.

20 Hayes, 2:393. The Wilson is Solkin, no. 74.

21 Quoted in Edgar Wind, "Hume and the Heroic Portrait," in Jaynie Anderson, ed., *Hume and the Heroic Portrait: Studies in Eighteenth-Century Imagery* (Oxford: Clarendon Press, 1986), 30.

22 Josiah Tucker, *The Manifold Causes of the Increases of the Poor Distinctly Set Forth* (Gloucester, 1760), 6.

23 Peters, 18–19.

24 Neeson, 25–27.

25 *Country Gentleman*, 59.

26 John Arbuthnot, *An Inquiry into the Connection between the Present Price of Provisions and the Size of Farms* (London, 1773), 81, quoted by Snell, 173.

27 Neeson, 22. I heard the rhyme from Alan Godson, late of Broad Campden, Gloucestershire.

28 Solkin, 127.

29 William Ogilvie, *An Essay on the Right of Property in Land* (London, 1782), 6.

30 Nathaniel Kent, *Hints to Gentlemen of Landed Property* (London, 1775), 205, 206.

31 Frances Brooke, *The History of Lady Julia Mandeville. In Two Volumes. By the Translator of Lady Cateshy's Letters*, 2nd ed. (London, 1763), 222–23, 59. For another example of the benevolent landlord in fiction see *Yorick's Skull; or, College Oscitations* (London, 1777), 50ff.

32 Oliver Goldsmith, *The Deserted Village* (London, 1770), 1, 3, 8, 22.

33 Oliver Goldsmith, "The Revolution in Low Life," in *Collected Works of Oliver Goldsmith*, ed. Arthur Friedman (Oxford: Clarendon Press, 1966), 3: 195–98.

34 See *The Public Advertiser*, 29 September 1780; *The Ipswich Journal*, 16 June 1770; John Scott, "On Goldsmith's Deserted Village," in *Critical Essays on Some of the Poems of Several of the English Poets* (London, 1785; reprint New York: Garland, 1970), 247–94.

35 Hayes, no. 87; see also nos. 73–87.

36 For a further discussion of this see Michael Rosenthal, "Landscape as High Art," in Katharine Baetjer, ed., *Glorious Nature: British Landscape Painting, 1750–1850*, exh. cat. (New York: Hudson Hills Press, 1993), 23–25. The painting reproduced as plate 5

would represent a summer's evening, because the angle of light implies a sun low in the sky, and it is far more likely to see people idle, say, at 8:30 pm, rather than at 5:00 am, and it would have made sense for the beggars to have spent all day, not all night, in place. Moreover, this painting is illumined by the warm golden light of evening, not the cold blue light of morning.

37 When the drawing was displayed at Gainsborough's House in December 1993, the caption suggested a link with the composition of the flight into Egypt. It is worth pointing out that Gainsborough would have known Hogarth's *Good Samaritan* at St. Bartholemew's Hospital, and that his erstwhile teacher, Francis Hayman, had painted the subject for Cusworth Hall in 1751–52 (Yale Center for British Art). For this painting see Brian Allen, *Francis Hayman*, exh. cat. (New Haven and London: Yale University Press, 1987), no. 47, and for Gainsborough's then associating with Hayman (39–44). For Laroon, see Robert Raines, *Marcellus Laroon* (London: Routledge and Kegan Paul, 1966), plate 21.

38 Although Gainsborough's antipathy to literature is celebrated by some, he may not have been able to avoid Sterne. Ronald Paulson first connected the two in a suggestive essay in *Emblem and Expression: Meaning in English Art of the Eighteenth Century* (London: Thames and Hudson, 1975), 204–31, esp. 205. William T. Whitley, *Thomas Gainsborough* (London: J. Murray, 1915), 366, tells of Gainsborough's friend Abel's rendering the tale of Lefevre on the viol da gamba which he would not then lay down until "he had made his friend Gainsborough dance a hornpipe on the bottom of a pewter quart pot." Gainsborough was a friend of the actor John Henderson (*Letters*, 92–95) who was besotted with Sterne's writings and known for his readings of them—John Ireland, *Letters and Poems by the Late Mr. John Henderson with Anecdotes of his Life* (London, 1786), 25–40; and, according to George Williams Fulcher, *Life of Thomas Gainsborough* (London, 1856), Mrs. Gainsborough's dog was called "Tristram." For Gainsborough and literature in general, see Marcia Pointon, "Gainsborough and the Landscape of Retirement," *Art History* 2, no. 4 (December 1979): 441–55.

39 Laurence Sterne, *The Life and Works* (New York: J. F. Taylor, 1905), 5:38, 46, 48.

40 The landscape lately in the collections of the Royal Holloway College and in 1996 on loan at the Tate Gallery. Paul Hills points out the connection with Raphael. It is pertinent to this discussion that, as Mary Webster points out, a contemporary painting by Zoffany, *Beggars on the Road to Stanmore*, c. 1768–70 (Cadland Settled Estate) bases its composition on the model of the *Holy Family with St. John*—Mary Webster, *Johann Zoffany, 1733–1810*, exh. cat. (London: National Portrait Gallery, 1976), 59, no. 55.

41 For a detailed account of Wilson's commissions from Watkins-Wynn, see Solkin, 130–31.

42 G. E. Mingay, *English Landed Society in the Eighteenth Century* (London: Routledge and Kegan Paul, 1963), 165–66.

43 John Millar, *Observations concerning the Distinction of Ranks in Society* (London, 1771), passim, quotation from 180–81.

44 George Crabbe, *The Village. A Poem. In Two Books* (London, 1783), 1:5, 7–10.

45 Neil McKendrick, "The Commercialization of Fashion," in Neil McKendrick, John Brewer, and J. H. Plumb, eds., *The Birth of a Consumer Society: The Commercialization of Eighteenth-Century England* (Bloomington: Indiana University Press, 1982), 34–99, 60–62.

46 Payne, 83. For oak trees, see Michael Rosenthal, "The Landscape Moralised in Mid-Eighteenth-Century Britain," *Australian Journal of Art* 4 (1985): 37–49; Stephen Daniels, "The Political Iconography of Woodland in Later Georgian England," in Denis Cosgrove and Stephen Daniels, eds., *The Iconography of Landscape: Essays on the*

Symbolic Representation, Design, and Use of Past Environments (Cambridge: Cambridge University Press, 1988), 43–82; Payne, 83.

47 Thomas Ruggles, "Picturesque Farming," *Annals of Agriculture* 9 (1788): 14.

48 Hayes, 1:125–26.

49 William Gilpin, *Remarks on Forest Scenery* (London, 1791), 2:39. See also E. P. Thompson, *Whigs and Hunters: The Origin of the Black Act* (London: Penguin, 1975).

50 Gilpin, 40–46.

51 Adam Smith, *The Theory of Moral Sentiments*, ed. D. D. Raphael and A. L. Macfie (Oxford: Clarendon Press, 1976), 10. Janet Todd, *Sensibility: An Introduction* (London: Methuen, 1986), 7.

52 For this, see J. G. A. Pocock, *Virtue, Commerce, and History: Essays on Political Thought and History, Chiefly in the Eighteenth Century* (Cambridge: Cambridge University Press, 1985).

53 *The St. James's Chronicle, or British Evening Post*, 29 April–2 May 1780, 4.

54 Tucker, 27–29

55 Frances Brooke, *Rosina, a Comic Opera in Two Acts* (Dublin, 1783), 3. The Hearne is Payne, cat. 40.

56 Brooke, 29.

57 Joseph Holden Pott, *An Essay on Landscape Painting with Remarks General and Critical on the Different Schools and Masters, Ancient or Modern* (London, 1782), 73. Hayes, 1:181.

58 For Gainsborough and Titian, see Michael Rosenthal, "Gainsborough's Diana and Actaeon," in John Barrell, ed., *Painting and the Politics of Culture: New Essays on British Art, 1700–1850* (Oxford: Clarendon Press, 1992), 167–94.

59 *Letters*, 115. Ellis Waterhouse, *Gainsborough* (London: Hulton, 1958), 30.

60 R. Reynolds, *St. Paul's Doctrine of Charity. A Sermon Preached in the Parish-Church of St. Chad, Salop, September the 6th 1759, before the Trustees of the Salop Infirmary. And Published at Their Request*, 29.

61 For this, see also Stephen Deuchar, review of Judy Egerton, *George Stubbs, 1724–1806*, exh. cat. (London: Tate Gallery, 1984) in *Oxford Art Journal* 8, no. 1 (1985): 62–66.

"Calculated to gratify the patriot": Rustic Figure Studies in Early-Nineteenth-Century Britain

Christiana Payne

AROUND THE TURN of the eighteenth century, a major change took place in the representation of agricultural laborers in British art. It has often been noted that many late-eighteenth-century agricultural landscapes are strongly influenced by pastoral conventions: in Thomas Hearne's *Summertime* (fig. 18), and in works of the same period by Richard Westall, Francis Wheatley, and Thomas Rowlandson, some of the workers are suspiciously elegant and refined, appearing to play at rural life in the manner of Marie Antoinette.[1] The women are dressed to reveal shapely necks and arms and trim waists; their small feet and dainty shoes hardly seem compatible with the rigors of field labor. These paintings are not concerned to document agricultural processes. In *Summertime*, for example, the mowing and carrying of the hay are shown as simultaneous operations, although in reality cut grass had to be left in the field to wilt before it could be transported. Such paintings often draw their subject matter from poetry, and, in keeping with the idea of pastoral, the emphasis is on relaxation or flirtation rather than work.

However, some thirty years later, in the work of the generation which included J. M. W. Turner, John Constable, David Cox, and Peter DeWint (fig. 19), the workers appear much more authentic. A remark made by Wilkie Collins, referring to the paintings of his father William Collins, could be applied to the agricultural landscapes of this generation and implicitly points out the contrast with earlier art:

> his villagers and fishermen are not fine ladies and gentlemen, masquerading in humble attire; but genuine poor people in every line of their countenances, every action of their forms, and every patch of their garments; characters, stamped with the thorough nationality of their class.[2]

It was particularly in those three areas specified by Wilkie Collins, physiognomy, occupations, and dress, that the agricultural laborers of early-nineteenth-century artists seem to us so much more convincing than those of the late-eighteenth-century pastorals, and this essay will argue that a group of artists connected with the early history of the Old Water-Colour Society—W. H. Pyne, James Ward, Thomas Uwins, Robert Hills, and Joshua Cristall—made a vital contribution to this development. The character and limits of their "naturalism" will then be discussed. Wilkie Collins's remark defends his father's paintings as true to "Nature," but his reference to "the thorough nationality of their class" suggests that other

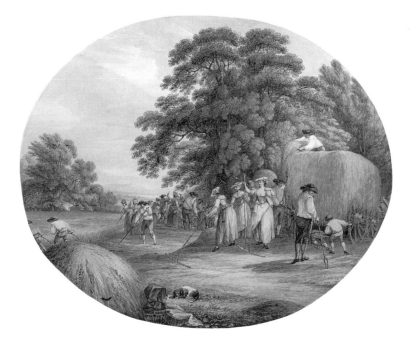

18. Thomas Hearne, *Summertime (A Landscape and Figures from Thomson's "Seasons")*, 1783, watercolor, 27.5 x 32.7 cm. The Whitworth Art Gallery, University of Manchester.

interests may be at stake beyond a simple desire to produce an accurate visual record.

Anne Lyles has written about the studies made of natural detail by this generation, "the better to understand the component parts of a completed view": studies of trees, plants, birds as well as mountains and clouds.[3] There are many studies of rustic figures, by founder members of the Water-Colour Society and their associates, which could similarly be seen simply as studies of natural detail, of component parts of pictures. William Hazlitt, commenting on Gainsborough's fancy pictures in 1814, declared that such subjects should be treated as "studies of natural history." He criticized the self-consciousness and the sentimental pensiveness in expression of Gainsborough's *Girl Going to the Well*, which, he said, were not taken from nature but were intended to improve on nature, and he continued:

> We think the gloss of art is never so ill bestowed as on subjects of this kind, which ought to be studies of natural history. It is perhaps the general fault of Gainsborough, that he presents us with an ideal of common life, whereas it is only the reality that is here good for anything. His subjects are softened and sentimentalised too much; it is not simple, unaffected nature that we see, but nature sitting for her picture.[4]

Hazlitt went on to say (using words echoed by Wilkie Collins some thirty years later) that Gainsborough had led the way to the "masquerade" style which gave

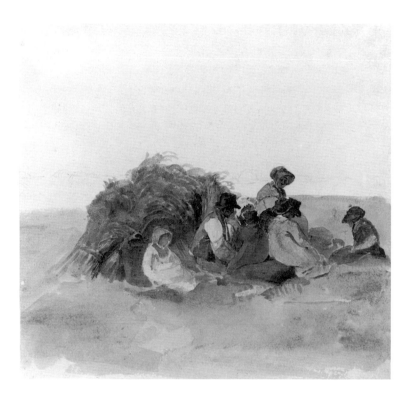

19. Peter DeWint, *Harvesters Resting*, c. 1820, pencil and watercolor with gum arabic, 32.4 x 34 cm. Fitzwilliam Museum, Cambridge.

the air of an Adonis to the driver of a hay cart and modeled the features of a milk-maid on the principles of the antique.

By contrast, the rustic figure studies of Pyne, Ward, Uwins, Hills and Cristall, all of whom were connected with the founding and early exhibitions of the Water-Colour Society, do appear to be "studies of natural history," of "simple, unaffected nature," undertaken in a spirit of scientific inquiry. Three of these artists, James Ward, W. H. Pyne, and Robert Hills, belonged to a Sketching Society which met once a week, from 1800 at least until 1804, to sketch and dis-cuss art, the other members being Samuel Shelley, James Green, and J. C. Nattes. In the summer they made excursions into the country in search of material to study. Three of this group, Shelley, Hills and Pyne, were originators of the scheme to found the Water-Colour Society.[5] Thomas Uwins and Joshua Cristall were not among the founders of the Society but contributed to its exhibitions from an early stage. Ward, Pyne, and Hills were exact contemporaries, having been born in 1769, while Cristall was just one year younger.

It would be hard to believe that members of the Sketching Society did not study rustic figures on their trips to the country, not least because Pyne subtitled his famous *Microcosm* (which he began publishing in 1802) "a Picturesque Delin-eation of the Arts, Agriculture and Manufactures of Great Britain in a series of

above Six Hundred [or, in later editions, a Thousand] Groups of small figures for the embellishment of landscape...the whole accurately drawn from nature and etched by W. H. Pyne." A large proportion of this work was devoted to agriculture, cottage groups, and rural crafts. Individual plates in the *Microcosm* illustrated agricultural occupations in some detail, alerting artists to their picturesque potential as subject matter: the subjects treated included gleaning (fig. 20), ploughing, hay and corn harvests, and hop-picking (fig. 21). In addition, several plates were devoted to cottagers and their occupations, including lace-making and beekeeping. In general, the selection of material in the *Microcosm* was weighted in favor of traditional and rural activities: manifestations of the agricultural and industrial revolutions, such as threshing machines and textile mills, may be mentioned in the commentary, provided by C. Gray for the second edition (1806), but were not chosen for illustration. In its preference for the old rather than the new, *Microcosm* was typical of the Picturesque; its emphasis on work, however, extended the boundaries of what could be seen as picturesque and is an interesting contrast to the well-known preference of Gilpin for the "loitering peasant" rather than the "industrious mechanic."[6]

In two later publications, *Etchings of Rustic Figures for the Embellishment of Landscape* (1815) and *Rustic Figures in Imitation of Chalk* (1817), Pyne stressed the importance of studying country figures from nature: "To become acquainted with the true rustic character, the student must go to nature, and view this class of persons in their occupations." Like Hazlitt, he mocked the absurdity of depicting "a race of gods and goddesses, with scythes and hay-rakes," and he was at pains to stress the need for a distinct style in drawing such figures, using words reminiscent of the distinction made between the "beautiful" and the "picturesque" by Uvedale Price in the 1790s:

> In the classic or elegant figure, the lines should be flowing, unbroken and proportioned with due attention to grace and beauty; whilst those of the rustic character are chiefly composed of lines that are not flowing, nor beautiful, but rather inclined to abruptness and grotesqueness.[7]

Pyne recommended that the student study and copy works by Richard Westall, Thomas Barker, George Morland, Hills, and Cristall; he also announced that he had made some models of the "English peasantry," eight inches high, casts of which were available at the Repository of Arts in the Strand. Unfortunately, none of these appears to have survived.[8]

Of the artists Pyne commended as models, two (Hills and Cristall) were members of his circle. Barker had acquired fame for portrait-like studies of beggars and laborers in the 1790s; Morland was also famous for relatively unidealized studies of the poor from the same period, although he showed little interest in depictions of agricultural work; and Westall was an artist whose agricultural landscapes contained a substantial element of the over-refined "masquerade." In

20. J. Hill after W. H. Pyne, *Gleaners,* from Pyne, *Microcosm*, London, 1806, hand-colored aquatint. Yale Center for British Art, Paul Mellon Collection.

21. J. Hill after W. H. Pyne, *Hop-Picking*, from Pyne, *Microcosm*, London, 1806, hand-colored aquatint. Yale Center for British Art, Paul Mellon Collection.

22. James Ward, *A Wiltshire Peasant*, c. 1810, red and black chalk, heightened with white, 41.7 x 29.2 cm. Courtesy of the Trustees of the British Museum, London.

Pyne's view Westall's compositions exhibited "as much elegance of form and tasteful arrangement as such a style can possibly admit of; indeed, some of the pictures of this artist have a superabundance of these qualities, amounting to a fault."[9]

However, the immediate inspiration for Pyne's studies of agriculture may have come from James Ward, who was a member of the Sketching Society of 1800, although he never joined the Water-Colour Society, probably because he had his sights set on the Royal Academy. In the 1790s he had produced livestock portraits and agricultural scenes, working for landowners with an interest in agricultural improvement, such as Lord Somerville, as well as for the new Agricultural Society of Great Britain.[10] Ward's *A Wiltshire Peasant* (fig. 22) indicates the closeness of his study of the human inhabitants of the agricultural landscape: it is a portrait-like representation of a distinct individual, which emphasizes the effects of hard work down to the curls of sweat-soaked hair clinging to the man's temples. An inscription on the back of the drawing reads "A man in Wiltshire who was in the habit of mowing two acres of grass per day," a tribute to the man's extraordinary industriousness.

Like James Ward, Robert Hills was another member of the Sketching Society of 1800 who made his name with his depictions of different breeds of farm livestock. Between 1798 and 1815 he published a series of 780 etchings of animals to

23. Robert Hills, *Studies of Haymakers,* c. 1804–10, watercolor over graphite, 29.2 x 22.2 cm. Yale Center for British Art, Paul Mellon Collection.

serve as embellishments to landscapes: these were recommended for study by Pyne in 1815.[11] Unlike Ward, however, Hills played a prominent part in the Water-Colour Society and was one of its founder members. He exhibited agricultural landscapes in most of the early watercolor exhibitions: for example, a sketch of ploughing in 1806, and pictures entitled *Harrowing, Ploughing*, and even *Agriculture* in 1808 (nos. 283; 8, 21, and 292). Hills's studies of rustic figures look very similar in format to pages from Pyne's *Microcosm*, although they may be later in date; Hills was still using them for his exhibition pictures as late as 1830. *Studies of Haymakers* (fig. 23), one of a set of four sheets in the Yale Center for British Art, is obviously done from nature and includes annotations, some in handwriting, some in Hills's own shorthand, made to record details in the interest of accuracy: in the top left-hand corner inscriptions read "about five feet in length," "small iron chain," "yokes leaning against a wall," and "net muzzles," all of which refer to the yokes for oxen carefully delineated in this part of the sheet.[12]

These vignettes of rural laborers are lacking in individuality—suggesting that they were undertaken in much the same spirit as Hills's studies of farm livestock—but their poses and dress are remarkably convincing. Precise details, such as the baggy trousers of the haymaker in the top right-hand corner, or the arrangement of bonnet and scarf worn by the woman in the bottom left-hand corner, are quirky enough to suggest observation from life rather than dependence on artistic precedents. Unlike Pyne's *Microcosm*, where lace caps, bare arms, and low necklines give the female figures some of the elegance and allure of late-eighteenth-century agricultural scenes, Hills's female laborers are well protected from the sun by their bonnets, scarves, and long sleeves, which are more practical and, on balance, more likely. The figures Hills studied from life were "transplanted" into compositions such as *A Village Snow Scene* (1819), which also made use of his widely admired skill in the representation of livestock.[13]

Another artist recommended for study by Pyne was Joshua Cristall: he was not a member of the Sketching Society of 1800, but he contributed to the first Water-Colour Society exhibition in 1805, and he began exhibiting "rustic figures" there in 1807. Pyne wrote approvingly of Cristall's work, although Cristall, with his neoclassical leanings, hardly conformed to Pyne's rules about the lines "inclined to abruptness and grotesqueness" which were needed for the accurate delineation of rustic figures. Recommending Cristall's figures for study in 1815, Pyne wrote: "simplicity of character, united with grandeur of style, distinguish his designs."[14] An early exhibition watercolor, *Hop-Picking* (1807; fig. 24), has some of the freshness and seriousness of Hills's studies, as well as a documentary approach to agricultural processes which is reminiscent of Pyne. In fact, Cristall's depiction of hop-picking is rather more in line with what is known of actual practices than Pyne's studies of the same subject in his *Microcosm:* in Pyne's illustration (fig. 21) small groups pick the hops into individual baskets, as if they are gathering them from a small plantation in their own garden. Cristall, however, depicts the operation taking place on a much larger scale, complete with a canvas

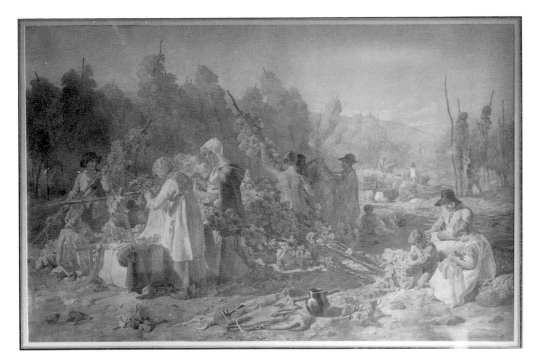

24. Joshua Cristall, *Hop-Picking*, 1807, watercolor, 64.7 x 97.7 cm. Private Collection.

hop-bin with its "horse pole" along the top and, lying in the foreground, one of the hop knives used to cut the hop bines ready for picking.[15] Only the children, who are too small to reach the top of the bin, are shown sitting down to their work. The contrast is significant, because it shows that an exhibition watercolor of this period could actually be more documentary than a book illustration, although one would expect the contrary to be the case. The care with which Cristall has evidently studied the operations involved in hop-picking is indicative of the serious interest taken in agricultural work by this group of artists.

Cristall's study of a *Country Girl with a Sheaf* (fig. 25), of around the same date or a little later, also indicates careful study from nature. This girl is obviously a gleaner—one of the women and children who were allowed into the harvest fields after the wheat had been cut, to pick up any remaining stalks or ears and keep them for their own use.[16] Her features are perhaps too classical to be convincing, but in other respects she is much more plausible than the gleaners in late-eighteenth-century art, or even those of Pyne's *Microcosm* (fig. 20): she stands solidly on the ground, her arms and chest are covered up, and the only hole in her garments comes in a likely rather than a provocative place, at the elbow; most striking of all, her rolled-up overskirt gives her a bulky silhouette, in contrast to the hourglass figures in earlier representations of gleaners. Such realistic details were, however, often toned down in Cristall's exhibited watercolors, and this study is rather exceptional in his work.

It is tempting to conclude that the rustic figures of Pyne and his circle fulfil Hazlitt's demand that such studies should be "studies of natural history." However, while the dress, features, and actions of rural laborers are depicted more accurately than in the work of a previous generation, these drawings give little hint of the poverty, degradation, and unrest which are recorded in written sources of the time. The workers depicted by Cristall, Uwins, and Hills may have torn or patched clothing, but they generally look healthy and contented; while their features may be more plebeian than those of eighteenth-century paintings of rural life, they are not deformed or unattractive. As Sam Smiles points out elsewhere in this volume, these artists stay within the bounds of aesthetic as well as social decorum: even their unexhibited studies have elements of the traditionally beautiful — such as the soft colors in Hills and Uwins's watercolors or the fine drawing of the shirt of Ward's *Wiltshire Peasant* (fig. 22) — which protect them from any charge of vulgarity. In the compositions designed for exhibition (figs. 24, 27) these features are even more marked. Social and aesthetic decorum were, of course, closely linked. John Barrell has shown that Morland's paintings and prints of the 1790s aroused strong disapproval when they hinted at the class conflict and distress of rural life.[20] The work of the Pyne circle, by contrast, represents a very positive and optimistic view of the poor.

It is no coincidence that they date from a time when the fears aroused by the French Revolution were still fresh in people's minds, and when the war against Napoleon made it imperative to encourage national unity. Pyne's *Microcosm* was self-consciously patriotic: it included many scenes of military life — indeed, the very first plate is entitled "Army" — and Gray's commentary in the second edition concluded with praise of Britain's commercial and naval achievements in the French war. Pyne declared in the introduction:

> Though expressly intended to be useful to the student, it is calculated also to gratify the patriot. It is devoted to the domestic, rural and commercial scenery of Great Britain, and may be considered as a monument, in the rustic style, raised to her glory.

Pyne stated that the work set before students "the various modes in which her capital is invested, and by which her industry is employed: in short, the various ways by which she has risen to her present high situation, as one of the first among nations."[21] Similarly, patriotic motives were expressed by George Walker, whose *Costume of Yorkshire* (1814) represented a comparable enterprise to Pyne's. In his introduction Walker wrote: "it is hoped the British heart will be warmed by the reflection that most of the humble individuals here depicted...contribute essentially by their honest labours to the glory and prosperity of their country."[22] Agriculture had special importance in wartime, when its productivity was increased to combat Napoleon's blockade. It is significant that Uwins, having virtually abandoned English rural themes after 1815, returned to them in 1854 in response to another conflict, the Crimean War.[23]

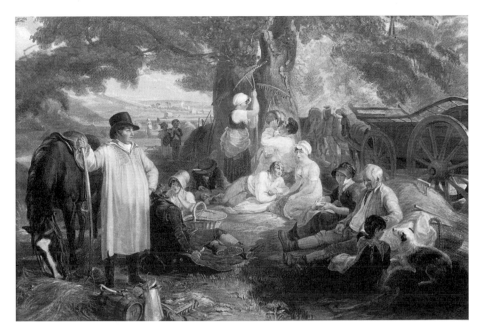

27. Thomas Uwins, *Haymakers at Dinner*, 1812, watercolor, 48 x 70 cm. Victoria and Albert Museum, London.

In this period the encouragement of patriotism went hand in hand with attempts to combat egalitarian ideas. Depictions of reasonably contented rural laborers could be both reassuring and didactic in this respect, deflecting the middle-class viewer's fear of revolutionary unrest and encouraging the lower-class observer to count his blessings. Gray's text to Pyne's *Microcosm* certainly seems to reflect such motivation in the following passage:

> The attentive observer knows well, with how much real equality, amid so much seeming inequality, Nature has distributed the means of happiness Such a person is highly gratified to see our sun-burnt peasants lift the keg of beer to their mouths...Accustomed, perhaps, to drink various wines himself, he envies the superior gratification which exercise bestows on those, who have not the means of procuring any but the homely, unbought blessings of nature.[24]

There is no irony here. Uwins's *Haymakers at Dinner* (fig. 27) actually shows the detail mentioned by Gray: in the center in front of the tree, a man lifts a keg to his mouth. The close study made of rural life by this group of artists may have created some tension between the positive images they were expected to produce and their own awareness of the distress and discontent of rural laborers. In 1828 Uwins made an explicit reference to this in a letter from Naples: "To live amongst the poor in England is painful and distressing, there is so much real misery, and that misery is so much increased by their discontented and fretful character."[25]

Another revealing text is the review of the Water-Colour Society exhibition of 1812, discussed by Andrew Hemingway, which mentions paintings by Hills, Cristall, and Uwins, including Uwins's *Haymakers at Dinner* and a painting entitled *Gleaners* by Cristall. In 1812 the price of wheat reached its highest annual average during the Napoleonic wars as a result of a succession of bad harvests from 1808 to 1811; and in his commentary to Pyne's *Microcosm*, Gray had deplored the meanness of modern farmers towards gleaners.[26] Yet this reviewer described Cristall's gleaners as: "such as we wish to meet in every village…a race of healthy cottage children…The group of figures…raises in the mind of the spectator none but images of pleasure. The gleanings are from a golden harvest and are not scattered with a sparing hand." Hills's *Farmyard* was regarded as "an image of English agricultural comfort arising from modest wealth"; and in Uwins's *Haymakers at Dinner*: "all the characters are stamped with nature; the farmer is an epitome of the independent English yeoman; his labourers are such as English peasantry should ever be—healthy, happy and neat."[27] To this reviewer, then, "stamped with nature"—a phrase similar to that used by Wilkie Collins to describe his father's work—did not necessarily mean a truthful representation of things as they actually were, but rather a depiction of how they should be. He found that the figures of Uwins, Cristall, and Hills personified "smiling peace" and "contentment and innocence," which he associated with the "respectable yeoman" and "decent cottager."[28] Yet, in this same period other observers were complaining that the enclosure of open fields and commons was diminishing the numbers of yeomen and cottagers (a class also praised by Gray in his commentary to the *Microcosm*), reducing them to the status of day-laborers.[29]

The plates in Pyne's *Microcosm* concentrate on processes which had not changed for centuries and ignore the new technology on which national prosperity was increasingly depending. Similarly, Thomas Uwins's figure studies focus on cottage industries, such as lace-making and straw-plaiting, which employed women and children in the home, away from the temptation and corruption of factories. This group of artists seem to have shared a general revulsion against industrialization: Pyne described Cristall's figures in 1824 as "selected from sequestered villages, yet uncontaminated by the vicinity of manufactories."[30] Another reviewer, writing about Cristall's studies of the peasantry, declared: "This class of persons, in districts remote from cities, manufacturing towns and seaports, retain a primeval health, strength and agility, and produce numerous instances of beauty."[31] Such comments were, of course, partly motivated by the need to explain Cristall's classicizing tendencies, but they do seem to reflect an underlying feeling that both the beauties and the virtues of rural life were under threat from the growth of cities and of the factory system. Significantly, Robert Southey in the same period linked the growth of the manufacturing system with revolutionary unrest, declaring that the peasant, if left to himself and allowed to enjoy possession of land, was naturally pious, patriotic, and contented.[32]

The rustic figure studies of W. H. Pyne and his circle, therefore, were not totally devoid of idealization. This group of artists helped to create a new image of the rural laborer, one which was more suited to bourgeois culture than the outmoded aristocratic pastoral of the late eighteenth century, showing rustics who knew their station in life and were "stamped with the thorough nationality of their class," but who also embodied the bourgeois (and, indeed, capitalist) virtues of industriousness and modesty. These artists' studies and exhibition pictures provide evidence of their careful observation of the rural world, especially of the features and dress of agricultural laborers and of the processes and implements involved in rural work. The images they produced are all the more persuasive because so many of the details suggest a "documentary" approach to the subject: yet it is evident that they were aware of the need to "raise in the mind of the spectator none but images of pleasure," to quote the review of the 1812 exhibition, and not to remind him or her of the distress and discontent of the contemporary countryside.

The "naturalism" of the Pyne circle requires both aesthetic and sociopolitical analysis in order to be fully understood and explained. These figure studies cannot be regarded in quite the same light as contemporary studies of clouds, trees, and birds, although they were undoubtedly part of the same "naturalist" movement. Nor can they be seen purely as a development in the Picturesque, although they show both the influence of Picturesque theory and reactions against it. Recent sociocultural interpretations of British painting have been criticized on the grounds that politics was of no concern to the artists, but the political dimensions of these artists' representations of rural laborers are embedded in the very texts which might seem to belong to the aesthetic sphere: the introduction and commentary to Pyne's *Microcosm*, exhibition reviews, and the writings of the artists themselves. Despite the attempt by the theorists of the Picturesque in the late eighteenth century to make a careful distinction between what was desirable in paintings and what was desirable in reality, the artists and critics of early-nineteenth-century Britain evidently operated within a different aesthetic, one in which "naturalistic" paintings represented the world as the bourgeoisie wanted to see it. This shift can be linked to the growth of a wider market and audience for art, reflected in the birth of new exhibiting societies and the proliferation of prints and illustrated books.

The Pyne circle devoted intensive study to a subject which interested many artists of their generation. Parallels to their work can be found in the paintings of J. M. W. Turner, John Constable, Peter DeWint, David Cox, and George Robert Lewis, but in most cases the studies of rural laborers by the Pyne circle predate those by these other artists.[33] The links of the watercolor medium with the "lower," more documentary forms of art such as topography and book illustration may explain why this development should have taken place in a group associated with the establishment of the Society of Painters in Water-Colours; and it

should certainly be seen in the context of the rise of a middle-class market for art, particularly concentrated in the buyers of small, reasonably priced watercolors.[34] Whatever its precise causes, the study of "rustic figures" by Pyne, Ward, Hills, Cristall, and Uwins paved the way for naturalistic — but optimistic — representations of agriculture and rural laborers throughout much of the nineteenth century.

I am very grateful to Andrew Hemingway, Michael Rosenthal and Scott Wilcox for their helpful comments on earlier drafts of this essay

1 For example, *A Storm in Harvest* by Richard Westall (Private Collection); *Noon* by Francis Wheatley (Yale Center for British Art, New Haven); *Harvesters Resting in a Cornfield* by Thomas Rowlandson (Yale Center for British Art, New Haven). All three are reproduced in Christiana Payne, *Toil and Plenty: Images of the Agricultural Landscape in England, 1780–1890* (New Haven: Yale University Press, 1993), cat. 5, 6, and 43. The major exception to this is Stubbs, whose series of paintings of reapers and haymakers do anticipate the accuracy in the representation of dress, occupation, and physiognomy displayed by Pyne and his circle (see Payne, 81–84). Pyne does not seem to have been aware of Stubbs as a precedent, but it may be significant that Stubbs's studio sale, which included drawings for *The Reapers* and *The Haymakers*, took place in 1807, just when Cristall began exhibiting rustic figure studies at the Old Water-Colour Society exhibitions.

2 William Collins, *Memoirs of the Life of William Collins, Esq., R.A.* (London, 1848; reprint Wakefield: E. P. Publishing, 1978), 2:314.

3 Andrew Wilton and Anne Lyles, *The Great Age of British Watercolours, 1750–1880*, exh. cat., Royal Academy of Arts (London: Prestel, 1993), 135.

4 William Hazlitt, "On Gainsborough's Pictures," *The Champion*, July 31, 1814, in P. P. Howe, ed., *The Complete Works of William Hazlitt* (London: J. M. Dent, 1930–34), 11:35–36. The painting he refers to is the *Cottage Girl with Dog and Pitcher*, 1785, now in the National Gallery of Ireland, Dublin.

5 Martin Hardie, *Water-Colour Painting in Britain*, vol. 2, *The Romantic Period* (London: Batsford, 1967), 140. On March 22, 1804, James Ward visited Farington and told him about this Sketching Society — *The Diary of Joseph Farington*, ed. Kenneth Garlick and Angus Macintyre (New Haven: Yale University Press, 1979), 6:2271.

6 For the citation from Gilpin, see Sam Smiles's essay in this volume, page 89. On the *Microcosm*, see John Barrell, "Visualizing the Division of Labour: William Pyne's *Microcosm*," in Barrell, *The Birth of Pandora and the Division of Knowledge* (London: Macmillan, 1992), 89–118. Barrell points out that Pyne concentrates on outdoor employments and thus excludes mechanized industries, such as textile manufacture, because they were not relevant to the landscape artist.

7 W. H. Pyne, *Rustic Figures in Imitation of Chalk* (London, 1817), ii, i. Price regarded roughness, sudden variation, and irregularity as the most efficient causes of the picturesque, distinguishing it from the smoothness and regularity characteristic of the beautiful — Uvedale Price, *An Essay on the Picturesque, as Compared with the Sublime and the Beautiful* (London, 1796), 61.

8 W. H. Pyne, *Etchings of Rustic Figures for the Embellishment of Landscape* (London, 1815), 4–5; Pyne, *Rustic Figures in Imitation of Chalk*, ii.

9 Pyne, *Etchings of Rustic Figures*, 7. On Barker, see Payne, cat. 1 and 2; on Westall, ibid., cat. 5. Morland's rural scenes have been discussed in detail by John Barrell in *The*

Dark Side of the Landscape: The Rural Poor in English Painting, 1730–1840 (Cambridge: Cambridge University Press, 1980), chap. 3.

10 Dennis Farr, *James Ward, 1769–1859*, exh. cat. (London: Arts Council of Great Britain, 1960), 6; on Ward's patrons, see C. Reginald Grundy, *James Ward, R.A.* (London: Otto, 1909), xxxv. Lord Somerville, who commissioned Ward's *Melrose Abbey* (1807; National Gallery of Scotland, Edinburgh), was President of the Board of Agriculture: see E. Clarke, "John, Fifteenth Lord Somerville," *Journal of the Royal Agricultural Society of England*, 3d ser., 8, part 1 (March 31, 1897): 1–20.

11 See note 8; also Hardie, 2:140.

12 Payne, cat. 47–50.

13 Yale Center for British Art, New Haven, Paul Mellon Collection; Wilton and Lyles, cat. 166.

14 Pyne, *Etchings of Rustic Figures*, 7.

15 See R. Filmer, *Hops and Hop Picking* (Princes Risborough: Shire Publications, 1982), 42–43; and Payne, cat. 114.

16 On gleaning, see Payne, 17–18; and P. King, "Customary Rights and Women's Earnings: The Importance of Gleaning to the Rural Labouring Poor, 1750–1850," *Economic History Review* 44, no. 3 (1991): 461–76.

17 Sarah Uwins, *A Memoir of Thomas Uwins, R.A.* (London, 1858), 1:33.

18 Private Collection, photographs in Witt Library, Courtauld Institute of Art, London (Private Collection LXXVI, nos. 133, 140).

19 Private Collection, photographs in Witt Library, Courtauld Institute of Art, London (Private Collection LXXVI, nos. 147, 109, 146).

20 Barrell, *Dark Side of the Landscape*, 128.

21 W. H. Pyne, *Microcosm…*, 2nd ed. (London, 1806), 2:34 and 1:Introduction.

22 George Walker, *The Costume of Yorkshire* (London, 1814), Introduction. This volume includes descriptions of the plates in both French and English, just as the *Microcosm* plates include titles in both languages.

23 On December 2, 1854, Uwins wrote a letter to his friend John Townshend in which he speaks of "the awful contest which is robbing every fireside of its joys" (i.e., the war). He goes on to say that he is "devoting all my time to the homely illustration of an English stubble-field, with the gleaners at their quiet occupation. If anything like quiet can find a place amidst the stirring events around us, my picture will try it"—Uwins, *Memoir*, 1:142.

24 Pyne, *Microcosm*, 1:5.

25 Uwins, *Memoir*, 2:134–35; quoted by J. F. C. Phillips, *Thomas Uwins, R.A., 1782–1857* (London: The Gallery Downstairs, 1989), 15.

26 J. M. Stratton and J. Houghton Brown, *Agricultural Records, A. D. 220–1977*, 2nd ed. (London: J. Baker, 1978); Christiana Payne, "Boundless Harvests: Representations of Open Fields and Gleaning in Early Nineteenth-Century England," *Turner Studies* 2, no. 1 (Summer 1991): 8.

27 *Repository of Arts*, ser. 1, 7 (April 1812): 301–10; discussed in Andrew Hemingway, *Landscape Imagery and Urban Culture in Early Nineteenth-Century Britain* (Cambridge: Cambridge University Press, 1992), 153.

28 *Repository of Arts* (April 1812): 308, 302, 304.

29 See Payne, *Toil and Plenty*, 10–12.

30 *Somerset House Gazette* 35 (June 5, 1824): 130; quoted in Hemingway, 152. The Reverend J. J. Blunt, in *The Duties of the Parish Priest* (London, 1856), emphasizes the need to teach girls in villages to knit and sew in order to substitute "domestic industry and housewifery for labour abroad, in the fields, or at the manufactory; virtuous

seclusion for (what it is to be feared it too often proves) exposure to temptation and shame" (183).

31 *Magazine of the Fine Arts*, 1821, quoted in Basil Taylor, *Joshua Cristall, 1768–1847*, exh. cat. (London: Victoria and Albert Museum, 1975), 34–35.

32 Robert Southey, "On the State of the Poor, the Principle of Mr Malthus' Essay on Population, and the Manufacturing System" (1812), in *Essays, Moral and Political* (London, 1832), 1:112–21.

33 DeWint and Cox began exhibiting agricultural landscapes in 1810. Turner, who knew the Pyne circle through his friendship with W. F. Wells, seems to have turned his attention to a closer study of rural life in 1806 and 1807 (in the Thames sketches and in the "Spithead" sketchbook of October 1807, TB C). Constable's studies of agricultural landscape and rural figures mostly date from 1813 to 1815, but there is a drawing of a country girl on the back of one of the sketches he made in the Lake District in 1806 which suggests the influence of the first book edition of Pyne's *Microcosm*— Graham Reynolds, *Catalogue of the Constable Collection in the Victoria and Albert Museum* (London: HMSO, 1960), no. 92a. G. R. Lewis's harvest scenes, three of which are now in the Tate Gallery, date from 1815 (see Payne, *Toil and Plenty*, cat. 14).

34 Cristall's *Hop-Picking* was sold to a Mr. Boardmore for £42; Uwins's *Haymakers at Dinner* was sold for £31-10-0 to an unknown buyer. Studies of figures by members of this group could sell for much lower prices, however. In 1810 Cristall exhibited *A Gleaner*, sold to Lady Lucas for 3 guineas (no. 241; such names in the lists of buyers show that the patrons of the Water-Colour Society were by no means exclusively middle-class). In 1811 Uwins showed a *Gleaner Leaving the Field*, priced at 5 guineas (no. 314); in 1810 Hills's *Ploughing* (no. 263) was on sale for 5 guineas. Some of these more modestly priced watercolors could well have been studies done directly from nature (Victoria and Albert Museum Library: Water-Colour Society Books of Prices, 86 BB 41–45, 47, 48).

Dressed to Till: Representational Strategies in the Depiction of Rural Labor, c. 1790–1830

Sam Smiles

Some of the most important work in British art history of the past fifteen years has had as its project the interrogation of eighteenth- and nineteenth-century landscape painting and the laying bare of its ideological meaning. Typically, these interrogations make reference at some point to sociological and historical data whose evidence about landscape can be counterpoised to the image of the countryside offered by painting or poetry. Comparisons between the depicted landscape on the one hand and the realities of rural life on the other are intended to demonstrate at the very least that paintings of landscape carried an ideological meaning obliquely related to what we believe to have been true of eighteenth- and nineteenth-century rural society and agricultural practices.[1]

In the light of such analyses it is tempting to regard many pictures of rural life as constitutive of an alternative, mythical world which suppresses or ignores a less pleasant reality. Such images might be considered to have provided a sensuous refuge for consumers who used art as a nostalgic substitute for the reality around them, disavowing it in a massive act of self-imposed amnesia. Thus, it seems feasible to suggest that picturesque landscape was popular primarily because it celebrated a rural culture that was rapidly giving ground to new forms of agricultural organization at the close of the eighteenth century.[2] By the middle of the nineteenth century, however, ignorance is at least as important as suppression. The expansion of an increasingly sophisticated metropolitan art market developed alongside the growing commodification of the countryside into a site of recreation and ease, for the delectation of the urban dweller. The growth of a more searching exploration of agricultural labor and the rural poor, particularly in the social reportage of artists and illustrators associated with *The Graphic* from the 1860s onwards, is testament to the fact that agriculture could become known through its representations alone and that these representations needed to be challenged.[3]

We need to examine the relationship between these two worlds of aesthetics and rural life and attempt to explore what happens to rural workers as they enter the aesthetic domain. If their dress, social relations, behavioral traits, and the like only rarely figure "accurately" in images, if they are often divested of their original identities to put on a more suitable set of characteristics (dressed to till, as my title has it), what is their new function to be? I suggest that we forget for a moment that these pictures may not necessarily correspond with the "truth" of agricultural labor and look instead at what they may represent in their own

terms. I hope to show that rural myth and nostalgia may indeed be part of the meaning of many of these pictures but that there are other layers of representation to examine as well.

Clearly, any examination of these sorts of images must sooner or later address the question of their veracity. Are they fanciful imaginings or accurate depictions of rural life? We pursue that inquiry by examining a variety of contemporary written sources to see how well our images match what we believe to have been true of eighteenth- and nineteenth-century agricultural practice and the rural scene—an approach which has a great deal to recommend it and demonstrates the extent to which we should be wary of taking pictures on trust.[4] But our task is misconceived if we merely conclude, on the basis of written records or other "reliable" documentation, either yes, this is an accurate portrayal, or no, this is a nostalgic myth. Beyond the empirical questions about what pictures depict and the wider concerns about what that subject matter may represent in ideological terms, we need to take account of the function of pictures as aesthetic objects. My contention is that even seemingly objective notation of agriculture in a particular painting is not a species of knowledge analogous to agricultural reports; by virtue of its participation in the aesthetic realm, such an image may be structured in line with ideological biases every bit as pungent as golden-age nostalgia or benevolent paternalism, and this wider containing frame should be seen as the appropriate epistemological context for any discussion of the meaning of agricultural imagery. The veracity of works of art cannot be tested solely by our knowledge of what is "true" in a documentary sense of their subject (whether or not workers actually looked like that, whether or not agriculture was conducted in such and such a way), for by that criterion many paintings of rural life would have to be considered guilty of misrepresentation, while a select few would be singled out as exemplary instances of a more engaged representation. I would like to emphasize instead that pictures of agriculture only operate within the strict limits of what contemporary aesthetics allows and that this aesthetic determinant should be our object of study as much as the images themselves. Artistic precedent and contemporary aesthetic debate provide contexts wherein the adequacy of a representation should be judged because the aesthetic realm controls the semantic field, the available language of representation. Seen from this point of view a picture can be assessed not simply with respect to the "realities" of labor but also with respect to the choices available to it, such that what it's not doing, the options it's not taking up become as important as the ones it employs.

What a picture represents, in other words, is not merely its subject but its own differentiated position within the whole cultural milieu from which it originates and within which it functions. To evaluate a picture of agriculture is to take into account not only what we know of rural life but also what we know of artistic protocols. Having set aside the naive assumption which treats pictures as transparent windows onto the world, we should still be cautious even about

emphasizing imagery as transparently constitutive of ideology; both of these analyses need to be moderated by an emphasis on pictures as functional objects within a cultural system. The meaning of a picture is thus simultaneously icono-logical, its content and that content's ideological position, and material, its status and value within the cultural realm. It is both sign and signifier.[5]

The question remains, therefore, how did agricultural landscape images function in the eighteenth and nineteenth centuries, and what should historians do in attempting to retrieve their presumed original meanings? To put it crudely, what happened when contemporary spectators put down their estate papers or newspapers and looked at works of art? To what extent did the aesthetic realm function as an invitation into a discrete mode of cognition, separated from their practical experience of the world? What I'm suggesting is that we don't limit our inquiries to an iconologically privileged definition of meaning but move on from that understanding to examine how these images were looked at—whether they were seen transparently or as representations.[6] It may be that when we consider the bulk of agricultural paintings we should grant their viewers a more nuanced engagement with them, capable of enjoying them disinterestedly as necessary fic-tions. The meaning of such art, then, would lie in its reception, which stemmed neither purely from nostalgia nor from ignorance but was a form of autonomous enjoyment, something much closer to what Coleridge famously called a willing suspension of disbelief. An art poised self-consciously between observation and aesthetic protocols and its consumption as such needs to be distinguished from mere ideological mystification or a species of false consciousness as regards the world of labor; such an art would need to be considered within a wider ideologi-cal frame regarding the function of art within polite society as a whole.[7]

William Henry Pyne's *Microcosm* first appeared in monthly installments during 1803 and was published as two volumes in 1806 and 1808.[8] It contained a "Series of above a Thousand Groups of small Figures for the Embellishment of Landscape," distinguished from one another by occupation, and was concerned almost entirely with the world of labor. C. Gray's letterpress to the plates provides a rich variety of information on the trades and occupations shown in the illustra-tions, which he normally treats neutrally as transparent documentation of social reality.[9] But in his description of a plate entitled "Rustics" (fig. 28) he makes a comment which explicitly compares the worlds of art and labor:

> Our artist has indulged freely in copying country groups, as there was a gen-
> eral wish for them. And indeed, however disagreeable the manners of rustics
> may be in real life, except to the studiers of manners and character, they are
> peculiarly pleasing in imitation, when accurately copied, whether by the
> dramatist, the poet, or the painter. No subject, when well-treated, is more
> popular, or commands more attention.[10]

What is Gray saying here? It seems that two statements are intertwined. First we

28. W. H. Pyne, "Rustics," from *Microcosm*, vol. 2, London, 1808. Yale Center for British Art, Paul Mellon Collection

have the idea that imitations of rustics, accurately copied, are popular ("there was a general wish for them"), but we are told in the second place that rustics have disagreeable manners which are somehow absent (or, at least, less disagreeable) in imitation, which Gray contrasts with real life. But what kind of accuracy is this which leaves out these rustics' disagreeable manners to make them "peculiarly pleasing in imitation"? A process of translation has occurred from disagreeable reality to pleasing representation, and the key to this translation is that innocent epithet "well-treated." What we are touching on here is a veiled reference to notions of pictorial decorum, which, broadly stated, might be characterized as aesthetic resistance to the demands of unmediated realism.

As an example of this, when we look at Thomas Barker's *Woodman* (fig. 29), not only are we confronted with an individual, George Kelston, whose well-known honesty and industry made him a suitably elevating subject for a picture of the virtuous poor, we are also in the presence of a well-treated subject, popular enough to allow Barker to sell at least four other versions, to have had one of them engraved, and for the figure to have been used on Worcester porcelain and in Staffordshire figurines.[11] Like Gainsborough's fancy subjects of peasants, Barker's figure is perfectly equipped to elicit the correct reaction of sentiment, a refined emotion which was at the forefront of public enthusiasm from the 1770s.

29. Thomas Barker, *The Woodman*, c. 1790,
oil on canvas, 226 x 124.5 cm.
The Lord Barnard, Raby Castle.
Photo: The Mansell Collection, London

Barker's depiction of George Kelston originates in a real woodman, but this point of departure is misleading if we intend thereby to somehow locate the truth of the picture in Kelston's biography, to examine it as a portrait. On the contrary, the truth of this picture is, in fact, located in the generic category "virtuous poor" to which Kelston is fitted; his personality takes on the character of a demonstration, a living reenactment of attributes already established abstractly in the discourse of sentiment. Similarly, the visual language Barker uses has already been established as a generic mode for the depiction of the virtuous poor. Aesthetic expectations are satisfied as George Kelston begins the process of transmogrification which dispenses with his biographical identity to turn him into an exemplar of the honest rural laborer and ultimately into a pottery figurine.

Gray mentions that dramatists and poets might also produce pleasing imitations of rustics, so let me pursue this idea of decorum further by looking at a work of literature written over thirty years later. In 1824 Mary Russell Mitford, the poet and dramatist, began to publish a series of narratives of rural life which she called *Our Village: Sketches of Rural Character and Scenery*. She wished to describe the reality of country life without pathos or sentimentality and based her accounts on the village of Three Mile Cross near Reading. The work

cemented her already substantial literary reputation and proved popular enough for her to develop the approach in other works of the 1830s, but not all the initial reviews were so encouraging.[12] In December 1824 *Our Village* was reviewed in the *Quarterly Review* in terms which repay examination:

> several of the pieces have too much of the manner of Teniers about them; particularly for the productions of a female pencil. They are too broad and Flemish in the outlines, too low in the situations, and too coarse in the expression, although, doubtless, free from intentional offence or impurity of thought. Miss Mitford is painting rural scenes and often humble life, it is true; and we are not fastidious enough to desire that she should people the tufted hedgerows and green uplands, the wild heaths and the shady lanes of her village, with the costumes of the drawing room; as artists in the last century were wont to adorn their prim landscapes with laced macaronies and furbelowed dames. But she seems to have forgotten, or to have yet to learn, that vulgarity is not nature; and that it is very possible…to seize, and to record with fidelity, the peculiarities of uneducated society, without identifying herself too closely with them; to describe the manners, the occupations, and even the pastimes of her rustic neighbours, without adopting their vulgarisms of language, or descending to clothe her ideas in the phraseology of the dog-kennel and the kitchen.[13]

This criticism can be seen as a fuller development of the conundrum I identified in Gray's account of rustics, for it demonstrates quite clearly that the central issue regarding the "vulgar" within the world of arts and letters was not that artists and writers ignorantly or willingly wished to falsify the realities of rural life (which may, indeed, have often been the case), but that the semantics of writing and painting insisted on an aesthetic decorum which set practical limits to what might be set down. These limits, of course, might shift over time and a reviewer in 1824 can scoff at eighteenth-century painters' artificial idylls; but it is also evident that "truth" in the 1820s is obviously meant to be conformable with a decorous aesthetic. Miss Mitford, remember, should be able to describe the peculiarites of uneducated society without identifying herself with them. To record them with fidelity she should not have to employ "their vulgarisms of language…the phraseology of the dog-kennel and the kitchen." Once again, the issue of translation into what Gray would call a "well-treated" mode of depiction is of concern here.

It is fortunate for my purposes that the *Quarterly Review* felt it necessary to make references to painting to substantiate its criticisms, for it demonstrates, I think, how important the visualization of the vulgar had become in this period, how the developing tradition of low-life representation in pictures had determined the limits of realism within polite society. References to Teniers and "Flemish outlines" indicate that distinctions in eighteenth-century academic

30. George Morland, *Morning—Higglers Preparing for Market*, 1791, oil on canvas, 69.8 x 90.2 cm. Tate Gallery, London.

theory between a low art that addressed the senses and a high art that addressed the mind were still current, in conservative quarters at least, well into the nineteenth century. We need to remember that this academic view of Flemish art saw it essentially as an art of realism and criticized it for its inability to escape the vulgar, for its preoccupation with detail and with unidealized documentation, and for its consequent inability to elevate the mind of the spectator above the routine, the base, and the commonplace. By definition, painters who took low life as their subject-matter ran the risk of abandoning the decorum of art for a vicious "Flemish" wallow in filth, rags, and squalor. What saved most artists from this was their compliance with that shifting boundary of taste which dictated just how much vulgarity was conformable with the fastidious dictates of aesthetic fashion. Our knowledge of where that boundary line was drawn comes from reactions to artists or to individual works that obviously transgressed it. It is important to emphasize, however, that this boundary not only shifted its position from one generation to another but also within generations, such that one critic's enthusiasm might be another's disgust.

A further example of aesthetic scruples exercised by the "vulgar phraseology" of low art is afforded by John Eagles, the critic and artist, attacking the work of George Morland in 1833 (fig. 30):

31. Richard Westall, *A Storm in Harvest*, 1796, oil on card, loosely mounted on canvas, 58.8 x 78 cm. Private Collection. Photo: Courtauld Institute of Art, London.

> What can be more annoyingly vulgar than Moreland's pictures…?–where there is not an atom of sentiment–where all that is not mud and dulness is disgusting–…where the colours are all crude and unmeaning–where the figures are of the basest low vulgarity, the man a wretch, the woman a fool and a slattern, and the brute more endeared and endearing than the human pigs. You would say the man at first sight had been committed as a thief and a vagrant, and whipped: he is a low villain, beats his wife, and kicks his children, and you have pity for neither. Such things are detestable. But they have been called picturesque; and swine, under the privilege of that word, have been admitted into drawing-rooms and boudoirs.[14]

Eagles is hardly a dispassionate witness and is known for his association with the more conservative arbiters of taste in this period, but it is telling, I think, that we hear the same rhetorical tone in this passage and in the review of *Our Village*. Both of them make the emphatic point that an unmediated representation of low life cannot be allowed because without mediation, without low life being "well-treated," low life itself will invade the polite world. Eagles goes on to suggest that such art is a form of contamination and that, when collectors come to their senses and repent, like prodigal sons, "of their occupation of participating

32. James Ward, *The Swineherd*, 1810, oil on panel, 70 x 80 cm. City of Bristol Museum and Art Gallery.

in the husks," the rooms will need to be purified. Aesthetic decorum insists that the language of the kitchen and the dog-kennel is not heard in the drawing room, that the swine are kept out of the boudoir.

In contrast, if we look at Richard Westall's *A Storm in Harvest* of 1795 (fig. 31) and Joshua Cristall's *Hop-Picking* of 1807 (fig. 24) we can see how agricultural practices might be brought within the aesthetic realm without causing offense, where the workers' dignified features are consonant with the technical refinement of their treatment. There may be a shift in emphasis from using professional models, as Westall is suspected of doing, to sketching real workers and idealizing the results, which seems to have been Cristall's procedure, but both of these images speak in polite language when compared with the coarser accents of their contemporaries, Morland and his brother-in-law, James Ward.[15] Ward's *Swineherd* (1810) (fig. 32) in particular, for all its connotative possibilities as a moral subject picture of the prodigal son, is uncomfortably physical in its treatment of animal husbandry and might stand for everything that Eagles detested.[16] I think it is worthwhile to look closely at the paint handling and composition of these pictures if we're to get any purchase on polite or vulgar treatments of the rural worker. There is a very real sense in which the more finished features in Westall and Cristall's workers help to keep them at a distance, the objects of our

leisurely scrutiny as we enjoy their smooth lineaments and regular features, but with Morland and Ward's workers there is something in the physical application of the paint, an urgency in the technique, a ruggedness of effect that makes for a more abrasive encounter. With the Ward especially there is a sense of uncomfortable proximity, but even the Morland is less easy to accommodate than the Westall or the Cristall. Although Morland's defenders were prepared to separate his technical facility from his uncouth subjects, Eagles's references to "crude and unmeaning" colors demonstrate the extent to which style itself could be seen as part of the insult. It is as though the paint Morland uses comes from the world he depicts, as though the picture is bespattered rather than painted. Within this active paint surface his figures lack that smooth modeling that might keep them unobtrusively at a distance; at that range and on that scale they should have less impact than they do, but their lumpen presence is insistent.

At this point we should return to Pyne, for I have quite deliberately taken most of my examples from the artists he chose in a later work to exemplify "English pastoral," "that species of landscape composition which best suits rustic figures of the humble class," as he put it.[17] One might imagine that Pyne intends to contrast his own detailed observations of rural workers with the more mannered, poetic treatment of pastoral, but in fact he advises his readers to learn from these artists even though he is mindful of the extent to which the tradition of English pastoral has seen an accommodation between truth and poetry. Pyne notes that Gainsborough's "poetic fancy" allowed him to idealize his peasants and that Barker is his artistic heir, that Westall's "elegance of form and tasteful arrangement" is occasionally overdone, that Cristall is distinguished for "grandeur of design," and that Morland provides breadth and "a just observation of character," but all of them will help the student of rural England to undertake the depiction of its workers.[18] The study of rustic figures is thus to be accomplished within a tradition and should satisfy the demands of art as well as of nature.

Let's come at this problem from another angle. So far I've been suggesting that notions of aesthetic decorum acted like gatekeepers, allowing only certain levels of representational precision to pass through, such that some contemporary commentators might be provoked when decorum was challenged by representations which failed to translate low life into a suitable aesthetic language. Is there any corresponding evidence to demonstrate that artists and other spectators of the rural scene were aware of these limits of representation and the fact that aesthetic and social understandings of that scene were in competition? I believe that such evidence can frequently be found and that it has implications for our understanding of this sort of painting. For example, William Gilpin's recommendations on picturesque landscape are well known, but it's worth reminding ourselves of how he insisted on separating the picturesque perception of landscape from other levels of understanding. The point to note is that these other levels were there already, as a hindrance to picturesque contemplation as far

as Gilpin was concerned, and had to be overcome. In arguing for an appreciation of landscape that subordinates these other comprehensions of it, Gilpin provides us with some inkling of how his audience normally understood the rural scene:

> In a moral view, the industrious mechanic is a more pleasing object, than the loitering peasant. But in a picturesque light, it is otherwise. The arts of industry are rejected; and even idleness, if I may so speak, adds dignity to a character. Thus the lazy cowherd resting on his pole; or the peasant lolling on a rock, may be allowed in the grandest scenes; while the laborious mechanic, with his impliments of labour, would be repulsed.[19]

Or again, writing of the picturesque appreciation of landscape, "It is not it's business to consider matters of utility. It has nothing to do with the affairs of the plough, and the spade; but merely examines the face of nature as a beautiful object."[20]

In insisting that the aesthetic and more practical approaches to landscape be separated, he suggests that an eighteenth-century audience was capable of making distinct evaluations of the same phenomenon, that they could see landscape as an economic or a picturesque entity. My point is that if they could do this for actual landscape, then perhaps their approach to pictures of landscape might be delimited as an aesthetic activity with no necessary implication for their wider understanding of agriculture outside the aesthetic realm.

On this analysis the power of images is attenuated precisely because their sphere of operations is recognized by contemporaries as tangential to real life. The impact of any picture is caught up in wider questions concerning the place of art in British society in the late eighteenth and early nineteenth centuries. We might want to argue that, if art of this period had any serious moral intent, its business was to show the world not as it was but as it might be. Equally, however, there is a world of difference between aspiration and delusion. To use twentieth-century terminology, it would have been a category error to confuse a painted landscape and a real one, to believe that a wholesome representation of benevolent agriculture and an ordered social world necessarily stood in anything other than a poetic relationship to agriculture itself.[21]

We can catch this discriminating approach to landscape in a further example. T. H. Williams was a printmaker and drawing master working in Exeter in the early 1800s. His picturesque guides to Devon provided an important part of the tourist's information on the county, and he may be seen as instrumental in helping to develop aesthetic interest in the scenery of the southwest of England. In his *Picturesque Excursions in Devonshire and Cornwall* (1804) Williams pauses in his description of a summer evening near the river Tavy to consider the life of the cottagers, whose chimney smoke casts a pleasing indistinctness over the scene as a whole. At first the account is a standard encomium on the importance of agriculture, the real wealth of the state lying in the industry of its inhabitants, the

modest pleasures of a cottage life, etc. But then a darker note is sounded:

> Can any mind receive delight from the richest assemblage of rural objects
> where there is poverty amongst the inhabitants?…The common repast of the
> labouring families, in this part of the country, is tea; it is their dinner, proba-
> bly increased by a few potatoes, and at the tea-hour of the evening it is alone
> their supper: on a Sunday the coarsest part of animal food is their luxury…
> Leaving this subject, which embitters every rural walk, renders as fabulous all
> the delightful visions of country life imbibed in youth, and reduces to fic-
> tions, extravagant as Arabian tales, the descriptions of poets, we return to the
> tranquil Tavey, silently flowing down the vale.[22]

Not the least interesting aspect of this passage is how Williams negotiates the
double swerve from aesthetic contemplation into social observation and out
again. No apology is offered, no special excuse presented for treating his readers
thus; he expects them to follow him, just as Gilpin expected his readers to under-
stand him a generation earlier. What distinguishes these two sorts of contempla-
tion, however, is that Gilpin expected his readers to elevate picturesque appreci-
ation over other knowledge and experience which could not be included in an
aesthetic response. Williams, on the other hand, is the heir to Archibald Alison's
association theory, first promulgated in his *Essays on the Nature and Principles of
Taste* (1790), and expects his readers to allow their knowledge and experience to
inform their reactions. The fact of poverty can therefore be acknowledged within
a work devoted to the picturesque, rather than being overlooked or dismissed as
irrelevant; but even in this more complex reaction to the rural landscape it is sig-
nificant, I think, that Williams can leave the subject of poverty to continue his
picturesque walk. My contention is that Williams provides us with a perfectly
understandable insight into any aesthetic response to landscape: such a response
exists as a separate mode of perception within a whole network of reactions, as a
decision to see rural life as picturesque. Outside that autonomous aesthetic realm
there is no question of mistaking myth for reality.

There is a further point to be made here which has a crucial bearing on the
representation of detailed observation. Alison championed the idea of the well-
stocked mind responding to a much wider set of cues than Gilpin considered
legitimate, such that the imagination's response to a scene, the associations pro-
voked by the landscape, were also to be considered part of its effect. As Williams
puts it, a response limited either to picturesque qualities or to prosaic observa-
tion is no adequate response at all:

> he who, in surveying a landscape, perceives only the relations of its parts, the
> harmony of colouring, and the proper distribution of light and shade, is but
> a superficial observer. – Pictures are like those scenic representations in which
> the spectator's imagination must be the interpreter: the generality, however,
> never conceive anything beyond what is literally represented.[23]

But who are the generality? Alison and his followers set great store by the well-stocked mind, an attitude which necessarily debarred all but the better educated from the true, imaginative appreciation of landscape. If we imagine a hierarchy of well-stocked minds with Alison at the top and the rural poor at the bottom, then the generality will include all the laboring classes and probably a fair proportion of the middling ranks as well. It seems fair to postulate that contemplation of a scene, for the exercise of the imagination, if it is to be distinguished from the generality's limited understanding, will not linger on detail but will instead develop associations on a more abstract level; specific features provide the spur to imaginative rumination, but if the imagination is to exercise its power, it must move away from detail to embrace the wider possibilities details suggest. In this, Alison is shadowing eighteenth-century academic precepts which recommended that painters eschew the detailed, prosaic, and mundane aspect of everyday reality and instead look to the more elevated realm of invention and the ideal. John Barrell has drawn attention to the way in which the elevated prospects and panoramic surveys of eighteenth-century poetry and painting literally lift their authors (and, by implication, their readers and spectators) above the world of distracting quotidian fact in a simulated physical enactment of what academic theory recommended.[24] There is thus a level of aesthetic continuity within the eighteenth century which recommends going beyond the everyday if the mind is to be stimulated. Given this aesthetic demand, the chances of a searching pictorial engagement with the minutiae of agricultural labor are extremely remote.

This immediately leads us back to the breaches of decorum discussed earlier, where excessive adherence to the material world was sharply criticized. We can now add a further dimension to our analysis of what that sort of criticism repudiated. Not only did this culpable art threaten to let low-life invaders into the polite world, with their language of the dog-kennel and the kitchen, but in employing that language, such an art risked showing the world from their viewpoint, where material reality remained unassimilated in any wider scheme of things. Even Wordsworth, who could hymn the rural laborer and celebrate the prosaic, wrote pungently of the imaginative impoverishment associated with a deprived upbringing:

And mark his brow!
Under whose shaggy canopy are set
Two eyes – not dim, but of a healthy stare –
Wide, sluggish, blank, and ignorant, and strange –
…
In brief, what liberty of *mind* is here?[25]

For artists to desert the protocols of aesthetics and embrace a form of realism would imply that they place their spectators not in their normal elevated posi-

tion but down among the customary objects of their gaze, seeing the world as though from under that shaggy canopy, seeing the world through uneducated eyes. As we saw earlier, Ward and Morland's paint handling can be seen as overly material in its textural effects, threatening to reproduce the coarseness of low life in its very facture. The critical disquiet prompted by tendencies towards "Flemish" vulgarity is thus activated by representational strategies which refuse or severely attenuate an aesthetics reliant on idealization, generalization, or transcendence.

If I am right about the importance of the aesthetic realm in offering an alternative to the world of understood agricultural reality, then it is obvious that the pictorial strategies which breached decorum were threatening precisely because they promised to collapse the separate worlds of agriculture and aesthetics into one another. The habit of mind, so elaborately theoretized in the eighteenth century, which might find pleasure and refuge in the aesthetic contemplation of the world, could find no comfort in those pictures which appeared to abandon the aesthetic realm altogether, presenting brute fact without the benefit of mediation. But by the same token, once aesthetic ideals eventually altered to accommodate new modes of depiction, these same pictorial strategies would be included within the aesthetic realm and could no longer threaten to rupture the membrane separating art from life. The development of naturalism in British nineteenth-century painting can be seen, on this analysis, as an aesthetic strategy of containment which allowed a more closely observed understanding of the world to become the stuff of art. Naturalism as an aesthetic device, as a form of representation, dulled the edge of those pictorial strategies which had shocked the more fastidious critics. There is thus a real sense in which many nineteenth-century paintings of agriculture are functionally equivalent to eighteenth-century examples, despite the fact that they sometimes seem to have a better grounding in the realities of agricultural practice. Their consumers could enjoy them because the world they depicted had been made safe through the agency of aesthetic validation. These were pictures you could admit without further thought to drawing room or boudoir, pictures that knew their place.

The conclusion to be drawn from this is, I think, a modest one, a restatement of the point that art operates as a system of representations and that even naturalism is a representational strategy rather than a transparent opening onto the world. I am quite sure, therefore, that any attempt to valorize different images on the basis of their presumed accuracy of notation, which would amount to a sort of empirical test, needs to be resisted. I would resist it not because such evaluations might upset the canon, subordinating imaginative images to documentary ones, but because it merely replaces one aesthetic hierarchy with another. Any account which sees developments in observational accuracy as a progression towards realism runs the risk of asking the wrong questions and operating with too limited an approach to the vexed question of representation. "Realism," I

would contend, makes sense only as a transgressive strategy which threatens the autonomy of art, which might annul the separation of art from life, and as such it cannot be ascribed a set of stylistic traits or a particular mimetic relationship to the real world. A picture of photographic verisimilitude, paying the strictest attention to agricultural practices, is not necessarily any less mythical than an eighteenth-century exercise in georgic celebration. Detailed observation of rural life, no matter how scrupulous, will remain mythical if it operates without demur within a system of representations conformable to the aesthetic expectations of polite society. Realism, on the other hand, is an irruption into that system, a new language of representation whose syntax, accent, and vocabulary are not conformable with a pre-existing aesthetic. Equally, however, the resilience of the aesthetic realm, its ability to reconstitute itself by incorporating disruptive strategies, means that realism cannot maintain a fixed identity or set of practices. As the twentieth century has shown, realism is a project which has to be continually renewed.

1 This tendency is characteristically represented by studies such as John Barrell, *The Dark Side of the Landscape: The Rural Poor in English Painting, 1730–1840* (Cambridge: Cambridge University Press, 1980); David Solkin, *Richard Wilson: The Landscape of Reaction* (London: Tate Gallery, 1982); Michael Rosenthal, *Constable: The Painter and His Landscape* (New Haven: Yale University Press, 1983), Ann Bermingham, *Landscape and Ideology: The English Rustic Tradition, 1740–1860* (London: Thames and Hudson, 1986); Andrew Hemingway, *Landscape Imagery and Urban Culture in Early Nineteenth-Century Britain* (Cambridge: Cambridge University Press, 1992). It would, of course, be over-reductive to consider this tendency as a united front working with an identical methodology. Although this developing historiography exhibits some shared assumptions, there is a spectrum of positions within these approaches and within the subsequent trajectories of their authors' individual development as historians.

2 See Bermingham, 9–85.

3 For Victorian artists and the rural poor, see Julian Treuherz, *Hard Times: Social Realism in Victorian Art* (London: Lund Humphries, 1987).

4 There is, however, a further and inescapable problem concerning this recourse to further texts, that they are themselves constitutive of the very phenomena the art historian is attempting to see straight. We cannot necessarily assume that written texts are in some sense "harder" evidence of the reality within which we wish to situate the work of art.

5 Needless to say, this cultural positioning is itself an ideological product. The idea that art occupies an autonomous space within society, that it may be enjoyed without further implications for understanding that society is, I believe, fundamental to the growth of the art world in the early nineteenth century. Paradoxically, even art that is freighted with spiritual and/or moral imperatives is ring-fenced by this belief in autonomy. Ruskin, more than most, realized the need to end this isolation and to renew the eighteenth-century debate on art's purpose, although now emphasizing its individual rather than its social responsibilities in society.

6 Hemingway in the work cited above provides the most sustained attempt to answer these exceptionally difficult questions, especially in his rigorous working-through of the relations between criticism and the social fractions within British society. See also his "Art Exhibitions as Leisure-Class Rituals in Early Nineteenth-Century London," in Brian Allen, ed., *Towards a Modern Art World*, Studies in British Art 1 (New Haven and London: Yale University Press, 1995), 95–108.

7 What I have in mind here is the application of Wittgenstein's remarks concerning interpretation, "seeing as" and "aspect blindness," especially his insistence that meaning is detected in the uses to which a word is put. Choosing to see a landscape painting predominantly *as a picture* of a landscape is manifestly a different use of it than to see it predominantly as a landscape. See Ludwig Wittgenstein, *Philosophical Investigations*, trans. G. E. M. Anscombe (Oxford: Blackwell, 1974), 193–216.

8 At the time of delivering this paper I had yet to read John Barrell's illuminating discussion of Pyne, "Visualising the Division of Labour: William Pyne's *Microcosm*," in his *The Birth of Pandora and the Division of Knowledge* (London: Macmillan, 1992), 89–118. Although Barrell's emphasis is different, some of his conclusions anticipate mine.

9 Gray's identity and Christian name remain unknown.

10 W. H. Pyne, *Microcosm; or, A Picturesque Delineation of the Arts, Agriculture, Manufactures, etc. of Great Britain in a Series of Above Six Hundred Groups of Small Figures for the Embellishment of Landscape*, 2nd ed. (London, 1808), 2:20 (text) and plate 97.

11 See Philippa Bishop, *The Barkers of Bath* (Bath: Bath Museums Service, 1986), 13–14, 26–27.

12 It is, perhaps, worth noting that while *Our Village* was intended to be free of clichéd sentiment, John Constable thought it "childish & immature…done by a person who had made a visit from London for the first time and like a cockney was astonished and delighted with what she saw." Seen in this light, the strictures of its critics can be seen to have been prompted explicitly by its descriptive strategies rather than its subject-matter, which was hardly contentious. See *John Constable's Correspondence*, vol. 2, *Early Friends and Maria Bicknell (Mrs. Constable)*, R. B. Beckett, ed. (Ipswich: Suffolk Records Society, 1964), 6:323, 325. My thanks to Michael Rosenthal for this reference.

13 *Quarterly Review* 61 (December 1824): 166–67. In this connection it is worth recalling the critical assaults mounted on Wordsworth and Coleridge's *Lyrical Ballads*, especially Francis Jeffrey's in the *Edinburgh Review* of October 1802: "[Their simplicity] consists…in a very great degree, in the positive and *bona fide* rejection of art altogether, and in the bold use of those rude and negligent expressions which would be banished by a little discrimination"—quoted in Derek Roper, ed., *Lyrical Ballads / William Wordsworth and Samuel Taylor Coleridge* (London: Collins, 1970), 410. It is worth remembering, however, that Wordsworth's preface to the *Lyrical Ballads* is a much more judicious defense of his practice than Jeffrey's caricature suggests. Wordsworth begins with an assault on the polite expectations surrounding poetry: "It is supposed that by the act of writing in verse an author makes a formal engagement that he will gratify certain known habits of association; that he not only thus apprises the reader that certain classes of ideas and expressions will be found in his book, but that others will be carefully excluded"—"Preface" to *Lyrical Ballads*, 4th ed. (London, 1805); in Roper, 19–20. Instead, he has "at all times endeavoured to look steadily at my subject: consequently…there is in these poems little falsehood of description" (ibid., 26). But although Wordsworth claims that he will choose "incidents and situations from common life" and that he will describe them "as far as was possible, in a selection of language really used by men" he quickly qualifies this by asserting that the language

has been "purified…from what appear to be its real defects, from all lasting and rational causes of dislike or disgust" (ibid., 20–21). Furthermore, a poet's duty is to order and select so that he may please his readers and remove "what would otherwise be painful or disgusting in the passion" (ibid., 32). To some extent, therefore, although the terms have changed, Wordsworth's "formal engagement" with his readers is still maintained.

14 John Eagles, *The Sketcher* (Edinburgh, 1856), 47. Originally published in *Blackwoods Magazine*, April 3, 1833. The best recent discussion of Morland's art and its critical reception is Barrell, *Dark Side of the Landscape*, 89–129. This present essay is indebted to that study's perceptions.

15 Christiana Payne, *Toil and Plenty: Images of the Agricultural Landscape in England, 1780–1890* (New Haven: Yale University Press, 1993), 20, 85, 142. For further discussion of delicate physiognomies and refined handling, see John Barrell, "Francis Wheatley's Rustic Hours," *Antique Dealer and Collector's Guide* (December 1982): 39–42.

16 Nygren notes that Ward's handling in this picture owes a debt to Titian, especially in the background and the head of the swineherd. This figure was probably derived from studies made of a laborer working for Thomas Crook of Tytherton, Wiltshire, whom Ward had met in August 1807. See Edward John Nygren, "The Art of James Ward (1769–1859)" (Ph.D. diss., Yale University, 1976), 52–53.

17 W. H. Pyne, *Etchings of Rustic Figures for the Embellishment of Landscape* (London, 1815), 6.

18 Ibid., 5–8.

19 William Gilpin, *Observations, Relative Chiefly to Picturesque Beauty, Made in the Year 1772, On Several Parts of England; Particularly the Mountains, and Lakes of Cumberland, and Westmoreland* (London, 1786), 2:44.

20 William Gilpin, *Remarks on Forest Scenery, and other Woodland Views (Relative Chiefly to Picturesque Beauty): Illustrated by the Scenes of New-Forest in Hampshire* (London, 1791), 1:298.

21 My thanks to Michael Rosenthal for an illuminating discussion of this point.

22 T. H. Williams, *Picturesque Excursions in Devonshire and Cornwall* (London, 1804), 75–76.

23 Ibid., 23–24.

24 See John Barrell, "The Public Prospect and the Private View: The Politics of Taste in Eighteenth-Century Britain," in J. C. Eade, ed., *Projecting the Landscape* (Canberra: Humanities Research Centre, Australian National University, 1987), 15–35.

25 William Wordsworth, *The Excursion* (1814), viii ("The Parsonage"), lines 407–10, 433 in John O. Hayden, ed., *William Wordsworth: The Poems* (New Haven: Yale University Press, 1981), 2:262.

Land, Locality, People, Landscape:
The Nineteenth-Century Countryside

Alun Howkins

THE ROLE OF A "straight" historian in relation to art history is much more problematic now than it was a few years ago. Then, he or she could have "told the truth about landscape" to the art historian—in other words talked about a kind of anterior "reality" to the paintings. However, a central point of much recent writing on landscape art is the argument that landscape paintings do not present a "natural" account or representation of the world; rather they are the bearers of complex ideological messages. "A landscape is a cultural image, a pictorial way of representing, structuring or symbolising surroundings."[1] These meanings can move from the most general to the very specific. One example of this is laid out by Stephen Daniels in his 1993 discussion of landscape and national identity.

> Landscapes, whether focusing on single monuments or framing sketches of scenery, provide visible shape; they picture the nation. As exemplars of moral order and aesthetic harmony, particular landscapes achieve the status of national icons. Since the eighteenth century painters and poets have helped narrate and depict national identity, or have had their work commandeered to do so.[2]

This way of looking at landscapes has been influential, although perhaps not influential enough, on historians. We have by and large stopped looking at paintings simply as unmediated presentations of a "real world" which simply serve to illustrate our books. However, I would wish to maintain that the historian still has a distinctive view to offer, and this essay is a provisional attempt to bring some thoughts together on this view. I want to start with a different tradition of writing about landscape—the writing of historical geographers and landscape historians working under the influence of W. S. Hoskins. To Hoskins, and those who followed him, the landscape was a complex and evolving entity whose very beauty and meaning was a product of that complexity. In his most famous, and very influential book, *The Making of the English Landscape*, he compares the English landscape "to a symphony, which it is possible to enjoy as an architectural mass of sound." This, however, is unsatisfactory—almost too cultural perhaps. "The enjoyment may be real, but is limited in scope and in the last resort vaguely diffused in emotion." In its place we need to

> isolate the themes as they enter, to see how one by one they are intricately woven together and by what magic new harmonies are produced, perceive

the manifold subtle variations on a single theme, however disguised it may be, then the total effect is immeasurably enhanced. So it is with landscapes of the historic depth and physical variety that England shows almost everywhere.[3]

From this view grew two key ideas for historians looking at landscape: first, the notion of the local. In this, landscape was part of a small world, defined (ideally) by the village and its immediate surroundings. In this is contained a true microcosm of England. As Hoskins writes in the final chapter of *The Making of the English Landscape:* "The view from this room where I write these last pages is small, but it will serve as an epitome of the gentle unravished English landscape. Circumscribed as it is with tall trees barely half a mile away, it contains in its detail something from every age from the Saxon to the nineteenth century."[4]

There clearly are problems for a historian with this kind of view of "deep" England. In this all change is natural and organic, an "accretion," as Daniels calls it, upon what has gone before.[5] Even apparently violent change like parliamentary enclosure is "added" to long-term changes to give the impression of organic transformation. Thus Hoskins writes of part of his adopted county, Leicestershire, which was enclosed in 1804–6 and where, although the period of enclosure was brief and the social effects probably traumatic, "this piece of the Leicestershire landscape is the product of various forces over a space of four hundred years."[6] This view is also deeply anti-modern. According to Hoskins, since the middle of the nineteenth century, "and especially since the year 1914, every single change in the English landscape has either uglified it or destroyed its meaning or both."[7]

Nevertheless, Hoskins's insistence on the local has a lot of strength in it, and this leads to the second and, to me at least, more important point about Hoskins's analysis. In this, landscape is not natural but created, created by a constant social and economic interaction between people and their environment. "Not much of England, even in its more withdrawn, inhuman places has escaped being altered by man in some subtle way or other, however untouched we may fancy it at first sight."[8] We are back now to our different "themes" of the original musical metaphor—what the historian had to do was to learn to hear them or read them. To one of Hoskins's many "followers," for example, East Anglia "is like a fragment of parchment or vellum that has been written across in many directions and by different hands."[9]

What I want to do in this essay is to take a little from Hoskins and a little from the "new" art history to look at some different landscape paintings of the late eighteenth and nineteenth centuries. I want to look at them as a historian but not simply to "tell the truth" about them as if historical fact were unproblematic; rather I want to talk about the kind of social system that was probably present in those landscapes, to give a sense of the variety and complexity of rural Britain in the nineteenth century—the land, locality, people, landscape of my

title. Some of the painters (and paintings) I have picked knew this variety and complexity and carefully chose a particular kind of landscape to have a particular meaning in social as well as aesthetic terms — others probably did not. For my purposes that doesn't really matter too much, no matter how offensive that may be to art historians. I want to use the painted landscape as a launching pad to talk about the landscape as what it is at one level to the historian — the site of a complex set of localized social, cultural, and economic relationships between people and their environment. The land both shapes and is shaped by those who live in it, who work on it, or who just admire its aspect.

It is to that I will turn now. I will then return to the representations of it in the light of these discussions. To do this I will take three regional landscapes of England and talk about the kinds of social/agricultural/cultural structure that they present or conceal. Finally, I will look briefly at changes, at how different landscapes could be and were made,

I begin with what are perhaps the least obviously "social or cultural landscapes," those of upland England. Specifically, I will take two watercolors of Cumberland by John "Warwick" Smith, who was born in the county in 1749. These paintings are of a type of loosely Romantic representations of upland areas — "Warwick" Smith also painted in Wales. They are both muted versions of the great Romantic landscapes of the late eighteenth century, whether of England or Continental Europe. They are also, of course, paintings of the "Lake District," already popular with artistic and literary tourists when Smith was painting, but soon to become much more widely known as a place of Romantic inspiration through the writings of Wordsworth.

In both these paintings we have, as well as the mountains and lakes, slight evidence of a worked landscape. In the first of them, *Ullswater, Looking towards Patterdale* (fig. 33), there are farms on the distant shores of the lake, and the other was, according to its title, painted from *Castlerigg Farm* (fig. 34). Thus, even if we leave out the boats (of seekers after the picturesque?) in *Ullswater* we realize straightaway that despite its emptiness and grandeur this is not simply a "wild" landscape.

What kind of "place" is it then — this painted landscape of Romantic beauty? Firstly and obviously, it is an upland area, and since it is in the northwest of England a wet and relatively cold one, although there are wide variations. Even the best of Cumberland was desperately poor soil, and even where, around the Lakes and in the valley bottoms, it is level enough for cultivation, little grows and it produces only poor pasture. It was, at the time Smith painted, overwhelmingly sheep country, mainly producing wool, although a small number of lambs were sold off for meat. On the lower slopes of the mountains mixed farming was possible, combining some breeding and rearing of sheep, and perhaps cattle, with growing fodder crops.

As elsewhere in England the vast majority of the land was owned by large

33. John Warwick Smith, *Ullswater, Looking toward Patterdale*, 1792, watercolor on laid paper with wash border, 34 x 51.5 cm. Yale Center for British Art, Paul Mellon Collection.

landowners—the Curwen family, for instance, who commissioned these two watercolors, were large Cumberland landowners. John Christian Curwen, who supported Smith, was an agricultural reformer but also a mine owner. Interestingly, and unusually, he lived much of the year on his Cumberland estates, arguing in 1796 for the importance of the gentry remaining in the country districts as local leaders.[10] At the time Smith painted the Lakes, they were a relatively prosperous area. The cattle trade had expanded during the early years of the eighteenth century, and nearby industrialization created other markets; some of this prosperity spread down the social scale and created a notion of a comfortably-off, if frugal peasantry, living a life of remote independence on their "wild hills."

However, this new prosperity was causing deep social rifts which the wild landscapes concealed. Most of the land of Cumberland was farmed by customary tenants holding small farms from the great landowners.[11] Rents and fines (the main source of landlord income) were fixed by custom and difficult to change. As prosperity grew in the mid-eighteenth century the landlords attempted, unsuccessfully at first, to bypass customary practice and impose "market" rents. The tenants fought back using the common law and the courts to defend those rights, and even in 1805 three-quarters of the land of Cumbria was still held on customary tenure. These battles added to the already romantic notion of the Cumbrian "peasant" which went alongside the wild and romantic landscape. This is epitomized by Wordsworth's "Michael," the small sheep farmer.

34. John Warwick Smith, *Keswick Lake from Castlerigg Farm*, watercolor, 33.8 x 50 cm. Museum of Art, Rhode Island School of Design, Anonymous Gift. Photo: Cathy Carver.

An old man, stout of heart, and strong of limb.
His bodily frame had been from youth to age
Of unusual strength: his mind was keen,
Intense, and frugal apt for all affairs,
And in his shepherd's calling he was prompt
And watchful more than ordinary men.[12]

As the bitterness of the memory of the battle between landlord and tenant vanished, this Romantic notion of the northern peasant remained, living, like Michael, "a life of eager industry." The landscape of the Northwest became the landscape of frugal industry based on the family farm. Here there was little or no true wage labor, but living in farm service continued right through the nineteenth century. It was also highly approved of by Victorian social observers. Even at the end of the nineteenth century Arthur Wilson Fox could write:

This custom provides growing lads with a comfortable home and an ample supply of food; it improves their physique and secures for them a sound agricultural training under the eye of a master who frequently shares in the toils of the day, and sets an example of industry and efficiency. Moreover, it creates mutual feelings of regard between master and man, and is conducive to sobriety, owing to the farms being...at long distances from the villages.[13]

Hard work, sobriety, and a rough equality coupled with small farms also

35. Thomas Gainsborough, *The Road from Market*, 1767–68, oil on canvas, 121.3 x 170.2 cm.
The Toledo Museum of Art. Purchased with funds from the Libbey Endowment, Gift of Edward
Drummond Libbey.

encouraged the idea that social mobility was possible and desirable. As a farmer
of twenty-four acres told a government Commission in 1894, "Up to ten years
ago I was a hind [servant], and my wife was a servant there too. We both worked
very hard, and saved a bit of money, and then took this farm."[14]

In this landscape the "virtues" of the system under which it was farmed are
related in its representation. It was wild, relatively uninhabited, and where
touched by agriculture that touch appeared slight. The people who worked the
land were given particular characteristics of hard work and frugality, which is
again reflected in some romantic notions of a northern peasantry which had
some basis in the social and agricultural system of the Northwest. It was also
archetypally a "Tory landscape" in the sense used by Nigel Everett. Everett argues
that the Lakes, both in their social structure and in their "appearance," accord
with the Tory reaction to the attempt to impose a Whig cultural dominance in
the years after 1750. Associated with the landscapes of Uvedale Price and Richard
Payne Knight (whose "landscape" for Thomas Johnes at Hafod in Wales was also
painted by "Warwick" Smith) and the poetry and prose of Wordsworth, it ele-
vated the "unimproved" landscape against the Whig improvers and their
Grandee patrons.[15]

However, wild landscape and the independence it was seen to generate could
also be associated with quite different constructions, which contained no such

positive resonance. Wild landscape, especially when it occurred among culti-vated landscape became "waste" or "waste land." This was especially true of areas of southern England. To illustrate this point I would like to look at a group of landscapes from southern and eastern England, beginning with Thomas Gains-borough's *The Road from Market* of 1767–68 (fig. 35). In contrast to the wild and "sublime" beauty of the Northwest, we are given a more controlled and delicate scene. Yet it is a scene which causes problems. Michael Rosenthal has argued that Gainsborough's early landscapes like this one articulate a complex support from the moral economy of the pre-enclosure countryside. This is given some support by Everett's situation of the painting, which he sees as being essentially "benevo-lent," and he notes that Uvedale Price "found Gainsborough's work particularly attractive as he sought…to redefine the nature of improvement as a means of promoting rather than fragmenting the connections of English society."[16]

Certainly this scene has many aspects of the pre-enclosure landscape, but more importantly for my purposes, it is a woodland landscape. The first thing to note here is that woodland landscapes, within the South and East at least, pre-sented an ambiguous message. Stephen Daniels has argued for what he calls "the political iconography of woodlands" when "in later Georgian England wood-land imagery was deployed to symbolise, and so 'naturalise' varying and conflict-ing views of what social order was or ought to have been."[17] However, as Daniels recognizes, the symbol of woodland often clashed with its original. Especially in the South and East, where rising agricultural prices pushed for more and more land to be turned to the plough or at least pasture, woodland became a symbol to many of waste — a fact recognized in the use of waste or waste land as synony-mous with open heath or common land.

This change was not a sudden process, nor was it a transformation which all accepted. Rosenthal has pointed out that in Gainsborough's landscapes a healthy and "free" peasantry inhabit the pre-enclosure landscapes of woodland and rough pasture like the shepherd boy in the well known *Wooded Landscape with a Cottage, Sheep and a Reclining Shepherd* of 1748–50 (fig. 36).[18] However, as the eighteenth century progressed, the way of life of the woodland areas was increas-ingly categorized by many writers, like the woodlands themselves, as wasteful or indolent. Indeed, some of that ambiguity is there even in the largely affirmative Gainsborough landscapes. For instance, *Wooded Landscape with Woodcutter Courting a Milkmaid* of 1755 (fig. 11) shows both enclosed farm land and open waste. On the enclosed ground in the background is honest toil, the ploughmen rendering the field into straight and orderly furrows. In the foreground, on the common, a young man gathers sticks but still has time to court a young woman looking after cows. In the background are donkeys — the stallions of the poor and ever a feature of common lands as much as of Gainsborough's rendition of them.[19] The contrast between work on the enclosed fields and "play" on the open could be read in two ways — either as "affirmative" of the gentler "bucolic" life of

36. Thomas Gainsborough, *Wooded Landscape with a Cottage, Sheep, and a Reclining Shepherd*, c. 1748–50, oil on canvas, 43.2 x 54.3 cm. Yale Center for British Art, Paul Mellon Collection.

the common-land economy, or critical of it. The young woman is distracted by her swain, and as a result of her neglect the cow kicks over a pail of milk. Either way the image is potentially contested.

Outside their artistic representation woodland areas presented the eighteenth- and nineteenth-century observer with a complex social system. If we move to another, and less well-known painter, Robert Hills (1769–1844), we can see this social system in detail and examine its contradictions. Hills's *A View over Chiddingstone, toward Westerham*, painted in 1817–18 (fig. 37), is of one such woodland area, the Weald of Kent and Sussex. Much of this area was Royal Forest until the middle of the seventeenth century. This meant not that it was covered in trees but that it was subject to Forest Law, which preserved the area largely for the hunting of deer. This area was also one of proto-industrialization — it was the center of iron mining, charcoal burning, and smelting until the end of the sixteenth century and continued to have these elements long after that date. The area was removed from Forest Law and partly enclosed between 1660 and 1693, but the enclosure award gave right of common over many stretches of former forest land, including a highly concentrated 13,000 acres in Ashdown Forest about fifteen miles from where Hills painted.[20]

37. Robert Hills, *A View toward Chiddingstone, Kent*, 1817–18, watercolor with faint traces of pencil, 18 x 25.1 cm. Museum of Art, Rhode Island School of Design, Anonymous Gift.

The rights of common—to graze animals, cut wood, dig marl and stone, and gather furze—coupled with a large number of tiny farms, many less than five acres, created a social structure of peculiar independence and, despite poor soil, resilience, which was to many decidedly "un-English." When Léonce de Lavergne, a French agriculturist, visited the area in 1854, he likened it to the poorest parts of France. It was "the most backward part of the whole of England in the point of agriculture," and its inhabitants were "as ignorant as they [were] poor."[21] In this, de Lavergne was echoing the views of most agricultural reformers from the mid-eighteenth century onwards, yet the system of farming in areas like the Weald bore striking resemblances to the system which was so praised in the North. Again, small family holdings worked with family labor and a small number of hired servants was the norm, as was a degree of social mobility. One life history shows these aspects. "Norfolk Jack" born in Diss, Norfolk in 1807, migrated to the Weald of Sussex at the age of twenty-two. At twenty-six he married a female servant, and they both continued to work until their mid-thirties when he bought three seed drills which he hired out to larger farmers. He then got four acres of land on the edge of the forest waste, and with that and the common rights on the forest he gradually built up to a holding of 130 acres.[22]

The moral values attached to this kind of life, though, were much lower than those attached to the virtuous northern peasant, at least until the 1880s and 1890s. When Richard Heath visited the Weald in the 1860s, he saw its people as

intellectually backward, sexually immoral, poverty-stricken, lazy, dirty, and credulous, although his descriptions of "life and work" are very similar to those given of the North at the same time.[23] There seem to be two sets of reasons for this. The first is directly to do with "landscape." The South and East were, by the 1850s, overwhelmingly arable, a tilled and worked land. In this the forest areas that survived stood out as different and as wasted. They were also often protected by customary agreements and tenancies which made it very difficult to "improve" them. De Lavergne noted this in 1854. In the Weald, he argued, the old system was too deeply entrenched and the landowners too poor to make a change, so capital must come from elsewhere and larger arable farms be introduced. As for the small tenant farmers, "who for generations have gone on increasing under the shelter of the old system," they will "be forced to emigrate."[24]

The second reason for the "moral disapproval" attached to these landscapes was that they harbored "independence" from wage labor. Common rights provided wood for firing, grazing for a cow or two and some chickens, and furze to bed animals. Less "legally" it provided a range of things to sell: wood, furze, stone, and gravel. In many forest areas the elite saw the woodlands and their inhabitants as a greater threat still. Arthur Young wrote of the Forest of Wychwood in Oxfordshire: "The vicinity is filled with poachers. Deer stealers, thieves and pilferers of almost every description abound so much, that the offenders are a terror to all quiet and well disposed persons; and Oxford gaol would be uninhabited, were it not for this fertile source of crime."[25]

In this situation it was possible for even the poorest to live at least in part from the land, turning to wage labor only to supplement these earnings. Edward Kilner was born in 1811 on the edge of Ashdown Forest. By chance we have a detailed record of both part of his working life in an employment record and an account of his life given in 1878. Kilner was a laborer but he had limited rights on the forest as his father had before him. "From 6 or 7 years old I used to go out on the Forest with my father cutting brakes for our pigs and scrub of any kind and turf for firewood we had these every year." In his own life it went further. At various times he had dug lime for mortar and cut firewood, including birch, willow, alder, beech, oak holly, and hazel. Some of this seems to have been sold. This gave him some small independence along with a garden (he had pigs) and probably traveling away to work as a migrant. As a result of this he needed only to work about a third of the year, according to the records of the man who employed him in the early 1870s.[26]

This kind of "freedom" put the forest dwellers "outside" the conventional structures of mid-Victorian England. They were not the hardworking peasants of Cumberland or the Pennines whose independence was laudable because of its orderliness; rather they stood literally on the margins of work (as casuals) and landscape (the forests were bad land at the edge of the cultivated). Thus,

although in the woodland areas we see a landscape which — although formally having much in common with the upland areas of the North — was actually very different. Crucially it was valued differently. From at least the late Middle Ages "forest and waste" had been seen as dangerous and outside the law. This view was, if anything, strengthened in the eighteenth and early nineteenth centuries, especially in relation to the South and East of England. Here, it was argued, the "waste" was not only literally that — land which could be better used in cultivation or even housing development when near a great city — but also the means of supporting "wasteful" people who stood outside the increasingly rigid and class-divided rural social structure. Pressure on these areas intensified, especially around London, as the common fields were enclosed, leaving only the "commons" for extensive development. Probably from at least the 1820s enclosure awards were mainly addressed to these areas, and the Act of General Enclosure of 1846 was overwhelmingly concerned with them.

Ironically, it also led to the preservation of some "common land," including parts of the landscape of the Weald where Hills's painting was done. From at least the 1830s there was pressure from some members of the metropolitan elite to preserve commons for their "natural" and "unspoilt" beauty. This is what essentially happened to the Ashdown Forest area of the High Weald after 1880. The victims were the cottagers whose tiny holdings moved from being peasant farms of little worth to valuable sites for country housing — a trend which continued into the twentieth century.

If the landscape of forest was at the margin, what was at the center crucially the farmed arable landscapes of the Southeast and Midlands of England — presented another set of values. From the end of the seventeenth century English agriculture concentrated more and more on the production of cereals, especially wheat, for white bread flour. From 1690–1780 England was a net exporter of wheat, and much of her economic "greatness" was based on this surplus. After 1780, although England became a net importer of wheat, production continued to increase on the basis of increased yields per acre, increased land being brought into cultivation, and increased labor productivity. Thus cereal production became the real and symbolic heart of English agriculture. All other kinds of agricultural produce were seen as secondary, as contributing to the production of wheat. Hay, for example, was seen in many arable areas as part of the four-course rotation and as fodder for horses needed for the production of cereals. When you had a surplus over that, in the East of England at least, it could go by canal and sea to London, and horse muck could be brought back for the all-important wheat fields — precisely the subject of many of Constable's lock and barge paintings. Turnips and mangolds were part of both the rotation and fodder for winter cattle whose main duty was to provide yet more manure. Other kinds of production, especially dairy production, were seen simply as inferior, a status added to the fact that for the eighteenth and most of the nineteenth centuries dairying was

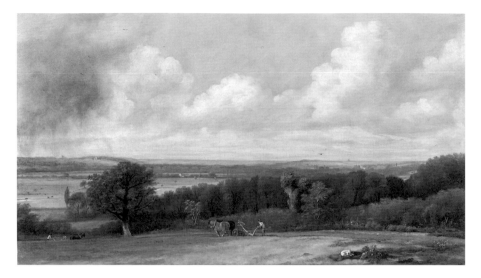

38. John Constable, *Landscape: Ploughing Scene in Suffolk (A Summerland)*, c. 1824, oil on canvas, 42.5 x 76 cm. Yale Center for British Art, Paul Mellon Collection.

women's work. The attitudes of a 1900s farmer remembered by his nephew could stand for generations: "If he saw grass he wanted to plough it, disc it, sow it, roll it, reap it, and plough again. He had a dairy herd and some sheep but simply to provide bread-and-butter money in between selling his grain crops."[27] Our French visitor had even less doubt. To him England meant large-scale farming "up to Wheat," as they used to say.

> The north and west of Norfolk forms an immense sandy plain of 750,000 acres, where there is no obstacle to proper and large farming, and where everything favors horse-tillage, cultivation of roots, the use of machines — in one word, the four-course rotation…The whole of this land formerly grew only rye; now it does not produce a particle of this grain, but instead are to be seen the finest wheat crops in the world.[28]

Constable is, as has often been argued, the painter of the enclosed, arable landscape of southern and eastern England. Although he painted the open heaths of Hampstead, a classic "common waste" landscape, it is in his landscapes of the Stour Valley that he captures the pride and order of England's agricultural wealth. Suffolk, the area in which he produced most of these paintings, was, according to Arthur Young, one of the best farmed arable counties of England in the first decades of the nineteenth century, where "a most valuable set of men, who, having the means and the most powerful inducements to good husbandry, carry agriculture to a high degree of perfection."[29] This is a picture of an ordered and structured society which accords with the social structure of the great arable districts. This was the landscape of paternalism — the landscape of hierarchy and

39. Alfred William Hunt, *Ullswater at Midday*, 1863, watercolor, 36.3 x 50 cm. Collection of Mellon Bank Corporation.

settlement. It also marks the completion of class separation in the English countryside with the landlord, the tenant farmer, and the laborer forming three distinct and separate socioeconomic groups. Although these divisions were seldom that clear in great areas of England (and especially Britain), in the arable areas of the Southeast they developed first and remained most rigid. This was the landscape (in an historian's sense) of physical separation. We can see this clearly in the Constable. His *Landscape: Ploughing Scene in Suffolk* of c. 1824 (fig. 38) is a powerful (and beautiful) statement of the loneliness and separation of farm work in the great fields of East Anglia.

In his *The Stour Valley and Dedham Village* of 1814 (fig. 2) we can see the psychical geography of this separation. Here the laborers live in a village in what is in essence an occupational community. On the villages edges, or a little away, stand the farms in which live the farmer and his family plus domestic servants. Finally, surrounded by their parks and completely separate from all, stand the great houses of the landlords. This physical separation, though, is concealed beneath the rhetoric of paternalism and of "the fortunes of agriculture." In this all work for the good of the land, and all are mutually dependent on one another in a God-given natural order. In striking contrast to the landscape and social structure of the woodland areas, all know their place, especially the poor.

The reality is, of course, different. Even in Suffolk, an old enclosed county, these were relatively new and created landscapes and social systems. Enclosure created the hedgerows which divided Constable country just as certainly as it ended customary tenures. The increasing relative wealth of the tenant farmers created the physical separation of master and man, and "living-in farm service"

gradually disappeared from all but a few areas of the South and East. It is also an achieved balance and harmony, not a natural one. It is in the South and East that the most violent and persistent radical movements appeared among the rural poor. Constable country, as was pointed out years ago, was the scene of rick-burning and cattle-maiming throughout the years after 1812. In the 1870s it was the great arable areas of East Anglia and the Midlands which saw the emergence of trades unionism among farm laborers. Finally, in de Lavergne's epitome of high farming, Norfolk, a socialist movement strong enough to return three MPs emerged in the 1920s.

This leads us to my final thoughts on these varied landscapes. They are not constant either in their socioagricultural structure or in how they were viewed by contemporaries.

Let us go back to our first example — the upland landscapes of the Lakes in a later picture, Alfred William Hunt's *Ullswater at Midday* (fig. 39). Stylistically this is clearly a different production, but it has changed little, and at this date (1863) the Lakes had not changed much to the outsider. However, their celebration — and it is significant that Hunt was much admired by Ruskin — had moved apace. They had come, even by this date, to assume a particular place in the national iconography. To the "insider," though, key changes had taken place which were to make for a different landscape and a very different social structure. Inside Cumbria the old customary tenancies were being whittled away and put on a more "modern" basis. This particularly involved loss of common wood-gathering and grazing rights. Outside, though, still greater changes were taking place. Sheep production for wool had shifted even further north to the larger and cheaper farms of the Cheviots and Scotland. Worse still, the New World, especially Australasia, was on the verge of mass exports, first of wool, then of frozen meat. The Scottish cattle trade, the basis of eighteenth-century prosperity, also withered as Irish cattle were imported in larger numbers after the famine. By the 1890s the hill farmer of Cumberland was a poor and endangered species — if still admired:

> Some of the very small-holders have doubtless a great struggle to exist and many could not get on without undertaking carting work when they can get it or even going out to work themselves on other farms. Their farm buildings are often little better than sheds, and their houses no better than labourers' cottages.[30]

However, economically hill farming was increasingly unable to compete with cheaper meat, wool, butter, and cheese. Even the admiration began to go: these areas were increasingly seen as "backward."

Ironically, it was the landscape, devoid of a social structure, which stopped their final extinction and particularly the enormous growth, especially after the 1880s, of tourism in the Lakes. From the solitary excursionist of Wordsworth's

"Prelude" came first the "parties" of Victorian and Pre-Raphaelite admirers seeking both Wordsworth and Ruskin, and finally the hoards of middle-class and even upper-working-class "tourists" brought to the heart of the Lakes by his feared steam railways. It is a profound irony that by providing "bed and breakfast" accommodation many a family descended from the eighteenth-century statesmen (as the Cumberland customary tenants were called) managed to keep a toehold in their native place.

Similar if less dramatic changes overtook the forest areas, as we have already noted. Gradually they were enclosed or brought under control—although some remained very late indeed. The Weald of Hills's picture lasted until the 1870s when a paternalist High Court judgment "protected" the forest by preserving its common rights but also by enforcing them to the letter. This simply meant that those, like Edward Kilner who had always taken more than "he was entitled to," simply could not survive. They were forced to wage labor, and since there was little of that in the area, they left for London or for the bigger farms south and west of the Weald. At their going they became celebrated. A picture of 1885 by Clayton Adams is Hills's successor. It shows the wild and open Surrey end of the Weald, covered in bushes and grazed by sheep. This landscape, essentially the same since the 1690s, was much admired by Ruskin. "There are no railways in it...no tunnel or pit mouths...no league-long viaducts, no parks, no gentlemen's seats, no rows of lodging houses, none of these things that the English mind now rages after."[31] Within ten years middle-class artists and intellectuals had moved onto the Weald—"Britain's Montpellier," as one hopeful guidebook had it—and they came in search of a lost rural England. As Short and Brandon write, "The south-eastern countryside became a means of satisfying their spiritual as well as physical needs. This was a purpose for which it was well suited, with a neat, ordered and variegated charm, part wild, part cultivated and its spaciousness with a touch of the sublime."[32]

Foremost among these literary incomers before the Great War, and the man who more than any painter rewrote the Weald, was Rudyard Kipling, who moved to Batemans in Burwash in the 1890s. From there he reinvented the smugglers, poachers, and fighters who were the small farmers of the Weald but left them in a landscape filled with villas and mock Tudor cottages. By the 1900s G. K. Chesterton could write sardonically that, "short story writers leapt from behind hedges. Minor poets dropped from trees like ripe fruit. Philosophers, sociologists and artists ran like rabbits about the woods."[33]

Finally, let us return to the landscape of arable England. That changed less dramatically during the nineteenth century at least. It was the "newest" of them and seemed the most stable if only because part of its own ideology was that it was (and had been) permanent. It was growing in area and influence, at least until the 1880s, and seemed set to last forever. America changed that. The opening of the Midwest wheat belt fundamentally undermined English wheat pro-

duction. The high profits which lay at the heart of paternalism began to fall, the "permanent" English gentry and aristocracy began to shift their money out of land and into commerce (where it still remains), and just as readily quit the countryside for the towns or even for Europe. The tenant farmers responded by cutting costs, cutting down hedges, and moving to machinery. The laborers simply left—what Hardy called "the proven tendency of water to flow up hill when pushed by machinery." A new and bleaker landscape—that of Clausen or La Thangue—began to appear.

The hundred and fifty years I have sketched in this brief essay were a particular period in the history of English landscape as a set of social and cultural relations as much as they were a period in which, as Rosenthal has argued, landscape painting became high art.[34] There is a relationship between them, but it is not a simple one. It is perhaps clearest in relation to the upland areas where an essentially frugal and thrifty peasantry fitted well with the harshness and sublimity of the romantic landscape (a similarity of course much more clearly noted in Scotland, Wales, and Scandinavia than in England). It fits least easily with the woodland landscape, where the ideology so clearly spelt by Daniels as the political iconography of woodland seems to have totally concealed the moral vilification which characterizes much eighteenth- and nineteenth-century writing about woodland. Perhaps the most interesting thought about relationships, and one to end with, is the way in which by creating a "pictorial" landscape of rural England, painters (along with other cultural producers) were able to shape how that landscape looked. The cultural tourists who began to visit the Lakes in the 1750s and 1760s came to "see" a particular landscape which enshrined within it particular moral and aesthetic virtues associated with the sublime and later with the romantic. They came back with accounts, paintings in endless amateur sketchbooks, engravings, and ultimately photos which created the Lakes as a landscape to be viewed from particular places and in specific ways. In a different way Constable's celebration of high farming found echoes in contemporaries who praised and valued his work above Turner's, preferring the domestic and small-scale to the "fastness" of Turner.[35] However, it was in the twentieth century that Constable and "Constable Country" took on iconographic status. As Alex Potts has argued, particularly in the inter-war period the "vision" of deep England as a farmed countryside, in fact a relatively new landscape, comes to be seen as timeless and moral—as standing for permanence as against the change of "urban" society.[36] Once the Lakes, the Weald, or Constable Country had become icons of art, it became difficult if not impossible to change them. All three areas are now substantially in public or trust ownership; all will remain—if those people have their way—social structure imitating art.

1 Stephen Daniels and Denis Cosgrove, "Iconography and Landscape," in Denis Cosgrove and Stephen Daniels, eds., *The Iconography of Landscape: Essays on the Symbolic Representation, Design, and Use of Past Environments* (Cambridge: Cambridge University Press, 1988), 1.

2 Stephen Daniels, *Fields of Vision: Landscape Imagery and National Identity in England and the United States* (Cambridge: Polity Press, 1993), 5.

3 W. G. Hoskins, *The Making of the English Landscape* (Harmondsworth: Penguin, 1979), 20.

4 Ibid., 299–300.

5 Daniels and Cosgrove, 8.

6 Hoskins, 210.

7 Ibid., 298. For a discussion of this aspect of Hoskins, see David Matless, "One Man's England: W. G. Hoskins and the English Culture of Landscape," *Rural History* 4, no. 2 (1993).

8 Ibid., 19.

9 Patrick Armstrong, *The Changing Landscape: The History and Ecology of Man's Impact on the Face of East Anglia* (Lavenham, 1975), 9.

10 J. V. Beckett, *The Aristocracy in England, 1660–1914* (Oxford: Blackwell, 1986), 167, 325–26.

11 For much of what follows, see C. E. Searle, "Custom, Class Conflict and Agrarian Capitalism: The Cumbrian Customary Economy in the Eighteenth Century," *Past and Present*, no. 110 (1986).

12 William Wordsworth, "Michael," in *Poetical Works*, ed. Ernest de Selincourt (Oxford, 1936), 104.

13 British Parliamentary Papers. Royal Commission on Agriculture (1894 XVI pt. 1), 64.

14 British Parliamentary Papers. Royal Commission on Labour. *The Agricultural Labourer. Report upon the Poor Law Union of Garstang* (1893–94 XXV), 167.

15 Nigel Everett, *The Tory View of Landscape* (New Haven and London: Yale University Press, 1994). See esp. 151–70.

16 Ibid., 113.

17 Stephen Daniels, "The Political Iconography of Woodland in Later Georgian England," in Daniels and Cosgrove, 43.

18 Michael Rosenthal, Lecture, Paul Mellon Centre for Studies in British Art, January 1994.

19 John Barrell, "Sportive Labour: The Farmworker in Eighteenth-Century Poetry and Painting," in Brian Short, ed., *The English Rural Community: Image and Analysis* (Cambridge: Cambridge University Press, 1992), 110.

20 See Linda Merricks, "'Without violence and by controlling the poorer sort': The Enclosure of Ashdown Forest, 1640–1693," *Sussex Archaelogical Collections* 132 (1994).

21 Leonce de Lavergne, *The Rural Economy of England, Scotland, and Ireland*, (Edinburgh, 1855), 202–3.

22 Alice Catherine Day, *Glimpses of Rural Life in Sussex during the Last Hundred Years* (Oxford, [1928]), 10–11.

23 Richard Heath, *The English Peasant* (London, 1893), 192–93.

24 de Lavergne, 204.

25 Arthur Young, *A General View of the Agriculture of Oxfordshire* (London, 1809), 247.

26 East Sussex Record Office. Raper Papers; Raper Transcripts Book 1.

27 Harold St. George Cramp, *A Yeoman Farmer's Son: A Leicestershire Childhood* (London: John Murray, 1985), 147.

28 de Lavergne, 225–26.

29 Arthur Young, *General View of the Agriculture of the County of Suffolk* (London, 1813), 8.

30 British Parliamentary Papers; Royal Commission on Labour (1893-94 XXXV), 148.

31 Quoted in Peter Brandon and Brian Short, *The South East from AD 1000* (London: Longman, 1990), 340.

32 Ibid., 355.

33 G. K. Chesterton, *Tremendous Trifles* (London, 1904), 63.

34 Michael Rosenthal, "Landscape as High Art," in Katharine Baetjer, ed., *Glorious Nature: British Landscape Painting, 1750–1850*, exh. cat. (New York: Hudson Hills, 1993).

35 Michael Rosenthal, *Constable* (London: Thames and Hudson, 1987), esp. chap. 7.

36 Alex Potts, "Constable Country between the Wars," in Raphael Samuel, ed., *Patriotism: The Making and Unmaking of British National Identity*, vol. 3, *National Fictions* (London: Routledge, 1989).

Representations of Early Industrial Towns: Turner and His Contemporaries

Maxine Berg

Cultural responses to industrial towns in Britain have been rooted in Victorian attitudes of horror and fascination with these mushrooming concentrations of population. Historians of literature and art have emphasized the arcadian and elegaic tone of cultural responses to economic and industrial change. For many critics from the nineteenth century onwards, British landscape painting of the eighteenth and early nineteenth centuries was an account, then a memory of landscapes lost to the smokestack capitalism of the Industrial Revolution. Ruskin sought in Turner's paintings support for his own fears and horrors of urbanism and industrialism. In contrast to the "bright cities" of Giorgione's Italy, Turner, as Ruskin put it, "saw the exact reverse of this. In the present work of men, meanness, aimlessness, unsightliness: thin-walled, lath-divided, narrow garreted houses of clay; booths of a darksome Vanity Fair, busily base."[1] Turner's view of Dudley was interpreted as "a smoke-shrouded church spire," "a premonition of 'what England was to become.'"[2] Ruskin echoed Thomas Carlyle's premonitions: "These are our poems," said Carlyle in 1842 on contemplating the new locomotives, "iron missionaries" to Birmingham and Wolverhampton with their "hundred Stygian forges, with their fire throats and never-resting sledge-hammers," and "wet Manconium." "England, say, dug out her bitumenfire, and bade it work; towns rose, and steeple chimneys; - chartisms also, and parliaments they named Reformed."[3]

The identification found in these writers commenting on industry and urban life with social dislocation and the decline of civilization was a potent nineteenth-century mixture. As early as 1807 Robert Southey in his *Letters from England* wrote of Birmingham:

> You will perhaps look with some eagerness for information concerning this famous city, which Burke...calls the grand toy-shop of Europe...I am still giddy, dizzied with the hammering of presses, the clatter of engines, and the whirling of wheels; my head aches with the multiplicity of infernal noises, and my eyes with the light of infernal fires...Our earth was designed to be a seminary for young angels, but the devil has certainly fixed upon this spot for his own surgery-garden and hot house.[4]

Southey's conservative alarm that "governments who found their prosperity upon manufactures sleep upon gunpowder,"[5] was also expressed in evangelical religious and radical political thought. The political economy deployed by Eng-

land's ruling classes was based in agrarian physiocracy and evangelical Christianity. Industrial towns were "unnatural," "man-made blots on God's landscape." Commercial crises were reminders to town dwellers, merchants and industrialists of God's providential government. A common distinction was that between the real (that is, rural) people and the false, that is, "the unfortunate portion of the population which inhabited great manufacturing towns."[6]

Radicals and Chartists in the early nineteenth century sought a return to the land. Agriculture was the "natural employment of man" in contrast to the "artificial labour in the manufacturing halls with their long chimneys." Bunyan's *Pilgrim's Progress* was recast in the *Northern Liberator* to the "Political Pilgrim's Progress." Christian, now baptized "Radical," does not make his pilgrimage to the Celestial City but rather meets temptations from true Chartism in the City of Plunder with its Quack Quadrant.[7] Historians of radicalism have divided between what Raymond Williams called a "precarious and persistent rural-intellectual radicalism" and a metropolitan association between progressive capitalism, urbanism and social modernisation." The one side of this radicalism was:

> genuinely and actively hostile to industrialism and capitalism; opposed to commercialism and to the exploitation of the environment; attached to country ways and feelings, the literature and the lore. The other side inherited a contempt from very diverse sources of the peasant, the boor, the rural clown.[8]

It was, furthermore, not just in ideas that antiurban prejudices prevailed, but in practice. As Asa Briggs put it in *Victorian Cities*, English businessmen made their money in the city, then left for the country." Towns were places where men made a livelihood: country houses were places where people lived. Man made the town: God made the country."[9] Historians since have reinforced this prejudice with characterizations of the British economy in terms of gentlemanly capitalism, and of British society in terms of a domestic ideology fostered in the garden suburb.

The assumption conveyed by these nineteenth-century perspectives, and by historians' absorption of them, was that this most urban of nations had always had arcadian aspirations, that cultural forms during the eighteenth and early nineteenth centuries were predominantly about a denial of industrial and urban growth. To establish ideas of and responses to urban and industrial growth during the eighteenth century and just after, however, it seems clear that we must begin differently, as with Raymond Williams, "not in the idealisations of one order or another, but in the history to which they are only partial and misleading responses,"[10] to go to this period itself, and first of all to establish just what the economic framework of urban growth was. If we do this, however, we must go far beyond the country-city dichotomy set out by Williams in the early 1970s. For what is soon evident in his book is that the only city he is comfortable in dis-

cussing is London. Yet the distinctive feature of Britain's early urbanization was not London but her new industrial towns. The response to these towns by literary writers, politicians, and economists form one framework. We can also look, however, to responses expressed in landscape art of the time, represented here by the great series of urban landscapes painted by J. M. W. Turner, and their context in contemporary urban topographies, histories, and directories. Placing Turner's watercolors of the industrial towns and regions within this broader framework of economic and political writing and topography leads to suggestions of a more optimistic interpretation of Turner's depiction of industrial change.

The Urban Framework and Industry in the Eighteenth Century

Britain experienced rapid urban growth during the eighteenth century, at a time when towns in much of the rest of Europe were stagnating. 13.3 percent of the population of England and Wales lived in towns over 10,000 by 1700; but by 1800, 20.3 percent did, at this time surpassed only by the Netherlands.[11] Britain's urban development, however, had taken a different course from the rest of Europe. The really big change was in the growth of towns of medium and smaller size — those with between 5,000 and 10,000 inhabitants doubled from fifteen to thirty-one between 1600 and 1750, while the number in Continental Europe declined.[12] Many of these newer small towns were heavily industrial, closely integrated with concurrent proto-industrial development. Indeed much of Britain's early industrialization was carried out in rural locations — domestic industry, mines, quarries, and ironworks set the framework. The expansion of the northeastern coalfield was one of the miracles of the seventeenth century, and Newcastle was the leading industrial city in England until the end of the eighteenth. New commercial and industrial towns were, furthermore, growing rapidly, with Birmingham, Liverpool, Manchester, Leeds, Sheffield, Plymouth, and Newcastle advancing into the top ten towns by 1801.[13]

Britain's eighteenth-century economy was a new departure both from the past and from the concurrent experience of her European neighbors. Population growth over the course of the century emerged from rural industrial expansion and an uninterrupted growth in the urban sector. In Linda Colley's words, for these towns "economic growth was a matter of the here and now, marked out for all to see by an explosion of new buildings, streets, shops, houses, taverns, inns and civic amenities."[14] And for the rest of the population it was hard to ignore either the towns or the industry.

Industrial Towns and Adam Smith

One who not only faced the challenge of the new industrial towns, but made these the cornerstone of his vision of the progress of nations and of his model of economic growth was Adam Smith. Book III of the *Wealth of Nations*, "Of the

Different Progress of Opulence in Different Nations," was simultaneously Smith's great comparative history of Europe and his outline of an integrated course of agricultural and industrial growth. The great commerce of every civilized society, is that carried on between the inhabitants of the town and those of the country."[15] The "great commerce" was the exchange of rude for manufactured produce; sustained urban growth depended on a commercialized agricultural sector. The great commerce also created the "natural progress of opulence." Smith's ideal type of economic development was one based in rising agricultural productivity, which in turn created the foundations for urban and industrial growth. Town and country grew together in a regional framework. This was a "natural progress"; but most of Europe's history had been built on "artificial" cities and commerce, which had used the vanity and desires for fashionable transitory consumer goods by the gentry and landlords to exploit the countryside. Smith's ideal "natural cities" were integrated with the countryside; their manufactures were the offspring of agricultural surpluses.

> In this manner have grown up naturally, and as it were of their own accord, the manufactures of Leeds, Halifax, Sheffield, Birmingham, and Wolverhampton. Such manufactures are the offspring of agriculture. In the modern history of Europe, their extension and improvement have generally been posterior to those which were the offspring of foreign commerce.[16]

The new growth of these towns was to be contrasted to the instability of Europe's metropolitan and port cities, which had favored the development of luxury manufactures using foreign raw materials and had been the "scheme and project of a few individuals," established "according to their interest, judgement or caprice." [17]

Smith was not alone among economists in his recognition of the new departure provided by the industrial towns. Defoe in 1724 wrote in a similar way that such towns were "full of wealth, and full of People, and daily encreasing in both; all of which is occasion'd by the meer Strength of Trade and the growing Manufactures establish'd in them." Yet most had "few or no Families of Gentry among them." Sir James Steuart in 1767 wrote, "From the establishment of Manufactures, we see Hamlets swell into Villages, and Villages into Towns." Dean Tucker in 1774 noted, "the Towns of Birmingham, Leeds, Halifax, Manchester, etc. being inhabited in a Manner altogether by Tradesmen and Manufacturers are some of the richest and most flourishing in the Kingdom."[18]

Smith's manufacturing towns were integrated with the needs of the countryside. So too were the towns of eighteenth-century Protestantism and radical enlightenment. Protestant millenarians struggled towards the "city on the hill"; they dreamed of building new Jerusalems in their own land.[19] They carried forward Bunyan's "Pilgrim" and with him sought the "Celestial City" where pilgrims would have houses of their own, and all their material needs would be met, or the "Holy City" where "plums and figs and grapes and apples...will be...in common

and free for all."[20] Enlightened ideals were civic, fostered in Scottish cities and in the literary and philosophical societies of the new industrial towns of the Midlands and the North. This view of the city was replicated in art. Stephen Daniels has written recently of the "civic, internationalist, republican patriotism represented by Joseph Wright and his circle" in contrast to the later "vernacular, insular patriotism" of the painters and poets of the English countryside.[21]

Civic Topography

Adam Smith's vision of industrial growth in new urban and regional settings became a popular theme in a new literary and scientific genre in the eighteenth century—the dictionary of commerce, encyclopedia of manufacture and the urban topography. The *Encyclopédie* placed manufacture and artisan crafts at the heart of the Enlightenment. But Britain's manufactures and towns were celebrated in town directories and histories, in travel diaries such as Defoe's *Tour* and Shelbourne's letters, and in dictionaries and encyclopedias such as Anderson's *Historical and Chronological Deduction of the Origins of Commerce from the Earliest Accounts to Present Time* (1764) and Chambers's *Cyclopedia: or an Universal Dictionary of Arts and Sciences* (1741).

We can look in some detail at the industrial town as conveyed in two texts of the period—James Bisset's *A Poetic Survey Round Birmingham Accompanied by a Magnificent Directory* (1799) and Walker's *Copper Plate Magazine...of Picturesque Prints* (1797). Both contained extensive and elaborate sets of engravings, and in the case of Walker a number of these were by Turner and other artists.

James Bisset was apprenticed as a painter to a Birmingham japanner in 1777 and, shortly after finishing his apprenticeship, invented a process of painting on glass which he called "Imperial." The japanned tray (fig. 40) was a typical product of Birmingham's japanning works. As a product of Birmingham, the one here displayed also conveyed to its sought-out market of bourgeois and gentry consumers the civic amenities of a new town. Its squares and streets were spacious, its shops well-appointed, and its tradesmen respectable, and it attracted the local gentry who had easy access to the surrounding countryside. The message conveyed by the tray in its place as a product for the upper echelons of the consumer market was also intended to dispel contemporary images of Birmingham as a dirty black manufacturing town. Bisset was an immigrant to Birmingham and wrote of his first impressions:

> I had expected to find Birmingham a black and dismal town, smokey and unhealthy, and was much pleased to find many very open and fine streets, extremely neat brick buildings, a fine open and spacious Church yard...and one of the handsomest churches I ever had seen called St. Phillip's. St. Martin's noble steeple had 12 musical bells, and the general appearance of the town quite pleased me.[22]

40. *The Bull Ring and St. Martin's, Birmingham*, japanned tray. Birmingham Museums and Art Gallery.

His business flourished to the extent that he was soon able to pursue his other interests as a collector of curiosities and then of paintings, and as a writer. His antiquities and exotic articles were displayed first in a cabinet of curiosities in his lodgings, subsequently with small art collections in a showroom in the front of his house, and eventually in a gallery.

Bisset's most notable publication was his wonderful *Magnificent Directory*, published in 1799. The directory provided a list of local manufactures and tradesmen and a topographical survey written in verse. The engravings cost him 500 guineas, and he lost £200 on the whole venture. The plates included drawings of a number of the factories and workshops, their products and the celebrated Birmingham tools and machinery, all executed in a classical style. These accompanied what Bisset called his "Ramble of the Gods through Birmingham."

> In Birmingham alone, — amaz'd they stood
> …
> They next, attracted by the vivid gleams,
> Saw Marcasites dissolve in liquid streams,
> And stubborn Ores expand, and smelting, flow
> …
> The different Button-works, they next review,
> And seem'd well pleas'd with sights so rare and new:
> …

The process of the Gilding look'd well o'er,
Yet scarce could tell rich gilt, from semilore;
Each Stamp, each Lathe, and Press they careful scann'd,
Then went to see the Paper Trays japann'd;

…

These seen, they next resolv'd with speed to go,
To visit Boulton's, at the great Soho

…

They went—but here description fails, I ween,
To tell you half the curious works there seen

…

Ingenious engines prov'd mechanic pow'rs,
And happy pass'd the months, weeks, days and hours;
"The Toy Shop of the World," then rear'd its crest,
Whilst hope and joy, alternate, fill'd each breast.[23]

Bisset's iconography of the Birmingham manufactures can be illustrated by the plate of the brass founders, which also became a trade card for nine different brass founders in the town (fig. 41). The front of the foundry was depicted as a classically-designed planned "royal or model manufactory," but the back of the foundry was also depicted with its chimneys, smoke, medley of buildings, piles of coal, and engines. For Bisset, the Birmingham manufactures were represented as modern industry with the classical facade. They were like the Birmingham commodities —novelties which looked like craft goods but were produced by means of the latest technologies. The patronage of bourgeois and wealthy consumers was emphasized in Bisset's engravings and in other contemporary engravings such as those of the Soho Manufactory. In the one reproduced here, the carriages, horsemen and attendants of the gentry marked out Birmingham's special place on the fashionable "English tour" (fig. 42).

James Bisset's *Magnificent Directory* was a celebration of the new manufacturing town. Not just directories but town histories proliferated during the eighteenth century. William Hutton's well known *History of Birmingham* (1781) was accompanied by similar works for Manchester, Liverpool, Halifax, Derby, Leeds, Nottingham, and Leicester. The topographies these conveyed might diverge as much as John Aikin's *A Description of the Country from Thirty to Forty Miles round Manchester* (London, 1795) did from John Whitaker's, *The History of Manchester* (London, 1771–75), which concentrated on the town's antiquities, its gothic edifices, and archaeological sites. Many of these histories, however, as surveyed by Peter Clark, conveyed a view of the town as a "vital, living entity," as the centers of a new style of civilization and of commercial and industrial expansion[24] (fig. 43).

Alongside such town histories and directories may be placed Walker's *Copper Plate Magazine* (1792–94)[25] with its advertisement of a cabinet of picturesque

41. Engraving from James Bisset, *Bisset's Poetic Survey round Birmingham*, London, 1800.
Yale Center for British Art, Paul Mellon Collection.

42. "Soho Manufactory," 1781, engraving from H. W. Dickinson, *Matthew Boulton*, Cambridge, 1937.
Courtesy of the Assay Office, Birmingham.

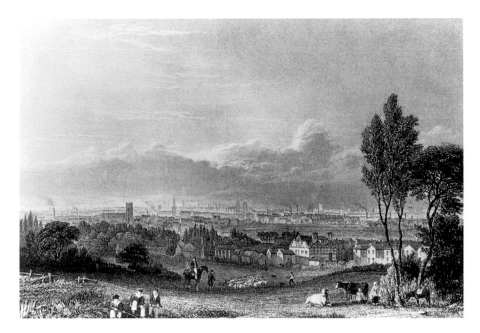

43. George Pickering, *View of Manchester from Kersal Moor*, 1834, hand-colored engraving, 20 x 13 cm. The Museum of Science and Industry in Manchester.

prints of sublime and interesting views, engraved by eminent artists from paintings of the first masters. Included amongst these were Turner's views of Birmingham and Nottingham, along with views by a number of other painters, including Walker himself, of an enormous range of British and Irish towns. The popularity of engravings and the close involvement of Turner, especially later in his collaboration with W. B. Cooke and Charles Heath, in the dissemination of his paintings in this form leads us to inquire for more information on the engravers themselves. One hundred and sixteen engravers took out new insurance policies with the Sun or Royal Exchange Fire Insurance Companies in London alone in the short period between 1775 and 1787. This compared with 237 printers and bookbinders.[26] When Turner worked in the 1820s with Charles Heath in his "England and Wales" series, nineteen engravers were employed in producing the prints; some cut as many as thirteen or fourteen plates each.[27]

With each engraving in the Walker series went a text with brief comments on the history, geography, main monuments, the canals and river systems, and always the industrial or commercial activity of the town. Birmingham is described as a town "famed for the ingenuity of its inhabitants," especially those employed in its manufactures in gold, silver, steel and other metals, "of such exquisite taste and workmanship as to excite the attention of the curious." Attention was drawn to Soho, two miles off:

a few years ago, a barren heath, and now exhibits one of the largest manufactories in the world, employing several hundred persons in the fabrication of buckles, buttons, etc....The lower part of the town, being chiefly the warehouses and manufactories, has, from the innumerable columns of smoke continually ascending, contracted a very dirty, and rather mean appearance; but the upper part is well built, and furnished with shops and houses that rival the metropolis.[28]

The topographical descriptions and engravings of Walker's *Copper Plate Magazine* provide a link between depictions of manufacturing and urban industrial settings found in trade cards, catalogues, and directories and the fine art of topographical watercolors. Engravings such as those in Bisset's *Directory* and the view of Soho used classical imagery to convey the craft and art of manufacture, and celebrated machines, tools, and factory buildings. The fine-art topographies, especially those of J. M. W. Turner, took a broader view, setting manufacturing and trade within their urban and rural landscapes.

J. M. W. Turner's Industrial Towns

Turner's prospect of Birmingham and one he produced of Sheffield a few years later followed the topographical convention of viewing the town from a rural vantage point, something he elected to do in many of his later urban watercolors. There are many ways of interpreting this juxtaposition of rural and urban in an art-historical framework, but I will not pursue these here. Neither will I pursue the nineteenth-century "city and country" debate explored recently for a range of views of Manchester and Leeds by Caroline Arscott, Griselda Pollock, and Janet Wolff.[29] What these pictures say to me fits with a working-out of the Smithian vision of industrial and agricultural growth through the emergence of a new type of industrial town integrated with its rural hinterland. The countryside depicted is one in movement, connected to the town through stagecoaches, canals and rivers, and human economic activity which is frequently non-agricultural. In Turner's early views of Birmingham and Sheffield (figs. 44, 45), it is church towers not factory chimneys which dominate and towns crowded with small buildings spilling over into the surrounding hillsides and countryside. In the case of Birmingham, the line between town and nearby village is now marked only by small clumps of trees. But the eye is drawn in the Birmingham picture to the road and to the horse and wagon conveying goods from the town out to the region and on to London. The road, wagons, and carriage of goods and people out from the manufacturing town to other parts of the country and to national and international markets were to feature in later watercolors, notably those of *Leeds* (1816) *Coventry* (1832), and *Kirkstall Lock on the River Aire* (1824–25). Turner paints the rapid growth of these towns clearly in a hurry, their roads major arteries to the metropolis or other major towns.

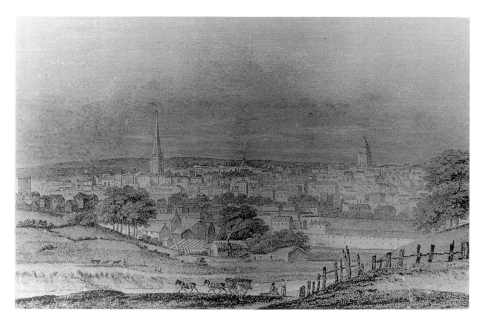

44. J. M. W. Turner, *Birmingham*, 1794, engraving from *The Copper Plate Magazine*. By courtesy of the Trustees of the British Museum, London.

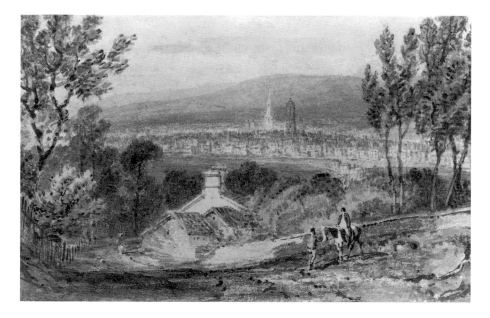

45. J. M. W. Turner, *View of Sheffield from Derbyshire Lane*, 1797, watercolor, 11.7 x 15.5 cm. Ruskin Gallery, Collection of the Guild of St. George.

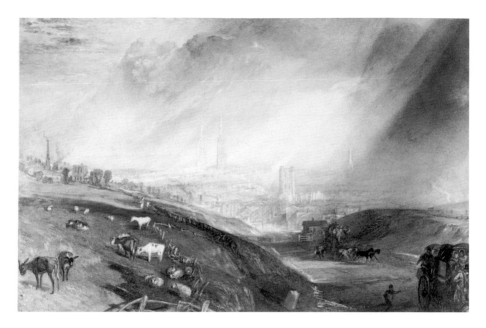

46. J. M. W. Turner, *Coventry, Warwickshire*, 1832, watercolor, R. W. Lloyd Bequest, 1958, 28.8 x 43.7 cm. Courtesy of the Trustees of the British Museum, London.

This becomes much clearer when we move on to the later watercolors. Stephen Daniels has provided a vivid analysis of how this was conveyed in Turner's *Leeds*.[30] Daniels argues that Turner depicts in this picture an "integrated, wholly industrialized landscape." Country areas were turned over to tenter grounds for drying cloth. A major road connects the industrial activities in the countryside with the factories in the city. The activity on the road, placed in the foreground of the painting — with a weaver carrying a roll of cloth, milk carriers, factory workers returning home, and a wagon going towards the city — are at least as important a focus as the distant factory chimneys of the town placed towards the back of the picture.[31]

Several other of the town views also convey these ideas: the foreground and distant views of the town in Turner's *Coventry* (1832; fig. 46), for example. Turnpikes, coaches, cattle, and rural metal processing on the neighboring coal field provide the economic dynamic of the rural framework of the city. The city is distant, bathed in bright afternoon sunlight as a storm passes away beyond it. It is depicted as a kind of "Celestial City," and again the road, a turnpike road leading to Birmingham and busy with travelers, dominates the front of the picture. Ruskin's summing up of the picture as a "story of tumult, fitfulness, power and velocity,"[32] misses the point that Turner depicted both Coventry and Leeds, with echoes going back to his early engraving of Birmingham, as cities spreading into the surrounding countryside and connecting outwards along their main roads to other cities. Not just the towns but the countrysides were painted with

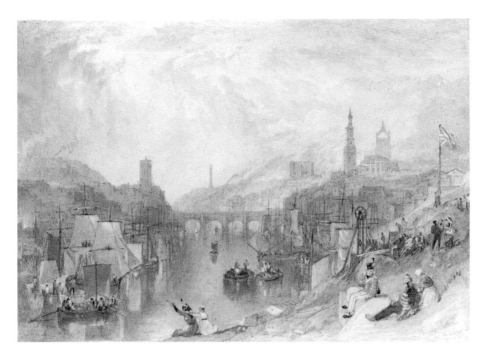

47. J. M. W. Turner, *Newcastle-on-Tyne*, 1823, watercolor, 15.2 x 21.5 cm. Tate Gallery, London.

48. J. M. W. Turner, *Shields on the River Tyne*, 1823, watercolor, 15.4 x 21.6 cm. Tate Gallery, London.

49. J. M. W. Turner, *Dudley, Worcestershire*, 1833, watercolor. Board of Trustees of the National Museums and Galleries on Merseyside (Lady Lever Art Gallery, Port Sunlight).

the activity of industry reaching out. The roads were painted prominently as main arteries busy with people on the move.

A further pair of paintings, *Newcastle-on-Tyne* (fig. 47) and *Shields on the River Tyne* (fig. 48), show the urban growth and vitality tied to the coal trade . It is not the road which forms the focus here, but the river. The river in the depictions of these industrial towns fulfills a similar role to that of the road in those discussed above. Its place also parallels some of the river views in Turner's Thames series—an image of "bustling commercial activity." "In the topographies, rivers served as threads, along which all that was regarded as most attractive, interesting and characteristic of a region was strung."[33]

Newcastle-on-Tyne provides a view of Gateshead on the left and Newcastle on the right, both in the distance in the picture, while in the foreground is the river, crowded with the action of the coal trade and the people of the port. On the front left of the picture, crowds of small sailing craft carry coal and busy keelmen, who look across the river to more action on the opposite bank, where a group of men haul timber up from a vessel below. Both towns in the distance have smoking factory chimneys on their hillsides. A pall of haze and smoke in the background contrasts with the golden light in the foreground picking out the detail of active life in the middle of the day in an industrial port.

Newcastle, the largest industrial town of the seventeenth century apart from London, was still famed for its wealth and population at the end of the eighteenth century. A sense of this great enterprise was conveyed by contemporary

comparison with antiquity. A local coalowner compared his wagonways to the Via Appia. Bourne in his *History of Newcastle* claimed that "these Waggon-ways, a small part of the whole Coal Works, may Vie with some of the great Works of the Roman Empire."[34] The keelmen depicted in the lower left were proverbial for their hard and dangerous work and their fierce independence and disciplined industrial action against employers.

The work of the keelmen is depicted in closer detail and close at hand in *Shields on the River Tyne*. Unlike the *Newcastle-on-Tyne* picture, this one is an evening or very early morning scene. Darkened ships queue up at the sides of the port, seeking their black cargoes. On the upper right of the picture there is a coal wagon which has reached the ships via one of the great coal wagonways. Down below, coal-heaving keelmen and women workers among them are all busy, their task and the ship they are loading lit by a brazier. Dark clouds move beyond a full moon shimmering onto the dirty waters.

The blue-black tones of *Shields on the River Tyne* compare well with *Dudley, Worcestershire* (fig. 49), another picture of industry at work into the night — the black and blue-grey tones of the picture help to hide figures in the distance shrouded in gloom. The industrial action is outside the center of the town, which is placed in the distance, veiled in smoke and darkness. In the foreground barges filled with iron goods are lined up, the darkness bringing their travel to rest for a few hours; a canal boat pony is ungirthed, and a bargeman empties refuse into murky waters. But the work carries on in the fiery chimneys and gas-lit windows of factories further along the canal, placed at the center of the picture. The outskirts of the towns here are industrialized — it is not the town that dominates, but an industrial region. The setting for this picture again is a waterway, this time a canal. Its stagnant waters lead into the close-crowded factories and smoking workshops of the industrial region. In contrast, the river in *Shields on the River Tyne* leads out to the open seas, meeting an endless sky, its expanse lit by the full moon.

Dudley has been the subject of longstanding debate on Turner's responses to industry — with Ruskin's "premonitions" echoed by Eric Shanes's "nightmarish industrial disorder," and Andrew Wilton's "transcription of the life of industrial man" and the "most complete of Turner's essays in the Industrial Sublime," followed by Rodner's "romantic suggestion of power and energy beneath the surfaces of observed industry."[35] Who can say whether Turner loved or hated the industrial scene he painted; but as a picture it brings us immediately into the smoke, fire, and action along a Black Country canal. Turner was the only artist of his time to depict urban modernity as fine art. He painted cities and industry in a manner parallel to Adam Smith's analysis of "the great commerce." Where Adam Smith analyzed the integration of rural and urban growth through commercial connections between town and country, Turner painted the great arteries of exchange, the canals, roads, and harbors around his industrial towns.

Adam Smith's model of industry rising out of its rural hinterland points to the fundamental diversity of industrialism in the eighteenth and early nineteenth centuries. One aspect of this was the extent of industrial activity in the countryside. Some of this was obviously connected with urban industrial expansion, as in the activity along the Leeds and Liverpool Canal depicted in Turner's *Kirkstall Lock on the River Aire*. But much of it was time-honored industrial activity carried out in pastoral, seaside, or mountainous regions. Wrigley has calculated that only 10 percent of the adult male labor force in 1831 worked in manufacturing, and half of them were to be found in Lancashire and the West Riding. But 32 percent of the male work force was occupied in retail trade and handicraft.[36] We may have some doubts about these estimates; nevertheless, large amounts of industrial work were of the kind depicted in the slateworkers of Turner's *Tintagel Castle, Cornwall* (1815) and the *Lime Kiln of Combe Martin* (1824).

Later-nineteenth-century preconceptions of what a landscape topography ought to be depicting, or what landscape artists ought to be saying about the general culture of the early industrial period, may not be the best guide to historical interpretations of these works. The encyclopedias, directories, and topographies of Turner's own time must claim a place in these interpretations. More fundamentally, Adam Smith's vision of town and country industrial development, as well as the great regional diversity of early industrial, experience provide an alternative framework.

1 John Ruskin, "From *Modern Painters*," (1860) in *Unto This Last and Other Writings* (Harmondsworth: Penguin, 1987), 151.

2 Cited in Stephen Daniels, *Fields of Vision: Landscape Imagery and National Identity in England and the United States* (Cambridge: Polity Press, 1993), 124.

3 Thomas Carlyle, "Chartism," in *Critical and Miscellaneous Essays, Collected Works*, (London, 1885–91), 13:311; "Signs of the Times," in ibid., 15:474.

4 Robert Southey, *Letters from England* (1807), cited in B. I. Coleman, ed., *The Idea of the City in Nineteenth-Century Britain* (London: Routledge and Kegan Paul, 1973), 33.

5 Ibid.

6 Boyd Hilton, *The Age of Atonement: The Influence of Evangelicalism on Social and Economic Thought, 1795–1865* (Oxford: Clarendon Press, 1988), 126.

7 See *The Political Pilgrim's Progress* (first published in the *Northern Liberator*, Newcastle upon Tyne, 1839), cited in Maxine Berg, *The Machinery Question and the Making of Political Economy, 1815–1848* (Cambridge: Cambridge University Press, 1980), 288.

8 Raymond Williams, *The Country and the City* (New York: Oxford University Press, 1973), 256.

9 Asa Briggs, *Victorian Cities* (Harmondsworth: Penguin, 1968), 72.

10 Williams, 37.

11 Jan De Vries, *European Urbanization, 1500–1800* (London: Methuen, 1985), 39.

12 E. A. Wrigley, "Urban Growth and Agricultural Change: England and the Continent in the Early Modern Period," in Wrigley, ed., *People, Cities, and Wealth: The Transformation of Traditional Society* (Oxford: Blackwell, 1987), 178.

13 Ibid., 160.

14 Linda Colley, *Britons: Forging the Nation, 1707–1837* (New Haven: Yale University Press, 1992), 39.

15 Adam Smith, *An Inquiry into the Nature and Causes of the Wealth of Nations*, vol. 1, Book 3 (1776; Oxford: Clarendon Press, 1976), 376.

16 Ibid., 409.

17 Ibid., 408.

18 Cited in P. J. Corfield, *The Impact of English Towns, 1700–1800* (Oxford: Oxford University Press, 1982), 23.

19 See Colley, 31, 32, for the apocalyptic imagery of clerical language.

20 Cited in Christopher Hill, *A Turbulent, Seditious, and Factious People: John Bunyan and His Church, 1628–1688* (Oxford, 1988), 220.

21 Daniels, 73.

22 *Memoirs of James Bisset* (Warwick County Record Office, 1818).

23 James Bisset, *A Poetic Survey Round Birmingham…Accompanied by a Magnificent Directory* (Birmingham, 1799), 29, 30, 33.

24 Peter Clark, "Visions of the Urban Community. Antiquarians and the English City before 1800," in Derek Fraser and Anthony Sutcliffe, eds., *The Pursuit of Urban History* (London: E. Arnold, 1983), 105–24.

25 *The Copper Plate Magazine or Monthly Cabinet of Picturesque Prints Consisting of Sublime and Interesting Views in Great Britain and Ireland Beautifully Engraved by the Most Eminent Artists from the Paintings and Drawings of the First Masters* (London, 1792 and 1794).

26 See L. D. Schwarz, *London in the Age of Industrialisation: Entrepreneurs, Labour Force, and Living Conditions, 1700–1850* (Cambridge: Cambridge University Press, 1992), 250–53.

27 Eric Shanes, *Turner's England, 1810-1838* (London: Cassell, 1990), 15.

28 *Copper Plate Magazine*, vol. 2, xlvi.

29 Caroline Arscott, Griselda Pollock, and Janet Wolff, "The Partial View: The Visual Representation of the Early Nineteenth-Century City," in Janet Wolff and John Seed, eds., *The Culture of Capital: Art, Power, and the Nineteenth-Century Middle Class* (Manchester: Manchester University Press, 1988).

30 Daniels, chap. 4, "J. M. W. Turner and the Circulation of the State."

31 See ibid., 119.

32 John Ruskin, *Modern Painters*, vol. 1, in *The Works of John Ruskin*, ed. E. T. Cook and Alexander Wedderburn (London, 1903), 3:407.

33 Andrew Hemingway, *Landscape Imagery and Urban Culture in Early Nineteenth-Century Britain* (Cambridge: Cambridge University Press, 1992), 225–26.

34 Joyce Ellis, "A Dynamic Society: Social Relations in Newcastle-upon-Tyne, 1660–1760," in Peter Clark, ed., *The Transformation of English Provincial Towns, 1600–1800* (London: Hutchinson, 1984), 201.

35 Shanes, 202; Andrew Wilton, *Turner and the Sublime* (London: British Museum Publications, 1980), 168; and W. S. Rodner, "Turner's *Dudley*: Continuity, Change and Adaptability in the Industrial Black Country," *Turner Studies* 8 (1988): 32–40.

36 E. A. Wrigley, *Continuity, Chance, and Change: The Character of the Industrial Revolution in England* (Cambridge: Cambridge University Press, 1988).

Gilpin on the Wye:
Tourists, Tintern Abbey, and the Picturesque

Stephen Copley

WILLIAM GILPIN's enormously popular domestic tours, written and privately circulated in the 1770s and published between 1782 and 1809 alongside his essays on travel and painting, were widely adopted by tourists and general readers in the 1780s and 1790s as the source of authoritative judgments on the picturesque qualities of landscape. At the same time, in the intense debate about the nature of the picturesque which developed in the 1790s and early 1800s, Gilpin's pronouncements on the topic were attacked by theorists such as Uvedale Price and Richard Payne Knight for their illogicality and inconsistency. Until recently, twentieth-century scholars have tended to endorse the view that Gilpin, while unquestionably popular, was a naive proponent of an aesthetic which was only rendered coherent as it was refined by those later theorists. In the last few years, however, commentators have sought to differentiate the various strands that run through the debate over the picturesque, and they have suggested that, rather than being seen as a single coherent aesthetic category, the term may have had strikingly different implications as it was deployed in relation to tourism, landscaping, architectural design, estate management, and narrative and pictorial representation in the period. In the process they have provided a good opportunity for a reassessment of the implications of Gilpin's work.[1]

Any such reassessment must involve consideration of the relation between Gilpin's definition of the picturesque and other established usages of the term in the late eighteenth century. Gilpin's aesthetic pronouncements are derived from one particular activity, domestic tourism, with its associated amateur pursuits of viewing scenery, sketching, and keeping journals; and the picturesque program which he develops in his *Observations* on various parts of Britain and formalizes in his essays is firmly rooted in the patterns of tourism and in the viewing practices of the period in which his tours were originally undertaken, in the 1770s. Commentators of the 1790s such as Price and Knight, who concentrate on the picturesque in estate management and landscaping, necessarily have a different engagement with the physical environment from that of the tourist, and their work has increasingly come to be seen not simply as a refinement of Gilpin's ideas, but as the expression of an aesthetic which is distinct from, or indeed inimical to, his. In this volume Stephen Daniels, Susanne Seymour, and Charles Watkins thus emphasize the disparities between Gilpin's account of the scenic attractions of the lower Wye and the landscaping projects carried out by Price and Knight on their estates in the middle reaches of the river. More generally,

Kim Ian Michasiw has recently attacked the assumption that the aesthetic progam developed in Gilpin's tours can be reconciled on any terms with that of landscaping. Instead, Michasiw identifies in Gilpin's writings an aesthetic that is in some ways radically opposed to the claims of the later landscape theorists, and he celebrates this aesthetic for precisely the reasons that had earlier caused critics to denigrate it as trivial and frivolous. For Michasiw, Gilpin is an ironically self-aware rather than naive commentator, whose "Enlightenment games" with the artifices of perception and representation are the antithesis of the Romantic mystification of nature. In consequence, his work is of considerable interest to modern readers: as Michasiw writes, "the implications of Gilpin's theories have some relevance to the necessary demystification of art and its ideolatry in the postmodern condition…the fact that they were unsuited to their era should not license our continuing to condemn and dismiss them."[2]

The idea that, despite their popularity, Gilpin's ideas were "unsuited to their era" is intriguing. His tour narratives are strikingly iconoclastic in relation to other written tours of the period in their rejection of the claims of educative utility in favor of the pursuit of aesthetic pleasure; and they are also atypical in Gilpin's repudiation of the characteristic encyclopedism of the tour form, and in the rigor of his aesthetic selection of the objects and landscapes that he is prepared to deem picturesque. Andrew Hemingway has commented that Gilpin's picturesque aesthetic involves "a distinction between the rules of selection derivable from painting and the overwhelming variety of natural phenomena which presented themselves to the amateur artist and traveller," and he has suggested that the exclusivity of Gilpin's selection of "picturesque" objects is not characteristic of the terms in which the word is habitually deployed in the period. As he writes, Arthur Young had already popularized a much more inclusive vocabulary of the picturesque in the course of his *Six Months Tour through the North of England* (1770) well before the publication of any of the volumes in Gilpin's series of *Observations*. In Young's model, celebration of the picturesque does not involve rejection of agricultural landscapes in favor of uncultivated, "natural" ones. It therefore does not involve the rejection of productive utility in favor of aesthetic pleasure, as it does in Gilpin, and descriptions of the attractions of picturesque landscape sit unproblematically alongside Young's program of agricultural instruction.[3]

The tendency to ascribe inclusive meanings such as Young's to the terminology of the picturesque remains marked in late-eighteenth-century publications. Even where tour and guide writers of the period acknowledge the source of their vocabulary in Gilpin himself, their discussions of the attractions of landscape are often incorporated into encyclopedic designs in terms which themselves undermine the exclusivity of Gilpin's concern with the aesthetic. In this sense, writers on picturesque tourism in the period who celebrate Gilpin as the source of authoritative pronouncements in the field can often be seen to depart implicitly

from him in the patterns of emphasis that mark their own works. Indeed, as I will suggest later, the tendency of the tour form to encyclopedism inevitably imposes its own pressure even on Gilpin's apparently single-minded concentration on his aesthetic program.

By the time of the popular dissemination of Gilpin's tours in the 1780s and 1790s, they inevitably describe historical landscapes — a fact which, together with Gilpin's declared lack of interest in providing empirically accurate accounts of those landscapes, causes considerable problems for late-eighteenth-century readers intent on taking his tours as guides to the regions they intend to visit. At the same time the delayed publication of the tours and the consistency of Gilpin's later advocacy of the positions expounded in them mean that, even at the height of their popularity, his published writings can be seen to deploy a vocabulary that is in some senses anachronistic in the face of changes in aesthetic fashion and developments in the patterns of tourism itself. In painting, for instance, the period sees the start of what Andrew Hemingway has described as the eclipse of the picturesque by the nineteenth-century aesthetic of naturalism, which he sees "partly as a critique" of the earlier category, and which is marked out from it not only by different approaches to technique and color, but also by a move from generalized representational signs for locale and landscape features to topographical specificity, and by a new attitude to the representation of rural labor.[4] Similarly, within the field of tourism itself, the late-eighteenth-century fashion for pedestrianism — with all the moral associations which attach to that form of travel in the period — exerts its own pressure on Gilpin's version of the picturesque. As Anne D. Wallace has suggested, pedestrianism "undermined the prevailing pictorial aesthetic in art and poetry, which, like destination-oriented travel, preferred perception rendered from selected discrete viewpoints or from the unbounded, processless 'flight of fancy'" — a trend which was confirmed in the early nineteenth century, as many commentators have noted, in texts such as Wordsworth's *Guide to the Lakes*, in which the construction of perception that characterizes the picturesque is sharply criticized, and in which the sources of descriptive analogy are overwhelmingly literary rather than pictorial.[5]

In this context an account of the combination of claims made by Gilpin in the course of the first and most concentrated of his published tours offers a useful index of the components that make up his version of the picturesque, and of the place of that version in the larger debates about the aesthetic in the period.

The *Observations on the River Wye*, an account of a fortnight's excursion in the Wye valley and South Wales undertaken by William Gilpin and his party in the summer of 1770, was not published until 1782, when the new technology of aquatint made it possible for Gilpin to achieve acceptable reproductions of the ink and wash sketches which had accompanied his original narrative. The published volume was most obviously influential in stimulating the taste of the period for domestic tourism, with its associated activities of sketching, painting,

and keeping journals, and it helped establish the lower Wye as a prime site for such tourism, just as Gilpin's subsequently published volumes of *Observations* on areas such as the Lake District and Scotland contributed to the popularization of those regions. The climax of the trip down the Wye for Gilpin, and for many of the tourists who followed in his footsteps, was the visit to the ruins of Tintern Abbey, which consequently became one of the most frequently described and represented picturesque historical sites in the country. Gilpin's instructions to the tourist in the course of the tour on the development of what he calls "the picturesque eye"[6] meet a series of challenges at Tintern, and his account of his visit offers a striking illumination of the claims that he makes for the picturesque as an aesthetic category.

The popularity of Gilpin's tour is clear from the numerous editions it went through, from the encomiums and imitations it provoked from later tourists, and in particular, from Rev. T. D. Fosbroke's incorporation of large parts of Gilpin's narrative into a guidebook of 1818, *Gilpin on the Wye*, which remained the standard companion volume to the area well into the nineteenth century.[7] Fosbroke's volume offers a useful framework through which to read the *Observations on the Wye*, providing an index of the terms on which Gilpin's vocabulary of the picturesque was absorbed—and in some respects transformed—in the burgeoning tourist literature of the period. Fosbroke is unstinting in his praise of Gilpin. In the preface to *Gilpin on the Wye* he insists that "in the picturesque, Gilpin is unquestionably an Oracle; and his work is a Grammar of the Rules, by which alone, the beauties of the Tour can be properly understood and appreciated."[8] He qualifies and rewrites Gilpin's descriptions extensively, however, in the interests of translating his narrative into a guidebook—a change which is in many ways inimical to Gilpin's original project but which is typical of the process of codification, popularization, and commodification of the picturesque aesthetic in the period that has been described by Ann Bermingham.[9]

Many of the revisions in Fosbroke's volume stem from his project of offering authoritative, comprehensive, and accurate guidance to the Wye valley, and of policing of the activities as well as the responses of the tourists who visit it. In the third edition Fosbroke's ambition "to render this work as much as possible a standard one on the subject" thus leads him to separate his picturesque, historical, and geographical material formally into different "departments" and instruct tourists on how—and when—to make use of each: the design is announced in the Preface, where the reader is offered "the Picturesque, that the matter might conform to the Tour; the Historical to be read at the Inn, and the source of the River...for perusal at leisure."[10] At the same time Fosbroke alters Gilpin's emphasis considerably throughout, suggesting in the first edition that Gilpin's failure to provide "precise accounts of the scenery, (his drawings being fancy-embellishments)" demands remedy, and deflecting his stress on the peculiar picturesque attractions of decay. At Tintern Abbey, for instance, he writes "Such,

even in ruin, is *holy* Tintern: what would it be, if entire, and 'with storied windows richly dight.'"[11] Comparison with Gilpin's passing comment on Cardiff in the original *Observations* suggests how far Fosbroke's imagined historical completeness is from Gilpin's conception of the picturesque: Gilpin had written that Cardiff "appeared with more of the furniture of antiquity about it, than any other town we had seen in Wales: but *on the spot* the picturesque eye finds it too intire to be in full perfection."[12]

Gilpin's volumes of *Observations* are not presented as empirically accurate guidebooks but as the sources of an aesthetic program, a way of seeing. For Gilpin, the tourist in search of the picturesque views and represents the landscape through which he or she travels in the light of an elaborate framework of preconceived expectations, derived from a wide range of visual and literary sources. At the start of the Wye tour, when Gilpin admits that "we travel for various purposes," he suggests that

> the following little work proposes a new object of pursuit; that of not barely examining the face of a country; but of examining it by the rules of picturesque beauty: that of not merely describing; but of adapting the description of natural scenery to the principles of artificial landscape.[13]

His comments introduce many of the conflicts that mark his writing generally — between nature and artifice, spontaneous observation and the generation of aesthetic rules, visual representation and narrative description, the pursuit of aesthetic pleasure and the various other "purposes" that motivate travel. The most striking conflicts involve what appear to be contradictory appeals to the natural and to the artificial, to codified aesthetic rules and to spontaneous perception. In the introduction to the Lakes tour, Gilpin tries to square the circle of representation and nature by claiming that although "examining landscape by the *rules of picturesque beauty*, seems rather a deviation from *nature* to *art*," this is not the case, "for the *rules of picturesque beauty*, we know, are drawn from *nature*";[14] but the problem remains pervasive in all his discussions. On the one hand, he finds attractions in roughness, irregularity, wildness, and decay because they can be taken as the signs and tokens of the spontaneously "natural." On the other hand, however, he suggests that picturesque objects "please from some quality, capable of being illustrated by painting," whereas beautiful ones "please the eye in their *natural* state."[15] Smoothness and neatness may thus please as components of natural beauty, but roughness and irregularity offer greater sources of picturesque interest in representation.

Gilpin's confused distinctions are certainly refined in the extended debates in which Price and Knight define the picturesque against the sublime and the beautiful, and disagree over whether the quality of picturesque attractiveness resides in objects or only in representations.[16] In the course of those debates, however, some of Gilpin's distinctive emphases are lost. In his search to define the pic-

turesque, for instance, Gilpin repeatedly sets that term against other aesthetic categories and "places" the whole activity of picturesque tourism against other, potentially more valuable or useful activities. His aesthetic lexicon thus includes a range of terms for the description of scenery or objects that are not picturesque, but that may still be enjoyed by the tourist. On the Wye tour Brecknoc castle is thus "too ruined even for picturesque use"; but the town's setting is "romantic," and the castle site remains "very amusing." Similarly the view from Ross church-yard is not strictly picturesque: "It is marked by no characteristic objects: it is broken into too many parts; and it is seen from too high a point." Nevertheless it is "indeed very amusing."[17] This last category — "amusing" — loses its place in the configuration of terms in which the later-eighteenth-century aesthetic debates are conducted. Morris R. Brownell suggests that Gilpin deploys the term in the "pejorative" sense that he finds in Dr. Johnson's *Dictionary* definition, in which the verb "amuse" is contrasted with "divert" (which "implies something more lively"), and with "please" (which suggests "something more important"), and in which Johnson comments that "amuse" "is therefore frequently taken in a sense bordering on contempt."[18] This is to over-emphasize the negative connotations in Gilpin's own usage of the word: instead, I would suggest that his deployment of the category of "the amusing" identifies his aesthetic discussions firmly as celebrations of the leisured pursuit of pleasure, but that it causes him considerable problems as a consequence precisely because of the availability of the condemnatory definition of the term that Brownell identifies.

The great attraction in landscape for the observer schooled in the picturesque is its appearance of unconstrained, spontaneous naturalness, signified by its irregularity. The extent (and limit) of Gilpin's break with earlier eighteenth-century perceptions in this respect is clear in a comparison of his tours with "A Trip to North Wales," from John Torbuck's anthology, *A Collection of Welch Travels* (1738), in which the anonymous author describes a visit to a Welsh circuit judge along part of the route that later became established as the North Wales tour. The author writes of the area that "the Country looks like the fag End of the Creation; the very Rubbish of *Noah's* Flood; and will (if anything) serve to confirm an *Epicurean* in his Creed, that the World was made by Chance." Malcolm Andrews remarks of this passage that "country which was unimproved, agriculturally or ornamentally, and which looked incapable of such improvement, had little appeal for the Augustan observer and often caused revulsion."[19] Even in Gilpin, however, the connection between wildness and attractiveness is not inevitable, and artful artifice in the landscape is by no means rejected. Snowdon, for instance, is seen as incoherent. It is unattractively wild and uncontainably large: it "no where appears connected enough as *one whole* to form a *grand* object," while it lacks "those accompaniments, which form a *beautiful* one," and it is consequently dismissed as "a bleak, dreary waste." Similarly, in Cornwall, on the Western tour, Gilpin notes that "Great part of this country, it is true, is in a

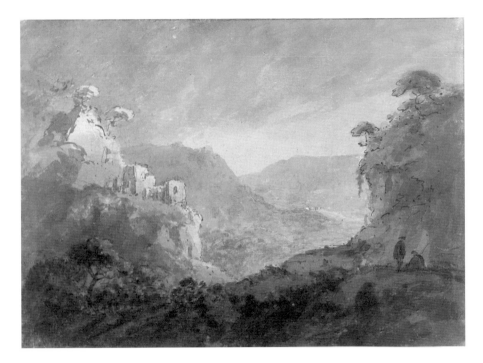

50. William Gilpin, *A View into a Winding Valley*, c. 1790. Leeds Museums and Galleries (City Art Gallery). "A view into a winding valley. The high ground, on ye right, is a part of one of ye side-skreens; & ye inlightened ground, on ye left is a part of ye other. The valley winds round a knoll with a castle upon it, just touched with light; and goes off between ye mountains."

state of nature, which in general is a state of picturesque beauty, but here it was otherwise."[20]

At times nature itself composes a fully pictorial view (or conspires with human artifice in such a composition). At Goodrich Castle, on the Wye, Gilpin thus finds a view which is spontaneously "correctly picturesque," but as he comments, this is unusual: "Nature is always great in design; but unequal in composition. She is an admirable colourist; and can harmonize her tints with infinite variety, and inimitable beauty; but is seldom so correct in composition, as to produce an harmonious whole."[21] In these circumstances, the artist or the observer may legitimately intervene to correct the natural composition of the landscape by adding or altering features to produce pictorial harmony.

One of Gilpin's geographically unspecific drawings, *A View into a Winding Valley* (fig. 50), illustrates very clearly the programmed components of the picturesque landscape, which allow the tourist to delight in natural irregularities of appearance but to see and represent them as parts in a sequence of composed whole pictorial views. As Gilpin's descriptive subtitle to the picture makes clear, the discontinuously observed high valley sides represented provide the side-screens and an effective end-screen to the image, clearly revealing their origins in the design of theatrical side-screens, and creating successive and sharply defined

51. The lower Wye valley. Detail from Ordnance Survey map, 1830.

planes of depth from each natural abutment. The generally indicated wildness of the terrain excludes the signs of human habitation, property division, and cultivation that Gilpin claims to find "disgusting" in landscape, and the human figures in the dark foreground of the picture take their place as "picturesque appendages,"[22] characteristically posed to indicate leisure, and minimally sketched. The castle, in its appropriate place according to various of Gilpin's comments on actual castles, has an outline softened and made irregular by ruination to the point at which it forms a continuity with the line of the "inlightened" rocky knoll on which it stands.

Seen in relation to this schema, the peculiar beauty of the river Wye derives from its "lofty banks" and its "mazy course" — both clearly indicated in the first ordnance survey map of the area (fig. 51) — which form and frame endlessly changing pictorial compositions, analyzed by Gilpin in terms of "the area" (the river), the two "side-screens" (the banks), and the "front-screen" offered by the sharpness of the bends in the valley.[23] Within this frame the "ornaments" of the scene, individually categorized as "ground – woods – rocks – buildings," are each negotiated in particular ways: the animals and people who inhabit the landscape are more problematic, particularly when the encounter with them becomes inevitable, as it does at Tintern.

The devices by which pictorial harmony is shaped by proponents of the picturesque — the rules of viewing, the frame provided by the Claude glass, the use of viewing stations — have been documented at length by modern scholars.[24] At the same time commentators have outlined the ways in which picturesque visual representation differs from earlier traditions of painting. Alan Liu, for instance, suggests that "the picturesque…forgot half the Classic picture — the narrative — to focus exclusively on the landscape mapping form": without "narrative reference" the "fact of interpretation became unapparent," so that in the picturesque "unapparent interpretation *is* form."[25] Picturesque pictorial "form" does not emerge pure and untrammeled in paintings and sketches of the period, however, any more than its descriptive equivalent does in narratives: in both, it is important to recognize the tensions that may exist between the claims of the picturesque and those of other, inherited aesthetics. In Gilpin's *Forest Scenery*, for instance, the residue of the emblematic tradition is clear in the author's suggestion that

> If a man were disposed to moralize, the ramification of a thriving tree affords a good theme. Nothing gives a happier idea of a busy life. Industry, and activity, pervade every part…In this fallen state alone, it is true, the tree becomes the basis of England's glory. Tho' we regret the fall, therefore, we must not repine.[26]

In this context, what Liu presents as the picturesque's suppression of narrative in favor of decorative pictorial form makes for an interesting relation between Gilpin's tour narratives and the sketches which accompany them.

In the preface to the Lakes tour Gilpin discusses the form of the tour narrative, while offering an elaborate apologia for his own interest in such self-confessedly trivial matters.[27] He suggests that the ensuing tour can be seen as "didactic, or descriptive (as in fact it is intended to be a species between both)." In this context, "What in argument would be absurd; in works of amusement may be necessary," and he justifies his narrative "digressions" from landscape description into "observations, anecdote, or history" as examples of "occasional relief" and "poetic licence," which literally and figuratively reinforce the picturesque's concern with avoiding "satiety"(xx). At the same time he makes analogies between descriptive writing and visual representation (and vice versa). On the one hand, he claims that "it is the aim of *picturesque description* to bring the images of nature, as forcibly, and as closely to the eye, as it can." This involves "*high colouring,*" which does not, however, depend on "*a string of rapturous epithets*…but an attempt to analize the views of nature"(xix). On the other hand, he comments on the inadequacy of the sketches included in the Wye tour (published three years earlier) as "*portraits*" of scenes in the area, even taking into account his original proviso that these "*portraits*" were only intended to give general impressions of locations. In the new work, he suggests, the prints are either "meant to *illustrate and explain picturesque ideas*" or to "*characterize the countries* through which the reader is carried…from the general face of the country; not from any particular scene." Such general representations, avoiding the specificity involved in the "*portrait*" of "a *single spot,*" "spread themselves more diffusely; and are carried, in the reader's imagination, through the *whole description*"(xxv). They are "the *most picturesque* kind of drawing," and Gilpin enumerates the changes to the observed scene that an artist "who works '*from imagination*'" may make in creating them. These must stay within the bounds of "liberty" rather than "licence": the "grand exhibition" must be copied faithfully, although its "fore-ground" may be redesigned—but only by altering components which are in any case naturally mutable rather than by adding "*new features*"(xxviii).

In Gilpin's sketches this program of licensed inventiveness results in the production of what Fosbroke calls "fancy-embellishments" rather than precise representations of the landscape. In the written narratives of the tours, too, the inventive evocation of fictitious experience at times threatens to efface the evidence of the physical surroundings through which Gilpin passes. In the Lakes tour, for instance, Gilpin's description of the road running past Derwentwater on the approach to Borrowdale leads him to generalize, and he confides that

> As we proceeded in our rout along the lake, the road grew wilder, and more romantic. There is not an idea more tremendous, than that of riding along the edge of a precipice, unguarded by any parapet, under the impending rocks, which threaten above; while the surges of a flood, or the whirlpools of a rapid river, terrify below.

He continues in this vein for a full page before confessing the complete irrelevance of this rhetorical evocation of sublime terror to the situation of his party: "But here we had not even the miniature of these dreadful ideas, at least on the side of the lake; for in the steepest part, we were scarce raised thirty or forty feet above the water."[28]

In this context the various traces of the ephemeral, the mutable, and the historical have crucial effects in the picturesque landscape, while the constraints of time shape Gilpin's narratives and visual representations and guarantee their expressive authenticity. In each tour, the tourist's journey through the landscape is narrated as a single experiential sequence, with the illustrations as part of that sequence. Despite his suggestion that "to criticize the face of a country correctly, you should see it oftner than once; and in various seasons," it is thus no part of Gilpin's design to revisit the Wye in the twelve years between the initial trip and publication of the tour, in order to supply missing or more accurate information about the area. Instead, "the descriptive part" of the book is offered as "a hasty sketch," as are the illustrations. In both cases "these scenes are marked just as they struck the eye at first." Although the "eye" in question only sees them because it is imbued with the conventions of picturesque representation, Gilpin insists that "Observations of this kind, through the vehicle of description, have the better chance of being founded in truth; as they are not the offspring of theory; but are taken warm from the scenes of nature, as they arise."[29]

The signs of commerce and industry are not precluded from Gilpin's accounts of attractive landscape: they may be appreciated in other terms (for instance, as elements of the sublime), or they may themselves be seen as picturesque. On the Wye Gilpin thus enjoys the sight of "abbeys, castles, villages, spires, forges, mills, and bridges…venerable vestiges of the past, or chearful habitations of the present times," while at Lidbroke Wharf "the contrast of all this business, the engines used in lading, and unlading, together with the solemnity of the scene, produce all together a picturesque assemblage."[30] At various stages, too, he comments on the incidental attractions of the smoke which rises from the hidden charcoal and iron works of the region, setting his commentary in the context of a long historical sequence of discussions of the pleasing aesthetic effects of smoke as a harmonizing or decorative element in landscape, which simultaneously reveals and conceals the human activities which produce it. In 1861 Mr. and Mrs. Hall, describing the Wye, still draw on this tradition when they comment that "dark and dense pillars of smoke issue here and there out of the matted foliage; they rise from occasional foundaries, for the smoke created by the charcoal burners is light and blue, and adds to the picturesque as it ascends upwards."[31]

A greater problem than industry, for Gilpin, is posed by the visible signs of agriculture and property division. On the Western tour, for instance, he rejects "*manufactured scenes*" and "*artificial appendages*" for their unfortunate pictorial

effect, while conceding their positive literary associations in pastoral or georgic: "however pleasing all this may be in poetry, on canvas, hedge-rows, elms, furrowed lands, meadows adorned with milk-maids, and hay-fields adorned with mowers, have a bad effect."[32] In contrast, the scenery on the banks of the Wye consists almost entirely of "wood, or of pasturage," both of which minimize or conceal the signs of cultivation: "the painter never desires the hand of art to touch his grounds—but if art *must* mark out the limits of property, and turn them to the use of agriculture; he wishes that these limits may be as much concealed as possible."[33]

In these examples the observer of the picturesque rejects the signs of productive utility in landscape in favor of those of "nature" read as decorative redundancy—a position that is formalized in *Forest Scenery* when Gilpin insists that it is not the "business" of "the picturesque eye" "to consider matters of utility. It has nothing to do with the affairs of the plough, and the spade; but merely examines the face of nature as a beautiful object."[34] As various agricultural improvers of the period point out, this stance, combined with endorsement of the picturesque attractions of decrepitude, aestheticizes the visible signs of economic deprivation. In the case of the Lake District, for instance, commentators on the picturesque celebrate exactly the features which cause the agricultural reporters anthologized by William Marshall to claim that

> In a county like this, that does not raise corn sufficient for the consumption of its inhabitants…it is lamentable to see such extensive tracts of *good corn land* lying waste, of no value to its owners, and of no benefit to the community. Instead of the present scarcity of grain, large quantities might be yearly exported; and instead of the ill-formed, poor, starved, meagre animals that depasture the commons at present, an abundant supply of good fat mutton would be had to grace the markets of the county.[35]

Seen in this context, the project of distancing and differentiating the tourist from the economic activities that are sustained in the locales he or she visits underlies every aspect of Gilpin's aesthetic program. Specifically amateur sketching, for instance, is recommended as a preferred activity for tourists at least in part because its amateur nature confirms their leisured status: "gentlemen-artists" can never be very good at painting in the higher forms, which would require application, and which might be tainted by associations with professionalism, "but the *art of sketching landscapes* is attainable by a man of business."[36] The tourist's view is positively superficial. It is the perception of a gentleman amateur, marked out from the local inhabitants by his leisure, and aware that his leisure-time pursuits are constrained but also justified by their status as relief from the more serious business which he pursues elsewhere.

Gilpin's account of his visit to Tintern Abbey, with its two accompanying illustrations,[37] raises in an extreme form many of the problems I have already

considered. The famously inaccurate impression of the ruins given by Gilpin's illustrations is clear if Gilpin's view of the abbey from the Chepstow road is compared with the engraving of the scene from the Halls' *Book of the Wye* (1861) (figs. 52, 53). The comparision shows clearly the radical simplification, alteration of perspective and proportion, and suppression of details, such as the run-down houses surrounding the ruin, which characterize Gilpin's sketch. (By contrast, the Halls' engraving shows something of the mixture of empirical accuracy and Gothic fantasy which characterizes Victorian medievalism, for instance in its combination of accurate visual detail with a Gothicized spelling of the place name—"Tinterne"—which has no historical provenance.) Gilpin's near view of the ruin (fig. 54) is similarly inaccurate in its proportions and rearrangement of detail; and both views are particularly striking for their replacement of the hamlet full of impoverished beggars that Gilpin describes at the scene with two lightly sketched and characteristically posed figures in each print.

Gilpin begins his description of Tintern by gesturing to the historical imperatives which originally dictated the sites of castles and monasteries, but he marks the redundancy of those imperatives—or, in the case of the monastery, their modification—as the ruined buildings are translated into sources of aesthetic pleasure for the modern observer. He writes that "Castles, and abbeys have different situations, agreeable to their respective uses. The castle, meant for defence, stands boldly on the hill: the abbey, intended for meditation, is hid in the sequestered vale"; and he moves into exclamatory blank verse to suggest that tourists in search of the picturesque will be "happy" at the first of these sites, and "most happy" at the second. The description of Tintern is thus framed with references to the visitors' expectations, which are then either confirmed or frustrated in the course of their visit. Disappointing them, the ruin itself "does not make that appearance as a *distant* object, which we expected" (32): later, disconcerting them, when they encounter an old beggar woman at the site, her narrative commands their attention, although "we did not expect to be interested" (36).

The description of the abbey begins with a survey of the pictorial arrangement of the whole scene, with its irregularities of ground and river screened and harmonized by wooded hills. The hills screen out "inclement blasts" and, literally and figuratively, leave "an air so calm, and tranquil; so sequestered from the commerce of life, that it is easy to conceive, a man of warm imagination, in monkish times, might have been allured by such a scene to become an inhabitant of it" (32). The hills also screen out the signs of nearby manufacturing industry (see fig. 55). As Gilpin writes at the end of his account, "The country about Tintern hath been described as a solitary, tranquil scene: but its immediate environs only are meant. Within half a mile of it are carried on great iron works; which introduce noise and bustle into these regions of tranquillity" (37). The site of privileged seclusion from the (nearly present) evidence of commerce and indus-

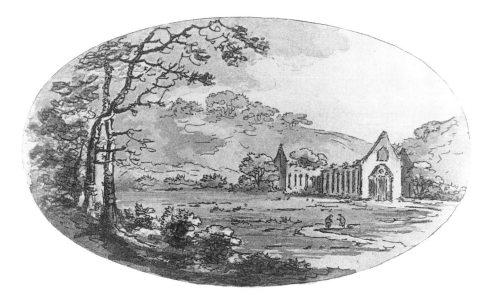

52. William Gilpin, "Tintern Abbey," from *Observations on the River Wye*, London, 1782.

TINTERNE, FROM THE CHEPSTOW ROAD.

53. "Tinterne, from the Chepstow Road," from Mr. and Mrs. S. C. Hall, *The Book of South Wales, the Wye, and the Coast*, London, 1861.

54. William Gilpin, "Tintern Abbey," from *Observations on the River Wye*, London, 1782.

try offers a scene in which the modern observer, himself disengaged from economic imperatives, can enjoy a meditative calm which links him imaginatively and transhistorically with the man of similarly "warm imagination" in "monkish times."

The evidence of the iron works is by no means excluded from later tourists' accounts of Tintern. Twenty years after Gilpin's visit, in Richard Warner's first *Walk through Wales*, the author describes and is entirely untroubled by the proximity of industry to the abbey site. From the window of the Beaufort Arms at night, he and his companion see "a scene perfectly new to us, highly gratifying to a warm imagination. Immediately opposite to the room in which we were lodged stands a large iron-forge, one among the many that are constantly worked night and day, in the valley of Tintern." The effect is sublime:

> This scene of bustle amidst smoke and fire, during the darkness and silence of midnight, which was only interrupted by the vibrations of the bar-hammer, produced a most impressive effect on the mind. We saw Virgil's description realized, and the interior of Etna, the forges of the Cyclops, and their fearful employment, immediately occurred to us.

The next day, "Having gratified ourselves with a minute observation of every part of this ruin, and visited the iron-works," the tourists continue on their way.[38]

Returning to Gilpin's account, the attractions of the ruins of Tintern are severalfold. Because of its ruination "Nature has now made it her own. Time has

55. Tintern Parva, Tintern Abbey, and Iron Works, detail from fig. 51.

now worn off all traces of the rule: it has blunted the sharp edges of the chissel; and broken the regularity of opposing parts," as well as adding its own "ornaments." In this context Gilpin famously complains about the inadequately ruined appearance of the ruins, and wishes he dared indulge in a little creative vandalism himself: "a number of gabel-ends hurt the eye with their regularity; and disgust it by the vulgarity of their shape. A mallet judiciously used (but who durst use it?) might be of service in fracturing some of them; particularly those of the cross isles, which are not only disagreeable in themselves, but confound the perspective."(33) This desire for intervention is echoed in the *Essays*, when Gilpin claims literary and pictorial precedents for suggesting that Palladian architecture is inappropriate in the picturesque: "Should we wish to give it picturesque beauty we must use the mallet instead of the chissel: we must beat down one half of it, deface the other, and throw the mutilated members around in heaps...Virgil would have done the same." So too, Gilpin claims, did Milton and Homer in their work: for the same reason Reynolds designs portraits with disheveled hair, and the "worn-out cart horse" is preferable to the glossy young animal as a model for painting.[39]

The situation at Tintern is complicated because of the presence at the site of various versions of ruination at once. The abbey's appearance is spoiled by the "shabby houses" that surround it, and it is inhabited by beggars; and Gilpin

cannot extend the category of the picturesque unproblematically to cover them—as Price does elsewhere when he suggests that

> in our own species, objects merely picturesque are to be found among the wandering tribes of gypsies and beggars: who in all the qualities which give them that character, bear a close analogy to the wild forester and the worn out cart-horse, and again to old mills, hovels, and other inanimate objects of the same kind.[40]

In the case of Tintern, Gilpin's delayed mention of the presence of industry near the abbey serves an important retrospective function in his description, bringing into play an alternative value system to that of the picturesque, and an alternative reading of the site, as he tries to negotiate his encounter with its occupants. He thus writes of "the poverty and wretchedness of the inhabitants," who "seem to have no employment, but begging, as if a place once devoted to indolence, could never again become the seat of industry" (35). The meditative tranquillity earlier celebrated in the monks becomes culpable indolence when it is associated with the beggars and set against industry, and Gilpin must differentiate all these categories firmly from his own secular meditative leisure as the observing tourist.

Distantiation of such laudable leisure from various forms of laziness on the one hand and commercial employment on the other remains an important concern in many published tours and guides of the period. In Charles Heath's guide to the Wye (1799), for instance, the author is acutely aware of the contrast between his own financial and social situation and that of the gentleman tourist. He writes that

> Considerable allowance will be made for my situation in life. The MIND of a person in the constant exercise of a retail trade, has many and indispensible claims upon its attention; whereas the Man of Letters sits calmly in his study, to meditate over and revise his thoughts, without the chain of them being interrupted by casual intrusion.[41]

In a quite different context, at the start of his mammoth pedestrian tour of 1799, which takes in most of the famous sights of Northern England, Scotland, and Wales, the Rev. James Plumptre discusses whether to take a servant with him. He thinks initially of a local "Gypsie Youth, whose life I thought had well disciplined him for such an undertaking" and resolves to take him despite knowing that "I would have much prejudice to encounter in attempting to civilize one of a race which have so bad a character and the peculiar trait of which is generally held to be thieving." Ultimately, and in a nice inversion of his expectations, the gypsy rejects Plumptre's offer for fear that it is a device to trap him into conscription into the army. Plumptre then thinks of a young local laborer but rejects him after a month's trial when he realizes that the youth in question does not understand the special nature of pedestrian tourism and simply regards being a porter on the

tour as an easy alternative to his proper agricultural employment of harvesting. Plumptre completes the tour alone.[42]

Among the "whole hamlet" of beggars that Gilpin encounters at Tintern his description of one particular old woman stands out as the only such extended description of an individual in the whole tour. Indeed it remains unusual, even in the context of his later tours, in which extended accounts of historical or mythological figures sometimes have a place alongside brief descriptions of local inhabitants. Gilpin writes:

> One poor woman we followed, who had engaged to shew us the monk's library. She could scarce crawl; shuffling along her palsied limbs, and meagre, contracted body, by the help of two sticks. She led us, through an old gate, into a place overspread with nettles, and briars; and pointing to the remnant of a shattered cloister, told us, that was the place. It was her own mansion. All indeed she meant to tell us, was the story of her own wretchedness; and all she had to shew us, was her own miserable habitation. We did not expect to be interested: but we found we were. I never saw so loathsome a human dwelling. It was a cavity, loftily vaulted, between two ruined walls; which streamed with various-coloured stains of unwholesome dews. The floor was earth; yielding, through moisture, to the tread. Not the merest utensil, or furniture of any kind, appeared, but a wretched bedstead, spread with a few rags, and drawn into the middle of the cell, to prevent its receiving the damp, which trickled down the walls. At one end was an aperture; which served just to let in light enough to discover the wretchedness within. – When we stood in the midst of this cell of misery; and felt the chilling damps, which struck us in every direction, we were rather surprised, that the wretched inhabitant was still alive; than that she had only lost the use of her limbs.
>
> The country about *Tintern-abbey* hath been described as a solitary, tranquil scene: but its immediate environs only are meant. Within half a mile of it are carried on great iron works. (36–37)

Ian Ousby has written of this passage that "it suggests much for Gilpin's humanity that he allowed himself to be distracted from picturesque appraisal into giving this compelling vignette."[43] I would propose an alternative formulation: that it suggests much for the power of the picturesque as a discourse that the tropes of sentimental benevolence which we might expect to see structuring the description as the conventional indicators of "humanity" in texts of this period are displaced to the extent that they are in what turns out to be a peculiarly inconsequential narrative episode.

The account of the woman involves several enforced perceptive shifts on Gilpin's part. The ruined abbey, which is attractive as an aesthetic object, is potentially disturbing when it is seen as a "loathsome" human dwelling. In this context the description of the woman herself partially bears out John Barrell's

suggestion that picturesque pictorial representation of human figures "is concerned only with visible appearances, to the exclusion of the moral and the sentimental" and is "absolutely hostile to narrative."[44] Gilpin's account is a narrative, however; and since non-narrative pictorial representation is altogether easier to envisage than non-narrative narrative prose Gilpin must fend off other expectations as he writes.

The encounter with, and relief of, poverty and suffering is a standard trope of sentimental narrative of the period, as Goldsmith's descriptions of the activities of the Man in Black and the Vicar of Wakefield, or Mackenzie's account of the behavior of the Man of Feeling, confirm.[45] As part of their complex repository of literary sources, tour writers absorb and deploy the tropes of sentimental narrative, which shape their accounts in a variety of ways. Two more or less random examples will illustrate this. At the end of Thomas Pennant's *Tour in Scotland* (1774), the author rapidly brings his account to a close by introducing the family he has left at home, which has never been mentioned before. He writes:

> SEPT 22. Hastened through *Preston*, *Wiggan*, *Warrington*, and *Chester*, and finished my journey with a rapture of which no fond parent can be ignorant, that of being again restored to two innocent prattlers after an absence equally regretted by all parties.[46]

The sentence provides a conventional moment of closure to the narrative and also gives retrospective point and weight to the repeated incidents earlier in the tour in which Pennant has reported, and sympathized with the victims of, the opposite of this ideal — the exploitation of women and children in Scotland. Twenty-five years later, on his second *Walk in Wales*, and much more responsive to the appeal of the picturesque than Pennant had been, Richard Warner nonetheless recalls an incident in the course of his first tour, in which he saved an old woman accused of bewitching a small boy in Caerwent; and he hears of the later death of the boy from smallpox. He writes: "The story was a simple, but an affecting one, and naturally introduced a train of serious reflections. I did not endeavour to restrain them, impressed with a conviction that the mind is never injured by the indulgence of a rational sensibility."[47]

In Gilpin's tour the description of the old beggar woman offers every expectation that the trope of charitable relief of suffering will be deployed. Reinforcing that expectation, Nigel Everett has pointed out that Gilpin's own awareness of the troubling conflicts between his moral and aesthetic values is clear from the time of the appearance of his first published work — the *Dialogue* on the gardens at Stowe (1748); and that his sermons, *Moral Contrasts* (1798) and *Dialogues* (written during his time as vicar of Cheam and Boldre and published in 1807) are marked by their espousal of benevolist charitable concerns. Indeed, Everett also makes the point that, in practical terms, Gilpin's improvement of conditions in his parish of Boldre was in part financed by the sales of the *Observations*, and he

quotes Thomas Bernard's approving comparison between "the beautifully and romantically situated schools of Mr Gilpin, at Boldre" which were one consequence of that improvement, and the frivolous and useless "*amusements*" offered by the merely decorative landscapes created by Horace Walpole at Strawberry Hill.[48]

At Tintern Gilpin is indeed surprised to find himself "interested" in a tale of suffering, despite his aesthetic expectation that he will not be. The old woman is described in terms of horror, which nonetheless hover disconcertingly on the edge of expressing interest in her as a species of picturesque ruination, on a par with the ruin she inhabits. The imperative of the narrative sequence then truncates the potentially sentimental episode that has begun to develop before it reaches its expected conclusion, however, and Gilpin's account leads straight on to the next landscape description. Near the end of the passage that I have quoted above, Gilpin thus moves abruptly, with a paragraph break, from expressing surprise that the old woman "had only lost the use of her limbs" to observing that "The country about *Tintern-abbey* hath been described as a solitary, tranquil scene: but its immediate environs only are meant."

In the different context of the guidebook, T. D. Fosbroke cuts Gilpin's original description of the beggars, as part of what he rather brutally dismisses as the author's "irrelevant expletory additions, inserted to make up a volume," which "are exchanged for historical and topographical illustrations, the evident desiderata of his work." He does continue Gilpin's complaint about the "mob of houses" that lie next to the abbey, however, on the grounds that "*Solitude, Neglect* and *Desolation* are the proper characteristics of ruins"; and some at least of the permanent inhabitants and passing observers of the scene continue to lurk vestigially in his account. As he writes, "Tintern would be a most unfortunate spot for visits of speculation concerning future destinies, at least in the minds of old women, and poets, (who resemble in many points old women) for superstition and imagination are relatives."[49]

Later individual tourists also retrace Gilpin's path through Tintern, marking the continuities and changes at the scene in their accounts, and echoing the motifs of Gilpin's original narrative. In a letter to his father describing a tour of the Wye in 1791, Samuel Rogers thus writes, "Adjoining to what is called the Monk's cell a poor woman has furnished a melancholy apartment. The vault and its tenant correspond with Mr. Gilpin's description, but are not the same. The woman he mentions died in the workhouse." As he is leaving the abbey Rogers asks another beggar woman the way to Chepstow and, making the same rapid transition as Gilpin, reports that "my question drew an appeal to my charity. She was returning home from the surgeon with a strengthening plaster and could scarcely crawl. Gained the heights, and saw the Severn."[50] The conflict between sentimental engagement and aesthetic enjoyment which underlies Gilpin's narrative suppression of the act of charity at Tintern, and which is reproduced in this

later account, offers a telling index of the problems attaching to picturesque tourism in the period; and it illustrates the dependence of Gilpin's aesthetic program on the specific activity and on the narrative form from which his discussions are derived. It thus helps to place the claims that he makes for the tourist's perception of the picturesque in the context of the larger debates conducted in the period about the moral and social implications of the picturesque aesthetic itself.

An earlier version of this essay appeared under the title, "Tourists, Tintern Abbey, and the Picturesque," in Peter Hughes and Robert Rehder, eds., *Imprints and Re-visions: The Making of the Literary Text, 1759–1818*, SPELL (*Swiss Papers in English Language and Literature*) 8 (1995): 61–82.

1 For varied perspectives see, for instance, Malcolm Andrews, *The Search for the Picturesque: Landscape Aesthetics and Tourism in Britain, 1760–1800* (Aldershot: Scolar Press, 1989); Dana Arnold, ed., *The Picturesque in Late Georgian England* (London: Georgian Group, 1995); Ann Bermingham, *Landscape and Ideology: The English Rustic Tradition, 1740–1860* (London: Thames and Hudson, 1986); John Dixon Hunt, *Gardens and the Picturesque: Studies in the History of Landscape Architecture* (Cambridge: MIT Press, 1992); Walter J. Hipple, *The Beautiful, the Sublime, and the Picturesque in Eighteenth-Century British Aesthetic Theory* (Carbondale: Southern Illinois University Press, 1957); Christopher Hussey, *The Picturesque: Studies in a Point of View* (London: Putnam, 1927); Sidney K. Robinson, *Inquiry into the Picturesque* (Chicago: Chicago University Press, 1991); essays in Stephen Copley and Peter Garside, eds., *The Politics of the Picturesque* (Cambridge: Cambridge University Press, 1994); and works cited below.

2 Kim Ian Michasiw, "Nine Revisionist Theses on the Picturesque," *Representations* 38 (1992): 94, 96.

3 Andrew Hemingway, *Landscape Imagery and Urban Culture in Early Nineteenth-Century Britain* (Cambridge: Cambridge University Press, 1992), 19–25.

4 Ibid., 19.

5 Anne D. Wallace, *Walking, Literature, and English Culture: The Origin and Uses of the Peripatetic in the Nineteenth Century* (Oxford: Clarendon Press, 1993), 10. See also William Wordsworth, *A Guide through the District of the Lakes in the North of England* in its various incarnations between 1810 and the definitive edition of 1835.

6 William Gilpin, *Observations on the River Wye, and Several Parts of South Wales, etc. relative chiefly to Picturesque Beauty; made in the Summer of the Year 1770* (London, 1782), 83.

7 Gilpin's *Observations on the River Wye* went through five editions and was translated into French between 1782 and 1800. Among contemporaries to pay tribute to Gilpin in their own works on the Wye are Samuel Ireland, in *Picturesque Views on the River Wye* (London, 1797), vii, and Charles Heath, in *The Excursion down the Wye from Ross to Monmouth* (Monmouth, 1799), Introduction.

8 T. D. Fosbro[o]ke, *The Wye Tour, or Gilpin on the Wye*, 1st ed. (Ross, 1818), vii.

9 See Bermingham, esp. chap. 2.

10 Fosbroke, *Gilpin*, 3rd. ed. (Ross, 1826), Preface.

11 Fosbroke, *Gilpin*, 1st ed., viii, 97.

12 Gilpin, *Wye*, 83.

13 Ibid., 1.

14 William Gilpin, *Observations relative chiefly to Picturesque Beauty, Made in the Year 1772, on Several Parts of England; particularly the Mountains, and Lakes of Cumberland, and Westmoreland* (London, 1786), 1:xxii.

15 William Gilpin, *Three Essays: on Picturesque Beauty; on Picturesque Travel; and on Sketching Landscape: to which is added a poem, on Landscape Painting*, 2nd ed. (London, 1794), 1–2.

16 See in particular Richard Payne Knight, *The Landscape: A Didactic Poem in Three Books* (London, 1794), and *An Analytical Inquiry into the Principles of Taste* (London, 1805); and Uvedale Price, *An Essay on the Picturesque* (1794), *A Dialogue on the Distinct Characters of the Picturesque and the Beautiful. In Answer to the Objections of Mr Knight* (Hereford and London, 1801), and *Essays on the Picturesque as compared with the Sublime and the Beautiful*, 3 vols. (London, 1810). For discussion of Knight, see Michael Clarke and Nicholas Penny, eds., *The Arrogant Connoisseur: Richard Payne Knight, 1751–1824* (Manchester: Manchester University Press, 1982). For Price, see Robinson, *Inquiry into the Picturesque*.

17 Gilpin, *Wye*, 51, 6.

18 Morris R. Brownell, "William Gilpin's 'Unfinished Business': The Thames Tour (1764)" *Walpole Society* 57 (1993–94): 56.

19 John Torbuck, ed., *A Collection of Welch Travels, and Memoirs of Wales* (Dublin, 1738), 62; Andrews, 109.

20 William Gilpin, *Observations on Several Parts of the Counties of Cambridge, Norfolk, Suffolk, and Essex. Also on Several Parts of North Wales; relative chiefly to Picturesque Beauty in two tours* (London, 1809), 155–58; *Observations on the Western Parts of England, relative chiefly to Picturesque Beauty; to which are added a few Remarks on the Picturesque Beauties of the Isle of Wight* (London, 1798), 196.

21 Gilpin, *Wye*, 18–19.

22 Gilpin, *Lakes*, 2:45.

23 Gilpin, *Wye*, 8.

24 See, for instance, Andrews, 67–82.

25 Alan Liu, *Wordsworth: The Sense of History* (Stanford: Stanford University Press, 1989), 75–76.

26 William Gilpin, *Remarks on Forest Scenery, and Other Woodland Views, Relative Chiefly to Picturesque Beauty* (London, 1791), 103–16.

27 See Gilpin, *Lakes*, 1:xv–xxxi.

28 Ibid., 1:187–88.

29 Gilpin, *Wye*, v, 2.

30 Ibid., 14, 22.

31 Mr. and Mrs. S. C. Hall, *The Book of South Wales, the Wye, and the Coast* (London, 1861), 54. Brownell comments on Gilpin's sensitivity to smoke as a component of "atmosphere" in "William Gilpin's 'Unfinished Business,'" 56. John Byng offers an alternative and perhaps more surprising form of endorsement of the salubrious effects of smoke during his tour of the Wye in 1781, when he comments on the "Iron furnaces" of the area, "whose smoke impregnating the air, felt to me very wholesome and agreeable." See *The Torrington Diaries*, ed. C. Bruyn Andrews (London: Eyre and Spottiswoode, 1934), 1:18.

32 Gilpin, *Western Parts*, 285.

33 Gilpin, *Wye*, 29.

34 Gilpin, *Forest Scenery*, 298.

35 William Marshall, *The Review and Abstract of the County Reports to the Board of Agriculture; from the Several Agricultural Departments of England* (London, 1818), *Northern Department*, 1:168.

36 Gilpin, *Essays*, 88.

37 See Gilpin, *Wye*, 31–37.

38 Richard Warner, *A Walk through Wales in August 1797* (Bath, 1798), 231.

39 Gilpin, *Essays*, 14.

40 Price, *Essays*, 62. The motifs that run through Gilpin's narrative are echoed by many later proponents of the picturesque in their comments on the scene at Tintern. In *Picturesque Views on the River Wye*, 132–34, for instance, Samuel Ireland negotiates the troubling transition from uncomfortable historical facts to an aesthetic appreciation of the ruins at the site in verse, and suggests that the elements of the scene "all conspire to impress the mind with awe, and for a moment withdraw from its vain pursuit of wealth and power, and abstract it from the world." In this context, even the cottages "serve…as a scale, and give magnitude to the principal object."

41 Charles Heath, *The Excursion down the Wye*, unnumbered pages.

42 James Plumptre, "A Narrative of a Pedestrian Journey through some Parts of Yorkshire, Durham and Northumberland to the Highlands of Scotland and Home by the Lakes and some Parts of Wales in the Summer of the Year 1799," in Ian Ousby, ed., *James Plumptre's Britain: The Journals of a Tourist in the 1790s* (London: Hutchinson, 1992), 85–87.

43 Ian Ousby, *The Englishman's England: Taste, Travel, and the Rise of Tourism* (Cambridge: Cambridge University Press, 1990), 121.

44 John Barrell, "Visualising the Division of Labour: William Pyne's *Microcosm*," in *The Birth of Pandora and the Division of Knowledge* (Basingstoke: Macmillan, 1992), 104.

45 See, for instance, Oliver Goldsmith, *The Citizen of the World* (London, 1760–61), letters XXVI and XXVII; *The Vicar of Wakefield* (London, 1766), chaps. 3, 4, 14, 27; *Henry MacKenzie, The Man of Feeling* (Edinburgh, 1771), chap. 14.

46 Thomas Pennant, *A Tour in Scotland and Voyage to the Hebrides* MDCCLXXII (London, 1774), 220.

47 Richard Warner, *A Second Walk through Wales in 1798* (Bath, 1799), 3–6.

48 Nigel Everett, *The Tory View of Landscape* (New Haven and London: Yale University Press, 1994), 127–43.

49 Fosbroke, *Gilpin*, 1st ed., viii; 3rd ed., 63–64, 74.

50 Quoted in P. W. Clayden, *The Early Life of Samuel Rogers* (London, 1887), 199. Later accounts of Tintern are discussed in Andrews, 94–105.

Border Country: The Politics of the Picturesque in the Middle Wye Valley

Stephen Daniels, Susanne Seymour, and Charles Watkins

River scenery featured prominently in the landscape arts of later Georgian Britain, in painting, engraving, poetry, topographical and antiquarian writing, and in works like tourist guides which combined a range of written and visual material. Major rivers like the Thames, the Severn, and the Clyde were represented, along with lesser streams like the various Stours and Avons. The economic functions, social conditions, topographical configuration, and cultural associations of river valleys were charted in series of landscapes from headwaters to estuaries. In combining many types of scenery in the course of their progress—highland, lowland, urban, rural, pastoral, arable, commercial, industrial—river valleys were visualized as varied, integrated. Moreover, Britain as a nation was imagined in and through its river scenery.[1]

Rising in the mountains of mid-Wales, the river Wye flowed 130 miles through a variety of country to the Bristol Channel. The river scenery of the Wye was a popular subject in the landscape arts, but the Wye valley as a whole was not easily envisaged as a coherent region. While some stretches were so frequently described and depicted as to provide a stereotype of British river scenery, others were largely overlooked or even shunned as resistant to scenic appreciation. The river flowed through a number of highly distinctive topographies and economies, across a border country of Welsh and English culture. In this essay we examine the field of landscape representation along the Wye valley in the later eighteenth century as itself a border country, a terrain of shifting and conflicting interests.

We focus on the Picturesque, the dominant landscape aesthetic in polite society of the period, and the most controversial.[2] We do so in the middle Wye valley, in Herefordshire, the home of the aesthetic theorist Uvedale Price, and a key market in the early career of the landscape gardener Humphry Repton. We consider their dispute over the Picturesque in the mid-1790s in terms of their rival claims on this stretch of river scenery.

The Wye Valley

In the landscape arts of the period the Wye valley falls into three distinct sections. The lower reaches, from Ross to Chepstow, were the most frequented by visitors. Here the scenery was dramatic, with the river winding past towering cliffs, medieval ruins, and smoking forges. This was the scenery made famous by William Gilpin in his *Observations on the River Wye* (1782), which ran into its

fifth edition by the end of the century and was routinely pirated by guidebooks. Drifting gently downstream, in deeply incised meanders, tourists enjoyed a spectacular, switch-back sequence of scenery.[3]

In its middle section through Herefordshire from Hay to Ross, the valley opened out into a lowland landscape, an old enclosed countryside of cornfields, woodlands, pasture, orchards, hop yards, manor houses, and hamlets. Problems of river navigation and some infamously poor roads made this area less accessible to tourists, but it had its admirers. The ancient enclosures brought "badness to the roads and beauty to the country," noted the roving agricultural reporter William Marshall; despite its problems, he found the county "a delightful land to *live* in."[4] This is the countryside celebrated in poems like John Philips's *Cider* and John Dyer's *The Fleece* as the home of the English georgic. While admirers complained that Gilpin and his followers had shunned this stretch of the Wye, they championed it as a more exclusive region, a landscape for seasoned and sophisticated appreciation by resident gentry and their polite circle.[5]

Guidebooks warned those venturing further up valley into the hill country of Wales that they were entering a wild and desolate region. If the headwaters of the Wye offered views of the conventionally scenic mountains of north Wales in the distance, there was little to recommend nearby. The bleak hills and dwellings were seen as expressions of a backward culture. The tourist was advised to take a detour into the valley of the Istwyth, to see how Thomas Johnes had redeemed the wilderness on his estate at Hafod, creating an Elysium of scenic and social improvement. Most tours in this region terminated at Aberystwyth, a busy port which was expanding into a seaside resort for polite society.[6]

A way of imagining the Wye valley as a whole as a cultural region transcending differences between England and Wales was to speculate on its ancient British history. The Wye was the principal river of Siluria, the tribal territory covering the counties of south Wales and also Herefordshire. The Silures were vaunted by eighteenth-century writers for both martial and agrarian virtues. Silurian resistance to Roman invasion under the leadership of Caractacus was a potent episode in myths of British liberty which was urgently recalled during the Napoleonic Wars. Guidebooks to the Wye were keen to identify likely sites of Caractacus's Last Stand, as well as relics of the more enigmatic history of Silurian resurgence under King Arthur, among the various earthworks and megaliths in the region. Sturdy Silurian virtues were ascribed to the modern Welsh, like bargemen on the Wye or those loyal crowds at Pembrokeshire who in 1797 frightened off a French landing party.[7]

But ancient British history was an unstable bond. When hill forts and cromlechs featured as landmarks in the landscape arts, they tended to align Siluria to a highland culture which reached throughout Wales and was being claimed by nationalist Welsh writers against English authority.[8] Despite the best efforts of some Welsh writers the Silurian history of agrarian peace and prosperity was

56. John Duncumb, *Collections toward the History and Antiquities of the County of Hereford*, 1804, title page with anonymous engraving of Arthur's Stone.

assimilated into an Anglo-British tradition. Uncommemorated by ancient monuments, it was scarcely discernible to polite observers in most modern Welsh farms. Rather it was incorporated in a literary tradition of cultivation firmly vested in a lowland landscape dominated by English landlords.

Herefordshire

Herefordshire was situated in both versions of Siluria. Throughout the eighteenth century the county was a zone of transition between England and Wales. Welsh was heard in the harvest fields, hop yards, river wharves, churches. and marketplaces.[9] The city of Hereford was a major urban center for mid-Wales; the *Hereford Journal* circulated news from throughout the region. The Rev. John Duncumb, a former editor of the *Hereford Journal*, compiled a history of Herefordshire which attempted to provide a broad, robustly British framework for the county. The title page features an engraving of the county's only cromlech, Arthur's Stone (fig. 56). This is sited high above the Wye on the border with Breconshire, one of a group of cromlechs on the scarps of the Black Mountains. Arthur's Stone was a landmark in a system of Silurian culture which was also traced from Wales by a fellow cleric Theophilus Jones in his *History of Brecknock*.[10]

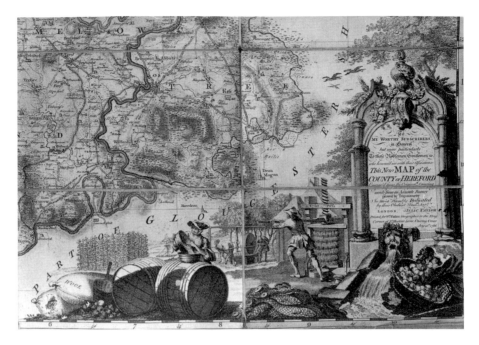

57. Cartouche, *The New Map of the County of Hereford*, 1786, surveyed by Isaac Taylor.

Most images of Herefordshire, however, focused on its cultivated lowlands, regarding the hills running into Breconshire as a border not a bond, a frontier to an essentially English landscape. John Clark, land agent to Lord Hereford, was commissioned by the Board of Agriculture to compile *General Views* of the agriculture of the border counties of Hereford, Brecknock, and Radnor, which were issued in 1794. Clark found "a sullen inactivity" over the pasturelands of the Black Mountains which shadowed the hill country on the Hereford border. "I do appeal to such gentlemen as have often served on *grand juries* in this county, whether they have not had more FELONS brought to them from *that* than any *other* quarter of the county."[11] For Clark the main virtue of the Black Mountains was to protect the rich Herefordshire lowlands from excessive cloud and rain.

> The county of Hereford is equalled by few spots in the island of Great Britain for the production of every article that can contribute to the comfort, the happiness, and in some degree the luxury of society. Here a verdure almost perpetually reigns. The wide flats, extended for many miles, are clothed in nature's fairest robes, and enriched by a profusion of her most chosen gifts…hence the ancients, with much propriety, complimented this favourable district as the GARDEN OF ENGLAND.[12]

Maps of Herefordshire emphasized its configuration as an enclosed garden, a riverine lowland surrounded by hills. The cartouche to Isaac Taylor's map of

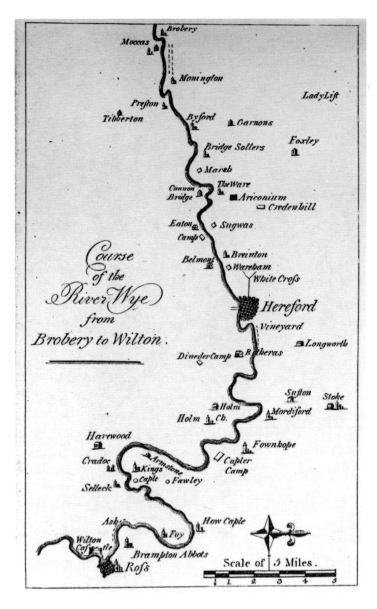

58. Course of the river Wye from Brobery to Wilton, from John Price, *An Historical Account of the City of Hereford*, 1796.

Herefordshire (fig. 57) displays its georgic iconography: an apple orchard, cider press, hop yard, a sack of wool, netted salmon, a sailing barge, and river god.

Conditions in the war years cast a shadow over the Herefordshire garden, especially during the famine conditions of the mid-1790s, when food rioters descended on market towns and raided grain barges. "Thy plain, where cheerful plenty's wanted bloom / Would be o'er saddened with a dreary gloom / Did not humanity a relief afford," so declared "Siluria" in the *Hereford Journal* for July 1795. The paper eagerly reported the efforts of larger landlords to sell grain cheaply.[13] John Duncumb voiced his concerns in the second *General View* of Herefordshire's agriculture published in 1805. Secretary to the county Agricultural Society, Duncumb reported progressive farming and enlightened landlordism which consolidated the county's georgic reputation, but also some developments which compromised it, notably a decline of resident gentry, the remittance of rents to institutional London interests, the increasing use of agents, attorneys, and middlemen and the lack of cottage produce to supply small towns and villages.[14]

From the later eighteenth century Herefordshire underwent a sharp period of modernization, evident in the look of Hereford and its immediate hinterland along the Wye. The medieval city was reformed—laid out with new streets and architecture. New bridges and roads strengthened links within and beyond the region. Nearby estates were expanded and consolidated. Old country houses and parks, new villas and pleasure grounds were fashioned in metropolitan style. In both city and country, timber frame and thatch gave way to brick and tile.[15] John Price's 1796 guide to Hereford identified improvements in and around the city which raised its cultural register: a new infirmary, gaol, asylum, and theater, wider streets, new walks by the river and excursions on it which displayed Hereford's civic and commercial elegance. These improvements opened up the city to the country beyond, to the many estates along the river. Short rides took the excursionist to the surrounding hills, from where the city was seen in its "most luxuriant vale, finely blended with woods, corn fields and pasture grounds."[16]

Price's guide devotes a long section to the "vale of Hereford," the stretch of the Wye valley fifteen or so miles either side of the city (fig. 58). This region is defined as a network of prominent landmarks. One is Credenhill, "the station on which the valiant Caractacus was encamped," but most are the residences of eighteenth-century landowners. While some, like Moccas and Belmont, overlook the river, others, like Foxley and Stoke Edith, are tucked into tributary valleys, but since many are visible from each other, they articulate the vale as a whole. The guide is careful to note how residences of varying size and pedigree, from new villas to ancient manors, play a complementary role. Old families and newcomers, noble and commercial families, landowners with extensive interests and those with only local property, professional landscapers and gentlemen amateurs all combine to form a coherently polite landscape.[17]

In the rest of this essay we will expose some of the fissures in this complacent, promotional image by examining the writing and landscaping of two of the most influential figures in the middle Wye, Uvedale Price and Humphry Repton.

Uvedale Price

Uvedale Price, the leading theorist of the Picturesque, lived seven miles from Hereford at Foxley and made the improvement of his estate his life's work.[18] Here, during a period of retirement from London society, Price wrote his *Essay on the Picturesque*.[19] A Foxite Whig hostile to centralized courtly and commercial power, Price constructed a theory and practice of picturesque landscape vested in "men of liberal education, who pass much of their time at their own country-seats."[20] Like his estate Price's *Essay* was expanded, "new modelled,"[21] in three editions from 1794 to 1810.

Price's patrimony is central to his principles of picturesque landscape. The Prices were relative newcomers to Herefordshire. A lawyer and landowner from North Wales, nicknamed "The Welsh patriot" for his opposition to the king granting Welsh titles to the first Duke of Portland, Robert Price married into a local family in the later seventeenth century and took full possession of Foxley in the early eighteenth. A new neo-classical brick house with formal, Italianate terraced gardens formed the nucleus of an estate that was expanded and remodeled by successive generations into a compact property of over 4,000 acres.[22] The Prices' connections extended well beyond Herefordshire. In London Robert Price was one of those powerful Welsh squires who "peopled the Inns of Court and colonized the law."[23] His heirs were well networked with polite society. In Bath Uvedale Tomkins Price befriended Gainsborough, one of a number of artists who sketched Foxley. Robert Price II took his Grand Tour with William Windham of Felbrigg in Norfolk, and from Felbrigg he imported the naturalist Benjamin Stillingfleet to conduct experiments on improved pasture at Foxley.[24] These experiments were part of a program of improvements from road building to cottage repairs.[25]

Uvedale Price began his friendship with Charles James Fox at Eton and continued it on his Grand Tour in 1767–68. Inheriting Foxley shortly after, Uvedale Price commissioned a leading professional land agent, Nathaniel Kent (who worked for Windham at Felbrigg), to reorganize the estate. As a result of amalgamating fields and consolidating farms, the rental of Foxley rose by about a fifth. Kent also transferred a considerable amount of tenanted land, especially woodland, to Price. While Price's personal command of property and revenue at Foxley increased, he maintained smallholders. This was congruent with Kent's general principles of estate management, which emphasized the commercial and social benefits of small farmers and cottagers.[26] About this time Price disposed of his family's estates in North Wales but, like his sketching and touring father and grandfather, sustained a commitment to Welsh landscape, specifically to scenery

within reach and view of the Wye valley.[27] Around 1790 Price commissioned John Nash to design him a seaside villa at Aberystwyth with views up the coast to the mountains of north Wales.[28]

Price's Foxite sympathies sharpened his sense of exile after the outbreak of war. He was alarmed by the expanding and increasingly centralized powers of the British state. Local, plebeian disturbances could and should be dealt with by local landowners and might be aggravated by State measures.[29] Upon learning of the French landing on the Pembrokeshire coast, and the social and financial fears it provoked, Price issued a pamphlet, *Thoughts on the Defence of Property*, addressed to fellow landowners in Herefordshire. He had visited most of the farmers around Foxley and found them "trembling, unarmed, without confidence of connection" at the prospect of being attacked by "profligate and desperate men of a great metropolis." Price advocated organizing local farmers in armed troops and stepping up benevolence to subdue insurrectionary feelings among the hungry poor: "He who can scarcely buy bread will scarcely buy arms unless driven to despair by long ill treatment."[30] Farmers proved reluctant to volunteer for Price's armed troop, for fear of being subject to military law or being ordered far from their homes. "A great part must be stationary if only for the sake of agriculture," Price told Lord Abercorn,

> [If] a military spirit did prevail…it would ruin industry and the habits of industry: what in my mind should be encouraged, is a spirit of confidence and union, and of security, from the means of resistance in every quarter; not a spirit of general enterprise and military ardour.[31]

Financially stretched by the new income tax, Price's confidence in Foxley momentarily weakened. In 1798 he considered selling "this beautiful but expensive place" and retreating to Aberystwyth, taking a small farm close to his seaside villa: "the country has not any riches to tempt invaders, as the coast is such as must prevent them from making any attempt, for it is uncommonly rocky and dangerous."[32]

Despite its proximity to Hereford and the Wye, Foxley was in fact a little out of the way, secluded in a heavily wooded, steep-sided combe.[33] Price made a virtue of this in his various writings, extolling its intimate, finely detailed landscape which demanded the kind of careful regard which only a resident landowner could give and show to small parties of close friends. Price was aware that Foxley lacked a main ingredient of picturesque landscape: water. As he admired the influence of rivers on the whole countryside in his *Essays on the Picturesque*, so he went to work at Foxley attempting to create a string of pools.[34] Foxley was not just inward-looking. The summits of its encircling hills commanded extensive views, which Price's family had made a key point in their landscaping. An 1805 guide to Herefordshire described

the vast extent of country which is here spread out before the sight, the great diversity and variety of its features, now swelling into bold hills mantled with rich woods, and again declining into luxuriant vales teeming with fertility, and animated by a a thousand springs, the numerous orchards, corn-fields, hop-grounds, and meadows, intermingled with castles, seats, and villages, and bounded by a bold range of distant mountains.[35]

Price considered Foxley unique in "the mixture of extensive distances with the near views, & above all places I have ever seen the appearance as well as the reality of being one person's property."[36]

Price's *Essay* constructs picturesque landscape as a bulwark against a "despotic" mode of improvement, of both "grounds" and "governments,"[37] signified by the landscaping of Capability Brown and his followers. Price likens the spread of Brownian landscaping to a military invasion, leveling and laying open the countryside, planting clumps like "newly drilled corps," "fearful of an enemy being in ambuscade among the bushes of a gravel pit, or hiding in some intricate group of trees."[38] Brown's style was one of "blind, unrelenting power," "should it become universal, [it] would disfigure the face of all Europe."[39] Price's view was confirmed by reports of the king's hostility to his own *Essay*, "he professed himself a most zealous admirer of Mr Brown [declaring] 'I should like to see all Europe like a place of Mr Brown's.'"[40] Price challenged the conventional view of Brown's landscaping as an expression of Whig ideals of British liberty. While the Glorious Revolution

> in politics, was the steady, considerate, and connected arrangement of enlightened minds...neither fond of destroying old, nor of creating new systems...the revolution in taste is stamped with the character of all those, which either in religion or politics have been carried into execution by the lower, and less enlightened part of mankind.[41]

Brown did for gardens what Knox did for churches: "no remnant of old superstition, or old taste, however rich and venerable was suffered to remain."[42]

Herefordshire had proved peripheral to Brown's practice. Of some two hundred estates with which Brown was involved in landscaping, only three were in the county; moreover, Brown's plan for the one on the Wye at Moccas had been decisively altered by its owner Sir George Cornewall to incorporate a mixture of agricultural land uses.[43] But Price himself, as a young man about town, had fallen for the Brown fashion. In a "*testament politique*" of repentance, Price describes how with much "difficulty, expence, and dirt," he had impulsively destroyed the old walled gardens at Foxley "probably much upon the same idea, as many a man of careless, unreflecting, unfeeling good-nature, thought it his duty to vote for demolishing towns, provinces, and their inhabitants, in America."[44]

Price upholds art as an alternative, more benign source of order in landscape and society:

59. Thomas Gainsborough, *Study of Beech Trees near Foxley*, 1760, brown chalk, watercolor, bodycolor, and pencil, 30 x 40 cm. Whitworth Art Gallery, University of Manchester.

> where a despot thinks every person an intruder who enters his domain, and wishes to destroy cottages and pathways, and to reign alone, the lover of painting, considers the dwellings, the inhabitants, and the marks of their intercourse, as ornaments to the landscape .[45]

Here Price pays tribute to his father and uncle who attended to the "comforts and pleasures" of their villagers.

> Such attentive kindnesses are amply repaid by affectionate regard and reverence; and were they general throughout the kingdom, they would do much more towards guarding us against democratical opinions, "Than twenty thousand soldiers arm'd in proof."[46]

For "men of moderate fortunes" Price recommends a study of "Dutch and Flemish masters" "in all that relates to cottages, hamlets, and villages."[47] As a native exemplar of the style, he singles out Gainsborough's cottage scenes and recalls coming across such subjects in excursions with the painter around Bath, when Gainsborough's countenance assumed "an expression of particular gentleness and complacency."[48] Price blends Gainsborough's art with Goldsmith's poetry in "affecting images" which might induce a landowner to respect village life, where it was neccessary to repair it.[49]

The key principle of Price's picturesque vision was "connection." If the scope

of this principle ranged "from the most extensive prospect to the most confined wood scene," Price found it best realized in occluded scenes over which a modest landowner might exercise control: ancient avenues, woodland glades, and "old neglected bye roads and hollow ways."[50] Rutted by heavy carts, trodden by laborers and livestock, weathered by wind and water, colonized by wildlife, such lanes revealed the "slow progress of beauty."[51] They were as much a habitat as a line of communication. In letters to friends Price pointed out the beauties of such hollow lanes at Foxley.[52] Gainsborough had drawn one passing an embanked beech tree and leading to the local church (fig. 59). Such lanes provided "useful hints" for walks and drives nearer a gentleman's house, and cheaper ones than those often put into effect.[53]

Price had witnessed the destruction of two hollow lanes, by a Brownian process of smoothing and leveling, carried out on contract by gangs of laborers, "not in a distant county, but within thirty miles of London, and in a district full of expensive embellishments":

> the rash hand of false taste completely demolishes, what time only, and a thousand lucky accidents can mature, so as to make it become the admiration and study of a Ruysdal or a Gainsborough; and reduces it to such a thing, as an Oilman in Thames-street may at any time contract for by the yard at Islington or Mile End.[54]

Substance gave way to surface; a deeply layered, historical sense of place gave way to the slick spatiality of a system striking out from the metropolis.

New systems of rural taste and design were also threatening extensive prospects, disconnecting features, reducing the depth and complexity of the field of vision. The associations helping hold prospects together as habitable worlds—"the different qualities and uses of trees; the advantages of a river to commerce, to agriculture, or manufactures; the local geography and history of an extensive prospect"[55]—were being sacrificed for instant, flashy effects designed to attract the tourist, the "prospect hunter (a very numerous tribe)":

> extensive prospects are the most popular of all views, and their respective superiority is generally decided by the number of churches and counties. Distinctness is therefore the great point...to him who is to reckon up his counties, the loss of a black or white spot, of a clump or a gazebo, is the loss of a voucher...Then again as the prospect-shewer has great pleasure and vanity in pointing out these vouchers...we...cannot wonder that so many churches have been converted into these beacons of taste, or that so many hills have been marked with them.[56]

The local virtues Price upholds are predicated on an extensive, patrician cultural education. A knowledge of painting "through which we may learn to enlarge, refine and correct our ideas of nature" is the lens for improving a local-

ity.[57] For Price, Brown and his followers inverted this order of knowledge. Bred a lowly gardener but rapidly growing rich, Brown abstracted from his knowledge of a confined area to extend a narrow system of landscaping to the country at large.[58] If the Brown style blinded landowners to the countryside, the Picturesque not only opened their eyes but brought them down to earth, literally so in its concern with stumps, roots, stones, and soil.[59] For Price a love of painting entailed a personal, physical engagement with the landscape. Guests at Foxley marveled at Price's expeditions with his troop of laborers armed with their scythes and pruning hooks. Wordsworth described Price "striding up the steep side of his wood-crowned hills with his hacker…slung from his shoulder like Robin Hood's bow."[60] He also observed the strictness of Price's authority:

> small as [Foxley] is compared with hundreds of places, the Domain is too extensive for the character of the Country…A man little by little becomes so delicate and fastidious with respect to forms in scenery, where he has a power to exercize a controul over them, and if they do not exactly please him in all moods and every point of view, his power becomes his law.[61]

Humphry Repton

Humphry Repton was the one professional landscaper with sufficient ambition to pose a threat to Price's picturesque vision. Repton set out to reform landscape gardening by raising its cultural register, by making it a pictorial art. While his style was more modest than that of Brown, indeed had aesthetic and social affinities with that advocated by Price, Repton claimed Brown's mantle and was busily expanding a business based near London.[62] Price's *Essay* was published just as Repton was rising to national prominence, along with another manifesto for the Picturesque, *The Landscape: A Didactic Poem* by Price's friend and fellow Herefordshire squire Richard Payne Knight.

Knight's attack was the more brutal. Coming across a manuscript Red Book of designs for Tatton Park, placed in a London bookseller's window to promote Repton's forthcoming volume *Sketches and Hints on Landscaping Gardening*, Knight noted down some passages which he used, with some judicious misquotation, to compose some savage lines on Repton's style, and burlesqued Repton's technique of before and after views to show how the damage Repton and his kind inflicted might be undone. Knight accused Repton of parading the property of his clients in the manner of Brown, displaying "wealth in land and poverty in mind." Price is more delicate in his attack and, in the light of Repton's pretensions for his profession, no less powerful. In little more than a footnote, Price acknowledged that Repton was superior to most of Brown's followers, that his skill in drawing, powers of observation, and practical knowledge put him "deservedly at the head of his profession," but that he needed to learn what Price had accomplished and "add an attentive study of what the higher artists have

done, both in their pictures and drawings." Moreover, he wondered whether this might in fact be beyond Repton if he chose to further his success. Repton's professionalism was based on systemizing his work, using standard categories and pictorial formulae, and he was thus faced with "the fatal rock on which all professed improvers are likely to split…that of system: they become mannerists, both from getting fond of what they have done before, and from the ease of repeating what they have so often practised."[63]

Knight's poem and Price's essay preempted Repton's book, forcing him to delay publication to reply to their criticisms. The assault from Herefordshire came as a shock. Relations had been amicable. Price and Repton had known each other before they each came to national prominence, perhaps through Price's connections with the Windhams of Felbrigg, Norfolk, where Repton had once lived.[64] Repton was a close friend of Nathaniel Kent, who had remodeled both Felbrigg and Foxley.[65] One of Repton's earliest commissions was at Ferney Hall near Knight's Downton estate, and aware that he was well beyond his familiar lowland scenery of eastern England, Repton consulted Knight and earned his approval for the designs.[66] "I was extremely pleased to hear that you had asked Mr Knight's advice with regard to the management of [a rocky dell]," Price told him, "acknowledging that you had not been so conversant as himself in that style of scenery."[67] "Those drawings of yours which were shewn to me…manifested talents which made me wish to know their author…I wished to be your ally, not your opponent, I flattered myself that…we might have been of reciprocal use to each other."[68] If Price fancied a role as Repton's cultural patron, educating the landscape gardener in the finer points of art appreciation and getting him to execute his own ideas, Repton saw things differently. He recalled the commission at Ferney in the words of his client: "Mr Repton, I have looked at the drawings with feelings which extend far beyond the subject before us—I see in you one who will have much of the landed property of this country under your control. I see you possess powers of fascinating by your pencil."[69]

There followed a series of commissions for Repton in the vale of Hereford.[70] These commissions were for clients who played a prominent public role, many as MPs, in the culture of the region. As a landowner Price was part of their circle but played a more occasional, less visible role in civic affairs. Price's financial difficulties, his political sympathies, and his aesthetic connoisseurship separated him from the rest of polite society. Despite his ideological commitment to localism, Price was something of an outsider in local society. His picturesque vision, expressed in his writings and on the ground at Foxley, proved to be somewhat remote from the views of Repton's clients among his fellow landowners in the vale of Hereford.[71]

Repton's commission at Garnons for John Geers Cotterell was at the neighboring estate to Foxley.[72] Cotterell had married a local heiress and was busy expanding his property, both at Garnons and elsewhere in the West Midlands.[73]

Price and Cotterell had exchanged land in consolidating their estates, and Repton's designs, which went some way to integrating their scenery, were executed by Price's gardener, the Hereford nurseryman James Cranston.[74] With James Wyatt's design for a large new house Repton wished to give the impression of "the seat of Hospitality, and where according to the custom of Herefordshire, not only the neighbouring Families but even their servants and horses may receive a welcome."[75] The magnitude of the landscape was enhanced. Moving the main road increased the depth of view of the house and park. While overlooking the Wye valley, Garnons did not in fact command a view of the river, so Repton corrected this by making a stretch of artificial water look like one of the Wye's meanders.

Repton's commission at Stoke Edith was for another powerful local figure, Edward Foley.[76] Foley was the very model of a georgical landlord. A new 1791 edition of Philips's *Cider* was dedicated to him, also a new poem of 1797, in the style of *Cider*, Luke Booker's *The Hop Garden*. Verses in Foley's honor, praising his residence on his estate and commitment to its welfare, even in winter, were published in the *Hereford Journal.*[77] Repton's remodeling was largely based on the movement of the turnpike, which had formerly passed close to the house, cutting it off from the park, and showing it to poor advantage.[78] Repton proposed demolishing the neighboring parsonage and removing the church spire; his friend, the Norwich architect William Wilkins, made plans to resite the village around the new turnpike, with a cider mill in the style of a primitive temple at the center of a new green.[79] As it turned out, much of the traditional village fabric was retained. The *Hereford Guide* of 1806 reported that Repton had

> displayed his taste and judgement to great advantage. The view of this elegant Seat from the public road has a fine effect: its beautiful front – the extensive shrubberies – the parish church – the parsonage house – the village – with its park richly clothed with fine timber on the back ground, rising to a considerable height above the mansion, present even to the passing stranger a very pleasant scene.[80]

John Nash was commissioned at Stoke Edith to redesign a room. It was here that Repton and Nash first met, beginning a partnership that proved lucrative to both men for the next few years.[81] Stoke Edith was thus a key site in the development of landscape architecture as a nationwide, professional art; the Cardiganshire architect moving east joined forces with the Norfolk landscaper moving west. Repton recalled Foley's reaction. " 'If you two, whom I consider to be the cleverest men in England, could agree to *act together* you might carry the whole world before you.'"[82]

Upon publication of Price's *Essay* and its personal criticism, Repton rattled off a reply during a journey into Derbyshire, an open letter which he published as an Appendix to *Sketches and Hints on Landscape Gardening*. In this Repton

recalled conversations with Price in his opponent's home territory:

> During the the pleasant hours we passed together amidst the romantic scenery of the Wye, I do remember my acknowledging that an enthusiasm for the picturesque, had originally led me to fancy greater affinity betwixt *Painting* and *Gardening*, than I found to exist after more mature consideration, and more practical experience; because, *in whatever relates to man, propriety and convenience are not less objects of good taste, than picturesque effect*…If, therefore, the painter's landscape be indispensable to the perfection of gardening, it would surely be far better to paint it on canvas at the end of an avenue, as they do in Holland, than to sacrifice the health, cheerfulness, and comfort of a country residence, to the wild but pleasing scenery of a painter's imagination.[83]

The georgical aspect of Price's views on picturesque landscape, his advocacy of a homely, carefully cultivated countryside, was overlooked by Repton as it was by most critics. In reviews Price's *Essay* was conventionally paired with Knight's *The Landscape* and tainted with the wild Jacobinism ascribed to Knight's poem.[84] In a review of both works the agriculturalist William Marshall described them as men "totally ignorant of all scenery, except that of a picture gallery, or the wild coppices of the Welsh mountains."[85] The very love of painting, which Price saw as a vehicle of careful, practical management, was seen by these critics as evidence of a speculative connoisseurship which threatened to pervert rural improvement. Repton told Price:

> Your new theory of deducing *landscape gardening* from *painting* is so plausible, that like many other philosophic theories, it may captivate and mislead…I cannot help seeing great affinity betwixt deducing gardening from the painter's studies of wild nature, and deducing government from the uncontrolled opinions of man in a savage state. The neatness, simplicity, and elegance of English gardening, have acquired the approbation of the present century, as the happy medium betwixt the wildness of nature and the stiffness of art; in the same manner as the English constitution is the happy medium between the liberty of savages, and the restraint of despotic government.[86]

Repton seized the middle ground of Whig conservatism.[87] The domain of Price's picturesque vision, which he had carefully constructed as a Whig constitutional polity, was pushed beyond the borders of patriotic landscape. If Price saw himself as a careful georgical squire among his cottages and country lanes, his opponents transformed him into the figure of a wild man of the western forests.

In a painstaking, 150-page reply included in a new edition of his *Essay*, Price attempted to reclaim his ground and that of Whig patriotism. Repton's aim, he complained, was to show that "by an attention to pictures…only wild and

unpolished ideas are acquired," that the picturesque "should convert its admirers into so many Cherokees, and make them lose all relish but for what is savage and uncultivated."[88] Anyone reading Repton's letter would think Price beyond the borders of culture itself, "a sort of tyger, who passes my life in a jungle, with no more idea of the softer beauties of nature than that animal."[89] In these times of political tension,

> he who expresses warmly his love of freedom and hatred of despotism…will be treated by zealots, as a friend to anarchy and confusion…I have been represented as a person, who, had I the power, would destroy all the comforts of a place…wet every body in high grass,—tear their clothes with brambles and briars,—and send them up to their knees through dirty lanes between two cart-ruts.[90]

To Price it was Repton who was uncivilized, degraded by his ignorance of the art upon which picturesque beauty was based. He had clearly proved unwilling to take Price's advice of studying "what the higher artists have done." "I cannot recollect," declared Price,

> amidst all the romantic scenes [of the Wye] we viewed together, your having made any of those allusions to the works of various masters, which might naturally have occurred to a person who had studied, or even observed them with common attention.[91]

So blind to beauty, it was not surprising that Repton took no "hints from any part of a natural river, towards forming an artificial one."[92]

Repton struck another, populist point against Price in the

> distinction betwixt a *landscape* and a *prospect;* supposing the former to be the proper subject for a painter, while the latter is that in which everybody delights; and, in spite of the fastidiousness of connoisseurship, we must allow something to the general voice of mankind. I am led to this remark from observing the effect of picturesque scenery on the visitors of Matlock Bath (where this part of my letter has been written). In the valley, a thousand delightful subjects present themselves to the painter, yet the visitors of this place are seldom satisfied till they have climbed the neighbouring hills, to take a bird's-eye view of the whole spot, which no painting can represent:— the love of prospect seems a natural propensity, an inherent passion of the human mind, if I may use so strong an expression.[93]

Given the virtues ascribed to tourism in wartime Britain, Repton made Price's disdain for prospect hunters look unpatriotic, and Price was quick to reply

> If I do despise prospects, I am constantly acting against my inclination…In my own place I have three distinct prospects,—bird's-eye views seen from high hills—of which I am not a little proud, and to which I carry all my

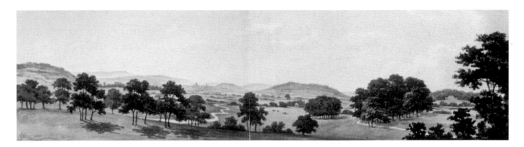

60. Humphry Repton, "Panoramic View of the Vale of Hereford," from *Sufton Court, Herefordshire, A Seat of James Hereford, Esq.,* 1795. Private collection.

guests of every description. If they like nothing else in the place, I do not converse with them on pictures, or landscape-gardening; but if they have the affectation I have sometimes been witness to, that of holding all prospects in contempt as unworthy the attention of a man of true taste, I do not feel eager to converse with them on any subject.[94]

Price was eager to effect some kind of reconciliation with Repton in "the present crisis":

The mutual connection and dependance of all the different ranks and orders of men in this country; the innumerable, but voluntary ties by which they are bound and united to each other…are perhaps the firmest securities of its glory, its strength, and its happiness…as [the principle of connection] so happily pervades the true spirit of our government and constitution, may it no less prevail in all our plans for embellishing the outward face of this noble kingdom.[95]

In his next commission in the Wye valley, following his exchanges with Price and Knight, Repton pressed home his attack. This commission at Sufton was especially opportune, for the client, James Hereford, Mayor of Hereford, had a local pedigree without parallel. The Herefords had occupied Sufton for some six hundred years. The estate commanded the main road and river route into Hereford from the east, looking up valley to the city and its flanking estates.[96] In the seventeenth century Sufton was a key site in the construction of the region's georgic reputation, as the vantage point of John Beale's *Elysium*.[97] James Hereford set about modernizing Sufton. He vacated the family's medieval mansion and had a new house built of Bath stone on the summit of the hill. Sufton adjoined Stoke Edith, and it was probably Repton's remodeling there around the new turnpike which prompted Hereford to commission him. In the Red Book for Sufton, Repton relished the opportunity to refute his opponents on their own territory, to challenge "the wild theory of improvement which has lately sprung up in Herefordshire."[98]

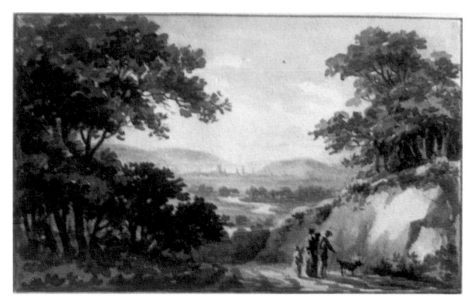

61. Humphry Repton, "Picturesque View of the Vale of Hereford," from *Sufton Court, Herefordshire, A Seat of James Hereford, Esq.*, 1795. Private collection.

Contrary to Price's principles of lifelong, local knowledge, Repton made a virtue of his flying visit:

> The whole of my observations on Sufton Court were made in two days of excessive rainy weather [with] no assistance from previous knowledge of the spot, or from any accurate survey of the premises…neither do I regret that the whole was the result of two days only, since I am convinced that a month's attention to the subject would not have altered my opinion.[99]

He ridiculed Price's painterly vision:

> I should no more advise the Landscape Gardener in laying out a place to affect the confined field of vision, or the careless graces of a Claude or a Poussin, than I should recommend to a Landscape Painter the quincunx or formal rows of the kitchen garden…My sketches, if they were more finished would be a sort of Panorama, or facsimile of the scenes they represent, in which very little effect is attempted on the principles of composition in painting, but like the shadow of a silhouette they may serve to please as portraits, while they offend the connoisseur as paintings.[100]

Repton's panoramic sketch (fig. 60) took in a variety of Herefordshire scenery, ranging east from a "snug cottage and small inclosures" tucked into a hillside through woodland, meadows, hedgerows, rivers, and roads to another mansion and park at Longworth to the west. The causeway carrying the new turnpike to Hereford was displayed to advantage, as was the river Wye carrying

62. Engraving after Humphry Repton, "Belmont, near Hereford, the Seat of John Matthews, M. D.," from *Peacock's Polite Repository*, 1794.

the eye to the city. Repton concluded his plans with a parody of what Price might have proposed for this view (fig. 61):

> First we must suppose the station so low and so near the trees as to look under their branches instead of over their tops…Secondly we must suppose the ground broken, with a hollow way, and a bank of rugged earth or rock…Thirdly we must suppose the naked bald banks of the river Lugg to be cloathed with trees which the first flood will sweep away. And lastly the whole must be enriched by a few beggars and ragged gipsies.[101]

Another of Repton's local clients took up his pen against Price. After a career as a London physician, John Matthews returned to his Herefordshire roots, married a county heiress, took an active role in Hereford public life, and purchased a small estate, Old Hill, which he renamed, in fashionable mode, Belmont. In 1788, in a ceremony celebrating the anniversary of the Glorious Revolution, the county community processed from Hereford to Belmont, where the foundation stone of a new house was laid, and a sapling raised from an acorn sown at Foxley.[102] Designed by James Wyatt with a great semicircular bay window, the house at Belmont enjoyed a sweeping panorama of the Wye valley.[103] Repton was probably called in after the completion of the house in 1790. No plans of Repton's survive, but an engraving of one of his drawings emphasizes Belmont's view of the valley[104] (fig. 62).

Matthews became a prominent public figure in Hereford, for twenty years as Mayor and Senior Alderman of the city, as a Colonel in the Militia, and as an MP who supported Pitt's administration. He enjoyed a local reputation as an agricultural improver and lover of fine arts with some influence in London too.[105] In August 1794 Joseph Farington consulted Matthews about an illustrated book he was contemplating on the Wye and the Severn and recorded Matthews's opinion

on recent publications: "Mr Prices book is written with information & spirit—He thinks very moderately of Mr Knights."[106] Under cover of anonymity Matthews abandoned politeness in *A Sketch from the Landscape*, "a didactic poem addressed to R. P. Knight Esq., to which is added a word to Uvedale Price Esq."[107] In this lampoon Matthews pushes the Picturesque to the margins of wildness and chaos. Knight stands accused of promoting the rights of men, women, and animals to break hedges, crop trees, and in general to subvert the virtues of cultivated order.[108] Price's promotion of "ruts and rubbish" is regarded as more snobbish than subversive. "Why," Matthews asks Price in a postscript,

> are the purchasers of "ready-made taste" to be treated so contemptuously. Are there no wealthy characters, who, having for the best part of their days been "In populous cities pent," retire from their shops and counting houses, to some newly purchased estate in the country, *stung* by the raging love of improving…*goaded* on by the desire of imitating his more tasteful neighbours. In these cases, and some others, I am inclined to think that "ready-made taste" is a great public benefit…let the Art, then, continue to be cultivated, and encouraged by the Public *as a profession*…diffusing wide the blessing of rural beauty, "Till Albion smile, / One ample theatre of sylvan grace."[109]

Postscript

The controversy between Price, Knight, and Repton dispersed after the 1790s. In commissions throughout the Welsh borderland and the West Midlands, Repton felt compelled to respond to his opponents but gradually mellowed his antagonism and even, in later commissions when his views were more nostalgic, endorsed some of their ideas.[110] He continued to work for clients around Hereford, notably for Price's neighbor Sir John Cotterell.[111] In his last book, published in 1816, Repton commented that "so many years have elapsed" since the exchanges of 1794, that he felt compelled to remind his readers who his opponents were.[112] Price, on the other hand, seems to have made little reconciliation with Repton, or with landscape gardening as a profession. Well into the nineteenth century he is consolidating his views on picturesque landscape in published writings, letters, on the ground at Foxley, and on occasional visits to friends' estates, leading parties of gentlemen and laborers.[113] Even after Repton's death in 1818 he is complaining to correspondents about Repton's charges and mercenary way of working, encouraging them to use cheaper, more careful men like the nurseryman and local surveyor James Cranston and the young draughtsman William Sawrey Gilpin, whose work Price reckoned projected his own ideas.[114]

The research for this article was funded by the Leverhulme Trust. We wish to thank David Whitehead for his help.

1 Andrew Hemingway, *Landscape Imagery and Urban Culture in Early Nineteenth-Century Britain* (Cambridge: Cambridge University Press, 1992), 216–91; Stephen Daniels, *Fields of Vision: Landscape Imagery and National Identity in England and the United States* (Cambridge: Polity Press, 1993), 55–72, 130–38.

2 Stephen Copley and Peter Garside, eds., *The Politics of the Picturesque: Literature, Landscape, and Aesthetics since 1770* (Cambridge: Cambridge University Press, 1994).

3 See Stephen Copley's essay in this volume. The lower Wye passed through a region notorious in polite society for the independence of its inhabitants. During the famine years of the 1790s foresters and colliers periodically raided grain and flour barges bound for Bristol. Tourists were largely insulated from the world beyond the riverbank but on occasion might confront less comforting aspects of the country. After low water forced Joseph Farington to leave his boat and scramble up to a cottage, he encountered a cottager bitter about the exploitation of labor: "His mind seemed to be in a fit state to receive, if it had not received, the notion of equal rights" — *The Wye Tour of Joseph Farington* (1803), Hereford Public Library, transcript by John Van Laun, 12 (copy in Paul Mellon Centre, London).

4 William Marshall, *The Rural Economy of Gloucestershire* (London, 1796), 1:188.

5 John Barrell, *The Dark Side of the Landscape: The Rural Poor in English Painting, 1730–1840* (Cambridge: Cambridge University Press, 1980), 95–96; David Whitehead, "Sense with Sensibility: Landscaping in Georgian Herefordshire," in Stephen Daniels and Charles Watkins, eds., *The Picturesque Landscape: Visions of Georgian Herefordshire* (Nottingham: Department of Geography, University of Nottingham, 1994), 16–32.

6 Samuel Ireland, *Picturesque Views on the River Wye* (London, 1797), 2–8, 17–19; George Lipscomb, *Journey into South Wales* (London, 1802), 86, 150–51, 163; Anon., *An Excursion for the Source of the Wye* (Chepstow, n.d) 9; Samuel Rush Meyrick, *The History and Antiquity of the County of Cardigan* (London, 1810); James Edward Smith, *A Tour of Hafod* (London, 1810); Malcolm Andrews, *The Search for the Picturesque: Landscape Aesthetics and Tourism in Britain, 1760–1800* (London: Scolar Press, 1989), 145.

7 T. D. Fosbrooke, *The Wye Tour, or Gilpin on the Wye* (Ross, 1818), i, 7; John Price, *An Historical Account of Hereford, with Some Remarks on the River Wye* (Hereford, 1796); John Duncumb, *Collections towards the History and Antiquities of the County of Hereford* (Hereford, 1804); Lipscomb, *Journey into South Wales*, 169; Anon., *Excursion for the Source of the Wye*, 89; *Hereford Journal*, 1 March 1797.

8 Sam Smiles, *The Image of Antiquity: Ancient Britain in the Romantic Imagination* (New Haven and London: Yale University Press, 1994); Prys Morgan, *The Eighteenth-Century Renaissance* (Llandybie, Dyfed: Christopher Davies, 1981), 93–95; Gwyn Williams, *The Welsh in Their History* (London: Croom Helm, 1982), 13–30.

9 Dorothy Sylvester, *The Rural Landscape of the Welsh Borderland* (London: Macmillan, 1969), 351; Linda Colley, *Britons: Forging the Nation* (New Haven and London: Yale University Press, 1990), 16.

10 Duncumb, *Collections;* Theophilus Jones, *A History of the County of Brecknock* (London, 1805–1809), 2:338. After taking Holy Orders Duncumb was instituted in a rectory in Breconshire in 1793. He used many of the Duke of Norfolk's manuscripts to compile his history of Herefordshire and obtained a living in the Duke's benefices of Abbey Dore in the county. In 1815 he obtained the vicarage of Mansel Lacey from Uvedale Price — *The Dictionary of National Biography* (Oxford University Press,

1922–23), 6:182–83. On cromlech landscapes in the Black Mountains, see Christopher Tilley, *A Phenomenology of Landscape: Places, Paths, and Monuments* (Oxford: Berg, 1994), 111–42.

11 John Clark, *General View of the Agriculture of the County of Radnor* (London, 1794), 32; *General View of the Agriculture of the County of Hereford* (London, 1794), 28. For an alternative view of these Welsh counties by Welsh nationalist writers, see Jones, *History of the County of Brecknock;* Jonathan Williams, *The History of Radnorshire* (Tenby, 1859) (completed in 1818, this failed to find a publisher).

12 Clark, *General View…of Hereford*, 8. In his *Historical Song of Herefordshire* (c. 1786), James Payne reassured an anniversary meeting of the Herefordshire Society that while "in London and other places, Herefordshire is called a Welsh county…according to our best and most impartial historian, it NEVER was."

13 *Hereford Journal*, 22 July 1795. See also reports for 13 May, 1 July, 15 July, 4 November 1795.

14 John Duncumb, *General View of the Agriculture of Hereford* (London, 1805), 23, 35.

15 David Whitehead and Ron Shoesmith, *James Wathen's Herefordshire, 1770–1820* (Little Logaston, Herefordshire: Logaston Press, 1994).

16 John Price, *Hereford*, 55–78.

17 Ibid., 157.

18 Stephen Daniels and Charles Watkins, "Picturesque Landscaping and Estate Management: Uvedale Price at Foxley," *Rural History* 2 (1992): 141–69.

19 Late in life Price referred to this period as one of "rustication." Uvedale Price to Samuel Rogers, 26 July 1824, in P. W. Clayden, *Rogers and His Contemporaries* (London, 1889), 1:381.

20 Uvedale Price, *Essays on the Picturesque* (London, 1810), 3:120.

21 Ibid., 1:xvii.

22 Denis A. Lambin, "Foxley: The Price's Estate in Herefordshire," *Journal of Garden History* 7 (1987): 244–70.

23 Gwyn A. Williams, *When Was Wales? A History of the Welsh* (London: Black Raven Press, 1985), 27–28.

24 Beryl Hartley, "Naturalism and Sketching: Robert Price at Foxley and on Tour," in Daniels and Watkins, *Picturesque Landscape*, 34–37.

25 Lambin, "Foxley."

26 Stephen Daniels and Charles Watkins, "Picturesque Landscaping and Estate Management: Uvedale Price and Nathaniel Kent at Foxley," in Copley and Garside, *Politics of the Picturesque*, 24–37. Price reported his views on woodland management in an article for the *Annals of Agriculture* which promised to enhance the scenic and commercial value of hedgerow trees by wresting control from "rapacious" tenants and "wanton" workmen — Uvedale Price, "On the Bad Effect of Stripping and Cropping Trees," *Annals of Agriculture* 5 (1786): 241–50.

27 Hartley, "Robert Price," 35–36; Lambin, "Foxley," 259.

28 Richard Suggett, *John Nash: Architect* (Aberystwyth: National Library of Wales, 1995), 65–71; Charles Watkins, Stephen Daniels, and Susanne Seymour, "The Marine Picturesque at Aberystwyth: Uvedale Price and Castle House," in *The Picturesque*, no. 14 (1996): 1–12.

29 Sidney K. Robinson, *Inquiry into the Picturesque* (Chicago: Chicago University Press, 1991), 51–52; Nigel Everett, *The Tory View of Landscape* (New Haven and London: Yale University Press, 1994), 103–6.

30 Uvedale Price, *Thoughts on the Defence of Property* (Hereford, 1797), 11, 28, 20, 19.

31 Uvedale Price to Lord Abercorn, 3 August 1798, BM, Add. MSS. Price was dismayed at the cost of prosecuting the war and confided to Abercorn that he was prepared to give up imperial possessions and power overseas to secure the "freedom, security and happiness" of agrarian prosperity at home — Uvedale Price to Lord Abercorn, 20 January 1801, BM Add MSS.

32 Uvedale Price to Sir George Beaumont, 18 March 1798, Coleorton MSS MA 1581 (Price) 16, Pierpont Morgan Library.

33 Until the publication of Price's *Essay*, Foxley scarcely featured in guidebooks, if its main viewpoint, the Ladylift, sometimes received a mention. Gilpin mentions Foxley in his second, 1789, edition of *Observations on the River Wye*, only to quote some "journal" which reported its scenery was "said to be worth seeing" — quoted in Lambin, "Foxley," 244.

34 Price, *Essays*, 2:59–77; Uvedale Price to Lord Abercorn, 21 December 1800, BM, Add. MSS.

35 E. W. Brayley and John Britton, *The Beauties of England and Wales* (London, 1805), 6:581.

36 Uvedale Price to Lord Abercorn, 12 June 1796, BM Add MSS.

37 Price, *Essays*, 1:374. On this issue see Ann Bermingham, "System, Order, and Abstraction: The Politics of English Landscape Drawing around 1795," in W. J. T. Mitchell, ed., *Landscape and Power* (Chicago: Chicago University Press, 1994), 77–102.

38 Price, *Essays*, 1:256, 33.

39 Ibid., 2:127; 1:331.

40 Uvedale Price to Sir George Beaumont, 2 February 1798, Coleorton MSS MA 2013 (Price).

41 Price, *Essays*, 2:147.

42 Ibid.

43 David Whitehead, "Sense with Sensibility," 25; Susanne Seymour, Stephen Daniels, and Charles Watkins, "Estate and Empire: Sir George Cornewall's Management of Moccas, Herefordshire, and La Taste, Grenada, 1771–1819," Working Paper 28, Department of Geography, University of Nottingham, 1994, 32–33.

44 Price, *Essays*, 2:125, 119.

45 Ibid., 1:338–39.

46 Ibid, 1:340.

47 Ibid., 2:342.

48 Ibid., 2:368.

49 Ibid., 2:345.

50 Ibid., 1:12–13, 2:247–50, 1:23.

51 Ibid., 1:27. These were the lanes which William Marshall reckoned were a drag on marketing the produce of the county — Marshall, *Gloucestershire*, 189.

52 Uvedale Price to Lady Margaret Beaumont, 29 April 1803; 13 October 1804; Coleorton MSS MA 1581 (Price) 39, 60.

53 Price, *Essays*, 1:30.

54 Ibid., 1:35, 31–32.

55 Ibid., 2:248.

56 Ibid., 1:166–67.

57 Ibid., 1:11.

58 Ibid., 2:150.

59 Ibid., 2:5, 26.

60 William Wordsworth to Samuel Rogers, 21 January 1825, in Clayden, 405.

61 William Wordsworth to Sir George Beaumont, 28 August 1811, in *The Letters of William and Dorothy Wordsworth: The Middle Years*, ed. Ernest de Selincourt (Oxford: Clarendon Press, 1937), 467.

62 Stephen Daniels, "The Political Landscape," in George Carter et al., *Humphry Repton, Landscape Gardener, 1752–1818* (Norwich: Sainsbury Centre for the Visual Arts, 1982), 110–21.

63 Richard Payne Knight, *The Landscape, A Didactic Poem*, 2nd. ed. (London, 1795), 12–13; Price, *Essays*, 1:398; Carter et al., *Humphry Repton*, 34.

64 Stephen Daniels, "Humphry Repton at Sustead," *Garden History* 11 (1983): 57–64.

65 Daniels, "Political Landscape," 112–14.

66 Humphry Repton, *Plans, Sketches, and Hints of Ferne-Hall in the County of Salop, a Seat of Samuel Phipps, Esq.* (1789). Pierpont Morgan Library.

67 Price, *Essays*, 3:90.

68 Ibid., 3:91, 29.

69 Humphry Repton, *Memoir*, part 2, BM Add MSS, p. 7.

70 Hazel Fryer, "Humphry Repton in Herefordshire," in Daniels and Watkins, *Picturesque Landscape*, 80–87.

71 David Whitehead, "Belmont, Herefordshire: The Development of a Picturesque Estate, 1788–1827," Part 2, *The Picturesque*, no. 12 (Autumn 1995): 9–10.

72 Humphry Repton, *Garnons in Herefordshire, A Seat of J. G. Cotterell Esq.* (1791). Private collection.

73 David Whitehead, "John Nash and Humphry Repton: An Encounter in Herefordshire, 1785–98," *Transactions of the Woolhope Naturalists' Field Club* 47, Part 2 (1992): 219.

74 Ibid., 222. Deeds, Garnons (1806). 33 Herefordshire Record Office D52 (unreferenced).

75 Repton, *Garnons*, "Character."

76 See David Whitehead, "The Purchase and Building of Stoke Edith Park, Herefordshire, 1670–1707," *Transactions of the Woolhope Naturalists' Field Club* 43 (1980): 181–201.

77 Whitehead, "John Nash and Humphry Repton," 226–27.

78 Humphry Repton, *Stoke Park in Herefordshire, A Seat of the Hon. Edward Foley, Esq., MP* (1792). Private collection.

79 William Wilkins, *Designs for the Intended Village at Stoke* (1792). Herefordshire Record Office B 30/1.

80 Quoted in Whitehead, "Stoke Edith Park," 198.

81 Whitehead, "John Nash and Humphry Repton," 221–31.

82 Repton, *Memoir*, 85.

83 Humphry Repton, "A Letter to Uvedale Price, Esq. of Foxley in Herefordshire," in *The Landscape Gardening and Landscape Architecture of the Late Humphry Repton, Esq.*, ed. J. C. Loudon (London, 1840), 105.

84 Stephen Daniels, "The Political Iconography of Woodland in Later Georgian England," in Denis Cosgrove and Stephen Daniels, eds., *The Iconography of Landscape* (Cambridge: Cambridge University Press, 1988), 62–67; Andrew Ballantyne, "Turbulence and Repression: Re-Reading the Landscape," in Daniels and Watkins, *Picturesque Landscape*, 66–78.

85 William Marshall, "A Review of *The Landscape*: also of *An Essay on the Picturesque*" (London, 1795), 185.

86 *Landscape Gardening…of Humphry Repton*, 106.

87 Many of Repton's early patrons among the Portland Whigs adopted this position, not least William Windham, who wrote a letter supporting Repton against Price which Repton published (Daniels, "Political Landscape"; *Landscape Gardening...of Humphry Repton*, 114–16).

88 Price, *Essays*, 3:33.

89 Ibid., 3:137.

90 Ibid., 3:164.

91 Ibid., 3:43.

92 Ibid., 3:45.

93 *Landscape Gardening...of Humphry Repton*, 108.

94 Price, *Essays*, 3:128.

95 Ibid., 3:178–79

96 David Whitehead, "Repton and the Picturesque Debate: The Text of the Sufton Red Book, *The Picturesque*, No. 1 (Winter 1992–93): 6–17.

97 Peter H. Goodchild, "'No phantasticall utopia, but a reall place': John Beale and Backbury Hill, Herefordshire," *Garden History* 19 (1991): 106–27. Henry Hereford, in his role as hermit and mystic, took Beale to the summit of Sufton to chart prophecies.

98 Humphry Repton, *Sufton Court in Herefordshire, A Seat of James Hereford, Esq.* (1795), "Introduction" (private collection). Repton reprinted passages in his next published volume, *Observations on the Theory and Practice of Landscape Gardening* (1803) — *Landscape Gardening...of Humphry Repton*, 220–24.

99 Repton, *Sufton Court*, "An Apology."

100 Ibid., "Of Landscape Gardening."

101 Ibid., "Conclusion."

102 David Whitehead, "Belmont, Herefordshire: The Development of a Picturesque Estate, 1788–1827," Part 1, *The Picturesque*, no. 11 (Summer 1995): 1–8; Part 2, *The Picturesque*, no. 12 (Autumn 1995): 1–11.

103 John Price, *Hereford*, 190.

104 Nigel Temple, *George Repton's Pavilion Notebook: A Catalogue Raisonné* (Aldershot: Scolar Press, 1993), 135–43.

105 Ibid., 136–37.

106 *The Diary of Joseph Farington*, ed. Kenneth Garlick and Angus MacIntyre (New Haven and London: Yale University Press, 1978), 1:229.

107 Anon., *A Sketch from the Landscape* (London, 1794). Matthews's identity as author was noted by Joseph Farington in September 1796 (*Diary*, 3:665).

108 *A Sketch from the Landscape*, 161.

109 Ibid., 27–28.

110 *Landscape Gardening...of Humphry Repton*, 220–30; Daniels, "Political Iconography of Woodland," 68–72; Humphry Repton, *Stanedge Park in Radnorshire, the Property of Charles Rogers, Esq.* (1803) (private collection).

111 Correspondence between Repton and Cotterell, Hereford County Record Office, D52.

112 *Landscape Gardening...of Humphry Repton*, 440.

113 Uvedale Price to Sir George Beaumont, 12 September 1823. Coleorton MSS MA 1581 (Price) 103.

114 Uvedale Price to Lady Margaret Beaumont, 31 May 1803; 17 June 1803; 10 August 1820; 13 December 1820. Coleorton MSS MA 1581 (Price), 41, 43, 91, 96.

The Constituents of Romantic Genius:
John Sell Cotman's Greta Drawings

Andrew Hemingway

I N THE YEARS 1803, 1804, and 1805, the young painter John Sell Cotman (then in his early twenties) made three successive visits to the estate of Brandsby near York, the home of Francis and Teresa Cholmeley and their five children.[1] During the last of these visits, Cotman was introduced by the Cholmeleys to John Morritt, the owner of Rokeby Park—an estate in North Yorkshire in the county of Richmondshire, celebrated for its natural beauty. Cotman stayed at Rokeby for three weeks in July and August 1805 and then spent about another week at the inn at Greta Bridge just outside the park gate after Morritt and his wife Katharine went away. During this month or so he made a group of drawings around the course of the river Greta, which together with the Tees borders the estate. To judge from the numbers on their backs, the drawings were probably conceived as a series. Twenty-five is the highest number on the dozen or so that seem to have survived. These so-called Greta drawings, which consist essentially of images of the river and trees, have sustained a very high standing among historians of watercolor painting since the early twentieth century, and one of them—*Greta Bridge* (which exists in two versions)—is one of the best-known of all British watercolors.

It has been customary to characterize the Greta drawings in anachronistic terms as displaying a quality of "abstraction" which derives from the particular bent of Cotman's mind. Their form and imagery is usually explained only as the result of an encounter between the artist's unique sensibility and a particular locale, mediated through the special demands of the watercolor medium. By contrast, in this essay I want to explore the particular historical conditions which made it possible for Cotman's contemporaries in 1805 to see genius in drawings so different from the dominant models of eighteenth-century watercolor practice.[2]

Cotman scholars have made much of the special relationship between the artist and the Cholmeley family, and Cotman later wrote that the hours he spent at Brandsby were "the happiest and blith[e]somest" of his life.[3] Even allowing for Cotman's customary hyperbole, he does seem to have enjoyed a degree of intimacy with the Cholmeleys highly unusual in relations between artists and the gentry. We know a great deal about these relations because surviving family correspondence contains numerous references to the artist, as well as some long and vivid letters by him. In 1980 transcriptions from this correspondence were published by the North Yorkshire County Record Office, where the manuscripts are

preserved. While this publication has proved a useful aid to scholarship, it should be noted that it is selective, and the excerpting of specific statements about the artist means that to understand the Brandsby milieu it is still necessary to go back to the archive at Northallerton. Here I will only make some points about the Cholmeley family which bear directly on what follows.

The relevant letters were addressed to the son of the household, Francis Cholmeley, junior, by his mother, his sisters, and friends. This correspondence was particularly extensive in the period when Cotman was closest to the family, because at that time Francis Cholmeley was often living away, either as a student at the University of Edinburgh or later in London. Many letters are from those he befriended among the Edinburgh student body, including the young Lord Palmerston. They reveal that Cholmeley was deeply involved in Edinburgh intellectual life and knew important figures in the university such as the philosopher Dugald Stewart and the mathematician and geologist John Playfair (who visited Brandsby in 1804). He also mixed in the circle of the *Edinburgh Review* and was acquainted with its editor Francis Jeffrey. Consistent with this, he was a convert to the Scottish moral philosophy and a liberal and Foxite in his political opinions.[4] He was evidently a keen traveler and landscape enthusiast and toured the Scottish Highlands in 1803 in company with Palmerston, who reported on other landscapes in his letters.[5] The correspondence of Cholmeley's mother and sisters suggests that the family as a whole had a high level of literary culture. His mother's letters show a strong interest in political affairs (not surprisingly at this stage of the Anglo-French Wars) and also reveal a woman sufficiently engaged with intellectual matters to discuss (disapprovingly) Hume's ideas and to read the *Edinburgh Review*, the foremost intellectual magazine of the day.[6] In addition to the usual accomplishments of daughters of the gentry, Harriet and Katherine Cholmeley wrote poetry, collaborating in 1804 on a poem of more than 1200 lines with the title *Feudal Strife*. Harriet seems to have taken poetry writing with particular seriousness, and her mother was proud of her accomplishment. From the letters she appears as the liveliest and funniest of the sisters and also the one with whom Cotman had the closest relationship. When Harriet became enamored of a Captain Macdonald of the 8th Foot in 1806, the family joked that the artist would have to console himself at her inconstancy. (To put this in perspective, she was only fifteen at the time.) It is also worth noting that Harriet was particularly enthused about the Morritts' estate at Rokeby.[7]

Cotman had been introduced to the Cholmeleys by Teresa Cholmeley's uncle, Sir Henry Englefield[8] — an antiquarian, and patron of art in a small way — and his first visit was probably part of the networking which any aspiring artist did to build up a potential clientele. Brandsby was also a strategic stop on a sketching tour, from which he could go to make drawings of Yorkshire antiquities and country houses which would be turned into finished watercolor paintings for local patrons or the London market. Yet, within a few days of their meet-

ing in 1803, we know that Cotman had impressed Mrs. Cholmeley as "more maniere'd and gentlemanlike" than his companion, Paul Sandby Munn,[9] and that she regarded his "command of his pencil" in drawing as "quite wonderful."[10] As the son of a Norwich haberdasher, Cotman was doubtless used to dealing with the gentry, and the education he received at the Norwich Grammar School was probably better than that of many artists. But he also seems to have touched Mrs. Cholmeley by his "kindheartedness" and "simplicity of character," and in the aftermath of his long stay in the summer of 1803 she described him as like "*a child* to my heart."[11] What she later refererred to as his "*attentions & devotement* to this family" were encouraged through letters and social engagements in London, to the extent that Cotman used family nicknames in his letters to the younger Francis (one year his junior) in 1805 and addressed him familiarly as "Francis" or humorously as "Sir Francis."[12] Their friendship was sufficiently close that when Francis left London after a visit there earlier that year, Mrs. Cholmeley wrote to him of Cotman, who remained in the city: "Pretty Poll pines for his mate, and has never been in spirits since you went."[13] However, it is important to remember the imbalance here: Cotman stayed as a guest of the Cholmeleys, but he also taught drawing to the daughters of the house, and there was probably a kind of informal *quid pro quo* involved. It does not detract from the sincerity of feeling of all concerned to note that Cotman was able to capitalize—quite literally—on his friendship with the younger Francis Cholmeley in 1810, when he asked him to act as guarantor for a bank loan of 200 pounds to help buy a new house.[14]

It was with Francis Cholmeley that Cotman visited Rokeby in 1805, and they explored the surrounding landscape together during the two to three weeks of Cholmeley's stay.[15] At Rokeby the artist taught drawing to Mrs. Morritt for a few hours every day and made an extended campaign of sketching of which the Greta drawings are the fruit. Despite a friendly reception from both of the Morritts, he evidently did not establish the kind of intimacy with them he enjoyed with the Cholmeleys.[16] The Cholmeleys seem to have preferred Mrs. Morritt to her husband, and in a letter of 1806 Teresa Cholmeley remarked of the latter: "there is too much of his family's presumption & self-conceit in him to be really agreeable in my opinion, but this must be passed over for his good qualities."[17] While it is hard to imagine that Rokeby offered Cotman the same kind of warmth and informality as Brandsby, it did offer patronage.

Cotman's movements in the social milieu of Brandsby and Rokeby matter not just because of their intrinsic interest as an instance of artist-patron relations, but because, in my view, that milieu determined in important ways the character of his Greta drawings. In this respect, the issue is not what may have made Cotman's relations with these patrons distinctive but, rather, what was typical about them. To understand this, we must also look at other responses to the Rokeby region.

63. John Sell Cotman, *The Scotchman's Stone*, 1805, watercolor, 26.7 x 39.4 cm. By courtesy of the Trustees of the British Museum, London.

The larger fame of Rokeby's natural beauties postdated Cotman's visit by a few years, and began with the publication of Walter Scott's immensely successful Civil War fantasy *Rokeby* in 1812. It was confirmed by Thomas Dunham Whittaker's sumptuous topographical history of the County of Richmondshire, which appeared in 1823 with magnificent copper-plate engravings after Turner and others.[18] Scott was introduced to the Morritts in 1808, he formed a strong bond with John Morritt (to whom the poem is dedicated), and in later years referred to him as "one of my oldest, and, I believe, one of my most sincere friends."[19] The novelist visited Rokeby for the first time in the summer of 1809 and described it in a letter, written shortly after, as among "the most enviable places I have ever seen, as it unites the richness and luxuriance of English vegetation with the romantic variety of glen, torrent, and copse which dignifies our northern scenery."[20] By December 1811 he could write to Morritt that "I have all your scenery deeply imprinted in my memory" and announced that he planned to write a poem using the region of Teesdale as a setting.[21] The following summer the pair rode out on a tour of the adjoining parishes of Rokeby and Brignal, visiting among other sites the ruined abbey of Egglestone, which stands at the junction of the Greta and Tees just outside the estate. Interestingly, Morritt was much impressed by the scrupulous notes which Scott made on the landscape and vegetation and which might stand as a literary equivalent to Cotman's on-the-spot studies.[22] Cotman probably made similar excursions in Morritt's company, and we know that he made them with Francis Cholmeley.

64. John Sell Cotman, *Greta Woods*,
1805–6, watercolor, 43.5 x 33.4 cm.
On loan to the Tate Gallery, London.

The seventh stanza of Scott's *Rokeby* was, in his own words, "an attempt to describe the romantic glen" through which the Greta takes it course. Scott's notes to this section of the poem give some sense of how this landscape affected contemporaries:

> The river runs with very great rapidity over a bed of solid rock, broken by many shelving descents, down which the stream dashes with great noise and impetuosity…The banks partake of the same wild and romantic character, being chiefly lofty cliffs of limestone rock, whose grey color contrasts admirably with the various trees and shrubs which find root among their crevices, as well as with the hue of the ivy, which clings around them in profusion, and hangs down from their projections in long sweeping tendrils. At other points the rocks give place to precipitous banks of earth, bearing large trees intermixed with copse-wood. In one spot the dell, which is elsewhere very narrow, widens for a space to leave room for a dark grove of yew-trees, intermixed here and there with aged pines of uncommon size. Directly opposite to this sombre thicket, the cliffs on the other side of the Greta are tall, white, and fringed with all kinds of deciduous shrubs.[23]

This is like a paradigm for the description of what was called in the period "romantic landscape," and it is striking how the features which Scott picks up on

65. John Sell Cotman, *Banks of the Greta*, 1805, watercolor, 22.5 x 33 cm. By courtesy of the Trustees of the British Museum, London.

to characterize Rokeby are those on which Cotman focuses in his drawings: the force of the stream, the steep banks, the almost impenetrable masses of trees, the abundant plant growth around the river's edge, and the rocky floor of the river bed. (Indeed, on the appearance of the poem, Cotman seems to have considered making illustrations for a new edition, although his plan came to nothing.)[24] Thus something of the power of the stream is suggested by the drawing called *The Scotchman's Stone* (fig. 63), which we know from Cotman's letters stood as a symbol for him of its force.[25] Weeds and shrubs form the main subject of several drawings, such as the *Banks of the Greta* (fig. 65). Trees seem to spring out of the very rocks in the so-called *Greta Woods* (fig. 64) (private collection). And the sheerness of the cliffs is well-represented in the *Devil's Elbow, Rokeby Park* (fig. 70), and the related drawing of *On the River Greta* (fig. 66).

It is not simply that both Scott and Cotman are describing something there in the landscape which is inherently pleasing. Rather they were selecting features from it which accorded with a pre-established aesthetic which they shared with their hosts, the Cholmeleys and the Morritts. Teresa Cholmeley's immersion in this aesthetic emerges from a letter she wrote to her son in August 1805 describing a visit to Castle Eden Dean near Durham, which Cotman later visited, perhaps on her advice:

> The valley is full of the most interesting changes and inequalities of ground. Sometimes you have a steep tho' short hill to ascend, and then as precipitate

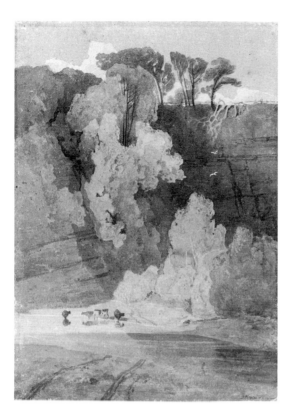

66. John Sell Cotman, *On the River Greta*, 1805–7, watercolor, 32.6 x 22.9 cm. Norfolk Museums Service (Norwich Castle Museum).

a descent....Immense rocks rise of either side, sometimes abrupt, sometimes receding and of various colours and kinds. Fine ash, oak and elm flourish tho' almost apparently growing out of the rock itself, which rocks are sometimes cloath[e]d w[i]th festoons of ivy, sometimes with thick dark masses of yew…and sometimes presenting a bold naked surface, seen thro' the light airy foliage of the ash…The road seems always conducted with the purest simple taste, often overhung by embowering trees that cross it in wildest fantastic shapes, and reminded me of the low garden walk at Rokeby by the side of the Greta.[26]

The terms of this description seem relatively abstract, as if a familiar typology were being invoked, and it could easily be paralleled in scenic descriptions in contemporary journals, guides, and novels. Still, there is some evidence that the Cholmeleys felt an almost proprietorial pride in the particular landscape of Teesdale, and wanted to impress its beauties on their young protégé.[27]

It might seem as if the category we need to invoke here is that of the picturesque, but this offers at most a partial explanation of the appeal of the Greta valley and the significance of Cotman's drawings of it. Gilpin's formulations of the picturesque aesthetic are much too oriented to seventeenth-century pictorial prototypes to accommodate drawings as different from earlier compositional models as many of Cotman's are. Further, their coloring is too fresh and vivid to

67. John Sell Cotman, *Distant View of Greta Bridge*, 1805, pencil and watercolor, 26 x 39.4 cm. Tate Gallery, London.

be comprehended within Gilpin's system. However, the picturesque, as reconceptualized by Uvedale Price in his *Essays on the Picturesque* of 1794 and 1798, does seem to have some relevance to this mode of description, and Price exemplified the category through "old neglected bye roads" and "hollow ways," banks overhung with trees, old quarries, and chalk pits among other things.[28] Price's theory of the picturesque was, of course, conceived in relation to the layout of the landed estate, and we may suspect that the Greta drawings would have signified for contemporaries like the Cholmeleys a kind of intimate and private zone within the cultivated landscape set aside for the use of the landed proprietor and his family. In 1819 the agricultural writer John Middleton observed that Morritt had made the area around Greta Bridge "very agreeable," and that trees, which had been planted by the former proprietor more than sixty years before, had been protected so that in some places they met over the roads. Thus Cotman's host and patron had particularly cultivated that which made one of the main subjects of his drawings.[29]

In a few of the drawings, such as *Brignall Banks on the Greta* (Leeds City Art Galleries) and the Tate Gallery's *Distant View of Greta Bridge* (fig. 67), we are given a sense of the river's ravine as lying within a landscape of use. But those of the river and its banks contain no signs of human labor, and the landscape they evoke could only suggest pleasures of the kind which the Morritts and their guests enjoyed there. However, Price defined the picturesque largely in terms of images drawn from Dutch landscape and genre painting, and he identified it

68. John Sell Cotman, *A Cottage in Guildford Churchyard, Surrey*, 1800, watercolor, 35.6 x 53.2 cm. City of Nottingham Museums, Castle Museum and Art Gallery.

with a more humanized landscape than that pictured in Cotman's drawings. Further, although the variety of light and shadow and irregularity of outline which characterize the Greta drawings were certainly licensed by the picturesque aesthetic, they were also representative of tendencies which were breaking apart the drawings modes which had stood as its equivalent in the eighteenth century, modes which were premised on the notion that certain restricted types of composition and effect were the causes of visual pleasure, in both paintings and the real world alike. You can see what I mean here by comparing an earlier Cotman drawing, *A Cottage in Guildford Churchyard, Surrey* of 1800 (fig. 68), which falls clearly within the parameters of the picturesque, with any of the Greta series. The former not only refers to seventeenth-century Dutch cottage scenes, it also depends on a kind of broken outline and mottled light and shade in widespread currency at the time.[30]

The aesthetic conception which is most immediately relevant to the Greta drawings was not actually articulated by any of the picturesque theorists. Rather, it was developed within the category of topographical publications known as the history of rivers. This genre had been developed in the 1790s by a number of publishers and artists and flourished in the first decades of the nineteenth-century, its most celebrated product being *The Thames*, published by the engraver William Bernard Cooke in 1811.[31] To appeal to the topographical market, such publications tended to focus on views of estates, monuments, and towns as seen from the river—but the upper reaches of the river also furnished the basis for

69. John George Wood, "Devil's Bridge,"
from *The Principal Rivers of Wales
Illustrated*, 1813, soft-ground etching.

unpeopled romantic views. Thus, in a work published a few years after Cotman's Greta drawings, John Wood's *Principal Rivers of Wales Illustrated* of 1813 (fig. 69),[32] the regions near the sources of rivers provided some motifs strikingly close to Cotman's. Again, I introduce these not to indicate an influence, but rather to illustrate the currency of a particular aesthetic.

To understand the Cholmeleys and Morritts' enthusiasm for the scenery of the Greta and Cotman's impulse to represent it, we also need to refer to the aesthetic of associationism. The most authoritative theory of aesthetic pleasure current in the period, associationism was premised on the idea that the human psyche was structured through the principle named by John Locke as the association of ideas. Although the theory had significant variations, all its proponents claimed that the main pleasures of taste arose not from qualities intrinsic to objects in nature, or to works of art, but rather from a particular effect these things exerted on the mind. This effect was a train of ideas, united by certain invariable causes and combined with a common overriding sentiment. The more associations an object evoked for the spectator, the more intense the pleasures it was likely to produce. Francis Cholmeley was so immersed in associationist philosophy that Palmerston teased him about it in a letter of 1805.[33] Among his Edinburgh acquaintances, Stewart and Jeffrey both wrote important essays on the theory of taste which stressed that the appeal of landscapes depended on associated ideas rather than any intrinsic qualities, although these were not pub-

70. John Sell Cotman, *Devil's Elbow, Rokeby Park*, 1805–7, watercolor, 45.1 x 35.1 cm. Norfolk Museums Service (Norwich Castle Museum).

lished until a few years later.[34] At Rokeby, Cotman was in the company of a veritable tutor in association theory, someone who could potentially advise him on the most sophisticated contemporary semiotics.

We can know something of the kinds of association landscapes of the Greta type conjured up both from Mrs. Cholmeley's letter about Castle Eden Dean and from Scott's *Rokeby*. The Cholmeleys' literary culture undoubtedly informed their experiences of real landscapes. Thus, when Mrs. Cholmeley described the valley at Castle Eden Dean, she noted that it "put me much in mind of Mrs. Radcliffe's Castle of Udolpho," referring to Ann Radcliffe's celebrated Gothic romance, *The Mysteries of Udolpho* of 1794. Radcliffe was famous for her picturesque landscape descriptions, and *Udolpho* is full of evocative imagery of mountains and forests. Cotman's Greta drawings do not seem very suggestive of the Gothic, which was usually associated with ominous crags, broken firs, mountain torrents, and banditti, but there is a landscape in the novel we might connect them with, namely that of "La Vallée," the estate in Gascony on the banks of the Garonne, where the heroine Emily St. Aubert passes her peaceful and virtuous childhood in the midst of a lush and thickly wooded nature. This is a landscape of established proprietorship and philosophical contemplation, in contrast to the wild and rugged scenes around the castle of Udolpho, where the novel's most Gothic episodes take place.[35]

That the Rokeby area could additionally suggest the Gothic is clear from Scott's response.[36] *Rokeby* is a tale of murder and revenge with all the usual Gothic trappings, and in his notes to Stanza VII of his poem, Scott writes:

> The whole scenery of this spot is so much adapted to the ideas of superstition, that it has acquired the name of Blockula, from the place where the Swedish witches were supposed to hold their sabbath. The dell, however, has superstitions of its own growth, for it [is] supposed to be haunted by a female spectre, called the Dobie of Mortham.[37]

We know from Scott's correspondence with Morritt that he asked him to provide details of legends and superstitious traditions about the area, and Morritt later recalled in a memorandum of the novelist's visit of 1812: "he was but half satisfied with the most beautiful scenery when he could not connect with it some local legend."[38] We should not interpret this as simply some quirk of Scott's mind. Local histories and topographies were filled with such material.

The absence of figures and the deep shadowy spaces in drawings like *On the River Greta* (fig. 66) and *Devil's Elbow, Rokeby Park* (fig. 70) become deeply suggestive in relation to the eerie connotations with which such landscapes were invested. For contemporaries, woods in themselves could evoke a whole realm of superstitions no longer credible to the enlightened mind, but for that very reason poetic. In *The Mysteries of Udolpho* the heroine's father remarks during an evening walk on his estate:

> The evening gloom of woods was always delightful to me…I remember that in my youth this gloom used to call forth to my fancy a thousand fairy visions, and romantic images; and, I own, I am not wholly insensible of that high enthusiasm which wakes the poet's dream: I can linger, with solemn steps, under the deep shades, send forth a transforming eye into the distant obscurity, and listen with thrilling delight to the mystic murmuring of the woods.[39]

Scott enacted this prescribed poetic response to the woods at Rokeby but also linked them with an elaborate fantasy partly fueled by the real history and antiquities of the area. Although the estate had been in his family for only one generation, Morritt would have certainly known of the associations of the name of Rokeby, of which Whitaker later wrote: "So much courage, patriotism, law, and piety, have rarely been assembled in one name."[40] The Rokebys were said to be a family of Saxon descent, and the remains of their castle of Mortham stands on the banks above the Greta opposite Rokeby Park. Also nearby was the Abbey of Egglestone, situated on high cliffs overlooking the Tees, from which Morritt had taken a massive Gothic tomb which he re-erected next to the castle. The fact that a paper mill and laborers' cottages stood adjacent to the abbey emphasized the contrast of past and present which underpinned early-nineteenth-century

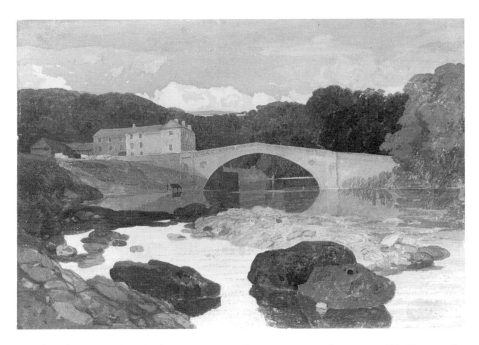

71. John Sell Cotman, *Greta Bridge*, 1806–7, watercolor, 22.7 x 32.9 cm. By courtesy of the Trustees of the British Museum, London.

images of antiquity and solitude. Even before the appearance of either of the publications which fixed the identity of Rokeby as a romantic region, a visiting artist (part of whose stock in trade was drawings of Gothic antiquities) could not but have been aware that the region around Rokeby was heavily redolent of the medieval past, and Morritt would probably have given Cotman the same kind of information as he gave Scott.

Given the romantic character of the Greta woods and the complex of poten tial historical and literary associations around them, there are good reasons to think that Cotman's drawings are far more than just exercises in watercolor pattern-making. His sensitivity to these associations can, I believe, be demonstrated through the best-known drawing of the series, *Greta Bridge* (fig. 71) — illustrated here through the British Museum version, which probably dates from 1806-7.[41] The design exemplifies a type of motif in Cotman's work which appears throughout his career: a frontal composition of balanced masses which is associated with the classical landscape tradition, and particularly with prototypes developed by Nicholas Poussin and Gaspard Dughet.[42] We have no need to posit any innate classicizing bent in Cotman's mind to explain his use of such motifs, for the clas sical landscape tradition was the most important resource for contemporary landscape painters attempting to enhance the status of the landscape genre as serious art. Turner made use of Poussinesque compositions in a small number of historical landscapes in the early years of the century, and also in his topographi-

cal landscape of *Bonneville, Savoy*, exhibited at the Royal Academy in 1802. Further, specialists in watercolor such as John Varley, Joshua Cristall, and William Havell used classical composition motifs in both historical subjects and what purported to be views of contemporary British scenery. Cotman had contact with all three artists in the context of the evening Sketching Club which grouped around him between 1802 and 1804 with the aim of fostering a "School of Historic Landscape."[43]

Cotman's interest in the classical landscape tradition was thus overdetermined. However, I want to suggest that there were more specific reasons for him to refer to that tradition in a representation of Greta Bridge: not only was the region of Rokeby rich in medieval associations, it was also a Roman site. Greta Bridge itself stood on the line of the Roman road known as Watling Street, and a number of antiquities had been unearthed from the adjacent Roman camp in the eighteenth century. John Morritt, a noted classical scholar, had several of these in his Palladian mansion, together with a collection of Roman bas reliefs and inscriptions he had accumulated while in Italy on the Grand Tour.[44] The elegant classicism of Greta Bridge itself, which was probably built for Morritt's father by James Carr in the 1770s, thus matched with the associations of the site. Further, the inn at the left of the design was owned by Morritt—who joked with Scott that he would have to raise its rent as a result of the influx of "cockney romancers, artists, illustrators, and sentimental tourists" who would flock there as a result of the celebrity of his poem.[45] Thus the watercolor was both an image of Morritt's property and also one seemingly well-suited to his classical tastes and the historical associations of the neighborhood. We know that the Morritts were "much pleased" with Cotman's drawings which they saw in London in 1806, and that John Morritt ordered a view of Greta Bridge from him in the previous year, which is likely to be the distant one in the Tate Gallery.[46] This again indicates how much Cotman's work was rooted in the cultural milieu of his hosts.

So far, I've been talking about the Greta drawings as if they were all of a piece. But in fact they vary in their sizes and degree of finish. It is predictable, of course, that the more sketchy drawings,[47] are somewhat smaller (approximately 7 x 11 or 12 x 9 inches), and the more finished ones are the larger (approximately 17 x 13 inches)—although this isn't uniformly the case.[48] These differences relate to the distinct aspects of Cotman's art as a social practice. Cotman did not simply go out to sketch around Brandsby or Rokeby because he happened to feel like it. Rather he drew for at least three specific functions. First, drawings were made in connection with his practice of teaching. That this involved making sketches outdoors (rather than merely copying) we know from the Cholmeley family letters.[49] Second, the practice of sketching and coloring on the spot was part of the landscape painter's self-education, and it provided the basic materials for the third function, that is, the production of finished watercolor paintings for exhibition and sale. In fact, only five or so of the extant Greta drawings can be

regarded as finished works, and so far as is known, Cotman sold only two of them in the years when they were made: the *Greta Bridge* to Morritt and the first version of *Hell Cauldron* to Sir Henry Englefield.[50] More than two decades later he sold a group of them to a local Norfolk patron,[51] and others remained in the Cotman family after the artist's death. It may well be that, without clear topographical landmarks, the motifs were too lacking in specific associations to have much appeal outside a local market.[52] Further, the drawings of 1805–6 were probably too bold and unfinished for contemporary tastes, for in 1806 Teresa Cholmeley replied to a letter from her son:

> I am very sorry Cotty's drawings shd still have deserved so much criticism, & hope Bob will speak to him & that he will listen & profit by it. He certainly has not ye art of rich coloring some of ye others possess & shd never rest till he obtains it.[53]

It is worth recalling that some of Thomas Girtin's drawings were seen as having a "carelessness," which was almost necessary to their "boldness and spirit."

At this point, the issue of the extent to which the Greta drawings were made outdoors has to be addressed. It has been a concomitant of the formalist interpretation of Cotman's work to insist that they could not have been colored on the spot.[54] Indeed, in the catalogue to the 1982 Arts Council Cotman exhibition, Miklos Rajnai redated several of the more finished drawings to 1807–8, presumably to reinforce this claim. Of course, Rajnai may be correct in his redatings. (There is nothing improbable in the hypothesis that Cotman produced finished drawings from sketches made several years before. It was a practice he engaged in throughout his career, and the second *Greta Bridge* is actually dated 1810. It is also highly improbable that a finished drawing such as *The Devil's Elbow* [fig. 70] was made outside.) However, it is correspondingly important to give due weight to statements in the Cholmeley letters which refer unequivocably to Cotman coloring on the spot in 1803,[55] and to his own well-known comment in a letter to Dawson Turner of 1805, that over the summer his "chief study" had been "coloring from Nature, many of which [studies] are close copies of that fickle Dame, consequently valuable on that account."[56] We should also note the appearance of some drawings, both smaller and larger, which have an improvisatory and sketch-like quality, such as *Distant View of Greta Bridge* (fig. 67) and *Barnard Castle from Towler Hill* (Leeds City Art Galleries). This issue is now rendered more complex by the appearance in 1986 of sixteen sheets of watercolors (some worked on both sides), which appear to be studies for several of Cotman's best-known drawings of the years c. 1805–10. Although in parts they lack the sureness we associate with the artist, there is a strong case for regarding these studies as authentic and as *plein-air* works.[57]

In fact, it would be rather suprising if Cotman had not made watercolor studies on the spot in this period. Girtin, the idol of the younger watercolorists,

72. John Robert Cozens, *Interior of the Colosseum*, 1778, watercolor, 36.1 x 51.6 cm. Leeds Museums and Galleries (City Art Gallery).

had done so, and to this practice was partly attributed the quality of his work.[58] Further, the brothers John and Cornelius Varley and Joshua Cristall, with whom Cotman came together in the Sketching Society, were all making outdoor studies and in the case of John Varley had been doing so since as early as 1800.[59] The very compositional format and selection of motifs of Cotman's Greta drawings derived from this practice. However, what distinguishes them from standard formats of eighteeth-century topographical watercolors based around Claudean vistas, framing masses, receding rivers, and so forth is their generally low viewpoints and the closeness of the motifs. Characteristic of the sketch mode is the sense it so frequently produces of being down there in the landscape, close up to rocks, plants, and the raw matter of nature. We can understand this partly in terms of the artist as representative of a kind of leisured traveler, making his or her way through the landscape for the purposes of individual pleasure and occluding all considerations of labor and utility. (It is no accident that one of the first watercolorists to employ this kind of viewpoint was John Robert Cozens in drawings he made in company with William Beckford on the Grand Tour [fig. 72].) We can also understand it in relation to the emergence of the aesthetic of originality in the eighteenth century, which placed a new premium on the signs of individuality in art. This aesthetic, which was articulated with particular clarity in Edward Young's *Conjectures on Original Composition* of 1759, worked in conjunction with the growing market economy for paintings, to license a species

of image which signified the experience of looking for a discrete viewing consciousness — a kind of roving curious eye, primarily concerned with its own pleasure. The viewpoint of this detached individual consciousness may stand as a pictorial counterpart to the new literary subject represented in the eighteenth-century novel and exemplified in Radcliffe's Emily St. Aubert, transparently an eighteenth-century lady transposed to sixteenth-century France and Italy, who — when she is not undergoing the trials of sentiment — consoles herself with the observations of a picturesque tourist. At any rate, I am claiming that the mode of looking embodied in the watercolor sketch, and the type of finished drawing based on it, stood for a particular mode of consciousness that both artist and patron (despite differences in social position) could in some degree share and recognize as represented therein.

From the historian's point of view, the Greta drawings cannot be just some mysterious effect of that unique individual John Sell Cotman. Rather, the issue is why anyone would choose to make them at that particular time and place. History has necessarily to deal with the collective forces which determine social behavior. Whether the Greta drawings have anything to do with some special quality in Cotman's mind (and obviously in some indeterminate sense they have), that quality was exercised in a social field which gave it both form and identity. This is not to say that Cotman's sensibilities were molded by external constraints, but rather that his very conception of his sensibilities was pregiven and historically and culturally specific.[60] When Mrs. Cholmeley wrote to her son in 1803 that Cotman's drawings of trees evinced the "boldness and spirit of [his] genius,"[61] this was effectively a recognition that Cotman's work contained the signs which denoted "genius." Cotman handled the familiar codes of representation with a particular personal inflection, but it was the culture he inhabited that gave a value to that inflection. The distinction of genius was a kind of social exchange based on a familiar currency. It was an acknowledgment of value, premised like all exchange transactions, on the recognition of that offered in exchange. It was this *recognition* of the species of novelty Cotman offered in his Yorkshire drawings — and not some transcendent aesthetic "quality" — which permitted their "genius" to be seen. It is the currency of that exchange I have sought to identify in this essay.

1 On the estate and the family, see John Cornforth, "Brandsby Hall, Yorkshire" I and II, in *Country Life* (2 January 1969): 18–21, and (9 January 1969): 66–69. I am grateful to Michael Pidgely for this reference. The basic biographical source for Cotman remains Sydney Kitson's *The Life of John Sell Cotman* (London: Faber and Faber, 1937). An important addition to this is Michael Pidgley, "Cotman's Patrons and the Romantic Subject Picture" (Ph.D. diss., University of East Anglia, 1975).

2 I have given a detailed critique of formalist interpretations of Cotman's work in my article, "Meaning in Cotman's Norfolk Subjects," *Art History* 7, no. 1 (March 1984): 57–77. I would argue that the differences between the Greta drawings and the water-

colors of the first Norwich period which I discuss there are to be understood primarily in terms of the different contexts for which they were produced: the milieu of the gentleman's park and the sketching excursion in the first case, and that of the provincial city and its art exhibitions and public in the second.

3 J. S. Cotman to Francis Cholmeley, 23 July 1822, in Adele M. Holcomb and M.Y. Ashcroft, *John Sell Cotman in the Cholmeley Archive,* North Yorkshire County Record Office Publications No. 22 (Northallerton: North Yorkshire County Council, 1980), 69 (hereafter "Holcomb & Ashcroft"). The surviving Cholmeley letters to Cotman are bound into the volume *Biographical Material &c. Relating to the Cotman Family*, James Reeve Collection, British Museum Print Room.

4 See: R. Richmond to Francis Cholmeley, 15 March 1803; Thomas Potts to Francis Cholmeley, 15 November 1803; Harriet Cholmeley to Francis Cholmeley, 15 April 1804; Lord Palmerston to Francis Cholmeley, 18 April 1804; Lord Palmerston to Francis Cholmeley, 13 January 1805. All letters, unless otherwise stated, are in the Cholmeley Family Papers at the North Yorkshire County Record Office, Northallerton, Yorkshire, where they were deposited by Mr. F. W. A. Fairfax-Cholmeley (Reference: ZQG Roll 959).

5 Lord Palmerston to Francis Cholmeley, 6 August 1804.

6 Teresa Cholmeley to Francis Cholmeley, 11 December 1803, 18 December 1803, and 22 January 1804.

7 In 1803, Harriet wrote a 56-line poem, titled "Cotmania." See Holcomb & Ashcroft, 18. Teresa Cholmeley to Francis Cholmeley, 22 January 1804; 10 August 1805; Katherine Cholmeley to Francis Cholmeley, 15 May 1806.

8 For Englefield's collection see *A Catalogue of the Valuable and Highly Interesting Collection of Painted Greek Vases of Sir Henry Englefield, Bart. Deceased; Also a Small but Very Select and Valuable Assemblage of Pictures*, Christie's, 6 March 1823 (copy in British Library). Englefield's modern pictures included works by George Beaumont, William Hodges, Patrick Nasmyth, William (?) Havell, George Jones, and J. M. W. Turner.

9 For Munn, see Martin Hardie, *Watercolor Painting in Britain*, vol. 2, *The Romantic Period* (London: Batsford, 1967), 137–38.

10 Holcomb & Ashcroft, 13.

11 Ibid., 17. Two years later she was to describe Brandsby as his "*home*" (ibid., 26).

12 Ibid., 21, 23, 27, 30. In their letters to each other the Cholmeleys referred to the artist as "Cotty."

13 Holcomb & Ashcroft, 23.

14 Ibid., 50–51. He had already got Sir Henry Englefield to stand security for 200 pounds for his father in 1808 (ibid., 36), and he may have borrowed 90 pounds from Cholmeley in 1810, to judge from a letter of that year (ibid., 37). Mrs. Cholmeley, who died in 1810, left the artist a bequest of 100 pounds. The intermingling of financial dependence with friendship is even more pronounced in Cotman's relationship with the Yarmouth banker Dawson Turner—although the quintessentially bourgeois and starchy Turner kept Cotman at far more of a distance, and the artist's relationship with the Turner family was far more servant-like.

15 Holcomb & Ashcroft, 27.

16 A letter from Cotman in late August 1805 to Francis Cholmeley reported that both Mr. and Mrs. Morritt had been "very kind to me" (Holcomb & Ashcroft, 29). In a letter of 8 March 1806 to her brother, Harriet Cholmeley remarked: "you would have been pleased to hear how highly both Mr & Mrs Morritt spoke in his favour both as to his drawing and himself."

17 Teresa Cholmeley to Francis Cholmeley, 23 March 1806. Mrs. Cholmeley approved of Morritt's unconventional marriage to a woman more than ten years older than himself in 1803 (which incurred the disapproval of his family), and the friendship with the Morritts seems to have begun with this event. See Teresa Cholmeley to Francis Cholmeley, 26 November 1803.

18 Thomas Dunham Whitaker, *An History of the County of Richmondshire in the North Riding of the County of York*, 2 vols. (London, 1823).

19 Scott Diary, May 1828, quoted in John Gibson Lockhart, *Memoirs of the Life of Sir Walter Scott, Bart.* (Edinburgh, 1839), 9:254. They are likely to have been politically sympathetic to one another, since Morritt was a Tory in his politics and on Scott's invitation was an occasional contributor to the *Quarterly Review* (see *DNB*).

20 Lockhart, *Memoirs of Scott*, 3:190.

21 Ibid., 3:369ff.

22 Morritt's Memorandum of Scott's visit, Lockhart, *Memoirs of Scott*, 4:19–20.

23 Walter Scott, *Rokeby* (London, 1842), 185.

24 Holcomb & Ashcroft, 54.

25 Ibid., 29.

26 Ibid., 25. The probable connection between this letter and Cotman's visit to Castle Eden Dean was first noted by Miklos Rajnai, in Rajnai, ed., *John Sell Cotman, 1782–1842*, exh. cat. (Arts Council: London, 1982). Interestingly, one of the things we know impressed the Cholmeleys about Cotman's artistic abilities almost from the beginning was his drawing of trees. See Holcomb & Ashcroft, 19.

27 Teresa Cholmeley to Francis Cholmeley, 3 August 1805 (Holcomb & Ashcroft, 25).

28 Uvedale Price, *Essays on the Picturesque* (London, 1810), 1:21–37.

29 "Notes made during a Journey from London to Holkham, York, Edinburgh, and the Highlands of Scotland, in July and August 1819, by John Middleton, esq.," *Monthly Magazine* 49, no. 340 (June 1820): 414. The Brandsby estate was also highly "improved," and both Francis Cholmeleys were deeply interested in tree planting.

30 I discuss the transformation of the picturesque in the early nineteenth century in my *Landscape Imagery and Urban Culture in Early Nineteenth-Century Britain* (Cambridge: Cambridge University Press, 1992), 19–26.

31 Which Cotman admired (see Holcomb & Ashcroft, 48). On the picturesque of rivers, see Hemingway, *Landscape Imagery and Urban Culture*, 219–24.

32 J. G. Wood, *The Principal Rivers of Wales Illustrated; Consisting of a Series of Views from the Source of Each River to its Mouth, Accompanied by Descriptions, Historical, Topograhphical and Picturesque* (London, 1813). John George Wood (d. 1838) was a Fellow of the Society of Antiquaries and a watercolorist who exhibited at the Royal Academy 1793–1811. He published a series of lectures on perspective, given at the Royal Institution in 1804, and several other books on drawing and collections of views. Cotman owned the *Principal Rivers of Wales*, which appears as Lot 255, Day 1, in Christie and Manson, *Catalogue of the Library of John Sell Cotman*, 6 June 1843.

33 Lord Palmerston to Francis Cholmeley, 13 January 1805: "You who have studied Moral Philosophy and know *all about the human mind*" (emphasis in the orginal). A joke about the association principle follows.

34 Dugald Stewart, *Philosophical Essays,* 2nd ed. (Edinburgh, 1816), pt. 2, chap. 5; Francis Jeffrey, Review of Alison's "Essays on…Taste," *Edinburgh Review* 18, no. 36 (May 1811): 13–18. On the associationist aesthetic, see Hemingway, *Landscape Imagery and Urban Culture*, 54–78.

35 On the interpretation of this novel, see Mary Poovey, "Ideology and the 'Mysteries of Udolpho,'" *Criticism* 21, no. 4 (Fall 1979): 307–30.

36 On Scott and the Gothic, see Fiona Robertson, *Legitimate Histories: Scott, Gothic, and the Authorities of Fiction* (Oxford: Clarendon Press, 1994), chaps. 1 and 2.

37 Scott, *Rokeby*, 185.

38 Lockhart, *Memoirs of Scott*, 3:372ff; 4:20–21.

39 Ann Radcliffe, *The Mysteries of Udolpho*, ed. Bonamy Dobree (Oxford: Oxford University Press, 1980), 15.

40 Whitaker, *History of Richmondshire*, 157.

41 The *Greta Bridge* in Norwich Castle Museum is from 1810 and is more "finished."

42 Other examples from around the same time include the so-called *Chirk Aqueduct* and the *Road to Capel Curig*, both in the collection of the Victoria and Albert Museum. Cotman made a pencil study after Poussin's *Roman Road* in Dulwich Picture Gallery (Norwich Castle Musem, 51.L.1967.9). See Miklos Rajnai and Marjorie Allthorpe-Guyton, *John Sell Cotman: Early Drawings (1798–1812) in Norwich Castle Museum* (Norwich: Norfolk Museums Service, 1979), no. 104.

43 Jean Hamilton *The Sketching Society, 1799–1851*, exh. cat. (London: Victoria and Albert Museum, 1971), 6–10. On Cristall, see Basil Taylor, *Joshua Cristall, 1768–1847* (London: Victoria and Albert Museum, 1975). See also Holcomb & Ashcroft, 20.

44 Whitaker, *History of Richmondshire*, 184.

45 Lockhart, *Memoirs of Scott*, 3:380–1.

46 Holcomb & Ashcroft, 8, 29, 32.

47 For example, Rajnai, ed., *John Sell Cotman*, nos. 35, 37, 40, 41, 54.

48 Ibid., nos. 36, 45. An exception is the first *Greta Bridge* drawing, which is approximately 9 x 13 inches.

49 Thus, in 1803 Anne Cholmeley wrote to her brother that she and her sister Katherine were "now seriously engaged in sketching from nature w[i]th Mr Cotman. I do wish you were here w[i]th him and c[oul]d draw with us" (Holcomb & Ashcroft, 15; cf. 21).

50 The earlier version of *Hell Cauldron* (1805–6) is in Leeds City Art Gallery, the later (1808?) in the National Gallery of Scotland, Edinburgh. See Rajnai, ed., *John Sell Cotman,* nos. 45 and 68.

51 *English Landscape, 1630–1850: Drawings, Prints and Books from the Paul Mellon Collection* (New Haven: Yale Center for British Art, 1977), 97–98.

52 Francis Cholmeley's well-known observation in a letter to Cotman of 16 April 1811 may well be pertinent here. Recording the response of the York bookseller Todd (of Messrs. G. & T. Todd) to Cotman's *Miscellaneous Etchings*, he observed: "I also gathered from him that they [i. e., the public] did not like the view in Duncombe Park, because it might have been *anywhere*. Two thirds of mankind; you know, mind more *what* is represented than *how* it is done" (Reeve Collection, British Museum Print Room).

53 Teresa Cholmeley to Francis Cholmeley, 24 May 1806.

54 A. P. Oppé, "Cotman and his Public," *Burlington Magazine* (July 1942): 163–71; Hardie, *Watercolor Painting in Britain*, 2:77–84; Rajnai, "Introduction: Cotman's Life and Work," in *John Sell Cotman,* 13, 16–17. Indeed Rajnai goes so far as to assert that none of Cotman's "known watercolors" appear to have been colored on the spot (67). However, there are a number of sketch-like works in Cotman's early output, and I can see no reason to assume that they may not have been executed wholly, or in part, outdoors. Among such I include: *Covehithe Church, Suffolk* (31), *Cottage at Cotthive* (32), *Study of Trees, Harrow* (35), *Near Brandsby, Yorkshire* (34), or *Duncombe Park, Yorkshire* (37) (numbers refer to the 1982 catalogue). By no stretch of the imagination can these be regarded as finished works in early nineteenth-century terms. Rajnai's assumption that the existence of a pencil study precludes a drawing such as *Brignall*

Banks on the Greta (54) from being made on the spot is contradicted by evidence in the Cholmeley letters that Cotman returned to locations with drawings he had made previously to tint them (Holcomb & Ashcroft, 15). Such a practice is no odder than Constable's of making small pencil studies of oil paintings he worked on outdoors, such as *Boat-Building at Flatford Mill* (Victoria and Albert Museum). This flattening out of the variety of Cotman's output arises because of an unwillingness to acknowledge the naturalistic element in his work—as if formal sophistication and naturalism were in some essential contradiction with one another. This is to impose a Modernist aesthetic on an early nineteenth-century practice, and it is no accident that the emergence of the formalist interpretation of Cotman coincided with the popularization of the notion of significant form (see Hemingway, "Meaning in Cotman's Norfolk Subjects," on this).

55 Holcomb & Ashcroft, 15, 26.

56 J. S. Cotman to Dawson Turner, 30 November 1805. Quoted in Kitson, 80.

57 Lot 210, Sotheby's sale catalogue, *Eighteenth and Nineteenth-Century British Drawings and Watercolors*, 10 July 1986, 234–41. Despite the obvious possibility that some of these might be the drawings referred to in the Cholmeley correspondence as colored on the spot, the cataloguers fought shy of any such conclusion (238). The attribution of the drawings remains in dispute.

58 On Girtin's outdoor sketching, see Anon. [William Henry Pyne], "Observations on the Rise and Progress of Painting in Water Colors," *Repository of Arts* 9, no. 50 (February 1813): 92–93. I take the British Museum's *Above Bolton* (1855-2-14-10) and *Gordale Scar, Yorkshire* (1855-2-14-19) to represent Girtin's sketch mode.

59 The Cholmeleys were certainly familiar with the work of Girtin, Havell, and Varley—hence their ability to recognize Cotman's talent (Holcomb & Ashcroft, 26). On Varley's outdoor studies, see C. M. Kauffmann, *John Varley, 1778-1842* (London: Batsford, 1984), especially 24–28, 37–38.

60 On the issue of agency from a social-science perspective, see Roy Bhaskar, *The Possibility of Naturalism: A Philosophical Critique of the Contemporary Human Sciences* (Brighton: Harvester Press, 1979), chap. 3.

61 Holcomb & Ashcroft, 19. Cf. Katherine Charlton (formerly Cholmeley) to J. S. Cotman, 6 April 1811, regarding his *Miscellaneous Etchings:* "To say how nearly they resemble your pencil drawings is sufficient to prove how beautiful they are" (James Reeve Collection, British Museum Print Room).

From Picturesque Travel to Scientific Observation: Artists' and Geologists' Voyages to Staffa

Charlotte Klonk

> *The changes which have taken place in the formation of the earth of this our Globe was a subject of conversation.*—Joseph Farington[1]

THE PERIOD BETWEEN 1790 and 1830 saw striking changes in the depiction of British landscape. Pictorial formulae like the sublime, the beautiful, and the picturesque lost their privileged place in the perception of nature and were slowly abandoned in favor of what I call a *phenomenalist* mode of representation. Although it had no currency among contemporaries, I choose this term to designate the complex of attitudes concerning the relationship between mind and nature that grew in force at this period for a variety of reasons. So far, two different terms have been most commonly used by commentators. Some writers refer to the growth of *empiricism*, particularly in relation to developments in science. This term (unlike phenomenalism) was certainly used by contemporaries, but its meaning was always multi-faceted and, in addition, changed hugely over the course of time, so that it is not particularly useful as an analytical tool in historical studies.[2] The changes in artistic practice that took place in the early nineteenth century are conventionally referred to in art history as *naturalism*. This term, however, like empiricism, carries the suggestion that the mind responds passively to reflect unproblematically a mind-independent, objective realm. Phenomenalism escapes this, in my view misleading, implication. According to phenomenalism, as I use it to describe the attitude that emerged amongst artists and scientists at this period, the observer must confine herself strictly to what is given to the perceiving subject, without making any prior suppositions concerning underlying mechanisms by which what is observed is connected. For phenomenalism, generalization is permissible only on the basis of the painstaking accumulation of particular instances. It is, however, important to emphasize that phenomenalism is not a form of *subjectivism*. It is true that, in placing the emphasis so heavily on the observer, phenomenalism can lead to the idea that reality is always refracted through the perceptions and emotions of the individual; but, in its (arguably unstable) original form, the role of the observer was consciously confined to being a screen for the way that reality is given. In other words, phenomenalism attempts to capture reality faithfully, not as it is in itself or in its underlying essence (if it has one) but *as it appears*.

The exploration of the connection between science and art is, as Martin Kemp has pointed out, "a considerable growth area."[3] It is one which has some dangers, however: not least, an endemic temptation to identify science or sci-

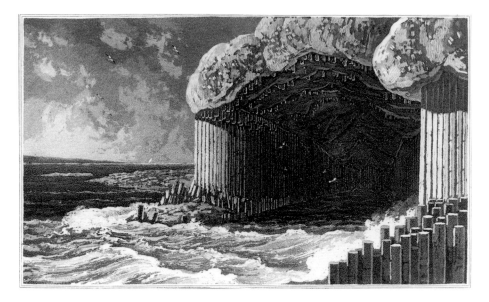

73. William Daniell, "The Cave of Fingal," 1807, engraving from *Interesting Selections from Animated Nature*, vol. 1. Bodleian Library, Oxford, RADCL. 1998I c. 33/1.

ence-related technologies (the invention of photography, for example) as the underlying cause of artistic developments. Although, of course, pictorial representation does not develop separately from scientific activities or social discourses, I see a methodological danger in attributing causal priority to any single realm. One way of retaining the complexity of motivations and causal connections is by concentrating on case studies, and that is the strategy I will adopt here. I will focus on the relationship between geology and pictorial representation in one location, the Isle of Staffa on the West Coast of Scotland.[4]

This small, remarkable island, which is part of the Inner Hebrides, became of particular attraction to naturalist travelers and artists alike in the eighteenth century because of its geological formation. The island consists entirely of basaltic columns which support a bed of strata on top and at intervals open into caves.[5] That such columns were present at the Giant's Causeway in Ireland had long been known. The very few earlier travelers to the Western Isles, such as Martin Martin,[6] however, were only interested in the islands' nature in relation to their peoples, and so uninhabited islands like Staffa were neglected. But the nature of such basaltic pillars became the subject of a dispute in the mid-eighteenth century. The dispute concerned the origins of the polygonal basalt columns to be found in France and Germany. Two views were advanced, one claiming their origin to be volcanic, the other explaining their formation as aqueous, the result of repeated precipitation from water or mud.[7] Thus a local report that similar geological features were to be found on Staffa was sufficient to induce Sir Joseph Banks, the future president of the Royal Society of London, to land there on 12

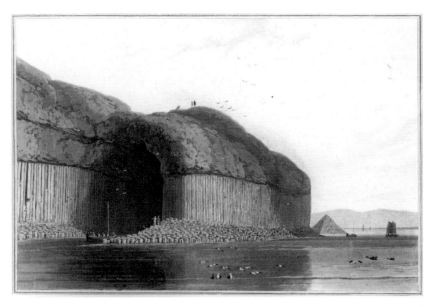

74. William Daniell, "Entrance to Fingal's Cave, Staffa," 1817, aquatint printed in color, hand-finished, from *A Voyage round Great Britain*, vol. 3. Bodleian Library, Oxford, G. A. GEN. TOP. b. 33 (opp. p. 34).

August 1772. His detailed published account, which appeared in print in Thomas Pennant's *A Tour in Scotland, and Voyage to the Hebrides* in 1776,[8] initiated the considerable interest the island received from then on.[9] Although he was certainly aware that the evidence for a volcanic explanation of the columns was stronger, Banks did not commit himself fully to either view when he described Staffa.

When William Daniell compiled his publication, *Interesting Selections from Animated Nature with Illustrative Scenery*, between 1807 and 1812,[10] he included a plate of what was by then the most famous part of Staffa, *The Cave of Fingal* (1807) (fig. 73).[11] It shows the entrance to the major cave on the island as if one were looking into the nave of a huge cathedral. In this way, Daniell makes conspicuous what he calls the "wonders of nature" and its "mysteries" waiting to be unravelled.[12] A vault-like formation of earth rests on even, rectilinear columns. The Cave of Fingal is shown as a natural and divine wonder, analogous to but more perfect than the products of human activity.

Between 1814 and 1825 Daniell produced a further publication, *A Voyage round Great Britain*,[13] a project which, in contrast to *Interesting Selections*, brought him considerable fame. In its third volume (1818) Daniell again showed a series of plates, aquatints printed in color, displaying views of the Isle of Staffa. Yet these plates are completely different from Daniell's previous representations.[14] In the second plate of the series, the *Entrance to Fingal's Cave* (fig. 74), the columns have become reduced in size and the earth formation above them no longer alludes to a cathedral vault. It has now become simply a massive varied

layer of strata lying above the columns. What is most noticeable is the lack of any emphasis on those features that could have curiosity value. The sea, this time calm and settled, forms a layer parallel to the columns and the earth strata above. Nothing is particularly startling; everything represented in the plate is equally important to the overall impression. The latter is enhanced by the calm weather which facilitates the clear observation of the actual distribution of light and shade. The eighteenth-century fashion for tinting the drawing in a muted brownish or bluish color to distribute an overall effect of chiaroscuro has been abandoned in favor of subtle local colors in blue, green, brown, and yellow. In contrast to the earlier plate, which emphasized architectural structures in order to evoke astonishment at nature's curiosities, this depiction conspicuously stays clear of such implications; it is plainly meant to appear as a neutral delineation of what has presented itself to the artist's eye. In the accompanying text Daniell makes the following statement, which can be read as an implicit criticism of his own former approach:

> This celebrated spot seemed the more worthy of attention, because those graphic delineations of it which have obtained most circulation are now found to be inadequate to the subject, and in many respects utterly erroneous. This remark will be understood to apply to the engravings in Mr. Pennant's tour, from drawings by his servant, Moses Griffiths, which have been so carelessly copied in several publications on the continent, that the various objects have been reversed in their position, and their relative proportions still more incorrectly given than in the originals.[15]

As we shall see, Daniell copied his own earlier depiction of Fingal's cave from one of the plates in Pennant's publication.[16] This shows a view of the cave looking into its mouth which places the island on the viewer's right, while, in fact, as Daniell's second plate rightly depicts it, the island lies to the left. Daniell goes on to say:

> To those who have perused the enthusiastic descriptions of Staffa which have been given by various tourists, it may be a source of some disappointment to find that the reality by no means justifies the notions they had been led to form, and that the optics of a poet's fancy must be requisite to convert the scene before them into the end of an immense cathedral, whose massy roof is supported by stupendous pillars formed with all the regularity of art.[17]

He then introduces a description of Staffa by the geologist John MacCulloch. MacCulloch was an early member of the Geological Society of London, set up in 1807 to promote a fieldwork approach to geology against what its founders saw as the purely speculative theories concerning the earth current at the end of the eighteenth century.[18] MacCulloch's research on Staffa took place between 1811 and 1813 while he was employed by the Board of Ordnance.[19] He subsequently

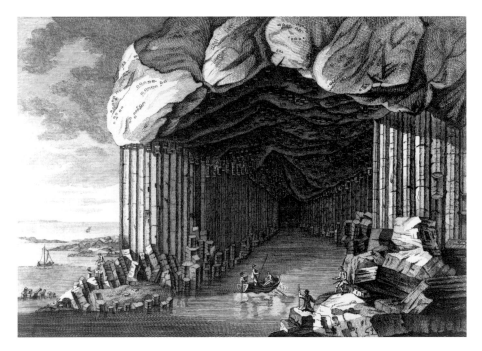

75. John Cleveley or James Miller or John F. Miller, "Fingal's Cave in Staffa," engraving (Major) from Thomas Pennant, *A Tour in Scotland, and Voyage to the Hebrides,* vol. 2 (1776). Bodleian Library, Oxford, GOUGH SCOTL. 277, plate XXVII.

published his account in the *Transactions of the Geological Society of London,*[20] and Daniell seems to have read this paper while preparing for his own voyage there. Daniell states:

> It is for this reason [Daniell's distrust of the exaggeration of former accounts] among others that the preference is due to his [MacCulloch's] paper on Staffa over those which have so long challenged the wonder of the public; he has forborne to stimulate curiosity by hyperbolical comparisons, and delivering his statements in plain and direct language, has reduced the prevalent opinions on the subject to a more just and reasonable standard.[21]

Daniell's abandonment of inherited pictorial conventions in the delineation of his plates in *A Voyage round Great Britain* is thus expressly linked to the new fieldwork approach in geology and its rejection of theoretical explanations involving causes and connections beyond the realm of the visible.

In contrast, Daniell's first text to his earlier plate relied on the description of the island given by Joseph Banks. Writing at the beginning of the golden age of the naturalist traveler, Banks concludes his account of Fingal's Cave with the following paean to nature:

> each hill, which hung over the columns below, forming an ample pediment; …almost into the shape of those used in architecture…Compared to this

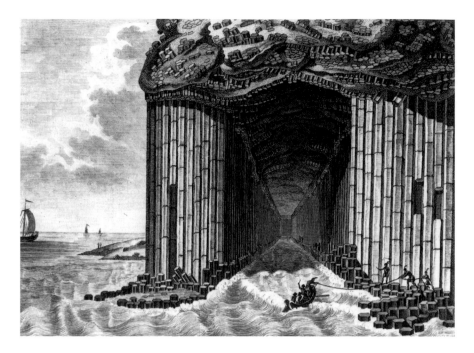

76. Durand, "Vue de la Grotte de Fingal," engraving (Boutrois) from Barthélemie Faujas de Saint-Fond, *Voyage en Angleterre*, vol. 2 (1797). Bodleian Library, Oxford, CC. 21. ART. SELD., plate III.

what are the cathedrals or the palaces built by men! Mere models or play-things, imitations as diminutive as his works will always be when compared to those of nature.[22]

Pennant accompanied Banks's account with five engravings of the island. One, a panorama of Staffa and its surroundings, was probably prepared by his own draughtsman, Griffiths.[23] The four other plates were executed by John F. Miller, James Miller, and John Cleveley, the professional draughtsmen who accompanied Banks in 1772.[24] One of these, *Fingal's Cave in Staffa* (fig. 75), is obviously the model for Daniell's earlier print. Not only does it exhibit the same cathedral-like structures as Daniell's *The Cave of Fingal*, but it is also taken from the same angle.[25] Banks's verbal description and pictorial delineation of Staffa proved to be so impressive that all subsequent travelers known to me refer to them. The French naturalist Barthélemie Faujas de Saint-Fond visited Staffa in 1784[26] and published three plates of the island in his publication on Great Britain thirteen years later.[27] In preparation for his voyage he contacted Banks and asked him for a copy of his illustrated account of Staffa in Pennant's tour.[28] The effects of this are apparent, since Faujas de Saint-Fond's *Vue de la Grotte de Fingal* (fig. 76), prepared by the artist Durand, seems to be a copy of Banks's, even more exaggerated in its architectural features, the nave having become slightly more elongated; in fact, he even criticizes Banks's otherwise esteemed

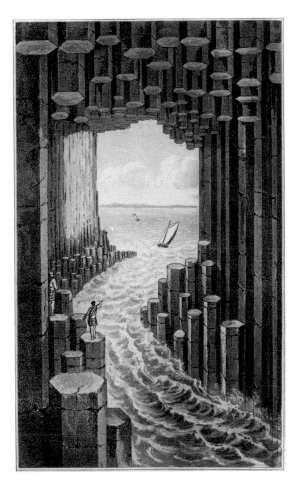

77. "Fingal's Cave," engraving (W. Read) from Louis A. Necker de Saussure, *A Voyage to the Hebrides* (1822). By permission of the Syndics of Cambridge University Library.

draughtsman for having depicted it too "irregulièrement."[29] The emphasis on the regularity, overwhelming size, and artful construction of this natural phenomenon is also the dominant characteristic of the plates in Thomas Garnett's *Observations on a Tour through the Highlands and Part of the Western Isles of Scotland*, which first appeared in 1800 with vignettes drawn by the artist, Watts, who accompanied him.[30] The same is true for Louis A. Necker de Saussure's depiction (fig. 77), which formed the frontispiece of his *A Voyage to the Hebrides*.[31]

All these geologists echoed Banks in their sense of wonder at the creations of nature. But it was Faujas de Saint-Fond who first offered a causal explanation for the geological phenomena at Staffa. Banks, whose descriptive account was typical of the naturalist traveler, did not, as was mentioned earlier, speculate on the origin of the basaltic columns. He referred cautiously to "lava-like material" and the "appearance of a lava" in the strata below the columns on the west side of the island, but he did not attempt to identify secondary causes for it.[32] Faujas de Saint-Fond inferred from observation of lava formations on the Continent that a similar volcanic process must have produced the basaltic structures on Staffa.

The study of volcanoes and their effects had received new impetus after William Hamilton published his brilliantly illustrated account of an eruption of Mount Vesuvius in the *Philosophical Transactions of the Royal Society of London* in 1775.[33] Hence volcanic activity was easily accepted by later geologists as the cause of the basaltic columns on Staffa. The aqueous explanation, however, was reasserted in 1800 when Robert Jameson published his *Mineralogy of the Scottish Isles.*[34] Explanations such as Jameson's were known as *neptunism*. Neptunism was developed by Abraham Werner at the end of the eighteenth century at the Bergakademie in Freiburg. It explained the origin of rocks by arguing that a distinctive series of compositions and densities had precipitated in temporal sequence from a universal ocean. Jameson had been a partisan of the neptunist theories of Werner since his time as a student in Edinburgh. He did not, however, visit Staffa himself during his journey and relied solely on Banks's account.

In the text accompanying his earlier depiction of basaltic columns of 1807, William Daniell did, in fact, refer to the conflict between "vulcanist" and "neptunist" theories, which are as he put it, "calculated to give scope to conjecture." [35] However, none of the explanations current at that time seriously called into question Daniell's reverential attitude towards a creation full of mysteries and curiosities, which "keep alive sentiments of admiration and reverence for the works of the Deity."[36] Neither vulcanism nor neptunism presented an account of nature which was inconsistent with Christian natural theology. Volcanic phenomena, such as the earthquake in London of 1750 and the devastating earthquake in Lisbon of 1755, as well as the series of eruptions of Vesuvius in the later eighteenth century, had been treated as miraculous catastrophes outside the ordinary course of nature and were taken as a sign of God's presence.[37] In maintaining that the mineral formations with which the globe is covered were precipitated from a primeval ocean, the Wernerian system could also easily be linked to the Mosaic account of the Deluge.[38] The Wernerian system was valued for its power and precision and for its supposed ready applicability to every country. Indeed, even after the turn of the century, when geologists had come to question such comprehensive, mono-causal explanations of the earth, their investigations were conducted in much the same terms as Werner's.[39]

It was not until John Playfair's publication of the Huttonian theory of the earth in 1802 that the theological controversy which that theory had aroused reached a wider public.[40] Hutton presented his theory of the earth before the Royal Society of Edinburgh on 7 March and 4 April 1785, and published an abstract, describing the theory essentially in its final form, later that year. The first full version appeared in 1788 in the *Transactions of the Royal Society of Edinburgh,*[41] but it was not until 1795 that his *Theory of the Earth with Proofs and Illustrations*[42] appeared. As Stephen J. Gould states, the latter "might have occupied but a footnote to history if his unreadable treatise had not been epitomized by his friend, and brilliant prose stylist, John Playfair."[43] Hutton argued that the facts

of the history of the earth were to be found in natural history, not in human records, and he ignored the biblical account of creation as a source of scientific information. According to Hutton the earth's formation of horizontal layers overlying vertical ones records two great cycles of sedimentation with two episodes of uplift caused by subterranean heat. The lines of disjunction between two successive formations, a phenomenon which was later to be called "unconformity,"[44] were the direct evidence for Hutton's belief that the history of our earth included several cycles and that it was in a permanent state of degeneration and regeneration. New continents were forever being naturally created out of the debris of former ones, he thought, and the earth might wheel on indefinitely with "no vestige of a beginning,—no prospect of an end."[45]

It was not Hutton's postulation of the igneous origin of rocks like granite which brought vehement accusations of impiety on him (this, after all, had been argued before) but his presumption of an indefinite time-scale for the earth's origins, unbounded by any specific act of creation. Whereas the biblical account had made the history of the earth the outcome of one or more acts of divine intervention (for example, the Deluge), Hutton, a Deist, relegated divine action to the sphere of primary causes, beyond the scope of scientific investigation. In this way he prepared the path for the fieldwork geologists after the turn of the century, who, as we shall see, rejected theories of the genesis of the earth which assumed causes going beyond direct evidence. For Hutton, the evidence of God's perfection was that he had designed a world that could maintain itself indefinitely. He writes that it is vain "to look for anything higher in the origin of the earth" than natural causes.[46] Hutton's denial of the role of divine causation in the history of the earth outraged writers like Richard Kirwan and Jean André de Luc. They set themselves against the idea of an earth in permanent revolution and defended the traditional view, advancing what Roy Porter has called "directionalist, catastrophist, Biblical theories of the Earth."[47]

However, although it was Hutton who first shook the understanding of earth's history as the result of divine causation, I want to argue that it was not Hutton but the fieldwork approach to geology after the turn of the century which most fundamentally affected the representation (and, ultimately, the perception) of nature. Hutton's account of the earth's history presented it as a natural economy of degeneration and regeneration in endless cycles which, in the end, confirmed the overall stability of the natural order. Furthermore, Hutton put forward his theory as having been derived by reason from certain key premises and then presented his observations only as confirmation of these claims.

In fact, Hutton's work was much disparaged in the early nineteenth century by the phenomenalist geologists. Kirwan had already accused Hutton's theory of reaching "a priori conclusions unsupported by facts," but he himself argued for a divine cosmogony no less remote from observation.[48] The members of the Geo-

logical Society of London, founded in 1807, on the other hand, responded to the struggle between vulcanists, neptunists, and theologians by a withdrawal from wider theorizing in favor of the accumulation of pure data, concentrating particularly on the stratigraphic appearance of whatever location was under examination. For them, the idea that natural processes—that is, secondary causes alone—could account for the origin and genesis of a particular locale was no longer a matter of dispute. But they went further: even if the evidence led to causal hypotheses, these must be restricted to the particular location under investigation, without leading to further generalizations. Their attitude, which claimed to abstain from speculative theorizing and to restrict itself to the realm of mere observation, has clear parallels to the contemporary restriction of discussion on the part of philosophers and aestheticians (for example, Dugald Stewart and Archibald Alison) with regard to the laws of the operations of the mind. In attempting to sidestep questions of general causation, geologists after the turn of the century manifested the attitude which I have been calling *phenomenalist*. At a time when Hutton's theory was being linked to the French Revolution as a threat to the existing social order, the restriction to the relations between natural formations in locally, temporally, and causally confined areas represented a step away from religious and political "counter-revolutionary turmoil."[49]

The fieldwork geologists' position was clearly expressed in the introduction to the first volume of the Geological Society's *Transactions:* "In the present imperfect state of this science, it cannot be supposed that the Society should attempt to decide upon the merits of the different theories of the earth that have been proposed."[50] Instead, the *Transactions* were established to draw up and distribute:

> a series of inquiries, calculated in their opinion to excite a greater degree of attention to this important study, than it had yet received in this country; and to serve as a guide to the geological traveller, by pointing out some of the various objects, which it is his province to examine.[51]

The Geological Society grew out of an earlier scheme for a national school of mines.[52] This initiative was typical of the late eighteenth century in bringing together individuals from a variety of backgrounds: wealthy landowners with mining interests, practical surveyors, and professional men whose occupations involved them in the analysis of minerals, like apothecaries, chemists, and pharmaceutical manufacturers. As Paul Weindling has argued, there was no unified political agenda behind the project apart from its commitment to economic utility. The participants' political outlooks ranged from the conservative to the radical.[53] Collaboration was particularly important in geology, which required people with quite different skills for the collection and analysis of its data. The first public statement made on behalf of the Geological Society in the *Transactions* of 1811 recognizes this and speaks self-confidently of bringing together the

scattered efforts of all those engaged in the study of the earth: the miner, the quarrier, the surveyor, and the traveler. The adoption of a phenomenalist rhetoric was well suited to this. Phenomenalism privileges observation, independent of theoretical or specialist knowledge, and so makes geology accessible to people from different backgrounds.[54]

Later, however, this rhetoric was used to exclude those who tried to steer geology towards its utilitarian application. This was largely due to the Geological Society's first president, George Bellas Greenough. He and his followers were concerned to establish geology as an independent science with its own distinct method, descriptive stratigraphy, based on field observation alone. Although the *Annual Report* of 1815 still describes the role of the Geological Society as supervising the efforts of artists, natural historians, and chemists, either for the sake of improvements in industry or as a branch of scientific research, those pursuing geology without concern for economic utility increasingly came to dominate.[55] The phenomenalist rhetoric served the establishment of a hierarchy, privileging those gentleman geologists who had the means and leisure to go on lengthy fieldtrips. Presenting geology in these terms was also useful in gaining public acceptance for it as an independent science, drawing on the old image of the leisured gentleman whose wealth allowed him to rise above factional interests. A fierce debate still continued within the Society, but as James A. Secord has pointed out:

> The relatively homogenous social background of those at the center of British geology ensured a very broad consensus on religious and political issues. One scarcely expected to find freethinking secularists and Scriptural literalists frequenting the rooms of a scientific society in Somerset House."[56]

It was undoubtedly an important factor behind the society's success that it apparently withdrew from a debate which had acquired increasingly political connotations. The phenomenalism of the Geological Society was a political strategy which avoided politicization. It proved, however, to be inherently fragile, as we shall see. But its departure from the belief in the overall stability of nature, which all eighteenth-century theorists from the natural theologians to Hutton had shared, led to a noticeably different perception of nature which corresponded to the changes in early-nineteenth-century art practice that we have seen in the case of William Daniell.

The difference between Daniell's early depiction of Staffa and his later one corresponds to the differences between the late-eighteenth-century naturalist travelers like Pennant and John MacCulloch in the early nineteenth century. Pennant's natural history is typical of the second half of the eighteenth century. Its primary interest is in taxonomical descriptions, and Pennant concentrates on the enumeration of peculiar phenomena rather than giving an account of their origin or relation to the surrounding environment. Banks's account of Staffa, with its emphasis on the island's extraordinary appearance, was of the same char-

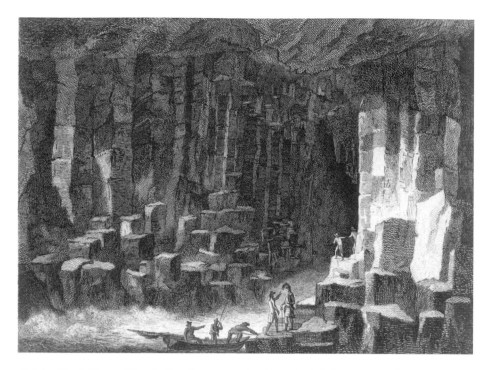

78. John Claude Nattes, "Fingal's Cave," 1802, engraving (James Fittler) from James Fittler, *Scotia Depicta* (1804). Bodleian Library, Oxford, GOUGH MAPS 171, plate 26.

acter, and Pennant, having been prevented from seeing the island himself by an overcautious boatman, offers Banks's account as a substitute for his own. The fame this publication bestowed on Staffa made it for a while the only location in the Western Isles to be included in picturesque travel literature. A typical example of a picturesque appreciation of Staffa is the depiction of *Fingal's Cave* by John Claude Nattes (fig. 78), published in James Fittler's *Scotia Depicta* in 1804, after the oil painting of 1802 had been shown at the Royal Academy.[57] Again, as in Banks's depiction, the entrance to the cave is shown with the little figures and a boat in the foreground to establish the awesome size of the location. But, in contrast to the earlier plates, which emphasized regularity in order to display by analogy the purposeful character of nature's creations, this engraving attempts to capture an air of irregularity and awesomeness more in tune with the increasing popularity of the sublime and the picturesque. The feeling of sublimity is evoked by a close-up view of the entrance, opening like a black hole. A dramatic chiaroscuro is distributed over the depiction, which does not come from a real light source but gives it a mystical illumination. The plate bears witness to the shift towards an appreciation of architecture in its ruined state, emphasizing the broken outlines in order to achieve a more textured appearance. However, this does not challenge the interpretation of Staffa as a mysterious wonder; rather it heightens it.[58] Nor, indeed, did the development of a causal explanation for

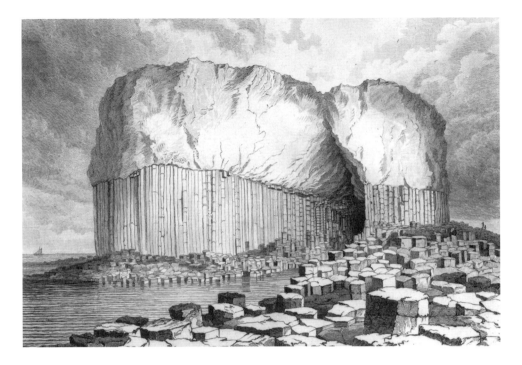

79. John MacCulloch, "Entrance of Fingal's Cave, Staffa," 1819, engraving (C. Heath) from *A Description of the Western Isles*, vol. 3 (1819). Bodleian Library, Oxford, G. A. SCOTL. 4.203.

Staffa's distinctive geological features; such action could still be regarded as a kind of miracle of nature.

It is in John MacCulloch's publication on the Western Isles of 1819[59] that we find the first geological drawings of Staffa which depart somewhat from the traditional pictorial formulae. MacCulloch, whose article had induced Daniell to see previous depictions as insufficient, does not focus in his own writing on the essential characteristics of individual objects, but on the variety of phenomena and their relations. The plate *Entrance of Fingal's Cave, Staffa* (fig. 79) shows the short basalt columns in the foreground leading up to the entrance not only as consisting of hexagonal stumps, but as having quite an irregular order and shape. The columns of the Isle itself also appear rather fragile; less solid, with breaks and irregularities. They support a massive stratum on top. The whole picture seems to be more like a drawing than an engraving, since stark contrasts are suppressed, and light and shade are used only tentatively to produce the effect of volume.[60] Thus the junction between the huge top and the columns appears somewhat unresolved. Yet, compared with Daniell's depiction (fig. 74), published a year earlier, this plate still exhibits some picturesque exaggeration—for example, the darkening sky and the imposing mass of the uppermost bed. However, the text shows that MacCulloch was consciously attempting a new kind of description. He explicitly criticized "that air of architectural regularity which [he has] cen-

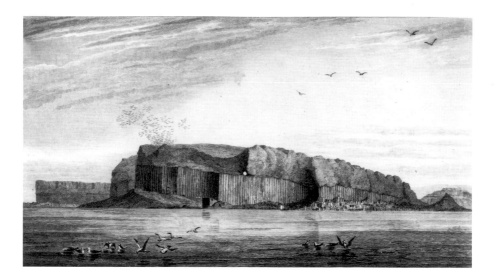

80. John MacCulloch, "View of Staffa from the South West," 1819, engraving (Byrne) from *A Description of the Western Isles*, vol. 3 (1819). Bodleian Library, Oxford, G. A. SCOTL. 4.203.

sured in the published representations."[61] In his paper in the *Transactions* Mac-Culloch had already expressed his intention to enter "minutely into the general description of the island."[62] Thus he does not concentrate solely on the structure of the columns but also examines the strata on top, where he had found some alluvial fragments of older rocks. This perhaps explains the emphasis on this layer in the accompanying illustration in the book, which, however, does not show what he emphasizes verbally: namely, that the portion which lies on each side of the fissure toward the outer part of the cave is, like the upper bed, formed of minutely fractured rock.[63]

Another view shows the island from the southwest (fig. 80). Banks's account also contained two side views of Staffa, which, as with the plate of Fingal's Cave, carry strong allusions to architecture, so that the strata over- and underlying the columns appear like floor and roof, with the caves as door-openings. MacCulloch's plate in contrast exhibits more strongly than any of his other plates his interest in the relative position and formation of the different strata of Staffa. But, again, Daniell's aquatint from the same viewpoint (fig. 81) seems more adequate, since MacCulloch's plate fails to convey a sense of the different textures. This is partly due to the fact that Daniell shows the scene in a realistic distribution of light and shadow, while MacCulloch presents it in a picturesque overall distribution of chiaroscuro. Again, though less strongly so, MacCulloch's graphical design alludes to a tradition from which, at least verbally, he wants to distance himself. To depict an object within a framework of chiaroscuro, outside the real light situation, is to depict it as if in some pre-established order, be that order perceived as a divine one or as a Huttonian overall order of cyclic motions.

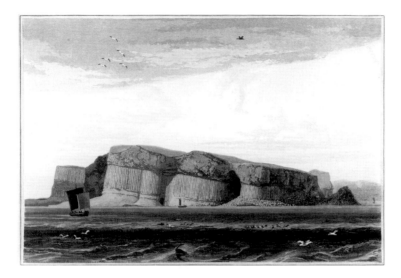

81. William Daniell, "The Island of Staffa from the South West," 1817, aquatint printed in color, hand-finished, from *A Voyage round Great Britain*, vol. 3 (1818). Bodleian Library, Oxford, G. A. GEN. TOP. b. 33, opp. p. 47.

But in the account in the *Transactions*, MacCulloch states that the appearances, which he had set out to grasp in their full complexity: "are perhaps insufficient to enable us to decide between two difficulties of equal magnitude, nor is it here necessary to enter further on that question."[64] He is here referring to the two current modes of explanation for Staffa, the igneous and aqueous theories, but refuses to decide between them, since that would, he says, presuppose "accumulating information on which a consolidated fabric may at some future time be erected."[65]

Yet, this attempt to unite the phenomenalist conception of the primacy of observation with the scientific ideal of objectivity is inherently unstable. A scientific approach which relies so heavily on observation by the individual who undertakes it opens the path to subjective relativism. That its inner tensions could lead to a more subjectivist mode of perception is already evident from MacCulloch's own account. Having stated that previous descriptions of Staffa were misleading, he argues that, in practice, Staffa leaves the visitor with a sense of disappointment which can only be overcome if the imagination is set free while visiting the island. And he concludes that not one thing exists in the natural world "which the imagination is not ready to exceed."[66] Thus MacCulloch's description falls into two parts, one in which he expresses the observations, and the other in which he allows himself to introduce subjective associations.

Even William Daniell's objective of simply noting what he perceived, without reference to pre-established patterns, presupposes the artist as a self-conscious subject, although the position of the perceiver is not, in this case, itself perceptible from the depictions. In 1831, when Turner went to visit Staffa, the

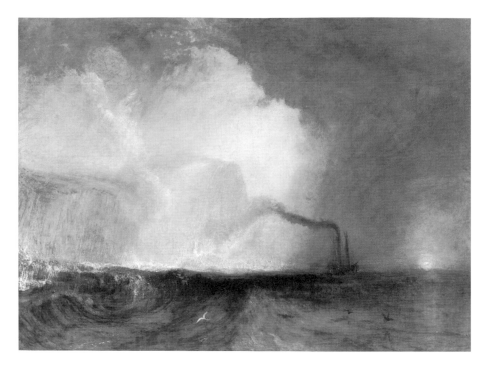

82. J. M. W. Turner, *Staffa, Fingal's Cave*, 1832, oil on canvas, 90.9 x 121.4 cm. Yale Center for British Art, Paul Mellon Collection.

implicit position of the perceiving subject had become a strong constituent of the depiction. A year after this visit he exhibited a painting at the Royal Academy with the title *Staffa, Fingal's Cave* (fig. 82) in which the cave itself is hardly visible.[67] Some of the vertical structures of the island can be traced on the left-hand side of the picture, piercing through the mist and haze behind a turbulent sea. The steam of a dark steamboat in the middle-ground towards the right mingles with the atmosphere. The moist impression is enhanced by the diffused light from the sun which is setting into the sea amid clouds on the right-hand side. The colors of the columns — red, yellow, blue — are echoed in the halo around the sun.

This painting was sold in 1845 through C. R. Leslie to James Lenox of New York. After having received the picture, the new owner complained about its indistinctness, and Leslie urged Turner to write to him about it. It is interesting to note that Turner replied with a description of his own experience on which the picture had been based. He stated that a strong sea was running, and it was "not very pleasant or safe to go into the cave when the wave rolls right in." On the voyage back the "sun getting towards the horizon, burst through the rain-cloud, angry, and for wind."[68]

However, a vignette executed in 1834 for Sir Walter Scott's poem *The Lord of the Isles* (fig. 83) shows that Turner had an interest not only in the atmospheric

83. J. M. W. Turner, "Fingal's Cave," 1834,
engraving (E. Goodall) from Walter Scott,
The Complete Poetical Works, vol. 10 (1834).
By permission of the Syndics
of Cambridge University Library.

effects which he encountered but also in the geological formations of the
island.[69] The engraving shows Fingal's Cave not from the usual standpoint (out
side), but from inside looking outwards.[70] The columns are quite carefully
depicted with breaks, or, in technical terminology, joints, in their structure. But
here too the water and weather which enter the cave are strongly emphasized in
their forceful movements. Thus Turner achieves a tension between the
dynamism of the elements — the water and the atmosphere — and the solidity of
the stones.

The fact that, as John Gage has pointed out, the sun in the oil painting is
haloed in a way which presages rain is significant.[71] This indicator of change,
linked by color to the columnar structure on the left-hand side of the painting,
does not appear in the sketches.[72] Atmospheric changes of this kind, although
not part of the perception of the moment, are nevertheless possible objects of
experience. Their inclusion signifies a conception of nature as in a process of
change, in which immediately given appearances point beyond themselves to the
future — or, as in the case of the rocks, to the past. In Turner's painting, just as in
the writings of MacCulloch, there is no viewpoint beyond the realm of the
observable from which such changes could be understood. Turner's depiction of
Staffa, however, unlike Daniell's, is strongly infused with his own attitude as an
observing subject who perceives in the ongoing atmospheric spectacle the quin-

tessence of a permanently forming and developing nature.[73] This understanding of a dynamized nature whose features are constantly changing makes the moment of encounter significant.[74]

There is a clear contrast between the strict phenomenalist position, with its prohibition on general theory and restriction to what is observed at a particular instant, and the conception of nature as dynamically evolving, implicit in Turner's depiction of Staffa. But that strict phenomenalist position is itself, it must be said, an abstraction or ideal type. As we have already seen with MacCulloch, phenomenalism is inherently unstable; without *some* kind of generalization no science would be possible at all.

Even within the Geological Society of London, such a strict position, which confined itself to the description of what is observed, was methodologically adhered to only in the first years of its foundation, most notably by George Greenough.[75] By the late 1810s and 1820s the Cuvierian approach to stratigraphy was being adopted by members of the Society. It was an attempt to go beyond the local descriptive stratigraphy which Greenough had been advocating, by correlating successions in different parts of the world, particularly by comparisons of fossil content. In this way paleontological stratigraphy was committed to the establishment of a generalized geological schema of the earth which a strict phenomenalist position would not permit. However, it could still be presented as a strategy which is solely based on observation. Thomas Webster, Keeper of the Museum and later Secretary of the Geological Society of London, was the first to employ the method that Georges Cuvier had used in his work on the Paris Basin, in order to determine the succession of the Isle of Wight. He immediately qualifies his conjectures by a warning straight from the phenomenalist rhetoric of the Geological Society. In the present state of the science of geology, he writes,

> it is more important to examine the actual position of the several fragments of strata now forming the surface of the earth, and by connecting them together, to endeavour to ascertain the curved and broken forms into which they have been reduced by some unknown agent, than, finally, to dogmatize, in this scanty state of our knowledge, on the precise nature of this power, which can be rationally sought for only by a careful examination of the effects produced.[76]

By the 1820s, however, a number of geologists were starting to address questions of revolutions in the history of the earth. Most prominent among them were William Buckland and W. D. Conybeare. Both advocated a diluvian theory of the earth's history, which assumed successive natural deluges, supposed to have caused the extinction of animal populations and to have transported masses of debris across the earth's surface. Yet even this renewed commitment to general theories was still couched in phenomenalist rhetoric. "It is not the business of the present work to propose theories, but to record facts," writes Conybeare in his

introduction to his and William Phillips's *Outlines of the Geology of England and Wales*, having presented a critical account of several such explanations.[77] It is clear that by that time phenomenalism amounted to very little more than paying lip-service to the principle that scientists should stick to the evidence before them—a methodological principle that hardly goes beyond the level of platitude.

When Turner reached the Isle of Staffa, Charles Lyell was publishing his famous *Principles of Geology.*[78] Lyell's new theory of the earth did justice to its progressive history, while at the same time integrating Hutton's notion of an unchanging earth history. In this way Lyell's work was part of a larger move in the 1830s among scientists towards a renewed acceptance of conjectural and imaginative elements in scientific thinking.[79]

By this time MacCulloch too had abandoned his abstinence with regard to conjectures going beyond the immediate data. But, instead of embracing one or other of the newly established secondary-cause models such as Lyell's or Cuvier's stratigraphic paleontology, he harks back to earlier global cosmogonies, both those of divine final causation and the Huttonian model. In his last geological work, *A System of Geology, With a Theory of the Earth* (1831),[80] as well as in his *Proofs and Illustrations of the Attributes of God* (1837), like the *Bridgewater Treatises* written as an attempt to infer God's handiwork from the perfection of geological appearances,[81] MacCulloch argues that, while neither a theory of the earth nor God's providence (which accounts for what even a theory of secondary causes cannot explain) can ultimately be proved, the attempt to develop such theoretical accounts is nevertheless worthwhile. Thus he now fully endorses what he had earlier rejected: speculations without immediate evidence.[82]

By this stage the depiction of Staffa had undergone dramatic changes. Generally speaking, at the beginning of the period—around 1780—the style of depiction shows a concentration on a single, central feature; the rocks are represented with an emphasis on their bizarre character, in abstraction from their natural context and situation. By the end of the period—in 1830—the structure of the depictions has become decentralized, and the rocks are shown as a part of an environment whose natural history results from their particular context. This shift of emphasis is, in fact, characteristic of a change that took place more broadly in British landscape art in the early nineteenth century.

In the case study presented here this change has been linked to a shift in the perception of nature by contemporary geologists. But this is also a good example of the way in which the relationship between science and art often turns out to be more complex than accounts which assume a unilateral effect of the former on the latter have it. Although, as we have seen, the geologists pioneered this new interest, the visual language of their representation did not match up to their verbal accounts. Their illustrations were limited by formulae which corresponded to an earlier conception of natural history, and it was artists like William Daniell who first developed new visual ways of depicting nature.

By the end of the 1820s, however, the particularist depiction of the connected appearances of individual locations gave place to a more subjectivist emphasis on the perceptions of the artist, and scientists now once again fully endorsed the necessity of hypothetical constructs.

1 Joseph Farington, *The Diary of Joseph Farington*, Kathryn Cave, ed. (New Haven: Yale University Press, 1983), 12:4306 (27 February 1813).

2 Richard Yeo in "An Idol of the Market-Place: Baconianism in Nineteenth-Century Britain," *History of Science* 23 (1985): 251–97, explores the shift of meaning in the evocation of Baconian empiricism from the eighteenth to the nineteenth centuries. He describes how Bacon was presented in the early nineteenth century as the advocate of theories of induction at the expense of eighteenth-century utilitarian readings of him "as author of a radical philosophy capable of transforming not only natural knowledge, but established social institutions and values" (288). Yeo's article thus illustrates the problems of using a label whose meaning is historically variable.

3 Martin Kemp, *The Science of Art: Optical Themes in Western Art from Brunelleschi to Seurat* (New Haven: Yale University Press, 1990), 3.

4 My discussion of the geological depictions of Staffa is greatly indebted to Martin J. S. Rudwick's pioneering article "The Emergence of a Visual Language for Geological Science, 1760–1840," *History of Science* 14 (1976): 149–95. I would also like to thank him for his perceptive comments on the research for this paper. The theoretical conclusions for which I argue here are obviously not convincingly established by one case study alone. For a broader contextual analysis, see my monograph *Science and the Perception of Nature: British Landscape Art in the Late Eighteenth and Early Nineteenth Centuries* (New Haven: Yale University Press, 1996). This article is a modified version of chap. 3.

5 For a brief discussion of Staffa in the eighteenth century, see Geoffrey Grigson, "Fingal's Cave," *Architectural Review* 104 (1948): 51–54.

6 Martin Martin, *A Description of the Western Islands of Scotland* (London, 1703).

7 Hugh S. Torrens, "Patronage and Problems: Banks and the Earth Sciences," in R. E. R. Banks et al., eds., *Sir Joseph Banks: A Global Perspective* (Kew: Royal Botanic Gardens, 1974), 52.

8 Thomas Pennant, *A Tour in Scotland, And Voyage to the Hebrides* (London, 1776), 2:299–309.

9 Banks published a short notice of his 1772 journey in the *Scots Magazine* 34 (1772): 637 and the *Gentleman's Magazine* 42 (1772): 540, declaring the sights of Staffa to be the "greatest natural curiosities in the world." The journal of his voyage is reprinted in Roy A. Rauschenberg, "The Journals of Joseph Banks's Voyage up Great Britain's West Coast to Iceland and to the Orkney Isles, July to October 1772," *Proceedings of the American Philosophical Society* 117 (1973): 186–226.

10 William Daniell, *Interesting Selections from Animated Nature with Illustrative Scenery*, 2 vols. (London [1812?]) n. p. The publication date of this book is not entirely clear. Judging by the dates on the plates, Daniell must have finished it around 1812.

11 William Daniell, *Interesting Selections*, vol. 1. This plate is one among five displaying bizarre earth formations. These plates had already appeared in William Wood's *Zoography: Or the Beauties of Nature Displayed*, 3 vols. (London, 1807). Wood employed Daniell for the design and execution of the plates in this work after the latter had established his reputation with paintings and drawings of India, which he visited with

his uncle Thomas Daniell between 1784 and 1794. William Daniell became an Associate of the Royal Academy in 1807 (and a full R.A. in 1822, being elected in preference to Constable). Since Daniell states in the preface to *Interesting Selections* that Wood's *Zoography* had appeared in the previous year, it can be inferred that he started his own project in 1808. The second volume consists almost entirely of engravings printed in 1809. All of these refer to subjects in Wood's publication and could well have been drawn for it but then not published. It seems that Daniell prepared a final eleven plates for his own edition in 1812 in order to make 120. the subjects for these plates are all taken from reference books noted by Wood. Barbara M. Stafford in "Rude Sublime: The Taste for Nature's Colossi During the Late Eighteenth and Early Nineteenth Centuries," *Gazette des Beaux-Arts* 1287 (1976): 113–26, discusses the non-distinction between artifacts and natural phenomena in pictorial material during the second half of the eighteenth century and uses three plates from *Interesting Selections* as examples (119–20). In her later *Voyage into Substance: Art, Science, Nature, and the Illustrated Travel Account, 1760–1840* (Cambridge: MIT Press, 1984) Stafford concentrates mainly on Daniell's earlier enterprise, the *Oriental Sceneries*, but nevertheless includes four plates of his *Interesting Selections* (71, 72, 76, 343). (In her article Stafford mistakenly states that the book was published in 1807, and in *Voyage into Substance* she also wrongly names Thomas Daniell as responsible for the publication.)

12 William Daniell, *Interesting Selections*, vol. 1.

13 William Daniell, *A Voyage round Great Britain*, 8 vols. (London, 1814–25). Richard Ayton provided the text for vols. 1 and 2, while from vol. 3 onwards, Daniell carried out the project on his own. A brief attempt to throw light on Daniell's publication contract has been undertaken by Iain Bain, *William Daniell's A Voyage round Great Britain, 1814–1825: a note on its production & the subsequent history of the aquatint plates now owned by Nattali & Maurice* (London: Bodley Head, 1966). See also Thomas Sutton, *The Daniells: Artists and Travellers* (London: Bodley Head, 1954); Sarah T. Prideaux, *Aquatint Engravings: A Chapter in the History of Book Illustration* (London: Duckworth, 1909); Martin Hardie and Muriel Clayton "Thomas Daniell, R.A., William Daniell, R.A.," *Walker's Quarterly* 35–6 (1932): 1–106.

14 Daniell, *Voyage round Great Britain*, 3:35–48. In the same year Daniell also published the set of nine Staffa views separately in a folio edition called *Illustrations of the Island of Staffa in a Series of Views: Accompanied by Topographical and Geological Description* (London, 1818).

15 Daniell, *Voyage round Great Britain*, 3:35–36.

16 But Daniell is mistaken in his assumption that Griffiths designed the plates in Pennant's section on Staffa. This section was taken from Banks and the depictions executed by Banks's own draughtsman.

17 Daniell, *Voyage round Great Britain*, 3:37.

18 On the foundation and development of the Geological Society of London, see Martin J. S. Rudwick, "The Foundation of the Geological Society of London: Its Scheme for Co-operative Research and its Struggle for Independence," *The British Journal for the History of Science* 1 (1963): 325–55; Paul J. Weindling, "Geological Controversy and its Historiography," in Ludmilla J. Jordanova and Roy S. Porter, eds., *Images of the Earth: Essays in the History of the Environmental Sciences* (Chalfont St. Giles: British Society for the History of Science, 1979), 248–71; Martin J. S. Rudwick, *The Great Devonian Controversy: The Shaping of Scientific Knowledge among Gentlemanly Specialists* (Chicago: University of Chicago Press, 1985), 18–27.

19 His long-standing work for the Ordnance Survey in Scotland did not pass without severe disputes. He was accused of submitting enormous bills and subsequently was

described as "a blackguard, a thief and 'the last high priest of a supplanted religion'" — Archibald Geikie, quoted after David A. Cumming, "John MacCulloch, Blackguard, Thief and High Priest, Reassessed," in Alwyne Wheeler and James H. Price, eds., *From Linnaeus to Darwin: Commentaries on the History of Biology and Geology. Papers from the Fifth Easter Meeting of the Society for the History of Natural History, 28–31 March* (London: The Society for the History of Natural History, 1985), 77. However, Cumming argues that the epithets were unjustified: "He was one of the earliest truly professional geologists in Britain…MacCulloch's Scottish surveys extended rather than plagiarised existing work, but brought on him the wrath of a jealous rival [Robert Jameson, a former friend]" (85).

20 John MacCulloch, "On Staffa," *Transactions of the Geological Society of London* 2 (1814): 501–9.

21 Daniell, *Voyage round Great Britain*, 3:37.

22 Pennant, *Tour in Scotland*, 2:300–1.

23 Ibid., 2:facing 299.

24 The original sketches executed on Banks's voyage to the Hebrides, Orkneys, and Iceland in 1772 and the preparatory copies for the engravings in Pennant's publication were left by Banks to the British Museum (BL, Add. 15509–12). The drawings and colored fair copies of Staffa are in the second volume (Add. 15510, nos. 20–43). Among them are drawings copied from the originals in 1774 by an artist whose name I was unable to decipher (Ruotta?).

25 Strikingly, the sketch in the British Library (Add. 15510, no. 40) does not display this regularity, nor does it show any accompanying figures, except for a single boat deep inside the cave.

26 This date becomes apparent from Banks's correspondence in which Faujas de Saint-Fond is mentioned a few times, particularly in the year 1784 with reference to his trip to Staffa — *The Banks Letters: A Calendar of the Manuscript Correspondence*, Warren R. Dawson, ed. (London: British Museum, 1958), 64–65, 276.

27 Barthélemie Faujas de Saint-Fond, *Voyage en Angleterre, en Ecosse, et aux Iles Hébrides*, 2 vols. (Paris, 1797). An English translation (*Travel in England; Scotland, And the Hebrides*, 2 vols.) appeared in London in 1799.

28 *Banks Letters*, 321. Faujas de Saint-Fond (*Voyage en Angleterre*, vol. 1) describes calling on Banks in London before he set off for Scotland.

29 He continues: "mais il n'y a absolument que des colonnes" (Faujas de Saint-Fond, *Voyage en Angleterre*, 2:55n). However, it transpires from Banks's correspondence that Faujas might not even have seen Staffa himself. On 21 October 1784 James Dryander wrote to Banks: "Faujas has not been to Staffa; when he came to the place of crossing to Mull he considered it dangerous and stayed on the mainland" (*Banks Letters*, 276). Five days later, Sir Charles Blagden tells Banks that "the conduct of Faujas de St. Fond on his Scottish tour will not easily be forgotten and he can never show his face again" (*Banks Letters*, 65). Later, Richard Kirwan writes that he treats Faujas "with contempt for his unfaithfulness" (*Banks Letters*, 493).

30 Thomas Garnett, *Observations on a Tour through the Highlands and Part of the Western Isles of Scotland, particularly Staffa and Icolmkill*, 2 vols. (London, 1800). The three plates of Staffa appeared in vol. 1, facing 219, 221, 224.

31 Louis A. Necker de Saussure, *Voyage en Ecosse et aux Iles Hébrides*, 3 vols. (Geneva, 1821). I consulted the second edition of the translation which appeared in London in 1822 (the first, in 1821, was without plates): *A Voyage to the Hebrides or Western Isles of Scotland*. Necker de Saussure traveled to the Western Isles in 1806, 1807, and 1808 and subsequently presented the first geological map of Scotland to the Geological Society

of London. His book was not published until 1821, by which time he was professor at Geneva and only occasionally returned to Scotland for further research.

32 Pennant, *Tour in Scotland*, 2:306.

33 William Hamilton, "An Account of the Late Eruption of Mount Vesuvius," *Philosophical Transactions of the Royal Society of London* 85 (1795): 73–116 (Tab. 5-11). Hamilton first published his extensive observations in the form of letters in the *Philosophical Transactions of the Royal Society* and subsequently as a book in English and French in Naples in 1776 — *Campi Phlegraei. Observations on the Volcanos of the Two Sicilies*, 2 vols. — later adding a supplement with plates in 1779. All three parts are bound in one volume in the copy in the Bodleian Library, Oxford (a second copy does not contain the supplement).

34 Robert Jameson, *A Mineralogy of the Scottish Isles*, 2 vols. (Edinburgh, 1800).

35 Daniell, *Interesting Selections*, vol. 1.

36 Ibid.

37 See Roy Porter, *The Making of Geology: Earth Science in Britain, 1660–1815* (Cambridge: Cambridge University Press, 1977).

38 Archibald Geikie, *The Scottish School of Geology* (Edinburgh, 1871), 21.

39 Rachel Laudan, *From Mineralogy to Geology: The Foundations of a Science, 1650–1830* (Chicago: University of Chicago Press, 1987), 108.

40 John Playfair, *Illustrations of the Huttonian Theory of the Earth* (Edinburgh, 1802).

41 James Hutton, "Theory of the Earth: Or an Investigation of the Laws Observable in the Composition, Dissolution, and Restoration of Land upon the Globe," *Transactions of the Royal Society of Edinburgh* 1 (1788): 209–304.

42 James Hutton, *Theory of the Earth with Proofs and Illustrations*, 2 vols. (Edinburgh, 1795). Geikie published a third volume in 1899 which was made up of Hutton's unpublished notes.

43 Stephen J. Gould, *Time's Arrow, Time's Cycle: Myth and Metaphor in the Discovery of Geological Time* (Harmondsworth: Penguin, 1988), 61. Gould notes that "Lyell admitted that he had never managed to read it all. Even Kirwan, Hutton's dogged, almost frantic critic…never read all of both volumes — for many pages of his personal copy are uncut" (93).

44 Hutton himself talks of "junction." Thus he writes that "at Siccar point we found a beautiful picture of junction marked bare by sea" (*Theory of the Earth*, 1:458).

45 Hutton, "Theory of the Earth," 304.

46 Ibid.

47 Porter, *Making of Geology*, 196. For Kirwan and de Luc, see Richard Kirwan, *Geological Essays* (London, 1799) and Jean André de Luc, *Letters on the Physical History of the Earth* (London, 1831).

48 Kirwan, *Geological Essays*, 483.

49 Porter, *Making of Geology*, 205.

50 *Transactions of the Geological Society of London* 1 (1811): viii-ix.

51 Ibid., v.

52 Weindling, "Geological Controversy and its Historiography."

53 Paul J. Weindling, "The British Mineralogical Society: A Case Study in Science and Social Improvement," in Ian Inkster and Jack Morrell, eds., *Metropolis and Province: Science in British Culture, 1780–1850* (London: Hutchinson, 1983), 120–50.

54 Richard Yeo, "Idol of the Market-Place," 284.

55 *Annual Report of the Meeting of the Council and Museum Committee of the Geological Society*, 1815. A copy is among the George Bellas Greenough Papers and Correspondence, held in the Manuscript Room, University College Library, London (classmark

5/2, p. 17).

56 James A. Secord, *Controversy in Victorian Geology: The Cambrian-Silurian Dispute* (Princeton: Princeton University Press, 1986), 20.

57 James Fittler, *Scotia Depicta* (London, 1804). Nattes went to Scotland independently of Fittler in 1799, as the text to the plate makes clear, and showed a picture of Staffa in the Royal Academy in 1803.

58 In fact, Ozias Humphry refers to Nattes's picture of Fingal's Cave at the Royal Academy exhibition in just such terms. He wrote to a friend from Edinburgh that this picture gives a particularly good impression of the Cave of Fingal, which according to him ranks among the wonders of the world. I owe this reference to John Brewer, who quoted it for me from a letter (G. Aust to O.H., 18 September 1804, Edinburgh) in the Ozias Humphry Correspondence in the Royal Academy (HU/1/6).

59 John MacCulloch, *A Description of the Western Isles of Scotland*, 3 vols. (Edinburgh, 1819). The third volume contains mainly depictions of sections and maps, but also eight landscape engravings, of which two are depictions of Staffa which did not appear in his previously published paper in the *Transactions of the Geological Society*.

60 MacCulloch himself states that he regrets not having illustrated it "by engravings as finished and as numerous as it merits" (*Description of the Western Isles*, 2:1).

61 MacCulloch, *Description of the Western Isles*, 2:10.

62 MacCulloch, "On Staffa", 501.

63 MacCulloch, *Description of the Western Isles*, 2:11.

64 MacCulloch, "On Staffa", 508.

65 Ibid., 509.

66 MacCulloch, *Description of the Western Isles*, 2:15.

67 The discrepancy between this painting and the topography of Staffa led John Gage — "The Distinctness of Turner," *Journal of the Royal Society for the Encouragement of Arts* 123 (1975): 448 — to suggest that the painting was not of the cave but of the opposite side of the island. However, as John Gage has pointed out to me, cleaning has now shown that Turner did indeed depict the cave with the sun setting in the west and so it must be concluded that Turner rearranged the topography for pictorial purposes.

68 Quoted in Martin Butlin and Evelyn Joll, *The Paintings of J. M. W. Turner*, rev. ed. (New Haven: Yale University Press, 1984), 1:198.

69 Walter Scott, *The Complete Poetical Works of Sir Walter Scott*, vol. 10 (Edinburgh, 1834).

70 This viewpoint had, however, some tradition: Thomas Garnett (*Observations on a Tour*, frontispiece), William Daniell (*Voyage Round Great Britain*, 3:facing 40), and Louis A. Necker de Saussure (*Voyage to the Hebrides*, frontispiece) had chosen it before Turner.

71 John Gage, "Distinctness of Turner," 449.

72 Butlin and Joll, *Paintings of J. M. W. Turner*, 1:199.

73 This dynamic understanding of nature seems to have become established as the conventional mode of representing Staffa by the time that Anthony van Dyke Copley Fielding prepared a series of drawings of it. These were produced between 1845 and 1853 and so fall outside the period I am considering. I mention them here because they exhibit the same concern for atmospheric appearance while at the same time trying to capture the material and structural formation in as detailed a manner as possible.

74 There is, of course, a difference in purpose behind an oil painting such as Turner's, exhibited at the Royal Academy, and topographical drawings such as Daniell's, produced to be reproduced for the mass market. A landscape painting at the Royal Academy would always demand a more obviously interpretative view. In Turner's case,

however, the comparison of an oil painting with book illustrations is justified, I think, because he himself contributed substantially to topographical publications, such as Walter Scott's *The Provincial Antiquities and Picturesque Scenery of Scotland, with Descriptive Illustrations*, 2 vols. (London, 1826), and this work does not differ in conception from his oil painting. Turner's concentration on the depiction of atmospheric forces in both media indicates a view of nature made up of constantly changing but interlinked appearances.

75 David Philip Miller, "Method and the 'Micropolitics' of Science: The Early Years of the Geological and Astronomical Societies of London," in John A. Schuster and Richard Yeo, eds., *The Politics and Rhetoric of Scientific Method* (Dordrecht: Reidel, 1986), 227–57.

76 Webster's account of the Isle of Wight appeared first in Henry C. Englefield, *A Description of the Principal Picturesque Beauties, Antiquities, and Geological Phenomena of the Isle of Wight* (London, 1816), 217.

77 W. D. Conybeare and William Phillips, *Outlines of the Geology of England and Wales* (London, 1822), xvi.

78 Charles Lyell, *Principles of Geology: Being an Attempt to Explain the Former Changes of the Earth's Surface by Reference to Causes Now in Operation*, 3 vols. (London, 1830–33).

79 Richard Yeo, "Idol of the Market-Place," 267.

80 John MacCulloch, *A System of Geology, with a Theory of the Earth* (London, 1831).

81 John MacCulloch, *Proofs and Illustrations of the Attributes of God, From the Facts and Laws of the Physical Universe: Being the Foundation of Natural and Revealed Religion*, 3 vols. (London, 1837). It was published posthumously.

82 His publication of 1831 brought MacCulloch the accusation that he was a defender of outmoded techniques, particularly so since he refused to accept the evidence of stratigraphical paleontology, as expounded by Cuvier, which became the major preoccupation of geology in the following decades (Cumming, "John MacCulloch, Blackguard, Thief and High Priest, Reassessed," 83).

Dido versus the Pirates: Turner's Carthaginian Paintings and the Sublimation of Colonial Desire

Kay Dian Kriz

AMONG THE MOST artistically ambitious and critically successful of J. M. W. Turner's poetic landscapes of the early decades of the nineteenth century were his three paintings of ancient Carthage—*Dido and Aeneas* (1814, fig. 84), *Dido Building Carthage* (1815, fig. 85), and *The Decline of the Carthaginian Empire* (1817, fig. 86).[1] These works have continued to generate critical interest among Turner scholars, who have variously sought to identify their textual sources and visual antecedents and have considered them as part of the artist's protracted dialogue with the art of Claude Lorrain.[2] It has also been argued that these portrayals of the doomed capital of an extensive maritime empire were intended by Turner as a warning about the possible fate of the British Empire. Clearly it seems far from accidental that in the early teens, when *Dido and Aeneas* and *Dido Building Carthage* were produced, Britain was at war with Napoleonic France, which openly styled itself after ancient Rome, the chief rival of Carthage. However, since Napoleon himself was frequently compared to the famed Carthaginian general Hannibal, as in Jacques-Louis David's *Napoleon Crossing the Alps* (1800, National Museum, Versailles), other scholars have alternatively argued that Turner's ancient Carthaginian Empire should in fact be seen as the antecedent of modern France, or perhaps as imaging the inevitable downfall of all empires, ancient and modern.[3] While these various accounts have contributed enormously to our understanding of Turner's pictures, none have seriously addressed the implications of their geographical setting. Despite the fact that these landscapes are set in North Africa, scholars have yet to ascertain whether the ancient site of Carthage was ever considered by the artist and his public in relation to their African contemporaries who were living among Tunisia's ruins and occupying its cities, deserts, coasts, and mountains. This essay sets out not simply to rectify this omission by examining these works within the context of European and British relations with North Africa. In addition, and perhaps more importantly, it seeks to reflect on the ways certain discourses on art function as ideologically conservative forces by discouraging the making of crucial connections between high art, print culture, and politics.

My primary interest in these works is their visual rhetoric. By the time they were exhibited Turner was famous for producing atmospheric effects which appeared both natural and magical: his veiling of forms via richly worked layers of paint appeared to transform matter into air in an act of painterly transubstantiation.[4] What happens, then, when this magic is worked on a non-Western site?

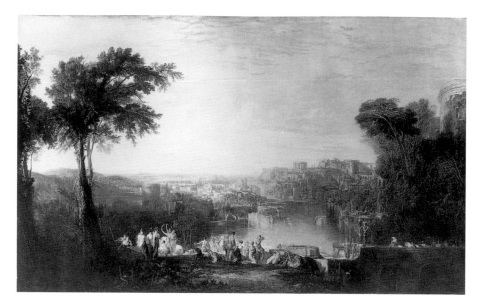

84. J. M. W. Turner, *Dido and Aeneas*, 1814, oil on canvas, 146 x 237 cm. The Turner Collection, Tate Gallery, London.

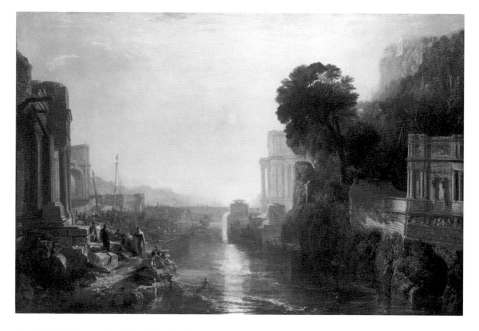

85. J. M. W. Turner, *Dido Building Carthage*, 1815, oil on canvas, 155.5 x 232 cm. Courtesy of the Trustees, The National Gallery, London.

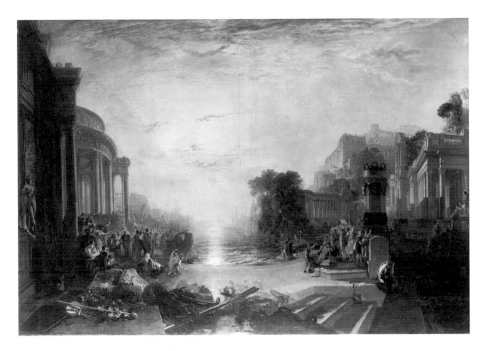

86. J. M. W. Turner, *The Decline of the Carthaginian Empire*, 1817, oil on canvas, 170 x 238.5 cm. The Turner Collection, Tate Gallery, London.

Analyzing this visual rhetoric in concert with other visual and textual representations of North Africa will provide a means of discerning how Turner made North Africa appear as a locale with qualities which would make it ripe for penetration by the imperial powers of Britain and Western Europe. The use of sexually charged language is here intentional, for a central dynamic of this process of visualization is the feminization of the non-European landscape and its mastery by the male gaze of the Western artist and viewer.

Let us begin by examining a review of Turner's *Dido and Aeneas*, which was displayed in 1814 at the annual exhibition of the Royal Academy. The work takes its subject from the fourth book of the *Aeneid*, where Queen Dido and the Carthaginian court have left the city at dawn in order to entertain the visiting Aeneas with hunting, feasting, and other noble amusements. The catalogue entry for the work included those particular lines from Book Four of Dryden's translation which provide a poetic description of the scene:

> The rosy morn was risen from the main;
> And horns and hounds awake the princely train;
> They issue early through the city gate,
> Where the more wakeful huntsmen ready wait,
> With nets, and toils, and darts, beside the force
> Of Spartan dogs, and swift Massylian horse.

A critic of a London newspaper, *The Champion*, invokes this passage in pointing out the discrepancy between Turner's view, with its lush vegetation, and the arid climate of the North African coast. He observes that, "Mr Turner may not have faithfully depicted the character of African scenery: he probably was not very anxious to do this." Instead the artist "has realized all that the most luxurious fancy would imagine." According to the critic, the artist's rejection of topographical accuracy in favor of an all-encompassing fantasy derives from his reading of the passage from Book Four, supposing "it to distain (sic) a reference to any particular quarter of the world."[5] From such a statement one might infer that after the Romans razed the North African site of Carthage in 146 BC, the city was shorn of its geographical moorings and reconstituted first by Virgil and later by Turner as a fantastic space for indulging the pleasures of the Western imagination. It would be a mistake, however, to dismiss too quickly the importance of the geography and history of North Africa in analyzing Turner's imaginative landscape. For it was precisely the ability of the ancient city to signify a multiplicity of times, histories, and spaces which made it such a fascinating subject for Turner and his British public.

The geographical site occupied by ancient Carthage and its North African neighbors bears many of the characteristics of what Michel Foucault has termed a heterotopia: a physical site in which diverse, discontinuous, and ambiguous slices of time and space can be accommodated.[6] The fact that North Africa was (and still is) frequently regarded as "Eastern" testifies to its status as such a heterotopia. Africa's primary cartographic orientation with regard to Britain, is south, not east. For Turner and his contemporaries North Africa's Eastern character derived not from its geography or its indigenous population, but from its subjugation by Eastern empires: Carthage was founded by the Phoenicians, who were from modern day Lebanon; centuries later North Africa came under the domination of the Arabs and then the Turks. Although Morocco, Tunisia, Libya, and Algeria are now independent nation states, they maintain this "Eastern" character within Western cultural consciousness.[7]

Multiple forms of representation are central to the production of ambiguous or incongruent heterotopic spaces. North Africa was pictured and described verbally by Europeans in ways that were extremely diverse. Despite, in fact because of, this diversity these images could and did function in concert to maintain a stance of Western superiority over the modern inhabitants of this region.

We have already observed that Turner's *Dido and Aeneas* could conjure up the geography of Africa in a fashion which allowed it to be perceived as a fantasy space of no discernible locality. The indeterminacy of Turner's image was also registered by William Hazlitt, who, in his review of it for the *Morning Chronicle*, noted that it defied those categories which traditionally constituted the genre of landscape painting: "This picture," he remarked, "powerful and wonderful as it is, has all the characteristic splendour and confusion of an eastern composition.

87. Claude Lorrain, *View of Carthage with Dido and Aeneas*, 1676, oil on canvas, 120 x 149.2 cm. Hamburger Kunsthalle, Hamburg, photo: Elke Walford.

It is not natural nor classical."[8] While the terms "natural" and "classical" were subject to various and sometimes conflicting interpretations within artistic discourse, in this context Hazlitt was clearly referring to the traditional division of the landscape genre into two categories: the "natural" referring to depictions of common nature broadly based upon seventeenth-century Dutch and Flemish models; and the "classical," denoting the imaginative rendering of an idealized nature based on seventeenth century Franco-Italianate models such as Poussin and Claude.[9] Different truth claims were associated with these two major categories. Universal and abstract truths were the province of the ideal, while empirical truth was associated with the natural.[10] It was via the application of these two modes of composing a landscape that external nature was rendered a fit subject for high art.

Although the surface of the picture has suffered a certain amount of deterioration over the years, we can still, I think, surmise why Hazlitt felt such discomfort with it. For the artist displays bodies and buildings in a very different way than, for example, Claude does in his *View of Carthage with Dido and Aeneas* (fig. 87) of 1676. Claude represents a geography which places human figures and buildings in spaces ordered by the laws of one-point perspective. This spatial ordering can be clearly seen in the stately procession of the classical structures on

the right along an orthogonal leading to the central vanishing point at the harbor's mouth. The figures are arranged according to the academic notion of "ordonnance"—that is, they are placed in groups which allow the viewer to assess their relative importance in the composition and in the narrative.[11]

Turner, on the other hand, displays both bodies and buildings in a bisque-colored jumble which works against easy legibility. Indeed, we must search the foreground carefully in order to discover the diminutive figures of the Queen and Aeneas, who are set against the parapet to the right of center. In the valley below them, stretching into a seemingly limitless distance, is the city—an urban vista Turner renders as a chaotic array of towers, bridges, houses, and temples.[12] The subtle gradations of light pigment worked into areas of bituminous browns and purples serve to dematerialize the fabric of the city and render it consubstantial with its gold-tinged lagoon and the atmosphere that surrounds it.

It is noteworthy that Hazlitt describes this amorphous and sumptuous composition not simply as unclassical, but as "eastern"—an identification which presumes that those forms of reason and intellection necessary to the orderly representation of nature are identified with the Western gaze. Given that the subject matter is also "eastern," one might argue that the artist succeeded in establishing a fitting congruence between an Eastern subject and Eastern modes of composition, but Hazlitt's qualified praise clearly refuses that option. Underpinning his use of the categories natural, classical, and Eastern is the assumption that for the Western observer to maintain cultural superiority over non-Western cultures, he must demonstrate his mastery of empirical and classical knowledge.

Hazlitt's reservations about the Eastern confusion of Turner's image were not shared by other critics. For example, Robert Hunt, writing in the *Examiner*, praised the imaginative effect of the picture, produced by the "splendid variety of Nature's colour, qualified by that agreeable unity which arises from one or two predominating hues."[13] For this critic *Dido and Aeneas* is a highly poetic image which combines natural effects of light and atmosphere with the "classical" harmony of an idealized panorama.[14] What unites these conflicting critical judgments of Turner's landscape is an emphasis on the value of empirical knowledge and on the power of the poetic imagination formed by a long engagement with classical art and literature. Hazlitt's remarks suggest that it becomes especially crucial to demonstrate mastery of these forms of knowledge when the Western gaze turns its attention to non-Western cultures.

This attention on the part of ruling elites in Britain, America, and France was particularly marked during the years between 1800 and 1817, when Turner produced these three works. Napoleon's invasion and occupation of Egypt in 1798 provide the most obvious instances of European involvement, which also included other military incursions into North Africa designed to protect, maintain, and expand the free flow of European commerce in the Mediterranean during and immediately after the French Wars.[15] Such military and economic

interest in North Africa manifested itself in a plethora of visual representations. Prints comprised the bulk of this visual material, and by far the most significant body of prints were French illustrations of Egypt published during and after the Napoleonic invasion and occupation of that nation.

It is fair to ask what relevance French prints of Egypt have to British paintings of ancient Carthage. Most obviously, Napoleon's Egyptian campaign and Lord Nelson's defeat of French forces in the Battle of the Nile in 1798 were events which generated intense interest about Egypt in Britain.[16] While the reception of French imagery and written accounts of Egypt would be markedly different in Britain and France, both nations maintained a keen investment and interest in representations of Egypt and its neighbors well after Napoleon's forces left the region. When considering Turner's Carthaginian landscapes, British art-historical discourse has traditionally limited the range of visual and textual materials it admits to classical and eighteenth-century accounts of Carthage and to paintings and sketches by established artistic masters such as Claude. However, Turner's public had access to a much broader, less homogeneous range of material. The literate public who read French publications on Egypt, travel literature about North Africa, and political reports of British military engagements in the region was coextensive with the polite public that attended Royal Academy exhibitions and read about the arts in the London press.[17] Thus it is important not to separate poetic landscape painting from texts and imagery which employ different codes and mobilize different forms of pleasure and knowledge to represent the Other. For, as Edward Said has argued, it is via the production and circulation of diverse forms of writing and imagery concerned with the Orient that European notions about the non-European Other are constructed, debated, and re-evaluated.[18] It is also worth recalling that Egypt and the so-called Barbary States of Tunisia, Tripoli, Algeria, and Morocco were part of the Ottoman Empire in the early 1800s. Although Morocco, Tunisia, and Algeria have often been seen as geographically and historically distinct from the eastern regions of Libya and Egypt, this view has recently been contested by Magali Morsy, who argues that North Africa should be considered as a regional entity bound by a shared history and religion as well as political and economic structures.[19]

Throughout the eighteenth and early nineteenth centuries the past glories of both Egypt and Carthage were repeatedly extolled in Western writings in order to emphasize the political oppression and cultural decline of their respective contemporary societies.[20] This state of "decline" was then offered as primary evidence of the need for Western economic, military, and political intervention throughout the region.[21] In visual culture Western interest in the region was realized most exhaustively in the vast quantity of illustrations (over three thousand) which were engraved for the *Description de l'Egypte*.[22] This twenty-one-volume work was produced by a technical team of engineers, architects, artists, and surveyors who followed Napoleon on his Egyptian campaign of 1798. The first five

88. after Edmé Jomard, "Heptanomide,"
copperplate engraving, plate 63, from the
Description de l'Egypte, Antiquities, vol. 4,
1817, Brown University Library,
photo: Brooke Hammerle.

volumes of engravings were devoted to ancient Egypt, the next two to modern Egypt, followed by three more volumes illustrating the natural history of the country. In a plate from Volume IV (fig. 88) showing antiquities from Middle Egypt, we can see how an assemblage of different types of images makes visible the various "scientific" procedures conducted on these historic sites. The landscape was viewed panoramically, evidenced by the topographical view in the upper central register; its ancient cities imaginatively reconstructed and mapped, displayed in the aerial view of Tel Amarna at the bottom; its artifacts were collected and their shapes recorded, shown in the schematic outlines of clay vessels; and its antiquities excavated, measured, and catalogued, seen in the elevations and plans of the pylon gateway. This plate does more than represent ancient Egypt to the Western viewer; it also displays the varied technologies employed by the Western male gaze in mastering objects of knowledge which are differentially gendered as feminine. For within eighteenth- and early-nineteenth-century epistemological discourses, the mental and emotional faculties that were understood to be needed for "disinterested" observation, dissection, and abstraction were

attributed to Western-educated men.[23] Women, working-class men, and non-Westerners were deemed capable of engaging with the local and the particular, rather than the abstract and the general.[24] But this ability to engage with the detailed particularities of their local environment was based upon their personal involvement in that environment; they were not seen to possess the distance or rationality necessary for the role of disinterested observer. The same assumptions held true for entire cultures. Thus Thomas Shaw, whose 1738 account of the Barbary States remained the definitive study of the region for nearly a century, complained that modern educators in Tunisia and Algeria betrayed no interest in ancient (Roman) history, preferring instead "some tiresome *Memoirs* of the transactions of their own Times: for such Branches of History as are older than their Prophet, are a Medley only of Romance and confusion."[25] Shaw's remarks presume a division between Western history as a disinterested, universalist, and rationally ordered pursuit and a narrow and confused vision of history skewed by religious interests.

With regard to the *Description*, its rationalized collection and ordering of empirical data, in the form of both texts and images, registered the action of a gaze which was not only male and Western, but specifically French. For to subject a culture, in this case Egypt, to such a high level of scrutiny requires open access not only to the actual sites, individuals, and monuments examined, but also to the network of local political and social institutions which are required to facilitate such a large and elaborate group undertaking. The *Description*, then, is a testimony both to intimate knowledge of the Other and the disinterested gaze — to a capacity for penetration and distance made possible by the particular relationship of domination France (briefly) enjoyed with Egypt which was distinct from that of Britain.[26]

Even though Turner as a British artist did not have this kind of physical access to Egypt or other North African sites, his mode of representing Carthage registers a way of "knowing" North Africa — through classical history and the classicizing pictorial tradition of Claude — that accorded well with the educational interests and leisure pursuits of a landed elite which still maintained a large degree of political, economic, and cultural authority at this time.[27]

This form of "penetration" is visualized not through an ordered display of artifacts upon a planar field like scientific specimens, but through movement deep into illusionistic space — seen most strikingly, perhaps, in Turner's *Dido Building Carthage*.[28] The viewer's gaze is forcefully drawn into the center of the scene via the brilliant reflection of the sun on the lagoon. The expanse of translucent water which frames the lower edge of the canvas narrows dramatically in its progress toward the bridge in the middle distance, drawing the spectator's eye through the city and toward the glowing horizon. The degree to which this composition "absorbs" the viewer can be judged by comparing it to the work which Turner originally wished to hang beside it in the national collection, Claude's

89. Claude Lorrain, *Seaport: The Embarkation of the Queen of Sheba*, 1648, oil on canvas, 148.6 x 193.7 cm. Courtesy of the Trustees, The National Gallery, London.

Seaport: the Embarkation of the Queen of Sheba (fig. 89).[29] The basic structure of the two pictures is quite similar — each scene is framed by classical buildings which are disposed around a central waterway leading to the sun glowing at the horizon. But in the Claude the pace of the visual movement to the horizon is not as rapid as in the Turner: the viewer's gaze must first pass over the shore of the lagoon in the foreground where men are unloading a boat, then move through the broad expanse of the water, which is far less compressed than in the Turner, and engage the prominently placed ship and tower in the middle ground before reaching the radiance at the horizon. While the gaze is permitted to "wander" toward the horizon in the Claude with its incidental details, in Turner's view it is aggressively pulled toward the bridge in the distance, where the viewer is invited to fantasize about the wonders of the city that are obscured by the brilliant sunlight.

It is false to assume, however, that British artists and their polite public preferred to encounter Eastern geographies only via classical representations. For the lavish and expensive *Description* found many buyers in Britain; and even more popular was the less scholarly, more anecdotal account of Egyptian life and culture by Dominique Vivant Denon, who was a leading member of Napoleon's scientific entourage. His *Voyage dans la Basse et la Haute Egypte*, published in

90. after Dominique Vivant Denon, engraving, plate III from *Voyage dans la Basse et la Haute Egypte pendant les Campagnes du Générale Bonaparte*, vol. 2 (Institut Français d'Archéologie Orientale, Cairo, 1989; orig. pub. 1802). Brown University Library, photo: Brooke Hammerle.

Paris and London in 1802, is profusely illustrated with engravings based upon his own drawings.[30] The illustrations include portraits of contemporary Egyptians, views of antiquities, and drawings of the local flora and fauna, often combined on the same page. Plate III (fig. 90) displays a locust, below it a blind beggar led by a child, and below that heads of beggars. Their placement on the same page and the similarity in the size of the three vignettes invite the viewer to make comparisons between an insect and human types which represented "problems" indigenous to contemporary Egyptian society. Through the use of these sorts of juxtapositionings, what both the *Description* and the *Voyage* make clear is that this accumulation of "scientific" information about Egypt is not simply a disinterested quest for knowledge, but part of a highly interested colonial enterprise, which is driven by the desire for political and economic power as well as scientific mastery of a foreign culture.[31]

Despite the fact that a state of war existed between Britain and France almost continuously from 1793 until 1815, there was a consensus among the Western powers that either nation had a natural right to rule such "uncivilized" territory. Thus a British reviewer of Vivant Denon's *Voyage* rejoiced that France had taken possession of Egypt. He justified this position by invoking the harrowing travel experiences of Europeans in that nation:

Côte d'Afrique et vue du Marabou et d'Alexandrie.

91. after Dominique Vivant Denon, " African Coast and View of Marabou and Alexandria," engraving, plate 6 from *Voyage dans la Basse et la Haute Egypte pendant les Campagnes du Générale Bonaparte*, vol. 2 (Institut Français d'Archéologie Orientale, Cairo, 1989; orig. pub. 1802). Brown University Library, photo: Brooke Hammerle.

> Since the origin of correct observation and minute inquiry in modern Europe, the political situation of Egypt has been such as to place all our travelers in circumstances of great disadvantage. Exposed to continual insult and suspicion on account of their religion and their curiosity, they have been obliged to pursue their researches amidst a nation of bigots and banditti, and to snatch a hasty and imperfect view of objects that require the most deliberate meditation.[32]

The absolute right of Europeans to subject non-Western cultures to extended observation and analysis is presented as a given here, and resistance to this penetrating gaze branded as suspicion and bigotry.

While both modern and ancient Egypt are made visible in these written and visual representations by French authors, the situation regarding Carthage is sig-

92. after Henry Parke, "View of Algiers from the Sea," colored aquatint from Filippo Pananti, *Narrative of a Residence in Algiers...* (London, 1818). Brown University Library, photo: Brooke Hammerle.

nificantly different. From the remaining evidence it appears that there were few topographical views of the area around Carthage and Tunis circulating in Britain between 1800 and 1820.[33] The relative sparseness of Tunisian ruins and the dangers of North African travel, in comparison to that in Egypt, Greece, or Rome, may account for this visual lacuna.[34] But, whatever the cause, the effect of this absence was to render a modern culture literally invisible — or rather, to render it accessible only through visual representations of its ancient and legendary past. What then, are we to juxtapose to Turner's *Dido Building Carthage*, its temples burnished by the glow of the sun bathing the lagoon? Vivant Denon's slight tracings of the North African coast, sketched as his ship made its way to Alexandria (fig. 91)? Or Henry Parke's awkward drawing of *Algiers from the Sea* (fig. 92) which appeared in Britain in 1818 as an aquatint in Filippo Pananti's travel account of Algeria? Obviously the crude and cursory nature of these drawings serves to highlight Turner's poetic mastery of landscape; but it also suggests that the actual subject matter of contemporary North Africa could not provide the type of "inspiration" which would motivate a recognized artistic "genius" like Turner.[35]

In fact, the most widely circulated "image" of the region was a written description published in 1811 by Thomas McGill. McGill was a merchant whose account of Tunisia was intended to persuade the British to upgrade their consulate and increase their trade with that nation at a moment when French influ-

93. after Conté, "Cairo: Perspective of the Exterior of Sultan Hasan's Mosque," copperplate engraving, plate 58, from the *Description de L'Egypte, Modern State*, vol. 1, 1809. Brown University Library, photo: Brooke Hammerle.

ence in the region was declining.[36] He declared that the architecture of Tunis was so mean and ugly as to be unworthy of description, but could not resist describing it: "The streets are narrow, dirty, and unpaved; the bazars are of the poorest appearance, and but indifferently stocked with merchandise. The inhabitants who crowd their miserable alleys present the very picture of poverty and oppression."[37] It is obvious here that the state of the urban fabric serves as a sign of the moral, economic and political condition of the people who dwell there. This way of coding architecture was a common trope in both written and visual representations, as evidenced quite clearly in a number of plates from the *Description de l'Egypte*.[38] For example, the oppression of the Turkish rulers of Egypt is rendered visible in a view of Sultan Hasan's mosque (fig. 93), its elaborate and perfectly maintained facade looming over the decayed houses below it. Similarly, in an engraving of the port of Alexandria (fig. 94), the moldering walls of the lighthouse on the right invite comparison with the French-held fort in the background and call up memories of the ancient Lighthouse of Alexandria, one of the Seven Wonders of the World.

And indeed the written descriptions of ancient Carthage which appeared in the spate of publications on North Africa produced between 1811 and 1820 served to emphasize the political, moral, and economic decline of this former flourishing republican empire into "oriental despotism." The point was made most tellingly in an article published in the *Quarterly Review* in 1816 that surveyed five

94. after Cécile, "Alexandria: View of the New Port," copperplate engraving, plate 85 from the *Description de L'Egypte*, *Modern State*, vol. 2, 1812. Brown University Library, photo: Brooke Hammerle.

recent books on North Africa. In a pacan to ancient Carthage the writer declares:

> In vain does the inquisitive traveller seek, in the neighbourhood of Tunis, for the triple wall with its lofty towers, whose capacious chambers contained stalls for three hundred elephants, and stables for four thousand horses with lodgings for a numerous army…a few remains of the public cisterns and the common sewers, are all that is left to point out where Carthage, with its 700,000 inhabitants, once stood. That commerce, which raised them to a pitch of wealth and glory unequalled in their day, is now dwindled to a few armed vessels and rowboats employed solely in rapine and plunder; and that manly republican freedom, which so successfully resisted every attempt at the establishment of tyranny, is now sunk into the lowest and most abject state of slavery.[39]

The decline of the North African Empire which radiated from Carthage is portrayed here in gendered terms which had political implications within contemporary colonial discourse. In this instance the writer invokes both the ancient destruction of Carthage by the Romans and the later domination of North Africa by the Ottoman Empire to explain the subsequent enslavement and feminization of the native population, and ultimately to rationalize certain forms of Western intervention.

If imperial decline was inscribed in these texts and prints through moldering architecture, it was encoded in Turner's paintings via other visual devices. His 1817 canvas, *The Decline of the Carthaginian Empire*, is a work which, as Kathleen

Nicholson astutely observes, pointedly avoids picturing the destruction of empire through the obvious device of ruined architecture.⁴⁰ Rather, decline is made visible through the rays of the setting sun, the cultural detritus strewn in the foreground, and through two tropes used in the previously quoted passage from the *Quarterly Review:* feminization and slavery. The full title of the work explains the action taking place: *The Decline of the Carthaginian Empire—Rome being determined on the overthrow of her hated rival, demanded from her such terms as might either force her into war or ruin her by compliance; the enervated Carthaginians, in their anxiety for Peace, consented to give up their arms and their children.*⁴¹ For a military power like Carthage to relinquish its arms is tantamount to being emasculated; similarly, to give up its children is to forfeit its capacity to wield power in the future. In the picture a lurid sunset plays over the classical architecture framing the harbor filled with Roman ships. The most highly emphasized figures in the well-populated scene are women. Through their positioning in the foreground and the play of light over their forms, the viewer's eye is drawn to the mother on the left clinging tightly to her child and the woman bent over with grief on the right. In the center is a nude male figure, whose lithe, feminized form is accentuated by his pose and contrasts sharply with the solid figures of the Roman soldiers on the left. These female and feminized bodies function as signs of the city's descent into slavery and its loss of "manly republican virtue," as the writer for the *Quarterly Review* would phrase it.

In the *Decline* slavery operates as a specific, but historically-distanced sign of the loss of national power, virtue, and honor, and also as a general metaphor for the transhistorical notion of imperial decline, universalized by virtue of its inscription within the visual and literary discourse of classicism. Much of the ideological power of classical discourse lies in its ability to evoke contemporary conflicts and private interests only to disavow their local and self-interested nature by cloaking them in ideal forms seen to represent universal values. For example, Benjamin West's classical landscape, *Cicero Discovering the Tomb of Archimedes* (R. A. 1797; purchased by the Dutch emigré banker Henry Hope) and David's pre-Revolutionary painting, *The Lictors Returning to Brutus the Bodies of His Sons* (Salon of 1787), mobilized classical forms, subjects, and motives in order to legitimate the specific ideological interests of very different constituencies in the name of an ideal of "Roman virtue" that was deemed to be universally esteemed and eternally valid.⁴² In a similar fashion the *Decline* can be seen to engage ongoing public debates about slavery and empire in its pictorial rendering of the loss of this classical ideal of virtue; but arrayed in the garb of classicism, the image appears to maintain a safe and dignified distance from the realm of contemporary politics.

In the early 1800s slavery was a highly volatile issue, spawning military conflicts and much heated political debate in Britain, France, and Africa. These debates in the early 1800s centered on the trade both in African and Western

Christian slaves. Although Britain abolished the trade in African slaves in 1807, debate on restricting international trade extended well into the nineteenth century. In 1814 at the conclusion of the Napoleonic Wars, abolitionists in Britain actively campaigned to prevent France from restoring the slave trade upon the return of its African colonies. Throughout negotiations of 1814–15 French West Indian planters attempted to discredit the abolitionists, charging that the British were motivated by commercial and imperial self-interest rather than humanitarian feelings. Abolitionists such as Bishop Wilberforce countered by asserting that French participation in the slave trade was yet another manifestation of Bonapartist tyranny.[43]

The visual rhetoric of Turner's *Decline of the Carthaginian Empire* takes up the discourse of slavery and race in a very different way from these sociopolitical debates. Turner depicts idealized figures unmarked by racial difference. In this way the ethnically diverse indigenous population of ancient Carthage, so clearly delineated in classical texts such as Virgil's *Aeneid*, is excluded from the scene: Carthage is figured solely in the form of its Tyrian colonizers, who are shown with light-skinned bodies and attired in vaguely classicized garments.[44] Within this universalized and idealized rendering of a doomed people, figures such as the grieving woman on the right and the mother and child on the left invite pity for the vanquished and enslaved rather than admiration for the martial prowess of the conquering Romans. As such, this picture could be seen as operating within the orbit of the British humanitarian discourse on slavery which appealed to Christian morality and human feeling rather than French or British economic arguments about the efficacy of slave labor. That Turner was critical of the slave trade in the late 1830s is apparent from his production of works such as the *Slave Ship* (R. A, 1849; Museum of Fine Arts, Boston). Given his liberal, reformist politics in the teens it is likely that he supported the abolitionist cause earlier as well.[45]

In *The Decline of the Carthaginian Empire* the artist's depiction of light-skinned women clinging to their soon-to-be enslaved children can even more directly be related to British and European attacks on the Barbary pirates and their activities as slave traders. Here the concern was not about the trade in African slaves, but the taking of white Christians as slaves. The above-quoted musings on ancient Carthage from the *Quarterly Review* were part of a review of five publications on North Africa that appeared between 1811 and 1816. The most polemical of these, by Admiral William Sidney Smith, was no less than a call for Britons and Europeans to wage a Holy War against the Barbary pirates. Smith formally presented this plea for intervention to the Conference of Vienna in 1814. Action was taken in 1815: Lord Exemouth and a Dutch commander were sent to Tunis to demand the return of all Western captives, and consequently 1800 individuals were released. The Dey of Tunis also promised to abolish Christian slavery. After Algerian corsairs refused to comply with these directives, Exemouth and the British navy sailed into the Bay of Algiers in August 1816 and

destroyed the Algerian fleet. As a result a treaty was signed in which over one thousand more slaves were released.[46]

It would be overly simplistic to suggest that Turner "intended" *The Decline of the Carthaginian Empire* to represent the beginning of a story about North Africa and slavery which was brought to a triumphant conclusion by the British fleet some 2,000 years later. Rather the work serves to fantasize the East as feminized, enslaved, given over to luxury, and in moral and political decline—yet still capable of inspiring sympathy. These attributes are played off against a less clearly defined notion of the West, embodied by the conquering Romans, who may be perceived as masculine and victorious, but not necessarily moral or virtuous. The ambiguous position of the Western conquerors is most overtly suggested by the work's title, which problematizes the morality of the Roman triumph by equating it with the taking of slaves—an action which would be seen as far from admirable in post-abolition Britain. Visually the Romans are inconspicuous. Although, as noted earlier, their presence in the scene is indicated by the ships in the harbor and the figures in Roman armor in the left middle ground, they appear less as victors than as witnesses to the Carthaginians' own self-destruction. Such ambivalence accords well with the current state of debates, both within Britain and among the Western powers, about the African and Christian slave trade.[47]

The gendering of the *Decline*'s classicized visual rhetoric is central to the process by which this image represents a form of power and desire which was coded as Western and masculine. We have already seen how the *Description de l'Egypte* inevitably assumed the male Western gaze as a disinterested instrument capable of scrutinizing and categorizing the landscape, culture, and human inhabitants of Egypt. Like scientific rationality, imaginative genius was also coded as a male faculty that could transform sensual desire for the exotic and feminized Other into refined aesthetic pleasure.[48] We have already considered the manner in which the feminine is heightened in *The Decline of the Carthaginian Empire* through the disposition of the figures. But the very means of representing the landscape itself is also feminized through its inscription of the beautiful in contradistinction to the sublime. These aesthetic terms became firmly attached to the discourse of landscape painting via aesthetic theories developed and popularized largely by Edmund Burke in the mid-eighteenth century and very much in circulation sixty years later.[49] The sexual coding of the sublime as masculine and the beautiful as feminine is a feature which runs through Burke's *Philosophical Enquiry into the Origin of Our Ideas of the Sublime and Beautiful*. It is especially apparent in his discussion of delicacy as a characteristic of beauty in which he notes that "the beauty of women is considerably owing to their weakness or delicacy, and is even enhanced by their timidity"; the sublime, on the other hand, is characterized by political and physical power, immensity, and magnificence—qualities which Burke associates with God and kings but not female rulers.[50]

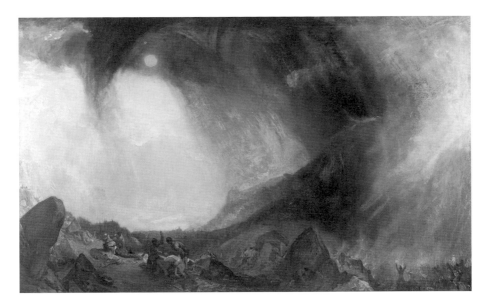

95. J. M. W. Turner, *Snowstorm: Hannibal and His Army Crossing the Alps*, 1812, oil on canvas, 146 x 237.5 cm. The Turner Collection, Tate Gallery, London.

A comparison of Turner's first Carthaginian subject, *Snowstorm: Hannibal and His Army Crossing the Alps* (fig. 95) of 1812 with the two "Dido" pictures produced in the years following will illustrate how the artist mobilized the highly gendered categories of the Burkean sublime and beautiful in connection with two very different geographical spaces. *Snowstorm: Hannibal* is a textbook example of the Burkean sublime. The picture represents Hannibal's army crossing the Alps in their passage to Italy. Once there they will meet and defeat the Romans; but as Turner's own lines that accompany the painting emphasize, the Carthaginians will then fall prey to the enervating and seductive pleasures of the Campagna, which, he implies, will lead to their final defeat.[51] Hannibal's troops are attacked both by the swirling storm that dominates the composition and by Swiss mountain fighters. The latter can just be made out in the foreground, mounting an ambush on the tag-end of the army. Signs of the sublime proliferate in the image storms, mountains, and armed combat are identified by Burke as sublime along with the qualities of obscurity, darkness, and immensity which Turner so masterfully represents through his management of color, tonal contrasts, scale, and form. The geography of Switzerland and the bodies of the Swiss fighters serve as the "material ground" for this representation of a sublime, masculine power, which, as the reviews of the work made clear, had a moral as well as a physical dimension.

This characterization of Switzerland was consistent with written accounts of the Alpine region. Contemporary Swiss resistance to Napoleon had been favorably reported in the British press in 1798, and both before and after that time

Switzerland was identified as a nation which valued and was willing to fight for its freedom.[52] In 1806 a review of Richard Payne Knight's *Inquiry into the Principles of Taste* took up the case of modern Switzerland as an example of the moral dimension of the sublime. The writer noted that the Swiss alps were frequently described as sublime but argued that the bravery of the Swiss militia before Napoleon's armies was even more awe-inspiring.[53] That Turner was able to combine both aspects of sublimity was clear to at least one reviewer. Robert Hunt, writing in the *Examiner*, concluded his highly favorable review of the picture by stating: "In fine, the moral and physical elements are here in powerful unison blended by a most masterly hand, awakening emotions of awe and grandeur."[54] There is much more to the story of *Snowstorm: Hannibal* and the contemporary criticism it generated, but for our purposes what is significant is the way Turner mobilizes the aesthetics of the sublime in order to gender this particular geographical site—Switzerland—so that it signifies moral and political character—love of liberty, fierce independence—as a male attribute which is consistent with contemporary discourses on empire.

If we examine *Dido and Aeneas* and *Dido Building Carthage* in a like fashion, it is clear that the artist applied similar visual and aesthetic strategies in the engendering of Carthage as a beautiful, exotic, and feminized spectacle. In both pictures Turner pointedly emulates Claudian compositions which were associated with "the beautiful." Furthermore, in comparison to Claude's relatively rectilinear architecture (see fig. 87), Turner's buildings are marked by feminizing curves, their straight edges broken by light or enveloped in atmospheric haze. The rich golden light, which Burke praised specifically as beautiful,[55] works with the harmony and delicate proportions of the architecture and the profuse variety of objects offered up to the viewer as a visual feast. As the writer for the *Champion* observed of *Dido and Aeneas*, "temples, palaces, groves, and waterfalls are brought together in the richness of a fairyland…The eye wanders entranced and unwearied over the picture, so infinite in variety and beauty are the objects which solicit attention."[56]

Robert Hunt also described the process of looking as the gratification of physical pleasures, the plethora of images spread before the viewer furnishing a variety of "treats" to be "relished." His review of *Dido Building Carthage* proceeds in the same vein. Individual aspects of the landscape are enumerated in sumptuous detail and connected to physical pleasures, especially evident in the description of the lagoon as a "bath of pleasure for the imagination."[57] This aura of sensuousness is enhanced by Hunt's repeated references to the beauty, glitter, and color of the two scenes. All of these terms were gendered feminine in cultural discourse and signaled the transformation of male sexual pleasure into the aesthetic pleasure of gazing at lush, exotic landscapes.[58]

The epic narrative taken up in the paintings further authorizes the pleasurable activity of the male gaze. According to legend Carthage was a city built

under the auspices of a woman — Queen Dido. Her beauty and power is thus inscribed in the magnificence of its palaces, temples, and lagoon. In *Dido and Aeneas* the city is laid out specifically as a pleasurable prospect to engage the attention and approval of a male viewer, the visiting Aeneas. Virgil's epic, Turner's painting, and Hunt's art criticism play on the elision between the desirable female body of the queen and the allure of her magnificent city.[59]

The trope of the Eastern pleasure garden and its association with a plethora of beautiful images designed to stimulate male sexual desire and (over)indulgence of the other appetites was well established by the nineteenth century. For example, Vauxhall Gardens, the pleasure grounds on the south bank of the Thames, was repeatedly described throughout the eighteenth and nineteenth centuries as a "Mahomet's" or Turkish paradise. Oliver Goldsmith's account of the Gardens from his "Citizen of the World" (1760) is typical in this regard:

> The illuminations began before we arrived, and I must confess, that upon entering the gardens, I found every sense overpaid with more than expected pleasure; the lights every where glimmering through the scarcely moving trees; the full-bodied consort bursting in the stillness of the night…the tables spread with various delicacies, all conspired to fill my imagination with the visionary happiness of the *Arabian* lawgiver, and lifted me into an extasy of admiration. Head of *Confucius*, cried I to my friend, this is fine: this unites rural beauty with courtly magnificence, if we except the virgins of immortality that hang on every tree, and may be plucked at every desire, I don't see how this falls short of *Mahomet's Paradise*! As for virgins, cries my friend, it is true, they are a fruit that don't much abound in our gardens here; but if ladies as plenty as apples in autumn, and as complying as any *houry* of them all can content you, I fancy we have no need to go to heaven for Paradise.[60]

Robert Hunt's description of Turner's *Dido and Aeneas* and *Dido Building Carthage* depends on similar invocations of light, a surfeit of sensations, and sexual desire as well. The critic's displacement of male desire from female bodies onto paintings is quite explicit in the remarks which conclude his review of *Dido Building Carthage*. "At second rate pictures," Hunt declares, "a look is sufficient; at first rate none will satiate. The spectator gazes on this. Returns again to feast his fancy before it. Is going a second time, but turns back to gaze. Finally goes, but still turns on it retiring looks, like a lover parting."[61]

We have seen how Turner's use of the aesthetics of the beautiful and the legend of Dido promoted a reading of Carthage as feminine. This engendering was not restricted to Turner's painting but was also employed in texts advocating British colonial intervention. For example, in 1818 yet another book was published in London which condemned the activities of Barbary pirates and called for the British to lead a European force which would subjugate and colonize North Africa. The *Narrative of a Residence in Algiers* was written by Filippo

Pananti, an Italian émigré who claimed to have been briefly taken as a slave in Algeria.[62] In the introduction he clearly alludes to Carthage when he writes:

> by far the most beautiful part of Africa [is] that nearest to Europe; a country which was once the abode of a polished and civilised people; that from whence...it would be the least difficult to trace the source of the Niger...or pass into other parts of the interior.[63]

This image of male penetration of a beautiful unknown Other is reinforced by Pananti's discussion of the natural fecundity of the area: "Africa," he writes, "has always been represented as a beautiful female, whose head is crowned with ears of wheat: this is a just symbol of the country's wonderful exuberance in that important necessary of life."[64] In the passages that follow Pananti continues to invoke a vision of North Africa as a beautiful body that may be penetrated by explorers, exploited by entrepreneurs, and probed by scholars as well:

> what a wide field of profitable research does the proposed colonization of Africa afford to the naturalist, antiquary, and man of letters? Totally ignorant of Carthaginian antiquities, its languages and manner, as we are, much yet remains unexplored of the literature, science and knowledge of the useful arts, which distinguished the Arabs.[65]

Just as the beauties of ancient Carthage were invoked in a passage devoted to the possibilities of exploring contemporary Africa, the scholarly pleasures of examining an unknown Carthaginian past are juxtaposed with those to be derived from examining an equally mysterious modern Arab culture. North Africa is produced as a heterotopia in a text such as this: the seemingly effortless elisions of past and present and of female bodies and geographical spaces are linked to this site in order to form a male colonizing consciousness based upon intellectual mastery, physical domination, and sexual pleasure.

Although the techniques are quite different, and far less obvious, Turner's pictures invite viewers to engage in a similar play of spatial and temporal displacements. We have already seen how in a work like *Dido Building Carthage* the disposition of forms and handling of perspective and color draw the viewer's gaze deeply into a highly feminized pictorial space. In *Dido and Aeneas* the eroticization of the landscape is achieved in large part by the artist's rendering of distance through the dissolution of forms and the materialization of atmosphere.[66] In 1821 William Hazlitt offered an explanation of this phenomenon as it relates specifically to the viewing of the natural landscape. In his essay titled "Why Distant Objects Please," he suggests that

> distant objects please, because...they imply an idea of space and magnitude, and because...we clothe them with the indistinct and airy colours of fancy. In looking at the misty mountain-tops that bound the horizon, the mind is...conscious of all the conceivable objects and interests that lie between;

…Whatever is placed beyond the reach of sense and knowledge, whatever is imperfectly discerned, the fancy pieces out at its leisure; and all but the present moment, but the present spot, passion claims for its own…Passion is lord of infinite space, and distant objects please because they border on its confines, and are moulded by its touch.[67]

And indeed Turner's paintings mobilize a discourse of fantasy and "passion" as evidenced in critics' detailed descriptions of sites such as theaters, palaces, temples, bridges, and baths—structures that are in fact "imperfectly discerned" but which are conjured forth in the interface between Turner's indistinct and generalized architectural imagery and the poetic recreations of the ancient city by classical and modern authors. Thus the indeterminacy of Turner's image is a controlled indeterminacy which plays on the cultural and political knowledge of a literate and classically educated elite who knew their Virgil and Livy, and who had access to modern writings on North Africa by Vivant Denon, McGill, Smith, and others.

We have seen in the *Description de l'Egypte* how the maintenance of a disinterested distance was essential to the process of observing, dissecting, and categorizing Egypt as an object of Western knowledge. The distance produced by Turner in his poetic landscapes offers other pleasures. In the imaginative spaces created by the lush and dissolved imagery of Dido's legendary Carthage and Carthage in decline, viewers are invited to multiply their fantasies of a heterotopia in which past and present cohabit a geography marked by mystery, corruption, illicit pleasure, slavery, and Western conquest.

The poet Paul Valéry has observed,

> In order to have the word ["Orient"] produce its full impact on the spirit, it is important *never to have been* in this uncertain territory. One should through images, narratives and a few objects have only the vaguest, most unscholarly, and most confused knowledge of this place. Only with this method are you able to prepare good material for dreams. You need a mixture of time and space, of pseudotruths and false certainties, of tiny details and vast, crude surveys. There you can find the Orient of the soul.[68]

If consciousness is indeed formed in such a fashion, understanding how "high art" images participate in such a process involves engaging seriously with a much wider array of textual and visual materials than traditional art-historical studies usually allow. I have tried to show through this analysis of Turner's early Carthage pictures that such a project does not involve reducing different types of visual imagery and written texts to a homogenized entity known as "orientalism." Quite the contrary: it is essential to attend closely to the aesthetic and artistic qualities which make an academic oil painting of a non-Western site a vastly different object than a travel account or an engraved topographical view of that region. Only by this close attention is it possible to see how these various repre-

sentations, which seem to have little to do with each other, interlink to promote and naturalize a set of power relations that places Britain, and more broadly the West, in a morally, culturally, and politically superior position to North Africa and other regions defined as East. To reject this type of analysis is to place ourselves in a position similar to that of Chateaubriand who wrote in his 1811 travel account of North Africa: "Before we proceed to Carthage, which is here the only interesting object, let us in the first place get rid of Tunis."[69] Within the domain of art-historical scholarship, as in the world of politics, getting "rid of Tunis" and all that this implies is an operation which is now both politically and intellectually untenable.

This is a revised and expanded version of an article which appeared in *Oxford Art Journal* 18, no. 1 (1995): 116–32. It was based upon a paper given at the Interdisciplinary Symposium on British Landscape Painting held in Denver and Boulder, Colorado, 28–29 January 1994, and at Harvard University's Center for Literary and Cultural Studies, 9 March 1994. I would like to thank Sheila Bonde, Andrew Hemingway, Laurie Monahan, Christiana Payne, Michael Rosenthal, Rose Marie San Juan, and Scott Wilcox for their helpful suggestions on various drafts.

1 Turner also painted a view of Carthage in 1828 and produced four more pictures of the ancient city in 1850.

2 See for example, John Gage, "Turner and Stourhead: The Making of a Classicist?" *Art Quarterly* 37 (Spring 1974): 59–87; John Gage, *J. M. W. Turner: "A Wonderful Range of Mind"* (New Haven: Yale University Press, 1987), 206–12; and Michael Kitson, "Turner and Claude," *Turner Studies* 2, no. 2 (January 1983): 2–15.

3 Kathleen Nicholson has an extensive discussion of the possible parallels that may have been drawn between ancient Carthage and imperial Britain or France in chap. 4 of her study, *Turner's Classical Landscapes: Myth and Meaning* (Princeton: Princeton University Press, 1990), see esp. 108.

4 See, for example, the remarks of the critic for the *Repository of Arts* who in 1812 described Turner's *Snowstorm: Hannibal and His Army Crossing the Alps* as "the effect of magic, which this Prospero of the graphic art can call into action, and give to airy nothing a substantial form" — "Notices of the Pictures in the Forty-Second Exhibition of the Royal Academy," *Repository of Arts* 7 (June 1812): 341.

5 "Royal Academy Exhibition," *Champion*, 7 May 1814, 149.

6 Michel Foucault, "Of Other Spaces," *Diacritics* 16 (Spring 1986): 22–27.

7 It could be argued that the so-called "Barbary States" were variously viewed by Turner's English contemporaries as "Eastern," as Hazlitt suggested in his critical remarks about Turner's *Dido and Aeneas* (see Note 8) or as part of a wide-ranging exotic culture that included the Mediterranean basin, encompassing North Africa, Southern Italy, Greece, and Spain, and extended as far as India and China. Taking my cue from Hazlitt, I employ the term "Eastern" in this analysis as a designation for a more narrowly defined, non-European, Mediterranean locale, since at this time in Britain, Tunisia and its neighbors were more commonly discussed in the context of Arab, Islamic, or North African culture than in connection with southern Europe, India, or China.

8 [William Hazlitt], "Royal Academy," *Morning Chronicle*, 3 May 1814.

9 That Hazlitt accepted these traditional subdivisions of the landscape genre is borne
 out by his comments regarding landscape in his review of the British Institution exhi-
 bition in the *Morning Chronicle* (5 February 1814) and in his discussion of the works of
 Wilson and Gainsborough in the *Champion* (17 July and 31 July 1814, respectively).

10 It is worth noting that many contemporary commentators, Hazlitt included, pre-
 ferred domestic landscapes which were considered "common" or "natural" and yet
 which manifested little concern with topographical accuracy or scientific truth.
 Nonetheless, the epistemological authority for such works rested primarily upon
 empiricist principles rather than on neo-Platonic notions of ideal nature and univer-
 sal truth.

11 See, for example, Joshua Reynolds's *Fourth Discourse* (1771) for his discussion of the
 conditions by which subsidiary groups can be introduced without entering "into any
 degree of competition" with the primary group in the composition — *Discourses on
 Art*, ed. Robert Wark (New Haven: Yale University Press, 1959), 58–59.

12 As Norman Bryson has noted in Turner's work generally, these forms possess the char-
 acter of glyphs; we are given only enough information via their silhouettes to recog-
 nize them as built, rather than natural forms — "Enhancement and Displacement in
 Turner," *Huntington Library Quarterly* 49, no. 1 (Winter 1986): 47–65.

13 [Robert Hunt], "Royal Academy Exhibition," *Examiner*, 29 May 1814, 349.

14 See Andrew Hemingway, "Genius, Gender and Progress: Benthamism and the Arts in
 the 1820s," *Art History* 16, no. 4 (December 1993): 619–46, for an analysis of Robert
 Hunt's role as a bourgeois art critic whose criticism engaged directly with his progres-
 sive politics.

15 One such military engagement, the British naval attack on Algeria in 1816, is discussed
 below.

16 Turner's *Fifth Plague of Egypt* (Indianapolis Museum of Art), exhibited at the Royal
 Academy in 1800, is one manifestation of contemporary British interest in Egypt. In
 order to render Egypt a fitting subject for the most elevated form of landscape paint-
 ing, the artist eschewed contemporary events, marshaling the visual language of the
 Burkean sublime to represent an equally sublime and fantastic biblical text. The art-
 viewing public in Britain would also have seen more straightforward representations
 of the Franco-British struggle over Egypt in battle paintings such as Philippe Jacques
 de Loutherbourg's *The Battle of the Nile* (Tate Gallery), also from 1800.

17 Indeed, as Richard Altick has demonstrated, "Egyptomania" gripped Britain as a
 result of Napoleon's occupation. This manifested itself in a wide array of accessible
 popular entertainments as well as literary and artistic productions — Richard Altick,
 The Shows of London (Cambridge: Belknap Press, 1978), 235–46.

18 Edward Said, *Orientalism* (New York: Random House, 1978), 7.

19 Magali Morsy, *North Africa, 1800–1900: A Survey from the Nile Valley to the Atlantic*
 (New York: Longman, 1984).

20 For example, in Anna Laetitia Barbauld's highly controversial poem *Eighteen Hun-
 dred and Eleven*, the poet calls into question the permanence of the British Empire by
 noting the rise and fall of ancient empires: "Then empires fall to dust, then arts decay,
 / And wasted realms enfeebled despots sway; / Even Nature's changed; without his
 fostering smile / Ophir no gold, no plenty yields the Nile; / The thirsty sand absorbs
 the useless rill, / And spotted plagues from putrid fens distil. / In desert solitudes then
 Tadmor sleeps, / Stern Marius then o'er fallen Carthage weeps" — Anna Barbauld,
 Eighteen Hundred and Eleven (1812), in *A Selection from the Poems and Prose Writings of
 Mrs. Anna Laetitia Barbauld*, ed. G. Ellis (Boston, 1874), 123. Within the space of four
 lines the poem transports the reader hundreds of miles and years from the fall of

Egypt to the destruction of Carthage. Such a literary tactic was also common in prose descriptions of ancient empires and served to link Egypt and Carthage in contemporary consciousness. I would like to thank William Keach for bringing this poem to my attention.

21 In *Orientalism* (84–86) Said discusses this Western claim of Eastern degeneracy in relation to the *Description de l'Egypte*.

22 For a brief but cogent analysis of the important role the *Description* played in the history of French colonialism, see Todd Porterfield, "Art in the Service of French Imperialism in the Near East, 1798–1848: Four Case Studies," 2 vols. (Ph.D diss., Boston College, 1991), esp. 1:66–69.

23 Although women can and do assume a masculine subject position in producing and consuming visual representations, in this case existing records of the Napoleonic mission indicate that only men were involved in surveying and producing the plates for the project.

24 Throughout his writings John Barrell has convincingly established that the mental capacities needed to abstract and generalize were identified in eighteenth- and nineteenth-century Britain as male attributes; see especially his "'Statesman, Chemist, Fiddler, and Buffoon,'" *Block* 13 (1987–88): 47–50. Harriet Guest has examined the issue of general and particularized knowledge with respect to gender and race in connection with the landscape painting of William Hodges in "'The Great Distinction': Figures of the Exotic in the Work of William Hodges," *Oxford Art Journal* 12, no. 2 (1989): 36–58. My discussion of the male Western gaze and the forms of knowledge which it engenders is deeply indebted to the work of both these scholars.

25 Thomas Shaw, *Travels or Observations Relating to Several Parts of Barbary and the Levant* (Oxford, 1738), 262–63. Shaw's investment in classical history is revealed in his sources, for the text is glossed almost exclusively with quotes from ancient Roman and Greek authors.

26 France's brief but privileged status as conqueror of Egypt did not, of course, prevent Britons and others from appropriating the "knowledge" produced by the *Description* for their own ends. Thus British artist John Martin produced in 1820 *Belshazzar's Feast*, an enormously popular biblical painting, which drew upon the *Description* for some of its architectural details. The "authenticity" of these details was a major draw for the picture and clearly was designed to underscore the truthfulness of the image — not only in terms of setting, but also as a moral critique of rulers (such as Britain's Prince Regent) who were corrupted by their attachment to luxury and sensual pleasures.

27 Individual British travelers had explored the interior of Egypt in the eighteenth century and published accounts of their adventures. For an account of the explorations of James Bruce and others, see Anthony Sattin, *Lifting the Veil: British Society in Egypt, 1768–1956* (London: Dent, 1988). However, these individuals could not amass visual and textual material on the scale of Napoleon's team of savants.

28 This discussion is heavily indebted to Alan Richardson, who in conversation noted how Turner's *Dido* inscribes a particularly "penetrating" male gaze.

29 In 1829 in the first draft of his will, Turner stipulated that *Dido Building Carthage* was to hang in the National Gallery beside Claude's "Seaport" and his "Mill." These paintings would appear to correspond to *Seaport: The Embarkation of the Queen of Sheba* and *Landscape: The Marriage of Isaac and Rebecca*, acquired by the National Gallery in 1824—Martin Butlin and Evelyn Joll, *The Paintings of J. M. W. Turner*, rev. ed. (New Haven: Yale University Press, 1984), 1:96.

30 The volumes, published in 1802, were sold in London for twenty-one guineas, but the less affluent could have seen eighteen large-scale paintings derived from Vivant Denon's drawings displayed as part of Mark Lonsdale's Ægyptiana, a popular entertainment held in the upper room of the Lyceum in 1802. For a brief description of Ægyptiana see Altick, 199.

31 For example, Vivant Denon writes about the manner in which the French should go about colonizing the Nile Delta—by importing settlers from the West Indies to grow sugar cane, indigo, and cotton. See his *Travels in Upper and Lower Egypt during the Campaign of General Bonaparte*, in French with intro. in English by A. Aiken (New York, 1803), 2:87.

32 Review of *Voyage dans la Basse et la Haute Egypte pendant les Campagnes du General Bonaparte* by Vivant Denon, *Edinburgh Review* 1, no. 2 (January 1803): 330.

33 These assumptions about the (non)existence of topographical views of Carthage are based upon my survey of extant materials in major collections in the U. S. and Britain.

34 My survey of travel literature and other publications relating to North Africa reveals that the (few) topographical illustrations they contain focus primarily on the city of Algiers, the Triumphal Arch at Tripoli, the Atlas Mountains in Morocco, and other natural sites. Although it is dangerous to speculate from the fragmentary material that remains, it would appear that views of Tunisia from 1800 to 1820 were much rarer than those of the other Barbary States and certainly of Egypt. This, in contrast to a French publication from 1844, Marie Armand d'Avezac, et al., *Afrique: Esquisse Général de Afrique et Afrique Ancienne, Carthage, Numidie et Mauritanie, et L'Afrique Chrétienne* (Paris: Firmin Didot Frères), which contains seven picturesque views of Carthaginian ruins.

35 Arguably, the most commonly represented North African site outside of Egypt was the Bay of Algiers, where in 1816 the British Navy destroyed the Algerian fleet and effected the release of European slaves. Capitalizing upon the victory, a flurry of popular prints, paintings, and at least two panoramas appeared in the ensuing years. See Peter Harrington, *British Artists and War: The Face of Battle in Painting and Prints, 1700–1914* (London: Greenhill Books, 1993), 113; for representative images, see also Michael Strang Robinson, *A Pageant of the Sea: The Macpherson Collection of Maritime Prints and Drawings in the National Maritime Museum, Greenwich* (London: Halton, 1950). Not surprisingly, these representations focused upon the drama of the naval battle, with the city of Algiers reduced to a ghostly backdrop hovering behind a veil of smoke and fire and the monumental forms of warships. Later, in 1821, Captain George Lyon published an account of his travels through the interior of Tripoli, *Narrative of Travels in Northern Africa* (London: John Murray), illustrated with colored aquatints based upon his own drawings. However, only four of the seventeen plates focused on the landscape and ancient monuments; the rest centered on the costumes and customs of the region's inhabitants.

36 Thomas McGill, *An Account of Tunis: Of Its Government, Manners, Customs, and Antiquities; Especially of Its Productions, Manufactures and Commerce* (Glasgow, 1811). See the preface and 94–102 for his comments on British commercial competition with France in Tunisia, and 107–10 for a discussion about upgrading the British consulate.

37 McGill, 56. McGill's *Account* remained the key source for Western information about Tunisia for the next thirty years. In 1837 Michael Russell cited this same passage from McGill as proof of the meanness of Tunisian architecture in his *History and Present Condition of the Barbary States* (New York: Harpers), 207.

38 The connection between crumbling architecture and the "moral fabric" of a society has been forcefully analyzed by Linda Nochlin in connection with nineteenth-century orientalist painting in "The Imaginary Orient," in *The Politics of Vision: Essays on Nineteenth-Century Art and Society* (New York: Harper and Row, 1989), 33–59.

39 "The Barbary States," review of five publications on North Africa, *Quarterly Review* (April 1816): 154–55.

40 Nicholson, 105. Nicholson also notes that crumbling architecture is present in Turner's *Dido and Aeneas* in the form of a ruined bridge in the center of the composition, appearing oddly out of place in a newly founded city. The ruin, she suggests, may serve as a portent for the tragic events which would later overtake the city (103). While this play with temporal elements testifies to Turner's ingenuity, it also serves to emphasize Carthage's status as a heterotopia — as precisely the type of site which can accommodate such temporal disjunctions.

41 Henry Hope fled to England when the French invaded Holland in 1794. Connoisseur and Tory landowner Sir George Beaumont may have suggested the subject of this work to West. For a discussion of West's *Cicero*, see Helmut von Erffa and Allen Staley, *The Paintings of Benjamin West* (New Haven: Yale University Press, 1986), 174–75; for David's *Brutus* see Thomas Crow, *Painting and Public Life in Eighteenth-Century Paris* (New Haven: Yale University Press, 1985), 247–54.

42 Turner's title encapsulates Oliver Goldsmith's account of the fall of Carthage in his *Roman History* (1749).

43 Betty Fladeland, "Abolitionist Pressures on the Concert of Europe, 1814–1822," *Journal of Modern History* 38, no. 4 (1966): 357–59.

44 The indigenous people of this region were variously called Libyans or Berbers by the Greeks and Romans, but there was and is no homogenous race of Berbers. For a brief discussion of this issue, see David Soren, Aicha Ben Abed Ben Khader, and Hedi Slim, *Carthage* (New York: Simon and Schuster, 1990), 45–46.

45 Perhaps the most widely circulated visual image associated with that humanitarian discourse was the seal of the Committee for the Abolition of the Slave Trade, designed by William Hackwood and produced as a jasperware medallion by his employer, Josiah Wedgwood in 1787. The design, which was soon reproduced in a variety of media, consists of the words "AM I NOT A MAN AND A BROTHER?" arching over the kneeling figure of a chained African slave. For a discussion of the Wedgwood medallion and other visual images in the context of the popularization of the humanitarian discourse on abolition, see J. R. Oldfield, *Popular Politics and British Anti-Slavery: The Mobilization of Public Opinion against the Slave Trade, 1787–1807* (Manchester: Manchester University Press, 1995), 155–84. For an analysis of Turner's most well-known painting on the subject of slavery, see Albert Boime, "Turner's *Slave Ship:* The Victims of Empire," *Turner Studies* 10, no. 1 (Summer 1990): 34–43.

46 Russell, 249–50.

47 A colored aquatint (anonymous, now in the British Museum's collection of British Historical Prints) issued on the occasion of the British victory over the Algerian fleet testifies to the way European and African slavery were regarded as interrelated moral and political issues. In the print, captioned "The DEY of ALGIERS Surrendering to LORD EXEMOUTH 1085 Christian Slaves and All the MONEY Received for Ransom Amounting to 382.500 DOLLARS," the figure of one of the freed Europeans stands erect, his arms outstretched in joy and thanksgiving at his release. Directly below him kneels a black slave who is returning to Lord Exemouth money originally paid to the Dey of Algiers as ransom for European captives. The formal juxtapositions of these two figures pointedly suggests that the British victory could only be a limited one as

long as black Africans remained enslaved—unransomed and, crucially, unliberated by the military forces of the West.

48 For a general account of the gendering of genius see Christine Battersby, *Gender and Genius: Towards a Feminist Aesthetic* (London: Women's Press, 1989). I take up this issue with specific reference to English landscape painting in my book, *The Idea of the English Landscape Painter: Genius as Alibi in the Early Nineteenth Century* (New Haven: Yale University Press, 1997).

49 See Andrew Wilton, *Turner and the Sublime* (London: Tate Gallery, 1980) for a discussion of the sublime as it relates specifically to Turner's landscapes.

50 Edmund Burke, *A Philosophical Enquiry into the Origin of Our Ideas of the Sublime and Beautiful*, ed. J. T. Boulton (London: Routledge and Paul, 1958), 106; for the relationship between sublimity and masculine power, see 72–73. Here Burke discusses the sublime quality of magnificence, which he illustrates by citing Shakespeare's descriptions of Henry IV's army and a biblical panegyric to the high priest Simon.

51 Kathleen Nicholson has convincingly argued that Turner's appended poetry works in concert with the image to form a hermeneutic circle in which meanings are generated, countered, and elaborated in a process which is unending and intentionally ambivalent (*Turner's Classical Landscapes*, 96–103).

52 Lynn Matteson has examined Turner's *Snowstorm: Hannibal* in the context of British reaction to the plight of the Tyrolese, who visited London in 1809 in quest of funding for their continued armed resistance to Napoleon—a cause enthusiastically supported by the British public and press. See Matteson, "The Poetics and Politics of Alpine Passage: Turner's *Snowstorm: Hannibal and His Army Crossing the Alps*," *Art Bulletin* 62, no. 3 (September 1980): 387.

53 "Knight's Inquiry into the Principles of Taste," review, *Edinburgh Review* 7 (January 1806): 323.

54 [Robert Hunt], "Royal Academy Exhibition," *Examiner*, 7 June 1812, 363.

55 Burke, 144.

56 "Royal Academy," *Champion*, 7 May 1814, 149.

57 [Robert Hunt], "Royal Academy Exhibition," *Examiner*, 28 May 1815, 350.

58 I discuss the gendering of high-key color and glittering surface effects in artistic discourse in chap. 2 of *The Idea of the English Landscape Painter*.

59 For a provocative discussion of the relationship between bodies and cities, see Elizabeth Grosz, "Bodies-Cities," in *Sexuality and Space*, ed. Beatriz Colomina (New York: Princeton Architectural Press, 1992), 241–54. Grosz posits a complex relationship (or "interface") between bodies and cities which is neither causal (bodies construct cities), nor straightforwardly analogical (bodies resemble cities): "What I am suggesting is a model of the relations between bodies and cities which sees them, not as megalithic total entities, distinct identities, but as assemblages or collections of parts, capable of crossing the thresholds between substances to form linkages, machines, provisional and often temporary sub- or microgroupings" (248). The indistinctly rendered bodies and buildings which inhabit Turner's images of Carthage superbly capture the provisionality and discontinuity of just such a socio-spatial terrain.

60 Oliver Goldsmith, Letter LXXI, *The Citizen of the World* (1760), quoted in T. J. Edelstein, "The Gardens," in *Vauxhall Gardens* (New Haven: Yale Center for British Art, 1983), 13. Vauxhall, with its "Turkish" tent and "Chinese Gothic" pavilions, clearly was designed to conjure up a Western fantasy of Eastern pleasure grounds. For other contemporary descriptions of the Gardens as a Turkish paradise, see Edelstein's essay and David Solkin's chapter on Vauxhall in *Painting for Money: The Visual Arts and the Public Sphere in Eighteenth-Century England* (New Haven: Yale University Press,

1993), 106–56. While most of the scholarly literature on Vauxhall acknowledges its exoticism, none, to my knowledge, analyzes the site within the context of British colonialism.

61 [Robert Hunt], "Royal Academy Exhibition," *Examiner*, 28 May 1815, 350.

62 Several such "slave" narratives appeared in the U. S. and Europe in the years around 1800. See, for example, Royall Tyler, *The Algerine Captive or the Life and Adventures of Doctor Updike Underville, Six Years' Captive among the Algerines* (Walpole, New Hampshire, 1797). But whereas the North Africans pictured in Turner's *Decline* are unmanned by the specter of bondage, the Western male explorer who is temporarily enslaved is empowered by the intimate knowledge of the Other which he gains in the course of his confinement in an Eastern household.

63 Filippo Pananti, *Narrative of a Residence in Algiers…Observations on the Relations of the Barbary States with the Christian Powers; and the Necessity and Importance of their Complete Subjugation* (London, 1818), xx. Later Pananti refers back to this passage when he writes that "the comparatively extreme facility of penetrating Africa from its northern side has already been alluded to" (415).

64 Ibid., 413.

65 Ibid., 415.

66 This discussion owes much to Harriet Guest's astute analysis of the relationship between the dissolution of forms and the production of male heterosexual desire in William Hodges's *A View Taken in the Bay of Otaheite Peha* in "'The Great Distinction,'" esp. 41.

67 William Hazlitt, "Why Distant Objects Please" (1821), in *The Complete Works of William Hazlitt*, ed. P. P. Howe (London: Dent, 1933), 8:255–56.

68 Paul Valéry, "Introduction" to Roger Bezombes, *L'Exotisme dans l'art et la pensée* (Paris, 1953), vii. Emphasis in the original. I would like to thank Dietrich Neumann for calling my attention to this passage.

69 François-René Chateaubriand, *Travels in Greece, Palestine, Egypt, and Barbary* (New York, 1814; orig. pub. in French, 1811). Chateaubriand in fact did include information about modern Tunis, in an appendix which contained an excerpt of a recently published anonymous description of the city.

For Publicity and Profit

Ann Pullan

> *The landscapes* [at the Royal Academy Exhibition, 1825], *as might be of course expected, are not numerous:— they are naturally attracted to the new Society in Suffolk-street* [the Society of British Artists], *which offers, at once, the prospect of publicity and profit—of an exhibition and a mart.*[1]

IN HIS ESSAY, "Landscape as High Art," Michael Rosenthal concludes by observing that if, in "exceptional circumstances, landscape painting had aspired to the status of a public art," in the period to 1815, this was far from being the case by 1830, when it had become something that was "to be looked at in passing but was not central to the pressing concerns of life."[2] Rosenthal quotes Henry Fuseli on the decline of public art in modern commercial society: "As…public grandeur gave way to private splendour, the Arts became the hirelings of Vanity and Wealth; servile they roamed from place to place, ready to administer to the whims and wants of the best bidder."[3] By public art, Fuseli would have had in mind the ennobling and universal themes of an ideal form of history painting, not the efforts of ambitious landscape painters, but his words allow me to establish a connection with my opening quotation from the *Monthly Magazine*. Here, the metaphorical "roaming" of the arts from place to place is historically manifested in the desertion of the Royal Academy (as an institution set up to promote the ideals of public art) by those landscape painters who are "naturally attracted" to the new Society of British Artists, and who "naturally" look to the "public" exhibition as a form of "publicity and profit."

In civic humanist terms Fuseli's definition of "public grandeur" invokes some notion of the disinterested and virtuous public man. Endowed by virtue of a classical education, landownership, and some involvement in public life, he is enabled to form those comprehensive and general ideas so necessary for an appreciation of history painting (and historical or moral landscapes). The public man rises above his own self-interests and the narrow concerns of everyday life, unlike, for example, those landscape painters drawn to the new society of artists. But while Fuseli was pessimistic about the decline of public art and the impossibility of forming a disinterested public for art in contemporary Britain, the *Monthly Magazine* appears to be untroubled by such considerations—significantly it assumes that landscape painters have the most to gain in the search for a newly defined "public." Seeking publicity and profit is here represented as a "natural," if self-interested, response of British painters to the specific conditions of artistic production in the early nineteenth century. By implication the *Monthly Magazine*'s formulation invokes very different notions of "the public." For the

painters to "profit" from the display of their work in a new "public" space, their "public" must be constituted in terms of consumption and spectatorship.

Also important for my argument is the *Monthly Magazine*'s use of the term "publicity."[4] The new Society of British Artists and its first exhibition in 1824 are clearly regarded as a means of producing publicity for the Society as a whole and for individual artists, especially landscape painters. Central to this publicity was the press, whose notices and reviews not only provided a space for advertisements but a space for the formation of public opinion about the relative merits of British art and landscape painters (individually and collectively). As Rosenthal notes, the *Literary Chronicle* of 1828 could claim that the "*truth*" with which English landscape painters have "delineated the features of the British landscape is, *according to the general admission* (my emphasis), unmatched…[by foreign schools]."[5] Contemporary debates about the nature, status, and function of British art in general and landscape painting in particular could also become vehicles for expressing opinions which carried overt or covert references to national public and political interests.

Although I will later try to tease out some of the early-nineteenth-century implications associated with the notion of publicity, I want to begin by suggesting that modern definitions of publicity provide a useful point of departure for rethinking our understanding of early-nineteenth-century notions of the "public" in relation to landscape painting. Defined by the *Oxford English Dictionary* as "the quality of being public; the condition or fact of being open to public observation or knowledge"; or "being open to general observation," it seems particularly applicable to the early-nineteenth-century exhibition and accompanying reviews in the press. By this definition exhibited landscape paintings could be thought of as a form of "public" art, whatever the nature of their subject matter. "Publicity" also refers to "the business of advertising goods or persons" and can also denote "notoriety" with all its connotations. As we will see, such connotations appear to have been part of the early-nineteenth-century understanding of the publicity engendered by the public art exhibition.

The concept of publicity is also employed by Habermas, whose work on the formation of the "bourgeois public sphere" has informed my argument.[6] The "bourgeois public sphere" refers to "that body of informed, polite public opinion ['a communicative rationality among free and equal human beings'] that emerges in literature and the press in the 18th century and that could be said to constitute the soon-to-be hegemonic cultural discourse of the bourgeoisie," a "place of the free and open exchange of ideas that results in political consensus."[7] Habermas's "bourgeois public sphere" is more ideal than actual, and he has been criticized for his exclusions and omissions, but my aim in this introduction is briefly to contextualize my paper. In particular, I want to draw attention to the distinction between the concept of a "modern" bourgeois public sphere and the civic humanist concept of the public sphere in order to suggest that the former

may be more useful than the latter when thinking about the status of landscape painting in the early nineteenth century: "Participants in this modern public sphere were to be conceived not as citizens of an ancient polis assembling together to engage in the common exercise of political will but as the dispersed members of 'a society engaged in critical public debate,'" where "'public opinion' [is] the ultimate source of authority."[8] But Habermas also preserves the distinction between a "public sphere," based upon free association of individuals reaching a consensus in the formulation of "public opinion," and the "private sphere" in which business or professional people gather to transact private affairs (such as we might want to identify with the transactions at the Society of British Artists exhibitions). However, the relationship between the two is ambiguous and often contradictory, a situation complicated by the fact that Habermas postulates the modern public sphere as being composed of private individuals whose subjectivities are formed in the sphere of the bourgeois family.

As Fuseli recognized, a modernizing commercial nation like Great Britain, especially one experiencing the rapid social transformations of an expanding capitalist economy—a nation whose identity was based upon some notion of national supremacy in terms of trade, agricultural production, and manufacturing, where there was little or no State support for the fine arts—could provide little more than an unstable base for the formation of any securely defined "public" for art, or even a consensus about what constituted "public" art. In considering landscape painting and contemporary notions of "public" and "private," we need to think in terms of a range of different, emergent, competing, and confusing "publics," variously defined in terms of sphere, class (or social status), interest group, and gender difference, and to recognize that any definition of "the public" may be contradictory, ambiguous, and that it was often highly contested. Furthermore, any investigation of historically located notions of "the public" necessarily involves some consideration of their binary opposites, notions of "the private."

I want to explore some of these issues and confusions by looking at the way the practice of landscape painting was mobilized in various attempts to formulate a less confusing, more stable and securely defined base for making distinctions between various dominant (consensual) and emergent notions of the "private" and the "public." My examples are all drawn from the periodical press c. 1810–30, but it should be recognized that confusions about the meaning and usage of the term "public" date well back into the eighteenth century.[9] Most, but not all, of my examples deal directly with various practices associated with landscape painting, and I must stress that I will be looking at the way these were represented in the press, not actual practices or experiences.

Painting Landscapes for Profit and Publicity

The oldest and most persistent distinction is, of course, that which opposes private "self-interest" to "public" good. Academicians like Fuseli were equally clear that painting, as a liberal art, should be protected from the "taint" of the marketplace. While accusations that British artists, even those associated with the Royal Academy, were only interested in protecting their own "selfish-interests" and in making a profit by "trading" in pictures were not new, the growth of interest in English landscape painting in the early decades of the nineteenth century meant that landscape painters were being singled out in this way. As early as 1816 William Hazlitt complained that Turner was only interested in painting for money.[10] In 1820 the *New Monthly Magazine* printed the observations of a German visitor to the Royal Academy exhibition where the author (a Dr. Meissner) remarked that, although many English artists have attained a degree of perfection in landscape, the landscape painters "are also fully aware that a view of Windsor or Richmond is more likely to find a purchaser than an original composition and thus they confine themselves to the representation of scenes which are familiar to every eye."[11] In the same year the *Edinburgh Review* complained that the object of English artists was not to look at nature, but to have their pictures exhibited and sold:

> The only pictures painted in any quantity as studies from nature…are *portraits of places;* and it cannot be denied that there are many of these that have a true and powerful look of nature: but then, as if this was a matter of great indifference, and nobody's business to see to, they are seldom any thing more than bare sketches, hastily got up for the chance of a purchaser, and left unfinished to save time and trouble.[12]

Clearly, the demands of the market were perceived as having negative effects upon landscape painters.

The formation of the Society of British Artists in 1823 and its first exhibitions from 1824 provided an important focus for debate on these issues.[13] The *Monthly Magazine*'s 1825 response to the new society and the motivations of its artists was a positive one, affirming the *necessary* connections between "publicity" and "profit," the "exhibition" and the "mart," and the fostering of a national school of art. In 1824 the *Literary Chronicle* had praised the society for its liberality and openness both to artists and the art public, noting that the exhibited works were being bought not by the "higher and polished orders of society," but by "the middle and respectable classes of an opulent and well-educated British public," in marked contrast to the Royal Academy with its exclusive privileges and distinctions among artists and its public. The *Literary Chronicle* had no doubt that the educated opinion of the middle classes is superior to "the petty favouritisms of creatures in office and the squeamish indifference of pretended connoisseurs."[14] Others were more hostile to the new society. In 1824 the *European Mag-*

azine complained that the Society had no noble purpose, its members being governed—like any assembly of commodity producers, that is, as a group of "wareshewing, money-getters"—by narrow views and selfish interests in present profits and publicity, rather than the future fame and honor of a national school of art. In 1825 it described their second exhibition as a miserable collection not fit for a pawnbroker's auction room in a rag-fair, expressing the hope that the idea would soon be given up, thus saving an infinite number of "wretched painters" from "*exposing themselves in public* (my emphasis) by having the only receptacle where they could possibly be admitted closed against them."[15] In such rhetoric we see the persistence of the idea that painting as a "liberal" art must be protected from any "taint" of trade and commercialism. We might also note the paradox implicit in the notion that a British "national" (could we describe this as a "public"?) school of art should be founded upon values antithetical to Britain's strengths as a commercial nation. How, then, do we explain the virulence of the *European Magazine*'s attack on the painters for "exposing" themselves in public?

Clearly, more is at stake than seeking financial gain in a market. In part, the answer must be connected with the wider politics of the period and the *European Magazine*'s general position vis-à-vis the status quo in the political and artistic spheres. However, the fact that the Society of British Artists are openly seeking "publicity" for their work *and for themselves* seems to represent the greater offense because it threatens the "body" and authority of the liberal artist. B. R. Haydon, a staunch supporter of painting as a liberal art and defender of history painting as the only true "public" art, declared: "The members are modern landscape painters who want all the staring light possible, destroying all sentiment and all art."[16] The *European Magazine* review focuses upon the negative effects and connotations associated with notions of notoriety and self-advertisement or unseemly (even unmanly or feminized) displays of the body or figure of the British artist. Although the *European Magazine* does not single out landscape painters, it is interesting to note that by 1830 the Swedish artist Carl Jacob Lindström was able to caricature the English landscape painter in Rome as being more concerned with self-display than the business of capturing "nature" (fig. 96).[17]

The Private Pleasures of Landscape Painting: A Retreat from Public Life?

Having considered one set of oppositions between the public and the private in terms of the market and publicity, I want to turn to a very different description of the private pleasures of landscape painting, written by a man deeply hostile to the idea of painting for money. In 1820 the essayist and journalist William Hazlitt published an essay, "On the Pleasure of Painting," which began with the words: "There is a pleasure in painting which none but painters know."[18] Hazlitt, who had earlier studied to become a painter and had once hoped to build a professional life as an artist before turning to journalism, goes on to contrast the private pleasures of landscape painting with the dissatisfactions of his

96. Carl Jacob Lindström, *The English Landscape Painter*, 1830, watercolor, pen, and ink, 19.3 x 28.5 cm. National Museum, Stockholm.

career as a professional writer, a career which positioned him at the heart of those transformations within the liberal "bourgeois public sphere":

> In writing, you have to contend with the world: in painting, you have only to carry on a friendly strife with Nature. You sit down to your task, and are happy…at peace with your own heart. No angry passions rise to disturb the silent progress of the work, to shake the hand, or dim the brow; no irritable humours are set afloat: you have no absurd opinons to combat, no points to strain, no adversary to crush, no fool to annoy—you are actuated by fear or favour to no man.
>
> I have not much pleasure in writing these Essays, or in reading them afterwards…But after I begin them, I am only anxious to get to the end of them…I sometimes have to write them twice over: then it is necessary to read the *proof*, to prevent the mistakes by the printer; so that by the time they appear in a tangible shape, and one can con them over with a conscious, sidelong glance to the public approbation…they have become "more tedious than a twice-told tale."[19]

It is otherwise with the act of painting. In several passages which might have struck a chord with John Constable,[20] Hazlitt represents the practice of land-

scape painting as a process of continual discovery: "One is never tired of paint-
ing, because you have to set down not what you know already, but what you have
just discovered.…There is a continual creation out of nothing going on. With
every stroke of the brush, a new field of inquiry is laid open; new difficulties
arise, and new triumphs are prepared over them"; and, as a process, later
described by Gombrich with Constable very much in mind, that of "making and
matching": "By comparing the imitation with the original, you see what you
have done, and how much you have still to do."[21]

> In tracing the commonest object, a plant or the stump of a tree, you learn
> something every moment. You perceive the unexpected differences, and dis-
> cover likenesses where you looked for no such thing. You try to set down
> what you see — find out your error, and correct it. You need not play tricks, or
> purposely mistake; with all your pains, you are still far short of the mark.
> *Patience* (my emphasis) grows out of the endless pursuit.[22]

Hazlitt shares a romantic love of retrospection (he had after all given up
painting for journalism) and nostaglia for a lost childlike innocence. While the
polemical journalist must contend with the affairs of the world, where juggling,
sophistry, intrigue, tampering with the evidence, attempts to make black white,
and white black are all too common, the landscape painter has nothing to do but
resign himself to the "hands of a greater power, that of Nature, with the simplic-
ity of a child and the devotion of an enthusiast." For Hazlitt, painting represents
private fulfillment and completion:

> The mind is calm and full at the same time. The hand and the eye are equally
> employed…The hours pass away untold, without chagrin, and without
> weariness; nor would you ever wish to pass them otherwise. *Innocence is
> joined with industry, pleasure with business; and the mind is satisfied, though it
> is not engaged in thinking or doing harm* (my emphasis).[23]

Constable, whose own self-representations reveal a far more troubled and
complex set of attitudes to his practice as a landscape painter, might have agreed
with some of Hazlitt's sentiments, but he is unlikely (even if reluctantly) to have
concurred with the idea that a landscape painter does not have to "contend with
the world" or that he does not think while he works, an idea which Hazlitt inher-
ited from academic theory, which held that the imitation of nature does not
require superior mental faculties. Far more appealing for Constable would be the
idea of the artist "heroically" contending with nature and his means of represen-
tation — "with every stroke of the brush, a new field of inquiry is laid open; new
difficulties arise, and new triumphs are prepared over them."

Such ideas had implications for women artists, either as amateurs or, more
exceptionally, professionals. Because landscape painting or, better still, landscape
drawing could be represented as a purely imitative art — a matter of copying

97. "Morning Dress," hand-colored engraving from *The Repository of Arts*, November 1824. Yale Center for British Art, Paul Mellon Collection.

nature with some selection and arrangement—and as an essentially private art form, it could be recommended for women. Indeed, the main "business" of commercial promoters of landscape painting like Rudolph Ackermann was directed towards the encouragement (and selling) of landscape drawing as a desirable occupation or accomplishment for women. Many of Ackermann's publications were designed to directly appeal to women, including the *Repository of Arts*, whose principal readers were being defined as "female" by at least 1812.[24] In 1824 the *Repository* included a fashion plate showing a young woman sketching from nature (fig. 97) which suggests a certain combination of "innocence" and "industry," "pleasure" and "business," and a satisfied if "unthinking" mind. More importantly, it presents an image of a young woman absorbed in a practice which instills "patience" and prevents "mischief-making"; but we are surely not meant to imagine her as doing anything like contending with nature and art in "heroic" terms.

In 1823 the author of an essay on the "Pleasures of Drawing" in the *New Monthly Magazine* begins by complaining of the noise made by a young lady next door, whose continual practice on the piano—like thousands of other daughters across the country—disturbed his peace. Instead he advocates the practice of landscape drawing: it is silent and it does not force itself upon the attention of men (you may shut your eyes if you do not like it). Landscape draw-

ing represents the ideal bourgeois accomplishment: "it is not a theatrical acquisition: it does not exhibit a tender female contending in a hot room for the applause of an unknown crowd; her bosom rankling with envy, or swelling with ambition; it does not make our wives and daughters public characters, nor infringe on the sex's first charm, its retiring modesty." Moreover, it is inexpensive, consumes little time, and its produce can be accumulated and stored away to provide future pleasure.[25] Similar views, expressed in a more diffuse and pervasive form, can be found in the *Repository of Arts*, whose principal purpose was to provide models for the "reform" and "improvement" of modern fashionable life. "Proper" notions of decorum and modesty were always inculcated for the benefit of a female readership. Its exhibition reviews of women's work were always restrained and modest in their praise; the (female) amateur was never "confused" with the (male) professional artist.

Not that we find such heroism in Lindström's 1830 caricature (fig. 96) of this dandified poseur, an English "paysagiste" in Rome, encumbered with the "modern" instruments (graphic telescope and camera lucida) for delineating nature with a "scientific" accuracy, although we might stretch a point by imagining Baudelaire's "modern hero," the urban "flaneur" on a sketching holiday. But while Hazlitt's artistic subject is engrossed with his private difficulties in "seeing" and "representing" nature,[26] both the Ackermann fashion plate and Lindström's caricature have more to do with forms of self-display and commodification—the display of the body and dress of painting "subjects," not displays of natural, or even unnatural, landscape scenery. But there is a crucial difference—the young woman in the fashion plate is not even looking at the landscape she is sketching. She is not presented as the bearer of an active "look," she is represented as the "modest" object of the viewer's gaze and as part of a commodified "nature" to be "consumed" in private, while the young man, equipped with all the tools necessary for the "scientific" mastery of the art of looking at nature, exhibits himself for public admiration.[27] Man is the surveying "subject," woman the surveyed "object." But just as the idea of "a tender female contending in a hot room for the applause of an unknown crowd—her bosom rankling with envy, or swelling with ambition" was regarded as threatening and transgressive of bourgeois notions of femininity—so too could the display and exhibition of the body (including his "body" of pictures) of the male artist excite feelings of disquiet and anxiety, as we have seen in the case of *European Magazine*'s anxieties about English artists "exposing" themselves in a public space defined in terms of the marketplace and the exhibition. If we are invited to admire, or to want to purchase, the young woman's dress and the materials for drawing that go along with it (or perhaps the young woman herself on the marriage market), we might also see something of the vanity, and what Hazlitt called "the delusions of self-love," in the figure of the fashionable English landscape painter abroad.

In his essay "On the Pleasure of Painting," Hazlitt argued that a dedication to the direct imitation of nature is preferable to the painting of imaginative landscapes, because "the test of the senses [empirical making and matching] is severer than that of fancy, and an over-match even for the delusions of self-love."[28] Hazlitt's reservations about the vanity, self-love, or self-interest of English landscape painters were echoed elsewhere in the press. An 1831 essay, "On Genius for Art," in the *Library of Fine Arts* describes

> a class of young men who adopt the profession…as a refuge from the tedium of idleness and the labour of learning…they seize the brush and pallette and cover a few squares of canvass with libels on the human face, or cabbage stalks set in a grass plot; they then dub themselves artist, and make that title the excuse for spending time and money unprofitably; visiting the Lakes, or perchance even Italy…They are as insensible to shame as they are incapable of improvement; and thus miserably waste all the energies such characters possess in multiplying abortions of form and colour, and bringing the profession of an artist into disrepute."[29]

Constable is well-known for his dislike of fashion—fashion endangers the masculinity of the artist.

If Hazlitt was in a position to compare the pleasures of landscape painting with the disadvantages of a journalistic profession which meant a constant engagement with the public and public opinion, a slightly earlier essay, "On the Superiority of the Painter's Feelings," in the *Repository of Arts* for 1817 provides another example of the way the private pleasures of landscape and the superiority of the (male) painter's feelings for nature could be set against some notion of more "public" enjoyments and spaces. This essay stresses the intellectual, but private, pleasures of landscape viewing: "To indulge in the contemplation of the pure scenes of pastoral nature, to pore over the near and distant landscape, and to watch the gradations of light and shade on the surrounding scenery, have ever been the highest enjoyment of those on whom Providence has lavished the luxury of intellect."[30] Here the writer reworks a more traditional, classical topos, that is, the pastoral landscape as a form of retirement from the constraints, responsibilities, and dissipations of public (urban) life, updating it, after Addison, where "public" life is more ambiguously interpreted in terms of the dangers and dissipations of fashionable upper-middle-class or aristocratic life.

In this essay "the luxury of pleasing emotion which the lover of Nature feels in the contemplation of her grand or serene exhibitions" is said to be far superior to the pleasure of greeting a hundred so-called friends in the drawing room, *and the air is purer*. But if these higher pleasures can be appreciated by those of "common capacities" (as distinct from the vulgar classes), they are most exhilarating and enlightening to "the soul of the poet and painter." The example of early Gainsborough is invoked in a representation of the "Natural" painter

whose solitary pursuit of nature during his Suffolk years erased/eased "all emotions arising from disappointed patronage, or the fears of cold neglect." Such unpleasant ideas were "neither thought of nor heeded"; Gainsborough "drew for pleasure alone"; his feelings "were as pure and serene as the landscape he was sketching." Men in tune with nature "often feel themselves constrained in the drawing room [a feminine space]…Their manners are not found to glitter with that polish and small talk which others possess who have not made Nature their study." They have not "had time to achieve those arrangements that are made at the toilet, nor have they learned the thousand unmeaning things, which please from their flattery."[31] A later representation of the character of Richard Wilson in the *Repository of Arts* (1826) made much the same point, describing him as having a refined and intelligent mind, but with coarse and repulsive manners.

The *Repository* essay also contrasts the transient and paltry pleasures of the fashionable ballroom, concert-room, or the theater to the "superior" and constant pleasures of contemplating the beauties of *one spot* at different times of day, under changing effects of light, colored immediately from nature, as in a scene by Girtin, Gainsborough, Turner, or Varley, which are to be enjoyed by the true poet, painter, or enthusiast of nature. The reader is invited to share the artist's sensitive response to nature, where "the valley, the foreground, and the distance, which were lit up by the morning sun, at even glow with another charm, they form another study; they vary as the sun tinges the horizon or recedes from the eye, until the whole outline is melted into vapour," while being reminded of her, or his, predilection for fashionable pursuits. Morning scenes are said to offer "the most luxurious feelings" and "pure delight," but the "most grateful aspirations" are to be "breathed in the repose of silence and the dusk of evening."[32] The repose of silence and the dusk of evening were decidedly absent from public exhibition spaces, if the all too common complaints about the glare and crowds associated with such events are to be credited. Yet it was to the public exhibition that increasing numbers of aspiring landscape painters looked for the "public" recognition of the superiority of their "private" feelings in the face of nature. For the landscape painter an engagement with the public was essential, while for many members of the public, the "private" enjoyments of landscape painting could be experienced only in crowded exhibition spaces.

The Exhibition, Publicity, and the Bourgeois Public Sphere

From their inception in 1760 public art exhibitions in England were conceived of as sites for the public display of the productions of artists working in a variety of media and genres at different stages of their careers and for the formation of public opinion and taste—for example, the Society of Artists of Great Britain, where the purpose of the exhibition was to raise artists "to Distinction who otherwise might languish in Obscurity and that their several Abilitys may be brought to Publick View."[33] Significant to my purpose here is the point that the

exhibited works were also referred to as "Performances" (as at a theater) for which the public regard might be "modestly Sollicited" and the "Publick Eye Attracted to Merit." Judges and Patrons may have "at Once under their View the present *State* of Art in England" (my emphasis) and may improve their taste by "comparing works of different Performers."[34] Despite disclaimers to the contrary, competition between individuals for public attention was at the heart of the exhibition and at the heart of the "State," not the "Republic," of Arts in England.[35] The founders of the Royal Academy also recognized the relationship between the exhibition and the formation of public opinion: "an Annual Exhibition, open to all artists of distinguished merit, where they may offer their performances to *public inspection* [my emphasis], and acquire that degree of reputation and encouragement which they shall be deemed to deserve."[36]

The early decades of the nineteenth century saw the multiplication of annual public and private exhibitions competing for public attention. Competition between established artists, as represented by the Royal Academy, and the patrons and connoisseurs, as represented by the British Institution, with their rival exhibitions and "schools" was a prominent feature of the period c. 1805–20. This institutionalized the struggle for power over the right to control the art world, especially in terms of establishing and controlling the frameworks within which members of the public were "free" to form their judgments and opinions. With the growth in the numbers of artists (including landscape painters) vying for attention in the ever increasingly crowded exhibition spaces, the adequacy of existing institutions to meet the needs of artists and the expanding range of spectators was frequently called into question. From the viewpoint of the Royal Academy, John Opie expressed the fear that competition for public attention diverted the artist from his true pursuit of excellence: "In a crowd, he that talks loudest, not he that talks best, is surest of commanding attention; and in an exhibition, he that does not attract attention does nothing."[37] Many critics were quick to point out that such conditions led to the production of gaudy pictures designed solely to attract attention in overcrowded exhibition conditions. By the 1810s the average number of exhibits at the Royal Academy had risen to over one thousand; the first exhibition of the new Society of British Artists (set up explicitly to meet the needs of increased numbers of painters) in 1824 included 754 works.

The public exhibition also gave rise to new forms and spaces for the "public" discussion of art — newpapers, pamphlets, periodicals, and books, with the critic or reviewer increasingly taking on the role of opinion-maker and mediator between the artist and a range of different publics, each of which were in some degree interpellated as "ideal" readers and viewers of certain kinds. The relationship between the public art exhibition and *publication* could be represented as being entirely interchangeable. John Landseer, an engraver of landscapes and an art critic, even went so far as to state that an exhibition of a picture is a mode of publication (*Review of Publications of Art*, 1808) while the *Library of Fine Arts*

(1831) described the exhibition as the artists' "proper periodical." Landseer, it may be remembered, produced an extended critique of the landscapes exhibited by Turner in his private gallery in 1808. Publication in the form of engraved views was—for Turner as for many other landscape painters, including those marketed by Ackermann—one of the most important means of reaching a wider public.

William Paulet Carey who wrote for the *New Monthly Magazine* in the 1810s and for the *Repository of Arts* in the late 1810s and 1820s was one of the most voluble writers on the fine arts at this time. Both magazines were politically conservative and very warm in their opposition to political reform. Carey stressed the importance of the press in the formation of public opinion in all matters, including the fine arts:

> in literature, the arts, customs, and morals, in religion, legislation, and politics, the press exercises so ample an influence in this country, that an institution [like the British Institution] which purposes to effect a revolution in public opinion and to overcome deep-rooted prejudice, without the direct and active co-operation of the press may be likened to an army, which has marched to battle without its artillery.[38]

In 1826 the *Repository of Arts* printed Carey's essay, "Observations on the Spirit of Individuality as Distinguished from Public Spirit," which sums up the ethos of this magazine in the 1820s.[39] From the late 1810s the *Repository* began to draw attention to the disadvantages of public exhibitions at the Royal Academy and the British Institution in favor of the "public-spiritedness" of individual patrons of British art, like Sir John Leicester and Walter Fawkes, for opening their private galleries to the public. In 1819 Carey had produced a *Descriptive Catalogue* of the pictures in Leicester's collection, and he was responsible for publicizing and reviewing Leicester's gallery in the *Repository of Arts*.

Carey's 1826 essay can be considered as an attempt to provide a redefinition of "public-spiritedness" in terms which accommodate both private interests/sensibilities and some notion of the "public" good:

> the public spirit which elevates the man into a benefactor of his country; turns the force and bearing of his better passions and private interests into a parallel direction with the interests of the state, without loss or injury to himself; delights in multiplying the excitements to benevolence and philanthropy, by confering public applause on the deserving; and is, in all its tendencies, actuated by the good of the whole people.

In his essay Carey defends the publication of, or publicity given to, individual acts of benevolence or charity and, by implication, to individual artists and individual works of art, on the grounds that the broadcasting of such acts works for the greater social good by stimulating other individuals to emulate those actions—the honorable report of one good action makes many. It is the duty of

the periodical press to influence, and give voice to, public opinion by censuring evil and applauding good:

> to emblazon merit deservedly, is to invigorate the excitements to public service, to increase the moral means of the state, and to multiply the number of candidates for approbation by a liberal patronage of the sciences and fine arts. The fair praise bestowed on the hero, the patriot, or the munificent patron of native genius; on the genuine poet, painter, sculptor, or actor, should not be regarded in the narrow light of a compliment of a friend or interested flatterer, or as gratifying the individual alone, but, because in rousing a noble emulation, and multiplying competitors for celebrity in the public service, the *just applause bestowed on one becomes a good to all* [40] (my emphasis).

Carey's model of the public man is the benevolent man who dispenses private charity without the "false modesty" of wanting to keep his benevolent action from the public eye. Our benevolent desires are "not meant to be indulged in privacy and loneliness without an eye to witness or a tongue to give our actions utterance as an example to the world." It becomes a Christian duty to publicize such actions because "Noble and generous actions operate as patterns, which inspire those who witness or hear of them with a laudable emulation; and by their publicity, become the means of multiplying the virtues in an unlimited circle." Although those in the best positions to act benevolently, especially as patrons of the fine arts, might well belong to the landed classes (those whose "independence" would have qualified them for membership in the civic humanist "body of the public"), Carey's definition of the "public-spirited" man (or woman?) is not intrinsically tied to landownership. Only in the final paragraph does he introduce a metaphor of the land, a metaphor linked to the increased production of "improved" farming practices where "public commendation, justly bestowed on a meritorious individual, excites others to imitate his public spirit, and operates like a rich manure on a cold and exhausted soil, producing abundance in the ensuing harvest"[41] (see fig. 2, Constable's *The Stour Valley and Dedham Village*, 1814). In light of my introduction I would suggest that we can see in Carey's argument some critique of the older liberal humanist concept of "public" man, metaphorically represented here by the "cold exhausted soil" of England. In any case the publicity which makes public the actions/works of private individuals and public approval, i. e., "public opinion," alone can reinvigorate the depleted "public spirit" of the landed elite.

Landscape Paintings as Pleasurable Commodities and How to Enjoy Them: The Repository of Arts *as a Pattern Book*

We can illustrate how landscape functions within these discourses if we return to Rudolph Ackermann. Ackermann was a major promoter of watercolor painting and drawing, especially for amateurs. His *Repository of Arts* magazine consistently

favored the practice of naturalistic landscape painting [42] and always championed the superior powers of the professional artist, thereby offering him both publicity and the potential for profit. Between 1809 and 1828 the *Repository* was at the forefront in promoting the opinion that the "English School of landscape painting" has "come to be of the first rank."[43] Although it still paid some lip service to the idea of painting as a liberal art and the traditional hierarchy of schools and genres, it often gave landscape painting the greatest notice and praise. As suggested above, the private pleasures of landscape painting could be represented as a means of countering or reforming the more dissipated splendors of upper-class fashionable "public" life.

Ackermann represents the private entrepreneur who advertised and publicized the splendors and pleasures of landscape painting for his own profit while claiming that he was working for the public good. Unlike Fuseli he celebrated the "improvements" made possible by the expanding commercial wealth of Britain, utilizing his many publications to display modern forms of "private splendour" and "public grandeur." Although Carey's essay appeared late in the publishing history of the *Repository of Arts*, it provides a useful model for understanding the aims of Ackermann and the *Repository* as a whole. Ackermann could justifiably present himself as a "public" benefactor because he gave publicity to individual patrons and artists, thereby providing patterns for the emulation of others for the "good" of British art as a whole. He also served the interests of the state and himself by running a profitable business. In its exhibition reviews the *Repository* was generous in the publicity it gave to the efforts of English landscape painters, but it often expressed even greater satisfaction on noting the multiplication of the numbers of exhibitors and exhibitions — a harvest based upon increased production provides the best proof of the "progressive" advancement of British art. The *Repository* welcomed the multiplication of exhibitions because they represented the best means of awakening public attention and approval. In 1819 it declared that: "the time is fast approaching when, *as it was in Athens*, it will be impossible for a man to be great, and at the same time obscure" (my emphasis), thus apparently conflating older and newer notions of "public" man. This reviewer adds that: "neither a poet nor a painter can any longer remain in obscurity, provided they address the public through the medium of their own legitimate work."[44] For the *Repository* the new opportunities for exhibition and publicity meant that it would be impossible for the mind of a future "Barry" to "work its own ruin by brooding over neglect and disappointment" (a point Haydon would not have appreciated). It would seem that the production of "public" art no longer depended upon painting history, but upon the production of models for the emulation of others (in any genre) and by attracting public attention and approval (getting your name in the papers).

At the same time the *Repository* came to be increasingly critical of the crowded conditions in the larger public exhibitions, especially when private col-

lectors like Leicester and Fawkes began to open their galleries to more select sections of the public. In 1819 it described the viewing conditions at the Royal Academy where "the walls are so covered with works in every degree of merit, that the pictures may be rather said to be viewed *en masse*, than examined with any particular or scrupulous attention"; where the "eye is so dazzled at one moment by a blaze of colour on the canvas, and then diverted from the pictures to the company so that it is absolutely impossible to get a calm and steady view, so as to appreciate the real merit of the work."[45] Praising the public-spirited benevolence of such private individuals of rank and taste as Leicester and Fawkes for throwing open their picture galleries to public view, the writer suggests that when "a picture-gallery becomes a fashionable lounge, the art itself steals insensibly on the imagination, and captivates the mind by the richness and variety of its moral energies."[46] Thus the seductive moral and aesthetic effects of paintings are best experienced in the space of the private gallery—a view shared by Hazlitt, although he certainly would have disapproved of the private gallery as a fashionable lounge.

Ackermann was in the business of selling cultural commodities: the "Repository of Arts" was both a show/sales-room situated in the fashionable end of London and a fashionable magazine-cum-catalogue which advertised the wares of Ackermann and other producers of luxury goods. With the monthly publication of the *Repository of Arts*, Ackermann hit upon a solution to the problem of accommodating his own private commercial interests with the promotion of what he regarded as the greater public good, including the promotion of British artists and a national school of art. In addition to the aforementioned publicity for artists, patrons, and collectors, this included: keeping up the pressure for the war effort until the final defeat of Napoleon in 1815; serving the ideological needs of the Prince Regent, later George IV; and serving those interests and needs of the land- and property-owning ruling classes as part of the establishment of a hegemonic order. Ackermann's publications pictured a nation united by an identity of different interests within a "natural" social order, based upon traditional hierarchical power structures, while at the same time celebrating the modern improvements made possible by an expanding commercial and industrial economy—whose public and private benefits included both the modernization of London and the improvement of the rural landscape. Above all, the *Repository* could be used to publicize and advertise the growth of opportunities for commercial enterprise and consumerism, facilitating the purchase of fashionable commodities, including works of art.

As a capitalist producer Ackermann needed to create a demand for his goods—a demand based upon the promise of pleasures which could be satisfied through the purchase of commodities and the adoption of a certain leisured lifestyle and set of attitudes, ideas, and ideologies. But it was a business which also depended upon the continual deferral of complete satisfaction and the cre-

ation of new demands. The promise held out by his drawing books and the impossibility of the amateur ever reaching the changing standards of professional practice in landscape painting might be seen as an example of this. Turner's work, with very few exceptions, was always well received and his "genius" represented in terms of a magical transcendence and captivating pleasure. But if Ackermann wanted to create a body of desiring consumers, he also wanted to establish clear limits and boundaries on the way and the extent to which they were to enjoy the pleasures to be acquired through the consumption of art, a matter of considerable importance when many of his readers/consumers were being defined as female. An example of the way the *Repository* used the pleasures of the picturesque landscape to control the excesses of vivid imagination and the exotic oriental pleasures of a Byron can be found in the 1817 essay, "On the Superiority of the Painter's Feeling." The writer describes the informed spectator's delight in:

> a green lane, not burnished by the light of day, but dimly lit…The shadows of the trees thrown across its many ruts, the distant gale, the cottage in the dell, with its blue curling smoke; or as he mounts the slight ascent, a distant spire peeping between the trees and backed by the hills, in unison or *keeping* with the blue horizon — the road-side clump of earth, on which a red-waist-coated rustic reposes and breaks the fore-ground — an irregular piece of transparent water, with a decayed or vegetative trunk stretching across it, and its strong reflected forms in the glass beneath — the lengthened shadows of eve, the clearing of a misty morn — or the preparation of Nature for her repose in twilight and in night.[47]

The reader is persuaded that a landscape by Gainsborough, or one of his successors, possesses greater charms than "all the prismatic hues thrown from a hundred lustres and forming the splendour even of an 'Arabian Night.'" The exotic, oriental "Other" is no match for the picturesque beauties of the English countryside.[48]

The *Repository of Arts* provided a pattern-book for the "reform" and "improvement" of the more opulent members of society, most of whom were represented as belonging to property- and land-owning families and a pattern-book for emulation by newly-enriched members of society. Like Ackermann's drawing books it established the outlines, the shading, and some of the coloring for the successful negotiation of modern upper-class social life, where the acquisition of cultural and artistic knowledge was as essential as the correct dress and furniture. The essay, "On the Superiority of a Painter's Feeling," appeared in the second series of the *Repository of Arts*. The leading article at this time (1817) was Papworth's "Architectural Hints," descriptive of rural residences. In opening this series, Papworth drew the distinction between the "splendid edifices" erected by public bodies as permanent monuments to the glory of our cities and England's country scenery, which is "converted by the taste of [private] individuals into an exten-

sive and embellished garden." The reader of the essay on the superiority of the painter's feelings was also being modeled as a consumer of improved country cottages and villas. She is likely to have read the description of a new cottage provided in this number, and she would find, a few pages later, a plate and description of the new penitentiary at Westminster. Here the text stresses the need to reform the "miscreant": "to correct the abandoned by habits of industry, by regularity, and by religious instruction, so that when the abridged term of his castigation shall be over, he shall be restored a reformed and useful member of society worthy of the protection of those whom he had formerly violated."[49] Some ten pages further on comes the review of the landscapes at the British Institution exhibition, where artists are offered hints for their progress and improvement while being reminded that an artist's life is to be filled with "toilsome and unremitting observation and industry."[50]

I want to conclude by returning to Carey's metaphor of manuring and Constable's representation of *The Stour Valley and Dedham Village* (fig. 2) — which was exhibited in 1815 — in order to suggest how Ackermann's publications may have provided frameworks and patterns for looking at the rural English landscape. Constable's picture was painted for a young woman to remind her of her agrarian background on her marriage and removal to London. The *Repository of Arts* was from the beginning designed for a female readership, although it was also intended to have some appeal for the male reader. In the first series from 1809–1815, agrarian improvement was presented as a matter of considerable interest and importance. There was a monthly agricultural column, and a number of prize essays on subjects like "On Waste in Agriculture" or "Agriculture with a View to the Application of our Knowledge of the Arts and Science to Its Improvement" were printed. Capitalist investment in improved farming practices was advocated, as was the enclosure of common land and the application of lime and manure to improve the fertility of the soil. While the exhibition reviews of rural English scenes rarely made such connections, they occasionally alluded to the pleasing associations of a productive rural economy. Rosenthal claims that Constable's landscape with a prominent dunghill in the foreground would not have been understood by visitors to the Royal Academy exhibition in London,[51] but I would argue that such associations were well within the capacity of many of the fashionable readers of the *Repository of Arts*, even if the magazine did not notice Constable's work that year.

However, by 1815 the readers of the *Repository* were being encouraged to adopt a more "picturesque" attitude to the rural landscape. The essays on agriculture ceased to appear by 1812, although the short monthly agricultural column was continued until the end of 1815. In 1812 the *Repository*'s political column was beginning to report the urban and rural unrest associated with the machine-breaking of the Luddites in the North. In the artistic field 1812 was the year marked by the commercial failure of the first watercolor societies. At this

time, as if in response to both events, the *Repository* began to publish a series of articles on the history of watercolor painting and to include W. H. Pyne's rustic figures for appropriation into landscape scenery. Unlike the unruly industrial laborers described in its political columns, these figures could be manipulated to suit such scenes as the female amateur deemed appropriate: "the gleaners may be appropriated to the embellishment of various landscape subjects, either in a field, in a lane, or immediately before a cottage; for being attired in rustic costume, they will suit any picture of the common pastoral character."[52] At the end of the Napoleonic War and in the context of the upsurge in rural unrest caused by declining agricultural profits, Ackermann published Francis Stevens's etchings of *Views of Cottages and Farmhouses in England and Wales* in 1815 and Elsam's *Hints for Improving the Condition of the Peasantry* in 1816, both of which were publicized and advertised in the *Repository of Arts*.[53]

Like the *Repository*, *Views of Cottages* claimed that the development of watercolor painting was largely the result of the influence of upper-class women "who spread the taste to the gentlemen." Like the *Repository* it stressed the importance of seeing rural nature through the (male) painter's eyes. The amateur was being invited to confine her studies to the imitation of picturesque farmshouses and cottages as produced by professional painters like Stevens, Varley, and Prout. The text also publicized/advertised the "superior" vision in the work of Turner which enabled him to convey the awefulness and sublimity of *Land's End* for Cooke's *Southern Coast* series. Like the *Repository* it also stressed the importance of coloring "on the spot."

But unlike the first series of the *Repository*, *Views of Cottages* deplored the way capitalist agrarian improvement had destroyed the old rural values based upon paternalistic ties of responsibility and loyalty. The dilapidated farmhouses were presented from a close-up viewpoint, focusing upon the timeless, domestic, peaceful, and productive performance of everyday tasks by contented members of the rural lower classes. Each etching was intended to provide a model for the emulation of others, both in terms of landscape drawing and the adoption of particular ways of looking at the rural landscape. The text accompanying a view of a cottage in *Huntingdonshire* (fig. 98) is suggestive of the way this publication may have functioned to "fashion" a public for some of the landscapes of Constable: "The cattle cooling themselves in the plashy brook, denote the time to be mid-day...Nothing but colouring is wanting to render this a finished picture of the English pastoral class." "Every part of the composition corresponds with one sentiment, that of a spot sequestered from the habits of a populous town."[54] Only one image, that of a row of cottages in Rutlandlandshire presents anything remotely indicative of an "imperfect" world (fig. 99) — the figure of the man with a wooden leg, perhaps lost as a result of using a scythe in harvesting or in fighting for his country, seated by the roadside with his wife beside him. The accompanying text makes no reference to his presence at all: "Neatness and comfort may

98. Francis Stevens, "Huntingdonshire, Orton," etching from *Domestic Architecture*, London, 1815. Yale Center for British Art, Paul Mellon Collection.

be supposed, with very little exertion of the poetic fancy, to reside in these humble cots." It is difficult to tell whether the standing figure is regarding the man as an object of charity or not, but in any case the couple are represented as being contented with "accidents" of picturesque nature. We might conclude that this figure was intended to evoke pleasurable moral feelings of charity and benevolence in the mind of the private viewer; or perhaps the injured man is merely "picturesque" staffage meant "to be looked at in passing but not central to the pressing concerns of life."[55] The design is described in the text as "simple, rural and agreeable, exciting none but happy associations."[56] Among those "happy associations" perhaps we could add something of Carey's notion of public action as private benevolence made public, or in terms of the "public" good ensuing from the broadcasting of approved models for the emulation of others.

From 1815 Ackermann's publications avoided anything that was overtly political (its political column was discontinued at the end of 1815) or disruptive of social order. Although the *Repository of Arts* never suggested that landscape painting and drawing was "cheap," the *New Monthly Magazine*'s "Pleasures of Drawing" of 1823 provides a good summary of an ethos promoted by Ackermann's publications: "The contemplation of Nature is a perpetual and a cheap gratification; improving the heart while it cultivates the mind, and abstracting us from the view, as it helps to guard us against the intrusion, of those cares, against

99. Francis Stevens, "Rutlandshire, near Uppingham," etching from *Domestic Architecture,* London, 1815. Yale Center for British Art, Paul Mellon Collection.

which it requires all our watchfulness and attention to shut the door."[57] Landscape painting may not have been "central to the pressing concerns of life," but it had an important part to play in keeping those concerns at bay.

As my examples have suggested, we can find in the periodical press of the early nineteenth century many attempts to provide clear-cut distinctions between "the public" and "the private" spheres, where the practice of landscape painting and drawing is very definitely positioned within the private sphere. But I would argue that we need to go beyond a conception of the "public" in civic humanist terms—as in the "ideal" but unrealizable formation of a "republic" of art—to look more closely at notions of publicity and the role of the press and exhibitions in the formation of "public opinion" or a "public consensus," if not in a direct Habermasian political sense, then in the sense of the formation of some public agreement in relation to the "state" of the arts. By drawing upon Hazlitt's and Carey's essays and by looking at the publications of Ackermann, I have tried to suggest that we need to extend our understanding of the complexity of historically specific conceptions of "the public" and "the private" and to examine more closely the complexity of the relationships between the two.

1 "The Exhibition, Royal Academy," *Monthly Magazine*, June 1825, 432.

2 Michael Rosenthal, "Landscape as High Art," in Katharine Baetjer, ed., *Glorious Nature: British Landscape Painting, 1750–1850*, exh. cat. (New York: Hudson Hills, 1993), 28.

3 Ibid., 27–28, where the Fuseli quotation is taken from Barrell's *The Political Theory of Painting from Reynolds to Hazlitt* (New Haven: Yale University Press, 1986).

4 A term which came into use in France and England at the end of the eighteenth century. My impression, based on reading early-nineteenth-century periodicals and journals, is that it was not widely used at this time.

5 Rosenthal, 13, 28.

6 See Jürgen Habermas, *The Structural Transformation of the Public Sphere: An Inquiry into a Category of Bourgeois Society*, trans. Thomas Burger (Cambridge: MIT Press, 1989); Craig Calhoun, ed., *Habermas and the Public Sphere* (Cambridge: MIT Press, 1992). See also F. Ward, "The Haunted Museum: Institutional Critique and Publicity," *October* 73 (Summer 1995): 71–78. Ward defines publicity as "the medium, not only for art, but for all those practices of intervention in the economies of cultural production and reception that go to realize conceptions of the public sphere. Publicity in this sense includes not only the familiar forms of corporate advertising and state propaganda, but such diverse cultural practices as, for example, museum exhibitions" (72).

7 Ann Bermingham's brief summary in the context of a review of Andrew Hemingway, *Landscape Imagery and Urban Culture in Early Nineteenth-Century Britain* (Cambridge: Cambridge University Press, 1992) in the *Art Bulletin* 76, no. 2 (June 1994): 371. Habermas: "By 'the public sphere' we mean first of all a realm of our social life in which something approaching to public opinion can be formed. Access is guaranteed to all citizens. A portion of the public sphere comes into being in every conversation in which private individuals assemble to form a public body" — quoted by G. Eley in *Habermas and the Public Sphere*, 289.

8 See K. M. Baker "Defining the Public Sphere in Eighteenth-Century France: Variations on a Theme by Habermas," in *Habermas and the Public Sphere*, 183.

9 My thanks to Michael Rosenthal for reminding me of this.

10 "The Catalogue Raisonné of the British Institution," *The Examiner* (3 November 1816). Reprinted in P. P. Howe, ed., *The Complete Works of William Hazlitt* (London: J. M. Dent, 1930–34), 18:110.

11 "Remarks on English Manners, Literature, the Fine Arts, and the Drama. By a German Traveller," *New Monthly Magazine* 13 (May 1820): 565.

12 [Hazlitt], "Review of Farington's *Memoirs of the Life of Sir Joshua Reynolds* (1819)," *Edinburgh Review* (August 1820): 102.

13 Roughly 195 landscape subjects (including views) were exhibited at the first Society of British Artists Exhibition in 1824. This count is based on a total of 580 paintings and drawings listed in the exhibition catalogue but excludes an estimate of the number of landscapes among the 173 exhibited engravings. Landscape artists most prominently associated with the Society include T. C. Hofland, W. Linton, J. Glover, C. Stanfield, P. Nasmyth, and J. Stark.

14 "Society of British Artists," *The Literary Chronicle*, no. 275 (21 August 1824). By this date the exhibition had realized nearly £4,000 in sales and raised approximately £2,000 in donations. See Hemingway, 134–38.

15 *European Magazine*, April 1824, 371; William T. Whitley, *Art in England, 1821–1837* (New York: Hacker, 1973), 91.

16 Letter to Miss Mitford in 1825, in William T. Whitley, *Thomas Heaphy (1775–1835): First President of the Society of British Artists* (London: The Royal Society of British Artists' Art Club, 1933), 27.

17 One of a group of four playing upon notions of national difference; the others include the French, German, and Italian landscape painter (reproduced in exh. cat., *Romanticismo: il nuovo sentimento della natura* (Milan: Electa, 1993), 128–29. The inscription here reads: "The Effect I am Sure of when first I have the lineaments."

18 First published in the *London Magazine* (June 1820), reprinted various editions. Hazlitt writes more generally of the pleasures of painting from nature. I am interpreting this as primarily associated with landscape painting, although I recognize that Hazlitt himself mainly painted portraits.

19 William Hazlitt, *Selected Writings*, ed. Ronald Blythe (Harmondsworth: Penguin, 1987), 66–68.

20 It is not my purpose to argue for any direct links between Hazlitt and Constable but rather to suggest a range of possible shared attitudes.

21 *Selected Writings*, 68–69, 66.

22 Ibid., 66.

23 Ibid., 66–67.

24 "Figures for Landscape," *Repository of Arts* 8 (October 1812): 244. Women, that is, "upper class ladies," were also described as having been primarily responsible for encouraging the "gentlemen" to take up an interest in watercolor. This claim appears in an early "history" of English watercolor painting published in the *Repository* in 1812 and 1813, where all of the principal innovators are men. See "Observations on the Rise and Progress of Painting in Water Colour," *Repository of Arts* 8 (November, December 1812) and 9 (January–April 1813).

25 "Pleasures of Drawing," *New Monthly Magazine and Literary Journal* 8 (1823): 385–92.

26 *Selected Writings*, 72, where Hazlitt's artist learns to see and understand "the texture and meaning of the visible universe, not by the help of mechanical instruments, but [through] the improved exercise of his faculties."

27 See Ann Bermingham, "The Aesthetics of Ignorance: The Accomplished Woman in the Culture of Connoisseurship," *Oxford Art Journal* 16, no. 2 (1993): 3–20, for a discussion of points similar to those raised here.

28 *Selected Writings*, 69.

29 "On Genius for Art," *Library of Fine Arts* 1, no. 5 (June 1831): 389.

30 "On the Superiority of the Painter's Feelings," *Repository of Arts*, 2nd ser., 3, no. 3 (March 1817): 140–42, 140.

31 Ibid., 140–41.

32 Ibid., 142.

33 Minutes, 12 November 1759, "Papers of the Society of Artists of Great Britain," *Walpole Society* 6 (1918): 116.

34 Plan, 26 February 1760, "Papers of the Society of Artists," 118.

35 For the sake of argument I am overlooking the point that references to the "State of Art" like this refer to the "Condition of Art"—as is clearly implied by this quotation. The editor reminds me that Johnson's first definition of "State" is "condition" and that it is only after five more entries along these lines that he comes to political usages. I am playing with the ambiguity of meaning as a shortcut to my point.

36 "Memorial to George III," 28 November 1768, in Sidney C. Hutchison, *The History of the Royal Academy, 1768–1968* (London: Chapman and Hall, 1968), 43. See David Solkin, *Painting for Money: The Visual Arts and the Public Sphere in Eighteenth-Century England* (New Haven: Yale University Press, 1993), chap. 7.

37 John Opie, *Lectures on Painting Delivered at the Royal Academy of Arts, London*, "Lecture One," delivered 16 February 1807, reprinted in Arnold's *Library of the Fine Arts* 4 (1832): 13.

38 [W. Carey], "Defense of the British Institution," *New Monthly Magazine* (December 1819): 558.

39 W. C., "Observations on the Spirit of Individuality as Distinguished from Public Spirit," *Repository of Arts*, 3rd ser., 7, no. 39 (1826): 148–52.

40 Ibid. Elsewhere Carey stresses that in painting the "Public Style" comprehends history painting alone. The public style must be sustained by state patronage; under individual patronage history painting can only have a mixed inferior character associated with the "Domestic Style." See [W. P. Carey], *Observations on the Probable Decline or Extinction of British Historical Painting* (London, 1825), 11.

41 W. C., "Observations on the Spirit of Individuality," 148–52.

42 See Hemingway, 142–46.

43 Rosenthal, 13, 28.

44 "Mr. Walter Fawkes's Gallery," *Repository of Arts*, 2nd ser., 7 (May 1819): 300.

45 "Exhibition at the Leicester Gallery," *Repository of Arts*, 2nd ser., 7 (April 1819): 230–1.

46 "Mr. Walter Fawkes's Gallery," 299–300.

47 *Repository of Arts*, 2nd ser., 3 (March 1817): 141.

48 See the essay by Dian Kriz in this volume.

49 *Repository of Arts* (March 1817): 153.

50 "Exhibition of the British Institution," *Repository of Arts* (March 1817): 163.

51 Rosenthal, 27.

52 "Figures for Landscape," *Repository of Arts* 8 (October 1812): 244.

53 Stevens's etchings for *Views of Cottages and Farmhouses in England and Wales* were also published as *Domestic Architecture* (London, 1815). The latter title appears in captions to figs. 98 and 99, but I have retained the former in the text in order to convey the rural/rustic character of the etched views more directly.

54 Francis Stevens, *Views of Cottages and Farmhouses in England and Wales* (London, 1815), 14.

55 Rosenthal, 28.

56 *Views of Cottages*, 24.

57 "Pleasures of Drawing," *New Monthly Magazine*, 392.

Industry from Idleness?
The Rise of the Amateur in the Eighteenth Century

Kim Sloan

LATE-TWENTIETH-CENTURY popular culture assumes certain things of the words "amateur artist": that amateur artists appeared first in the eighteenth century, that they were most often female, and that they produced mainly landscapes in watercolors. Numerous images reinforce this perception. In Paul Sandby's *Roslin Castle, Midlothian*, c. 1780, Lady Frances Scott standing over her camera obscura making her own, mechanically assisted version of the scene we survey, and her friend Lady Elliot seated beside her, constitute a picturesque feature in a professional watercolorist's landscape (fig. 100). But such images are even more familiar to us from Victorian literature, most succinctly exemplified by Wilkie Collins in *The Woman in White*, describing what would be required of the hero of the novel, a drawing master, in his new post:

> After lunch Miss Fairlie and I shoulder our sketchbooks and go out to misrepresent Nature, under your direction. Drawing is her favorite whim, mind, not mine. Women can't draw — their minds are too flighty, and their eyes are too inattentive. No matter — my sister likes it; so I waste paint and spoil paper, for her sake, as composedly as any woman in England.[1]

Occasionally, however, images surface which seem to challenge these commonly held assumptions. In Thomas Hearne's drawing of the professional artist Joseph Farington painting by a waterfall, he is accompanied by a male amateur artist, Sir George Beaumont (fig. 101). This drawing and others, less well-known than the pictures of female amateurs, signal that the issue of amateurs being mainly female and mainly indulging in painting watercolor landscapes from nature is more complicated than it first appears. The evidence shows, as I hope to demonstrate, that not only did far larger numbers of men indulge in this pastime than we assume, but also that landscape, although it did eventually become dominant, was but one of the various genres which amateurs attempted.

My title "Industry from Idleness?" serves to underline these traditional assumptions about amateur artists and is also intended to remind us of the perception that amateurs were numerous enough to participate in the eighteenth-century commercialization of leisure, a key factor in the beginnings of what can be called, for want of better terms, the Industrial and Romantic Revolutions.[2] In addition, the queried reference to Hogarth's modern moral series, signifies that the sources of our assumptions may not be as straightforward as they first appear, and it acts as a reminder that in the eighteenth century, all public and private activity carried moral implications and overtones.

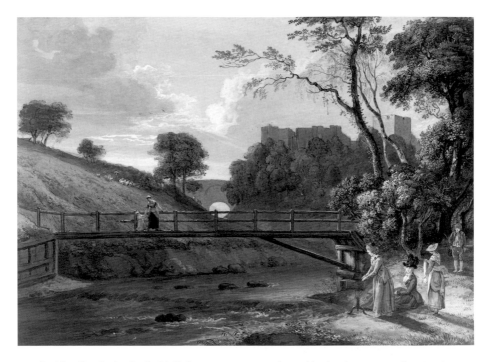

100. Paul Sandby, *Roslin Castle, Midlothian*, c. 1780, watercolor and bodycolor over pencil, 45.8 x 63.5 cm. Yale Center for British Art, Paul Mellon Collection.

Before analyzing the numbers of amateurs, their sex, what they learned to draw, and why, we must address the commonly held belief that they were simply not good artists and therefore contributed almost nothing to the development of art. This is best illustrated by the final paragraph of Iolo Williams's history of *Early English Watercolours* in his chapter on amateurs. Written in 1952, it was the first modern examination of their work, and it contained notes on the better amateurs, all male except two, Lady Diana Beauclerk, whose work he found "somewhat pretentious and vapid," and Lady Farnborough, whom he described as a "highly talented, if unoriginal, artist." A third female amateur he mentioned was Charlotte St. Asaph, who had appended her name to a landscape which Williams found so remarkably like the work of Hearne that it prompted him to write: "And yet may it not perhaps be by Hearne after all, for did not the stupid Princess in *The Rose and the Ring* put 'Angelica fecit' at the bottom of sketches she never drew, and may not other great ladies have done the same?"[3]

In his final paragraph Williams stated:

There is an incidental thought which occurs to me, upon reading through this chapter, and that is how small a part women have played in the development of watercolour in England. Among the amateurs, at least, one might have expected to find many skillful women practitioners, since so very many ladies have had lessons in the medium. Yet, in fact, hardly any of the better

101. Thomas Hearne, *Sir George Beaumont and Joseph Farington Painting a Waterfall*, c. 1777–78, pencil and wash, 43.8 x 28.8 cm. Dove Cottage, Grasmere. The Trustees of the Wordsworth Trust,

amateurs were women…the total contribution of women to watercolour art up to the first half of the nineteenth century seems curiously unimpressive.[1]

The fact is, the role of amateurs, male and female, is completely obscured by the tendency to look for a contribution of the traditional sort provided by professional artists, such as new techniques, new approaches to composition, or evidence of the interpretation of new aesthetic philosophies. Simply because their work was not as skillful as the professional artists and appeared, to use the modern pejorative term, "amateurish" in comparison, it was not considered to be successful and therefore could not possibly make a contribution. This is, however, a judgment which comes from placing the amateurs in an arena in which they themselves never intended to compete — that is, in the world of professional artists, painting full-time in order to make a living in the public world of commerce. The amateur's was a private sphere, one of leisure. In fact, most advocates of drawing as a pastime warned of spending too much time on it for precisely these reasons: expertise in art would imply time spent in acquiring a craft more appropriate to commerce than polite society, which would in turn imply the neglect of a more important activity in his sphere as a gentleman or, in the case of a woman, as a wife or mother. Drawing was also intended to be a pleasant activity, not one deserving of arduous application or passionate dedication.

102. Edward Lens, *Landscape with Fortress*, engraving from *A New and Compleat Drawing Book*, 2nd ed., 1751. Courtesy of the Trustees of the British Museum, London.

Pursuing this activity, amateurs never aspired to a contribution to watercolor in what many art historians have conventionally considered to be the only way of value, a progressional development, as set out in the 1993 exhibition *The Great Age of British Watercolours, 1750-1880.*[5] It is not surprising, then, that they have never been accorded a place in it. Yet the mere fact so many were known to have practiced seemed to imply, even in the traditional hierarchical approach, that they should have played some role, a role described by Andrew Wilton as "the loam from which great art can grow."[6]

This essay will examine some of the assumptions we have made about amateurs that have arisen from always trying to place them within a hierarchy of the greats or as markers in a developmental progression of art. By ignoring their aesthetic value or relative achievement of skill in their productions, and by trying instead to establish who the amateurs were, why they learnt to draw, and what they hoped to achieve, perhaps they can be seen as something other than a sort of fertilizer for the great age of British watercolors. The 1993 watercolor exhibition also underlined how the medium was predominantly concerned with landscape. We always tend to assume that amateurs shared this obsession, but this in fact was a state of affairs which developed in quite a complex way.

The few studies that have been done on amateurs indicate that it was during the last few decades of the eighteenth century, around 1770 to 1800, that their activity rose to sufficient proportions to be worthy of the term "industry."[7] In order to suggest some possible reasons for this industrious activity in the last quarter of the century, we need to establish how many amateurs were active at its beginning and what type of drawing they were pursuing. If one goes back to those seventeenth-century advocates of drawing for gentlemen, Henry Peacham, Sir Francis Kynaston, and Sir Balthasar Gerbier, it is clear that they felt young men should learn to draw not only because historically it had been an accomplishment of royal princes, but also because it was useful for practical reasons, especially during war and when traveling. The weight of classical philosphers was

103. Philip Mercier, *Portrait of a Young Man with a Drawing of a Fortress*, 1748, oil on canvas, 227.5 x 177.5 cm. (formerly with Appleby Bros., Ltd., present location unknown). Photo: Paul Mellon Centre.

also behind them, Aristotle having argued that drawing was not only a practical accomplishment, but helped to make young men better judges of the works of artists. In his advocation of a more liberal, less classically-oriented education, the effects of which were felt in the first few years of the eighteenth century, John Locke recommended drawing for all of these reasons; and, particularly because it was a useful practical accomplishment, he emphasized that it was morally virtuous, not simply a pleasurable pastime.[8] A great deal has been published on these issues recently by Ann Bermingham and David Solkin, particularly concerning Peacham, Locke, and Shaftesbury.[9] Their work on the early eighteenth-century definitions of what constituted a man of taste, the new polite and virtuous gentleman, when combined with an examination of the concurrent liberalization of education, can help to inform our understanding of male amateur activity in the first half of the century.

I have made a study of public and private sites of instruction in drawing from c. 1690 to 1800 and found that, of the roughly 350 artists or drawing masters offering lessons during that time, approximately one hundred were active before 1770.[10] Looking at their advertisements, it is significant that not only did they offer lessons privately in the home, as one would expect, but most of them emphasized the drawing lessons they gave in connection with an educational establishment for young men. To summarize what I have dealt with at length

elsewhere, basically they taught at charity schools, training boys for apprentice-ship or life at sea or in the military, Christ's Hospital being the first to include drawing lessons, from around 1700; soon afterwards drawing appeared in adver-tisements for Watt's Academy, a sort of business academy in the city. It was also on the list of subjects offered at Weston's Academy for Young Gentlemen at Greenwich from around 1720. Various members of the Lens family taught at the first two, and George Bickham taught at the third. Cheam Preparatory School may have been offering lessons as early as the 1730s, and it was certainly encour-aged by William Gilpin when he took over in 1752. By this time drawing masters were available in the town at Eton, although drawing was not actually offered as part of the education there. By then, drawing had become so much a part of a more enlightened liberal education that if Eton College itself didn't offer it, there were parents who required it for their sons, and thus drawing masters made themselves available for this market by taking rooms in town during term.[11]

On the evidence of their work that survives and the drawing manuals which began to be produced mainly for use by the pupils at these institutions, we find, not surprisingly, given the traditional reasons for including drawing in a young man's education, that they eventually came to draw topographical landscape. But first they learned to copy parts of the human figure then whole figures, still in accordance with the Renaissance idea that man was the measure of all things. The drawing manuals of this time are extremely technical but begin to show some evidence of introducing new types of plates to copy for the new type of stu-dent, such as the fortification-type drawings Bernard and Edward Lens[12] included for the naval students at Christ's Hospital (fig. 102). Few of their pupils' drawings survive, but what they were taught and how is borne out by the few images of young amateurs from this time. A portrait of Thomas Pennant of 1726, attributed to Joseph Highmore,[13] shows him with a drawing manual open to a plate of old-master heads to be copied, and a portrait by Philip Mercier shows a young naval pupil with a drawing of fortifications (fig. 103). Most young men learned a rather technical form of drawing and learned it by rote by copying and by using mathematical perspective. Artistic license, invention, and freedom to paint in colors or out of doors, except occasionally when traveling, had no place in the drawing curriculum.

The fact that their teaching was mainly in connection with male educational establishments indicates that, as one might expect, young men learned to draw as part of their formal education between the ages of six and fifteen. The under-standing has always been that young women in the first half of the eighteenth century, unlike young men, received their drawing lessons at home, mainly because it was very rare for females of the middle to upper classes to be educated in an institution. The information I have been able to obtain about female ama-teurs in the first half of the century confirms this. It is not surprising, then, that their numbers were far lower than those of the young men learning drawing at

this time, nor that they began to take these drawing lessons at an older age than the young boys who began at school well before they were ten.

But there are other less obvious factors at work here. The education received by women in the first half of the century had so different a purpose from that of young men that drawing was definitely not yet seen as one of the female accomplishments. It was still enough at this time, particularly in the upper classes, for women to read, cast basic accounts, and be able to sew. Locke's advocation of the accomplishment of drawing was directed towards the education of young men only, and it was a long time before women were considered candidates for a liberal education. They were fitted out not for a place in the world but in the domestic sphere. As Kathryn Shevelow has shown, popular periodicals of the early eighteenth century were concerned with reform and progress for women, and at this stage this reform was still aimed at the encouragement of reading and writing.[14] Although more women read, it was not on a level with the higher and university education already being received by the sons of the clergy or wealthy merchants, and it was more and more common well into the eighteenth century for women of the higher social classes to be supposed to remain ignorant and illiterate in comparison to their social inferiors. Most men of the upper classes believed that a little learning for a woman was advantageous but education such as that received by a man was a waste, not only because it was not necessary to their domestic sphere but it made them and their husbands objects of ridicule. Such women were generally perceived to be unwomanly and masculine, and it was thought that their obsession led to the neglect of their husbands, homes and children, and un-sexed their men.[15]

Nevertheless, a small group of women did learn to draw in the first half of the eighteenth century, and interestingly they tended to belong not to a group of society defined as one might expect by class, but rather by a shared attitude to education which flew in the face of the norms and positively encouraged participation in intellectual pursuits and in what was normally seen as men's social spheres. This select group of women were all contemporaries, and all knew each other through a close network of family and friends. Arthur Pond began giving drawing lessons to Countess Dysart in 1734. She recommended him to Mrs. Pendarres (Mrs. Delany from 1743), who in turn recommended him to the Duchess of Portland, and so on, so that the group expanded to include Catherine Dashwood, Princesses Mary and Louisa, and Rhoda Delaval, later Lady Astley, whose portrait (fig. 105) shows her with one of her flower paintings.[16] Few drawings from these particular lessons are in public collections, but in general they were basic lessons in copying prints and drawing figures, and they also seem to have included learning to paint in oils, as indicated by a sketch by one of her friends of Mrs. Delany at her easel.[17] She wrote frequently of friends lending her oils to copy, and during her lifetime she made about seventy, after old masters and contemporaries.[18] The subjects were mainly figural compositions, portraits, or still

104. Mary Delany, *The Ancient Bridge at Kenwood*, 1757, pen and ink with brown and grey wash, 23.8 x 33.8 cm. English Heritage, Kenwood. Photo: Paul Mellon Centre.

lifes but seldom landscape. The purpose of these copies was to exercise her hand in painting in oil and to provide her friends and herself with duplicates of works of art, not to attempt to compete with the orginals in skill but to provide duplicate images for display.

There is evidence that the same group of women shared other drawing masters like Bernard Lens, who taught some of them miniature painting in gouache and occasionally landscape, topographical in character and executed not in watercolors, but in pen and ink with brown or grey wash (fig. 104).[19] Some of this group of women are known to have had lessons in painting in gouache from Joseph Goupy.[20]

Pond was additionally patronized by a particular group of men — some of whom he taught to draw — who included Philip Yorke, Daniel Wray, Admiral George Anson, Francis Blake Delaval, Robert Price, Henry Hoare, and Peter Delmé.[21] These men are interesting because they, like the women, did not come from one particular social class — they were merchants, middle-class clergy or lawyers, bankers, landed gentry, and peers. All of them were more than usually active intellectually, and all had sisters, wives, or daughters who were amateur artists. Thus the circle included women like Lady Anson, wife of the admiral,[22] and the Marchioness Grey (wife of Philip Yorke), who owned Wrest Park and was one of the most active patronesses of the arts in the eighteenth century.[23] Their other mutual friends included the large family circle around Mary Howard, Viscountess Andover, whose 1746 portrait by Hudson (fig. 106), now at

105. attributed to William Bell, *Rhoda, Lady Astley*, oil on canvas, 87.5 x 56.3 cm., (present location unknown). Photo: Paul Mellon Centre.

106. Thomas Hudson, *Mary Finch, Viscountess Andover*, 1746, oil on canvas, 127.4 x 88.3 cm., Ranger's House, Blackheath. English Heritage.

Ranger's House, Blackheath, depicts her in the guise of a "Muse of Art," as Shelley Bennett has shown.[24] Viscountess Andover's brothers and sisters of the Finch family, the Earls of Aylesbury, were diligent amateurs, as were the Howard family she married into, the Earls of Suffolk. Two albums containing works by themselves and their friends from the 1730s through the century are now at Kenwood.[25] The contents are mainly imaginary figure compositions, sketches of each other, flowers, and their homes, with only a few landscapes, and they show the influence of a series of drawing masters. Susannah Highmore, daughter of the artist Joseph Highmore, and wife of the poet John Duncombe, described by his contemporaries as "an able Advocate for Female Worth"; Charlotte Hanbury Williams, later Lady Walsingham; and Lady Mary Wortley Montagu all wrote of lessons received during this time, and they complete the circle.[26]

These individuals formed what was in fact a compact defined group that did not number any more than fifty, and the evidence points to these being almost the only women in the first half of the eighteenth century who were studying drawing. At this time it was still a practice confined largely to young men. What this group of women had in common was their pursuit of amateur art in various media and subjects, with landscape playing a very minor role, while none of them began before 1730; men as well as women in their families received lessons, and they were all extraordinarily liberally educated for the time.

In their letters to each other, the women in this group indicated that they were wary of letting strangers or general society know of their intellectual accomplishments, their ability to read Latin, and their study of contemporary writings on science, philosophy, and taste. Advising Lady Bute on the education of her daughter, Lady Mary Wortley Montagu wrote that if she was capable and desirous of learning she should be indulged, but Lady Bute should caution her daughter "(and which is most absolutely necessary) to conceal whatever Learning she attains, with as much solicitude as she would hide crookedness or lameness."[27] The Marchioness Grey wrote to a friend that she was wary of leaving behind "the Character of *Précieuse*, *Femme Savante*, Linguist, Poetess, Mathematician, & any other name that any Art can be distinguished by."[28] All were terms used to ridicule learned women, terms to be replaced later in the century by one term — Bluestocking.

Some of the men and women in this circle were actually members of the Bluestocking group active in the second half of the eighteenth century, but this earlier group, although less studied, is certainly a cohesive one, recognized as the intellectual precursors of the actual Bluestockings and centered around and emanating from the Duchess of Portland's home at Bulstrode. Although they did not share the later Bluestockings' evangelical zeal for contesting the norm of women's education, they were aware that their interests and pursuits were not the generally accepted ones for their time. Like these other intellectual pursuits, they saw drawing as an activity that marked them out as different from the rest of society.

Mary Delany wrote that her sister was ever being hospitable to her neighbors and friends and giving healing medicines to the poor and the sick, while her own time, in contrast, was "too much filled with amusements of no real estimation; and when people commend any of my performances I feel a consciousness that my time might have been better employed."[29] These are the reasons, then, why there were so few women amateurs in the first half of the eighteenth century and why nearly all of them can actually be named.

This early group of female amateurs consisted of women who were unmarried, widowed, or had supportive husbands who had themselves already benefited from the liberalization of education and the emergent ideas of what constituted a man of taste. Within two decades, that is by around 1760, their numbers and influence had increased sufficiently that larger numbers of women were able to read and study more widely and seriously and were able to emulate their brothers and husbands in certain aspects of learning and accomplishments. When the Royal Academy was founded, it included two women members. Popular culture was almost ready to accept some women on an equal footing with men. However, the middle of the century was also the time of the emergence of the appreciation of the sublime, and with this came a polarization, even genderization, of taste. This thesis needs to be argued at length but can only be summarized briefly here.[30] Basically it meant that entire areas of serious learning, certain aesthetics, and even types of artistic production became out of bounds to women. The female sphere was one of smooth rounded forms, beauty, sentiment, or ingeniousness, while sharp rugged precipices, powerful awesome sublimity, and creative genius were male preserves. The activities of male and female amateur artists in the second half of the century increasingly reflect this dichotomy.

Other factors than changes in taste were at work on the numbers and activities of male and female amateur artists. It has been argued convincingly that by 1770 a consumer society had become established and leisure time had increased to such an extent that it reached more levels of society and featured in more people's lives than ever before.[31] Social rules dictated that wives in the middle and upper classes must pursue and be seen to pursue leisure activities which reflected their husband's new wealth in the case of the upwardly-mobile middle classes or, in the case of the aristocratic classes, their elite established culture. They were encouraged to find pursuits which could still be undertaken in the home but would endow their husband with status by reflecting his prosperity, culture, and virtue. It is no mere coincidence, therefore, that from this date we find amateurs beginning to concern themselves with landscape, particularly of their own and their friends' gardens. Music and drawing were perfect accomplishments for the settled wife or a young woman embarking in the marriage market, because they enabled the woman to reflect the fact that she had enough wealth to buy leisure time — that she needn't concern herself with the work of the house, that there

were enough servants to do the work for her.[32] The pursuit of the "polite" accomplishment of drawing reflected her own character and her father's or husband's, showing him to be a man of taste to be encouraging an interest in the arts, and most of all it showed her to be a virtuous and moral woman who did not spend her leisure time in idle pursuits like reading novels or gambling, or in unwomanly pursuits like serious intellectual study, still considered a waste of time by middle- and upper-class families in the second half of the century. Women were seen as lacking the sound judgment needed for intellectual pursuits, and their sphere of expertise was in the outward appearance of things and in sentiment; it was these perceived characteristics of women that made the accomplishments of music and drawing seem most appropriate and the most easily accessible to women. It is this that partly accounts for the growth of drawing as a leisure pursuit from the 1770s onwards and also for the increasing trend towards lessons in the more ornamental artistic accomplishments like japanning, painting flowers, varnishing, and gilding.[33] Economics, the commercialization of leisure, and the compelling need to follow fashion are all interwoven issues here that help explain this trend. Fashion in particular was a key factor in social emulation and consumer demand; thus fashion, and not merely in matters of clothes, plays a fundamental role in the increase of amateur activities of all kinds.[34]

For evidence of this with respect to the activity of the amateur artist, witness "the fashionable damsel" depicted by Hannah More in *Coelebs* (1809):

> Then comes my drawing master; he teaches me to paint flowers and shells, and to draw ruins and buildings, and to take views. He is a good soul, and is finishing a set of pictures, and half a dozen fire screens which I began for mama…I learn varnishing, and gilding, and japanning. And next winter I shall learn modelling, and etching, and engraving in mezzotinto and aquatinta, for Lady Di. Dash learns etching, and mama says, as I shall have a better fortune than Lady Di, she vows I shall learn every thing she does.[35]

This satirical tirade not only indicates that landscape was but one of many things one learnt from a drawing master, but it also appears to signify that etching was one of a series of elite, rather rare fashionable accomplishments. However, the volume of works by lady etchers collected by Richard Bull and now in the British Museum[36] and the hundreds of young women who learnt the art from William Austin[37] indicate that it was as common a pursuit as all the other more purely ornamental artistic accomplishments listed; the desire for improvement and constant struggle for upward mobility that characterized life at this time meant that if one aristocratic young lady acquired the ability, there would be numerous other young ladies wishing to emulate her.

Thus far this essay has examined the sites of instruction of amateurs, in educational establishments and in the home; the surprisingly large number of young men who learned right through the eighteenth century in contrast to the small distinguished group of women who learned in the first half of the century; and

some of the social reasons for the tremendous rise in numbers of women ama-teurs from the 1760s. There was a substantial difference between what male and female amateurs wished to achieve during the distinct periods into which this study seems to fall. The young men of the first half of the century learned a form of technical and topographical drawing, while women learned everything from copying in oils to paintings of flowers and birds, portraits, miniatures, and monochromatic topographical landscape. For the first half of the eighteenth cen-tury, then, the accepted history of amateur practice, that it consisted mainly of young women creating watercolor landscapes from nature, must be revised.

In the third quarter of the century everything changed—the beginnings of the polarization of activities between what was appropriate for male and female amateurs that was discussed earlier, the genderization of taste, was in place. For adult male amateurs, those young men who had first learned drawing in schools and had by now trained their hand, or for their sons, the next generation, land-scape became everything in amateur art as practiced and even written about by men. The number of male amateurs certainly did not decline; if anything, it increased as rapidly as the number of women at this time, but the activity they engaged in as amateur artists reduced itself to one kind—landscape. Their let-ters, discussing the latest aesthetic philosophy or what they saw while traveling in Britain and abroad, and their sketchbooks were suddenly filled with their efforts in the interpretation and proper appreciation of landscape. Their portraits are keen to show that they drew or etched the landscapes directly from nature, with their wives supporting or participating marginally in this active way of appreci-ating nature.

In his well-known 1786 portrait by Joseph Wright of Derby,[38] the Reverend Thomas Gisborne, a former pupil and good friend of William Gilpin, shows all the required moral attributes of a gentleman amateur in every sense of the word. Seated at ease at the base of a tree on his own estate, his wife leaning on his shoul-der and his dog at his knee, Gisborne's left hand rests on a just-closed portfolio, while the other holds his pencil and points possessively to the picturesque land-scape ending in mountains to the right. With this clergyman from a newly wealthy provincial family, author of two popular books inquiring into the duties of "Men of Higher Ranks and the Middle Classes" and the "Duties of the Female Sex,"[39] landscape, the subject of an amateur's art, takes over the entire activity. He was also the author of *Walks in a Forest* (1795), a didactic moralizing poem deceptively disguised as an appreciation of landscape.[40] Works such as Danloux's portrait of Sir William Forbes of 1801 (fig. 107), showing him almost startled by the interruption of the painter, signify that man is no longer copying nature but his whole being is completely caught up and inextricably woven with it—an attribute which for men probably reached its peak with images like this around the turn of the century, and then suddenly fell away, leaving something this close to passionate involvement to the Romantic writers.

107. H. P. Danloux, *Sir William Forbes, Bt.*
1801, oil on canvas, 43.8 x 35 cm.
(Christie's 17 April 1936, lot 32,
present location unknown).
Photo: Paul Mellon Centre

Artists like John Hoppner, George Romney, and Charles Grignion, who painted Lady Charlotte Clive at Rome in 1787 (fig. 108), were the portraitists of the female amateurs of the last decades of the century. No longer requiring the classical validation of muse of art, it was enough for the sitter to merely lean on a portfolio for the viewer to be aware of the presence of this accomplishment in a young woman. The Bulstrode circle had widened to include increasing numbers of women from the middle and upper classes, for reasons outlined above, eager to follow fashion, improve their stakes in the marriage market, or display their virtues, and the numbers of women amateurs finally rose to what have always erroneously been assumed. But unlike the activity of male amateurs at this time, imitating landscape was not the only skill sought. Some women—like Lady Diana Beauclerk, her relative, Lavinia Countess Spencer, and the daughters of George III—were determined to master figural composition and spent years training their hands by copying figures from drawing manuals, prints, old masters, and even gems, before inventing their own compositions. These women were in a minority, however; most women hoped to accomplish landscape or the more ornamental types of amateur activity, and they wanted to achieve them quickly with as little work as possible. In a recent perceptive study Ann Bermingham has explained that this mass of women amateurs were essentially perceived as copyists, and themselves found no insult in this.[41] But copying was not the only shortcut available to the acquisition of the title amateur.

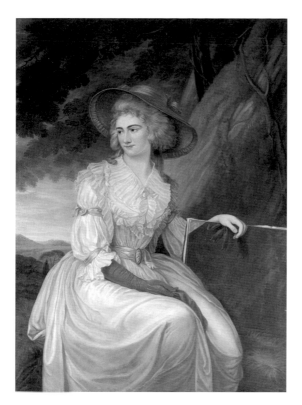

108. Charles Grignion, *The Honourable Charlotte Clive,* 1787, oil on canvas, 134 x 101.6 cm. Powis Castle, The Powis Collection, The National Trust. Photo: Photographic Survey, Witt Library, Courtauld Institute of Art, London.

Throughout the eighteenth century, drawing manuals had reflected to some extent the changes in the types of amateurs and the kind of drawing they hoped to achieve. From around 1760, however, the drawing masters, their manuals, and their teaching methods began to show more clearly that there was an increase in demand for the accomplishment of drawing, particularly landscape, and that it was mainly coming from women who, unlike their brothers and husbands, had not had early training to accustom their hand. These women saw men appreciating and sketching from nature and felt that here was something that should suit a woman's supposed innate special abilities. They needed a short cut, and William Austin, Alexander Cozens, and William Gilpin all inadvertently provided them with one. Their drawing manuals and their treatises on art and the methods they used to teach were the first, after centuries of teaching by training hands by rote through copying, to validate *the sketch* as a means of depicting landscape, ideal or from nature.

William Austin, who was an etcher, engraver, caricaturist, and printseller as well as drawing master, published a manual c. 1755 titled *A Specimen of Sketching Landscapes in a Free and Masterly Manner*, which was aimed at attracting pupils of etching as much as drawing. In etching, the technique made sketchy drawing an acceptable manner, and this was probably partially an attempt to legitimize this style of drawing. Austin prefaced the plates with a two-page essay stating that

he felt "the seeming rudeness of the Designs deserves to be explained and vindi-cated to those not much conversant in the art of Drawing" and who expect a high degree of finish.[42] His notes on sketching mentioned that it was the best way to capture the thoughts, and "one of its greatest beauties is the freedom which appears through the Whole and by the unknowing is mistaken for negli-gence." His approach to teaching drawing through sketching was obviously a success, as fewer than twenty years later Austin was able to append a list of four hundred former pupils to his advertisements.[43] By 1780 he was forced to place an advertisement in provincial papers by way of apologizing to the ladies and gen-tlemen of Bristol, Bath, and Cambridge that due to pressure from clients in London he would be unable to attend them in their towns for some time.[44]

Alexander Cozens's first manual in 1759 was entitled *An Essay to facilitate the Inventing of Landskips*. This and his later treatises—offering various methods for inventing and sketching landscapes, which included blots, originally described by him as rude sketches—have been extensively examined and published else-where.[45] He too could claim pupils in the hundreds, from the provinces as well as London, all keenly following to their own various degrees his techniques for drawing landscape, which were based on sketching from imagination or from nature.

The Reverend William Gilpin is now known mainly for his methods of view-ing landscape; at the beginning of his first published "picturesque tour," of the Wye Valley, he indicated that he was trying to provide a new way of passing the time while traveling, with the added attraction of this being a species of instantly acquired culture. Less well-known, however, is the fact that during his lifetime Gilpin advised and personally taught large numbers of interested amateurs, and even greater numbers followed his technique through the plates illustrating his tours. In his few written texts concerning technique, particularly in his 1768 *Essay on Prints* and in his letters, Gilpin praised sketches, advising that details were not important and that overall impression through light and shade and composition in landscape were all that was necessary to produce a picturesque image.[46]

The confirmation of this theory that technique played an extremely impor-tant role in the dramatic increase in the numbers of female amateurs engaged in landscape is available in several comments on the phenomenon in histories of watercolor written expressly for ladies' periodicals which fed the demand. In 1812, for example, W. H. Pyne, the author of "Observation on the Rise and Progress of Painting in Water Colours" in Ackermann's *Repository of Arts* (aimed at a female audience), was crediting Gilpin with singlehandedly "having created so general a love for travelling, and for so laudable and pleasing an object [as landscape]" that

> every reader of feeling caught the enthusiasm of the author, until in a few
> years the prevalence of landscape-drawing became general in every polite

family; and almost every library contained his works. These interesting publications became the subject of imitation with numerous amateurs, and portfolios were filled by ladies as well as gentlemen, who undertook journies expressly to study the picturesque.[47]

Pyne went on to explain that because Gilpin had paved the way with his style, characterized as "so loosely sketched," the reception of the next popular drawing master, William Payne, was guaranteed.[48] Payne was working for the Board of Ordnance in Plymouth, but the favor in which his landscapes were received encouraged a visit to London where,

> immediately after his arrival, he had an introduction to the first families, who were desirous of acquiring his style…The simple means by which this artist accomplished his effect, induced innumerable amateurs to become acquainted with his style; and hence it is said, that no artist of this or any other country, could enumerate so long a list of pupils, amongst whom are included the sons and daughters of the highest families in the kingdom.

The passage continues:

> Shortly subsequent to the fame of Payne, the study of landscape-drawing became so general in the fashionable circles, that every professor of eminence was tempted to enter the list of teachers, and the highest source of emolument has been derived from instructing the rising generations in this pleasing art. And here it should be mentioned to the honour of our enlightened countrywomen, that the great display of talent which the English artists have exhibited to the world, has been called forth by that love of the art which has so generally been shewn by the female part of the higher circles within the last twenty years…The celebrity of Payne, and the consequent rage which spread so rapidly amongst the fashionable world, to become acquainted with the art of landscape drawing, excited many ingenious provincial artists to try their fortunes in the metropolis.[49]

With this passage from the *Repository of Arts*, the discussion has come full-circle back to the assumptions about female amateurs, drawing masters, and landscapes in watercolor with which this essay began. The purpose in reassessing the traditional assumptions we carry about amateurs was to attempt to make a small contribution towards opening the discourse of eighteenth-century art to include them.[50] It should now be clear that in the eighteenth century there were probably more male than female amateurs, and the practice of drawing for amusement did not rise simply out of women's excessive spare time, nor from the desire to "capture nature." They did not see the products of their work in light of the work of professionals, but rather as a sign of their gentility or politeness, and the increase in numbers of those who studied landscape occurred less because of the availablity of new colored cakes of paint and more because of the gradual

acceptance of freedom of technique. Finally, their portraits in particular indicate that drawing was for them not the twentieth-century idea of a commerical industry based on hordes of young women following an idle pursuit, but rather, to put it in eighteenth-century terms, a kind of polite virtuous industriousness which could be used to avoid wasteful pernicious idleness.

I should like to thank Brian Allen for inviting me to participate in the session he organized for the 1993 Royal Academy/Institute of Historical Research symposium on "The Great Age of British Watercolours." I am also grateful to Michael Rosenthal for encouraging me to adapt this paper for inclusion in the present volume and for his many helpful suggestions for its improvement.

1 Wilkie Collins, *The Woman in White* (1860; Harmondsworth: Penguin, 1971), 61.

2 I use these terms in the widest possible sense, not as definitions of brief historical periods with specific beginnings and ends. For the most cogent discussions of the commercialization of leisure in the eighteenth century, see particularly Neil McKendrick, chap. 1, "The Consumer Revolution of Eighteenth-Century England" and J. H. Plumb, chap. 6, "The Commericalization of Leisure," in Neil McKendrick, John Brewer, and J. H. Plumb, *The Birth of a Consumer Society: The Commercialization of Eighteenth-Century England* (London: Hutchinson, 1983). See also the discussions of their theories by Colin Campbell in *The Romantic Ethic and the Spirit of Modern Consumerism* (Oxford: Oxford University Press, 1987), Introduction and chap. 2, "Accounting for the Consumer Revolution in Eighteenth-Century England" and chap. 7, "The Ethic of Feeling."

3 Iolo A. Williams, *Early English Watercolours* (Bath: Kingsmead Reprints, 1970), 241.

4 Ibid., 248.

5 Royal Academy, London, 15 January–12 April 1993, and National Gallery of Art, Washington, 9 May–25 July 1993. Only two or three amateurs were represented in the exhibition, and it did not contain any works by female professional artists or amateurs.

6 Andrew Wilton and Anne Lyles, *The Great Age of British Watercolours, 1750–1880* (London: Royal Academy of Arts, 1993), 28, quoting Vaughan Williams in another context.

7 The most extensive discussions of the work of eighteenth-century amateurs published to date are: Ian Fleming-Williams, "The Amateur," Appendix 1 in vol. 3 of Martin Hardie, *Watercolour Painting in Britain* (London: Batsford, 1968); Joan Friedman, "Every Lady Her Own Drawing Master," *Apollo* 105 (1977): 262–67; and Kim Sloan, "Drawing—a 'Polite Recreation' in Eighteenth-Century England," in *Studies in Eighteenth-Century Culture*, vol. 11, ed. Harry C. Payne (Madison: University of Wisconsin Press, 1982), 217–40.

8 This is a very brief summary of information from the Introduction and first two chapters of my Ph.D. dissertation, "The Teaching of Non-Professional Artists in Eighteenth-Century England" (University of London, 1986).

9 See Ann Bermingham, "'An Exquisite Practice': The Institution of Drawing as a Polite Art in Britain," in Brian Allen, ed., *Towards a Modern Art World*, Studies in British Art 1 (New Haven and London: Yale University Press, 1995), 47–66; David Solkin, "ReWrighting Shaftesbury: The Air Pump and the Limits of Commercial Humanism," in John Barrell, ed., *Painting and the Politics of Culture: New Essays on British Art,*

1700–1850 (New York: Oxford University Press, 1992), 72–99; and Stephen Copley, "The Fine Arts in the Eighteenth Century," ibid., 13–37.

10 See Sloan, Ph.D. diss., Appendix A, "Drawing Masters in Eighteenth-Century Britain," 266–308.

11 Ibid., chaps. 2–6 and Appendices B ("Private Academies and Public Schools where drawing was taught"), C ("Lens Family"), and D ("Bickham Family").

12 *A New and Compleat Drawing-Book…*, 1750, always attributed to Bernard Lens III, is probably a compilation of plates after drawings by his father, Bernard Lens II (1659–1725), and his brother Edward Lens (1686–1749), who in 1725 succeeded Bernard Lens II as drawing master at Christ's Hospital. Edward Lens's initials can be seen in at least two of the plates of coastal fortresses. The book and authorship of the text and plates is discussed in Sloan, Ph.D. diss., 52–66.

13 Sale, British Paintings, Sotheby's, London, 15 July 1992, lot 21 (color repr.).

14 Kathryn Shevelow, *Women and Print Culture: The Construction of Femininity in the Early Periodical* (London: Routledge, 1989), 3, 6–9.

15 See Ibid., 22–23, and Bridget Hill, *Eighteenth-Century Women: An Anthology* (London: Allen and Unwin, 1984), 44–45.

16 Louise Lippincott, *Selling Art in Georgian London: The Rise of Arthur Pond* (New Haven and London: Yale University Press, 1983), 38–42, 68.

17 The drawing by Lady Catherine Hanmer is reproduced in Ruth Hayden, *Mrs. Delany, Her Life and Her Flowers*, 2nd ed. (London: British Museum Publications, 1992), 94. Lippincott, 178n38, notes that Rhoda Delaval's work is still in the possession of the family and includes portrait heads, probably oil on canvas.

18 Ibid., 96–99, copy after Correggio. See also Ellen Clayton, *English Female Artists* (London, 1876), 1:114–17.

19 A group of these drawings was most recently in the collection of the late Dudley Snelgrove, sold Sotheby's, 19 November 1992, lots 232–236 (repr.); the largest collection of early drawings of this type by Mary Delany is in the National Gallery of Ireland.

20 See Lippincott, 68, and C. Reginald Grundy, "Documents Relating to an Action Brought against Joseph Goupy," *Walpole Society* 9 (1921): 81.

21 Lippincott, 46, 58–60.

22 Lady Anson, née Elizabeth Yorke (d. 1760), was the sister of Charles and Philip Yorke and thus the sister-in-law of the Marchioness Grey. She wrote frequently to the Marchioness and her daughters about her drawings and in 1752 wrote that she was working on a "Dictionary of Taste" with Mr. Anson and Catherine Talbot. Their correspondence is in the largely unpublished Lucas papers from Wrest Park in the Bedfordshire County Record Office (brief references in Sloan, Ph.D. diss., 213–14).

23 See note 22 above. For the details of her life, see Joyce Godber, "The Marchioness Grey of Wrest Park," *Publications of the Bedfordshire Historical Record Society* 47 (1968), which does not discuss her activities as an amateur or patron. There is a chapter on the Marchioness and her friends, Catherine Talbot and Elizabeth Carter, in Sylvia Myers, *The Bluestocking Circle: Women, Friendship, and the Life of the Mind in Eighteenth-Century England* (New York: Oxford University Press, 1990), 61–75.

24 Shelley Bennett, "A Muse of Art in the Huntington Collection," in Guilland Sutherland, ed., *British Art, 1740–1820: Essays in Honor of Robert R. Wark* (San Marino: Huntington Library, 1992), 57–80.

25 Two albums and a folio of views were sold at Sotheby's 16 July 1987 (lots 22–23), and a number of drawings, some attributed to Alexander Cozens, were extracted by dealers before the bulk of the material was purchased by English Heritage for the Iveagh Bequest at Kenwood, where they are known as the "Andover albums." I am very grate-

ful to Henry Wemyss at Sotheby's for informing me of this album and providing me with the opportunity to take notes before the sale.

26 For Susanna Highmore and John Duncombe, see Charles R. Beard, "Highmore's Scrap-Book," *Connoisseur* 93 (May 1934): 290–97; Warren Mild, "Susanna Highmore's Literary Reputation," *Proceedings of the American Philosophical Society* 122, no. 6 (December 1978): 377–84; and Myers, 120, 128–29, 140; for Charlotte Hanbury Williams, see Clayton, 1:352; and for Lady Mary Wortley Montagu, see Robert Halsband, *The Complete Letters…* (Oxford: Oxford University Press, 1967), 3:23–24.

27 Halsband, 21–22.

28 Quoted in Myers, 5.

29 Hayden, 95. The Bulstrode circle is discussed in Myers, 21–44, although it does not include a discussion of their activities as amateur artists or patrons.

30 See Christine Battersby, *Gender and Genius: Towards a Feminist Aesthetics* (London: Women's Press, 1989), chap. 8, "The Passionate Revolution," 71–80, for the evidence in the writings of Kant, Burke, and William Duff on the notion of genius and the divisions of appropriate realms of taste and art for male and female in the second half of the eighteenth century. Ann Bermingham in "The Origin of Painting and the Ends of Art: Wright of Derby's 'The Corinthian Maid,'" in Barrell, ed., *Painting and the Politics of Culture*, 148–64, has argued a slightly later and different type of genderization and polarization of artistic spheres, noting that tracing, copying, and the more reproductive "decorative" artistic pursuits were appropriate for women, while creative inventive art indicative of genius was for male professionals.

31 See note 1 above, especially the essay by J. H. Plumb, and also his exh. cat. *The Pursuit of Happiness: A View of Life in Georgian England* (New Haven: Yale Center for British Art, 1977).

32 Hester Thrale, for example, was told by her husband "not to think of the Kitchen" (see Shevelow, 54–55).

33 See Ann Bermingham's discussion in "The Corinthian Maid," note 30 above.

34 For fashion's key role in social emulation and consumer demand, see Colin Campbell's chapter on "The Ethic of Feeling" in his *Romantic Ethic and Modern Consumerism*, esp. 151–53.

35 Hannah More, *Coelebs in Search of a Wife: Comprehending Observations on Domestic Habits and Manners, Religion and Morals* (1st ed. published anonymously, 1808; 3rd ed., London, 1809), 1:333–34.

36 Richard Bull, "Etchings and Engravings Done by the Nobility and Gentry of England," vol. 2 (Department of Prints and Drawings, 189* b. 23). The contents of both volumes were discussed and indexed by David Alexander in *Amateurs and Printmaking in England, 1750–1830*, exh. cat. (Oxford: Wolfson College, 1983), 5, 29–33.

37 In an undated advertisement (British Museum, Department of Prints and Drawings, Engravings by W. Austin, c.14*, 1978 U 1719) Austin appended a list of the "Names of the Nobility, Gentry, Ec. Mr Austin has had the honor to attend in Drawing, Painting, Etching and Engraving" from 1768. The number of pupils in the 1768 advertisement was printed as 308, but this was struck through by Austin when preparing for a later printing of this advertisement, and the number was altered in manuscript to 400, names of pupils added on the right side and at the bases, and the address was replaced with two new addresses, York Street, St. James's, and Lawrence Street, Chelsea.

38 Now at the Yale Center for British Art, New Haven, and reproduced most recently in Judy Egerton, *Wright of Derby*, exh. cat. (London: Tate Gallery, 1990), no. 146. Gisborne's own watercolor view of Snowdon of 1789 is in the British Museum—repro-

duced in Michael Clarke, *The Tempting Prospect: A Social History of English Water-colours* (London: British Museum Publications, 1981), 114, fig. 73.

39 Thomas Gisborne, *An Enquiry into the Duties of Men in the Higher and Middle Ranks of Society in Great Britain* (London, 1794) and *An Enquiry into the Duties of the Female Sex* (London, 1797). These popular works contained his contribution to the program for the moral reform of society along the lines of his fellow evangelicals, William Wilberforce and Hannah More. See *Dictionary of National Biography*.

40 This volume of blank verse, published in 1795, ostensibly describes the forest at different times of the day and year; but as Dian Kriz points out, it also repeatedly draws an analogy between external nature and a divinely ordered human society: see Dian Kriz, "Genius as an Alibi: The Production of the Artistic Subject and English Landscape Painting, 1795–1820" (Ph.D. diss., University of British Columbia, 1991), 86–89 (published by Yale University Press in 1997 as *The Idea of the English Landscape Painter: Genius as Alibi in the Early Nineteenth Century*). I am very grateful to her for allowing me to read her dissertation before preparation for publication and for her support and encouragement during the early stages of the preparation of this paper.

41 See note 30 above.

42 The full title of Austin's book continues with *A Pen or Pencil; Exemplified in Thirty Etchings, done from Original Drawings of Lucatelli, after the Life, in and about Rome. By William Austin…Hanover Square, where Drawing and Etching are taught in the most expeditious Manner* (1st ed., British Museum, Department of Prints and Drawings, n.d.; 2nd ed. published by Robert Sayer, 1757).

43 See note 37 above.

44 From an advertisement of 1780 in Daniel Lysons, *Collectanea: or a collection of advertisements and paragraphs from the newspapers, relating to various subjects*. British Library, 1881.b.6(1) f.4v.

45 The 1759 *Essay* is reproduced and the early teaching methods are discussed in Kim Sloan, "A New Chronology for Alexander Cozens," Part I, *Burlington Magazine* (February 1985): 70–75, and Part II (June 1985): 355–63. For the later treatises see Kim Sloan, *Alexander and John Robert Cozens: The Poetry of Landscape* (New Haven: Yale University Press in association with the Art Gallery of Ontario, 1986), 36 ff.

46 The standard monograph on Gilpin is Carl Paul Barbier, *William Gilpin: His Drawings, Teachings, and Theory of the Picturesque* (Oxford: Clarendon Press, 1963), but see also my discussion of this aspect of his teaching in my dissertation, 122–24, 245–47.

47 *The Repository of Arts* (London: Ackermann, 1813), 9:146.

48 See David Japes, *William Payne: A Plymouth Experience* (Exeter: David Japes, 1992), published to coincide with the exhibition at The Royal Albert Museum, Exeter, 15 September–28 November 1992.

49 *The Repository of Arts*, 9:147–48.

50 Dian Kriz (see note 40 above) and Ann Pullan have both written doctoral dissertations (Pullan, "Fashioning a Public for Art: Ideology, Gender and the Fine Arts in the English Periodical, c. 1800–25," University of Cambridge, 1992) which deal with similar issues concerning gender, landscape, and amateurs in early- to mid-nineteenth-century-Britain. Since writing this essay, I have learned of a third dissertation which adds a useful dimension to the subject: Carol Jordan, "'Pilgrims of the Picturesque': The Amateur Woman Artist and British Colonialism, circa 1750–1850" (Ph.D. diss., University of Melbourne, 1996).

Looking Backward: Victorian Perspectives on the Romantic Landscape Watercolor

Scott Wilcox

IN HIS *Academy Notes* of the 1850s John Ruskin lamented what he saw as "the steady descent" of Britain's watercolor societies. His comments were echoed by other critics, such as the reviewer for the *Spectator*, who wrote in 1858: "England, with great traditions in her water-colour school, and with an amount of potential skill in that school beyond comparison with any country, has at this moment scarcely a water-colour painter who is thoroughly an artist."[1] He went on to ask who was to succeed Joseph Mallord William Turner or David Cox. Turner had died in 1851, Peter DeWint two years before that. Anthony Vandyke Copley Fielding (president since 1831 of the Society of Painters in Water-Colours) died in 1855, and David Cox in 1859. There was at the time a widely shared awareness of the passing of a great generation of watercolor artists and a concern about who would carry on the tradition they embodied. British watercolor did not, in fact, come to an end with that generation, but that mid-century perception of the ending of an era fostered a new historical perspective on the achievements of the watercolor school up to 1850.[2] The *Spectator*'s critic referred to the "great traditions" of England's watercolor school. In an 1855 watercolor society review the *Art Journal* wrote of "the stars of the old school of water colours…setting one by one."[3] Alongside such general expressions of nostalgia and regret, the 1850s witnessed developments pointing to a new, more serious consideration of the much-lamented old school of watercolors.

For example, the Gallery of Drawings in Water-Colours at the Manchester Art Treasures Exhibition of 1857 presented 969 drawings selected, as the catalogue stated, "for the purpose of illustrating the rise, progress, and recent state, of painting in water-colours."[4] The watercolor display consisted of four rooms: a long gallery containing masterpieces of the present and the recent past, off which opened three smaller rooms: one devoted to eighteenth-century pioneers set in the context of a smattering of earlier continental drawings by Dürer, Rembrandt, Ostade, and Van Huysum; a central room given over to the watercolors of J. M. W. Turner and a few of his contemporaries; and a third room of sketches and studies from nature by various artists.

The reviewer for the *Art Journal* thought the room devoted to the beginnings of watercolor lacked the requisite variety and depth of coverage that "must be comprehended in any history of water-colour art" — a history that as yet no one had undertaken to write. Paul Sandby, represented by fifteen drawings, was the earliest English exponent in the display, fostering the notion, first advanced in an

obituary of the artist back in 1810, that he was the father of English watercolor. The next room contained works by "giants of the art," and if the reviewer acknowledged Turner's preeminence among them, he complained that Turner's work was to a degree segregated from that of his colleagues. Due in large measure to Ruskin's advocacy, Turner's reputation as a landscape painter stood particularly high, bolstered in 1857 by the exhibition at Marlborough House of a selection of oil paintings and watercolors from the Turner Bequest.[5] The reviewer of the Manchester Exhibition took the position that "the truth of very much that Ruskin has written about Turner must be admitted; but it can never be received that he was the only painter that ever understood nature." For this critic, it was crucial that the triumph of British watercolor, interpreted as both an unparalleled mastery of the medium and an incomparable fidelity to nature, should be seen as the joint effort of a national school and not the achievement of a single individual.

The reviewer may have had quibbles with aspects of the watercolor display, but he concluded: "The collection at Manchester is such as we may never see again; it contains certainly a great proportion of the best works in this class." The great desiderata was a national collection of British watercolor art. "May we venture to hope that such a collection will ever be formed?" he asked, and then went on:

> In answer to such a question it can only be said, that if we have a national feature in Art, it is our school of water-colour; and the formation of such a collection is certainly due to the *prestige* it enjoys. But whenever such addition is made to our museums, it is earnestly to be desired that it will appear as well in the form of a progressive and circumstantial history as in that of an illustrative collection. In little more than half a century this branch has been carried from a thin raw wash to its ultimate perfection.[6]

The reviewer's call for the establishment of a national collection was, in fact, already on the way to being answered by John Sheepshanks' gift of British art to the South Kensington Museum, which included, in addition to the oil paintings that formed the heart of the gift, a small and not particularly distinguished group of watercolors. It did, however, include one work by J. M. W. Turner, *Hornby Castle, Lancashire, from Tatham Church* (fig. 109).[7] This gift provided a start, and under the direction of the Art Referee of the museum, Richard Redgrave, it was augmented by purchases and followed by a succession of other more significant gifts.[8] In 1860 Mrs. Ellison presented fifty-one watercolors, an additional forty-nine arriving by bequest in 1873. In 1869 the bequest of the Rev. Chauncey Hare Townshend added another 173 watercolors to the collection. The Ellison and Townshend collections covered much the same ground, concentrating on works of the early and mid-nineteenth century: John Varley, David Cox, Samuel Prout, George Fennel Robson, Anthony Vandyke Copley Fielding, William Henry

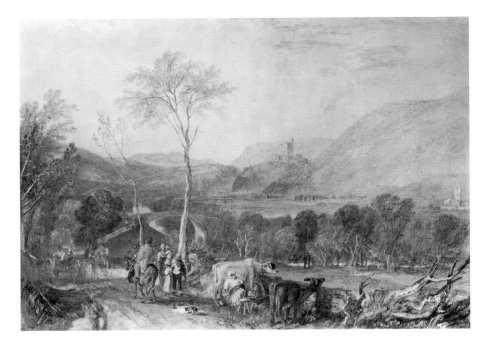

109. J. M. W. Turner, *Hornby Castle, Lancashire, from Tatham Church*, 1816–18, watercolor, 29.2 x 41.9 cm. Victoria and Albert Museum, London.

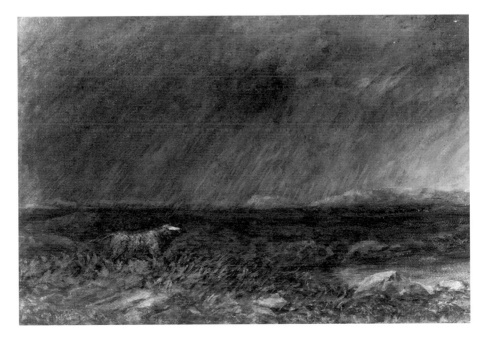

110. David Cox, *The Challenge: On the Moors near Bettws-y-Coed*, 1856, watercolor, 45.5 x 66.6 cm. Victoria and Albert Museum, London.

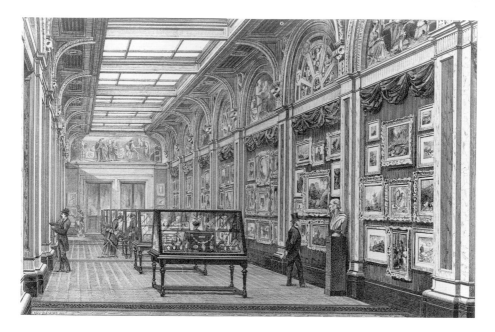

111. John Watkins, *South Kensington Museum: The Watercolour Galleries*, c. 1876, pen and ink. Victoria and Albert Museum, London.

Hunt, and David Roberts. Cox's *The Challenge* (fig. 110) was part of the Townshend Bequest. In 1871 William Smith, who had been a major contributor to the watercolor display at the Manchester Art Treasures Exhibition, allowed Redgrave to choose eighty-six watercolors from his collection. This immeasurably strengthened the representation of eighteenth-century artists, with examples by Edward Dayes, Samuel Hieronymous Grimm, Thomas Hearne, William Marlow, and Thomas Malton.

From 1861 the watercolors at the South Kensington Museum were on more or less permanent display. On May 26 of that year, Redgrave congratulated himself in his diary:

> Today the Ellison gift of watercolour paintings was opened to the public for the first time. I have taken much pains to secure the gift for the South Kensington Museum, and much trouble on the whole subject of watercolour art, of which there is now the beginning of a good collection, both in point of view of beauty and historically.[9]

A drawing by John Watkins of the watercolor galleries at the South Kensington Museum shows the display a bit later, in 1876 (fig. 111). The London public now had continually on exhibit before them watercolors arranged in an historical sequence — something that today, for conservation reasons, would be unthinkable. Indeed, the question of the over-exposure of these watercolors would in the 1880s spark a heated and protracted controversy which was closely bound up with their historical appreciation and to which I will return below.

The watercolor galleries at the Manchester Art Treasures Exhibition and the inauguration of a national collection of watercolors at the South Kensington Museum were the first steps in the creation of a new historical awareness of British watercolors. The following decades would see the publication of books, the organization of further exhibitions, and the establishment and expansion of public collections of watercolors. These developments together created a history of British watercolors to which we still subscribe in outline today. But why did this happen at this particular time? And what forces shaped the way the story of British watercolors came to be told?

To some degree the perception that the middle of the century marked the end of an era quite simply invited an historical perspective. That the careers of so many important and popular artists should come to an end within the span of a few years suggested a certain closure; relegated now to the past, these figures seemed suitable subjects for historical inquiry. The works of these artists were also national treasures, and this was the period of international expositions celebrating national achievements. It had long been a popular notion that watercolor painting was one of Britain's great contributions to western art. Although British claims in this regard were exaggerated, the watercolor societies had given watercolor painting in Britain an independent status unmatched in other national schools. Even critics outside Britain frequently accepted at face value the assertions of British preeminence in watercolor. Edward Holmes began his introduction to the watercolor section of the Manchester Art Treasures catalogue with the commonplace observation that "the practice of this branch of the fine arts is so much followed in England, and the principal professors have sent forth such numerous examples…that we generally look upon this as peculiarly a national school of art."[10] Certainly, then, the history of the British achievement in watercolor painting was a worthy subject for study, reflecting favorably on the national character and open to appropriation for nationalistic ends.[11]

In 1861 an "Historical Exhibition of Water-Colour Painting," consisting of 218 examples from the past one hundred years, was held at the Society of Arts in the Adelphi for the benefit of the Female School of Art. Looking at the earlier watercolors in the display, a reviewer considered the progress of the national watercolor school:

> When we see in the exhibitions of our day works that not only vie with oil in depth and richness, but win deservedly the plaudits of every European school — when we contemplate such results, and see them side by side with mementos of the infancy of the art — when we thus see the first and the last with so little in common between them, and such a vast hiatus to be accounted for before we can understand that the last has any family relation with the first, — then it is that we desire to know something of the adolescence of an art which in a hundred years has developed itself into a maturity so splendid.

It was this sense of tremendous advance over a short span of time that made the story of British watercolor painting so remarkable in the eyes of commentators, and it was precisely in terms of growth and advancement that the developments over the past century were framed. If the public had the fruits of that advance continually before them in the contemporary exhibitions of the watercolor societies, the full impact of that extraordinary progress could only be seen by comparison with examples of the watercolor art of fifty or one hundred years earlier. Even so, the critic felt it necessary to justify an exhibition devoted to artists of the past rather than the present: "The living school is well known: it is the past on which the public desire enlightenment."[12]

But what if—as some commentators suggested—the watercolor school was petering out? What if the passing of the grand old men of watercolor really did signal the end, and "splendid maturity" had already given way to a declining old age? If the tradition was in jeopardy, then it was now more than ever important to affirm that tradition, in the hope either of perpetuating it or, if that was not possible, then at least of directing the light of attention away from present deficiencies and onto past glories.

While there were in the first half of the nineteenth century—the heyday of British watercolor painting—no serious attempts at a full-fledged history of the phenomenon, a few writers were concerned with defining its place in the larger sweep of Western art and with recording something of its practitioners. In 1806 William Marshall Craig, an artist from Manchester, delivered a series of lectures at the Royal Institution in London, in which he asserted the superiority of watercolor over oil painting. Watercolor was not the primary subject of his lectures, nor did he make any attempt to sketch out a history of the practice of watercolor art in England. But he did place the development of watercolor within a larger evolutionary view of the history of Western art, and in this evolutionary scheme, he saw watercolor superseding oil painting as the preeminent form of artistic endeavor. It was, needless to say, a contentious assertion; certain of his colleagues, such as Joseph Farington, dismissed Craig's claims as absurd and presumptuous. But Farington records in his diary that in the spring of 1806, just a year after the first exhibition of the Society of Painters in Water-Colours, the lectures were a frequent topic of dinner conversation and that some of Farington's dining companions shared Craig's notion that watercolor was indeed the superior medium.[13] The lectures were undeniably popular; they were repeated in successive seasons and published in 1821.[14]

The first attempt to document the British school of watercolor appeared in a series of articles titled "Observations on the Rise and Progress of Painting in Water Colours" in Ackermann's *Repository of Arts* in 1812 and 1813.[15] The author of these unsigned articles may have been William Henry Pyne, one of the founding members of the Society of Painters in Water-Colours. A decade later Pyne published in his short-lived weekly miscellany of the fine arts, the *Somerset House*

Gazette, another series of articles titled "The Rise and Progress of Water-Colour Painting in England."[16]

The *Repository of Arts* articles set out a lineage for watercolor art going back to medieval manuscript illumination, before asserting the novelty and originality of modern British watercolor painting. The distinction was sharply drawn between transparent watercolor painting and both the use of bodycolor or distemper and the practice of tinting drawings. Paul Sandby occupied a key but transitional role in the emergence of this "new art." While dozens of watercolorists were mentioned, Turner and Girtin were clearly the heroes of the account. Yet the figure painter, Richard Westall, was actually given precedence: "The entire development of that powerful union of richness and effect which at length elevated this art to vie with the force of painting in oil, was left for the genius of Richard Westall to complete."[17]

In Pyne's series in the *Somerset House Gazette*, the story became streamlined: fewer artists are mentioned and fewer topics are broached. Westall remains an important figure, but Turner and Girtin loom far larger. To them Pyne attributes the true beginnings of the art, thereby shifting the emphasis even more towards landscape as the central concern of watercolor painting. The articles hardly constituted a comprehensive history, but Pyne did set out several key themes which would be taken up by later writers. One was the tremendous and rapid advances in techniques and materials over the second half of the eighteenth century and the beginning of the nineteenth — the shift from the stained or tinted drawing in which watercolor was but the pale accompaniment of a linear drawing to full-fledged painting in watercolors. Another was the concurrent evolution from topography to a naturalistic landscape art. Pyne is particularly interesting and influential in his insistence, firstly, that the technical advances accompanying the shift from drawing to painting were the direct result of watercolorists' response to naturalistic subject matter and, secondly, that it was specifically the topographical nature of Turner's and Girtin's training that provided the necessary grounding in natural observation, which, under the stimulus of their poetic and original genius, became an unprecedented understanding of the grander themes of nature.

When we move into the Victorian period, we find that John Ruskin, from whom we would expect the most telling commentary on the development of watercolor, showed little historical awareness of, or at least little historical interest in, watercolor art. He grew up with the Society of Painters in Water-Colours annual exhibitions, and *Modern Painters* and his *Academy Notes* are full of references to the mainstays of the Society: David Cox, Copley Fielding, Samuel Prout, Peter DeWint. But Ruskin is almost completely silent about earlier practitioners of watercolor. He did at times refer generally to the early days of watercolor as a sort of age of innocence, but this was more rhetorical device than historical analysis — something to set in opposition to the meretricious sophistication of much

Victorian watercolor. And he could just as easily characterize watercolor before Turner as mannered and formulaic, so as better to set off Turner's achievement. "Turner was," he wrote, "destined to annihilate such rules, breaking through and scattering them with an expansive force commensurate with the rigidity of former restraint."[18]

The first serious, detailed history of the watercolor movement in Britain came with Richard and Samuel Redgrave. I have already noted Richard's exertions on behalf of watercolor at the South Kensington Museum. In 1862 he and his elder brother Samuel organized, together with the landscape painter Thomas Creswick, an historical display of British watercolors for London's International Exhibition, provoking a storm of protest from the members of the watercolor societies, to which neither Creswick nor the Redgraves had any official ties. It was largely a matter of bruised professional egos; the society members felt that the selection should have been their responsibility.[19] But there may also have been a real difference of opinion as to the orientation of the exhibition. While the society members were clearly eager to promote the work of current practitioners, the Redgraves' viewpoint was more historical and indeed rather critical of much contemporary watercolor.

In 1866 *A Century of British Painters* appeared. This joint work by the two Redgrave brothers was the first popular account of British art to devote important chapters to the watercolorists, elaborating or playing variations on themes familiar from William Henry Pyne, for instance, the importance of topography to the creation of a naturalistic landscape painting. The Redgraves wrote:

> The direct reference to nature, both at home and abroad, which was the essence of the art of these [topographers], was beginning to work a change, and was in itself a source of steady progress towards true art. Topography had given the first direction of the new art to landscape painting, and for a time it continued faithful to this impulse. It was impossible for men like the topographers, brought face to face with nature, though at first attending only to the most obvious facts and details which were their chief aim, not to observe also nature's more varied moods and changes; and it only required a man of genius to arise, who, pursuing the same course, should be able to give life and vitality to the meagre truthfulness of the topographer, to place the art on a wholly different footing. In such hands, and with the new materials, there were no traditions of the "black masters" to stand in the way of progress — to prevent a man using his own eyes, and seeing nature as she really is.[20]

But in a period of Pre-Raphaelitism and Ruskinian naturalism, the concept of "seeing nature as she really is" could be taken to convey an approach to nature that was more specific and more limiting than what the Redgraves had in mind; so that in contrasting their idea of naturalism to the topographical literalism from which it had arisen, they were also more subtly contrasting it with Pre-Raphaelite literalism:

Landscape art owes its first advance to the direct reference made to nature by the topographical draftsmen; its second to our water-colour artists who broke loose from the fetters of mere antiquarianism. The exact transcript of local objects, places, or antiquities, naturally required a clear daylight, unobstructed by clouds or shadows, and free from that mystery of light and shade, so important a feature in art, by which the painter gives variety and contrast, and hides any unimportant or ugly features of the scene. Simple literal truth is all that is required of the topographer. The artist's aim is general truth and the vivid impression of scenery as a whole, and under those varied circumstances which elevate it from the commonplace into the poetical.[21]

Another of Pyne's themes which appeared in the Redgraves' account was the special connection between the medium of watercolor and a naturalistic approach to landscape. Whereas in Pyne's formulation naturalism was the engine driving developments in watercolor techniques and materials, the Redgraves saw the medium as actually encouraging and enabling a more naturalistic painting:

The nature of the materials tended to emancipate the artist from the thraldom of the "black schools" — working on white grounds with transparent colours, whose luminousness depended on the careful preservation of the ground, the colour and richness of the pigments being destroyed if laid on too heavily, the constant effort of the artist was towards delicacy, purity, and precision of touch; this required onceness and clearness of aim. While the painter of the old school, relying on memory, was groping blindly for some ideal treatment, some theory of tone or composition, the follower of the new art, stored with sketches, and referring directly and imitatively to nature, obtained, from the facility of execution afforded to him, a clearness, luminousness, and power hitherto unknown. Moreover, the extreme dilution of the pigments with pure water as a vehicle, permitted infinitely delicate gradations, obtained only with great difficulties by scumbling, and hardly possible in glazing in the more unctuous vehicle of oil.[22]

In the Redgraves' account Paul Sandby, William Payne, and John "Warwick" Smith all rate mention as precursors of Girtin and Turner, but John Robert Cozens is given pride of place, following Charles Robert Leslie's treatment of Cozens in his *Hand-Book*, published in 1855, which must in turn reflect John Constable's high regard for Cozens.[23] In the Redgraves' words he was "the first to break away from the trammels of topography, and raise landscape painting in water colours to a branch of the fine arts."[24]

From Cozens the Redgraves passed to Thomas Girtin: "To the poetry of the art, as practised by Cozens, Girtin added power — power of effect, power of colour and tone, power of execution."[25] Turner was considered by the brothers as the preeminent watercolorist, but because of his stature as an oil painter as well, he was treated separately from the rest of the watercolorists. They gave the

founding, early days, and subsequent history of the Society of Painters in Water-Colours a lengthy treatment, quoting Pyne from the *Somerset House Gazette* as a major source of information.

The rise of watercolor painting is presented in *A Century of British Painters* as the triumph of naturalism, but a naturalism transmuted by poetry in contrast to the prosaic naturalism of much of the landscape painting the Redgraves saw around them. *A Century* also celebrates the properties of watercolor and the advances in the nature and use of the medium, while criticizing those methods and materials resorted to in the search for an inappropriate forcefulness. This emphasis on the technical development of the medium and the rather purist line on what was appropriate to good watercolor practice became the focus of the introduction to the *Descriptive Catalogue of the Historical Collection of Water-Colour Paintings in the South Kensington Museum*, on which Samuel Redgrave was at work when he died in 1876. The catalogue was completed by Richard and published the following year. In it an historical account of the development of techniques and materials leads to a repudiation of the use of opaque color in contemporary watercolors and a plea for a return to older methods.[26]

It is important to see the Redgraves' concern with the history of watercolor in *A Century of British Painters*, in the formation and presentation of the collection at South Kensington, and in the catalogue of that collection as their response to current debates about contemporary watercolor painting. Certainly by the later 1860s the initial impetus behind Pre-Raphaelite landscape painting was waning, and even those artists who had been the most ardent advocates of a meticulous stipple technique in bodycolor were searching for less constricting methods of constructing landscape watercolors.

In 1863 a young Manchester-born watercolorist named Thomas Collier painted a view of a rude stone bridge in North Wales (fig. 112), which, in its bright color and meticulous detail, is a very Pre-Raphaelite work. By 1869 he was painting the mountains of North Wales in a manner that proclaimed his allegiance to an earlier school of watercolor landscape, being very much the subject and style of David Cox (fig. 113). For the rest of Collier's career (he died in 1891) he was the foremost painter among a group of watercolorists, including Edmund Morison Wimperis and James Orrock, who took as the model for their landscape watercolor style the works of Cox and DeWint.

Even artists who had most deeply imbibed the tenets of Pre-Raphaelitism and had—like Alfred William Hunt—enjoyed (or suffered) the personal attention and advice of John Ruskin felt that too much had been forfeited by an over-concern with fidelity to natural detail and an obsession with a scrupulously minute touch. For Hunt the way out of this artistic dead end was to be found in the work of the artist of whom Ruskin was such a champion, J. M. W. Turner. While Hunt's own landscape watercolors, among the most original of the later nineteenth century, were by no means simply imitative of Turner's, they did

112. Thomas Collier, *Pentre Ddu Bridge, North Wales*, 1863, watercolor, 24.4 x 35.2 cm. Yale Center for British Art, Paul Mellon Fund.

113. Thomas Collier, *Welsh Mountain Landscape*, 1869, watercolor, 34.7 x 53.3 cm. Birmingham Museums and Art Gallery.

116. *South Gallery of the Whitworth Institute*, 1898, photograph. Whitworth Art Gallery, University of Manchester.

The first edition of Monkhouse's book was one of three devoted to the history of watercolor in Britain that appeared in the early 1890s: Monkhouse's *The Earlier English Water-Colour Painters* in 1890; John Lewis Roget's *A History of the "Old Water-Colour" Society* the following year, and Gilbert Redgrave's *A History of Water-Colour Painting in England* a year after that. Roget's history remains one of the most comprehensive and useful volumes (actually two volumes) ever written on the subject — a treasure trove of information not just on the Society and its members but on the whole development of watercolor painting in Britain.[37] The little book by Gilbert Redgrave, the son of Richard, does not add that much to the account already given by his father and uncle, but it is another instance of the family's keen promotion of an historical appreciation of watercolor art.

If the exhibitions and publications of the 1870s appeared in the context of establishing an alternative to Pre-Raphaelitism, these books reflected a concern with the inroads made in the practice of younger British artists and critics by French impressionism. In the second edition of his *The Earlier English Water-Colour Painters*, Monkhouse asserted that "the traditions remain from David Cox to Tom Collier, from Turner to Alfred Hunt, from Copley Fielding to H. G. Hine, from Cattermole to Sir J. D. Linton," but also noted that there was "a new school based not at all on English traditions, but rather on the example of the French and the Dutch…It is perhaps the school of the future, but it is yet too young for the historian."[38]

Monkhouse's perception of the new school as unrelated to English traditions was by no means universally shared. There was little agreement among the English about just what impressionism was, but the assertion that Turner and Cox had long ago pioneered an indigenous impressionism was frequently made both by those who sought to portray French impressionism as a bastardization of a good old English idea and those who sought to make the new foreign style acceptable by stressing its compatibility with longstanding native traditions. Once again the English responded to the new by looking backward.

1 *Spectator*, April 24, 1858, 447.

2 These mid-century concerns and the subsequent reputation and influence of Cox, DeWint, Copley Fielding, and Turner in the later Victorian period are discussed in "They Leave Other Lights Behind Them," in Scott Wilcox and Christopher Newall, *Victorian Landscape Watercolors*, exh. cat. (New York: Hudson Hills Press, 1992).

3 *Art Journal*, June 1, 1855, 185.

4 Edward Holmes, "Gallery of Drawings in Water-Colours," *Catalogue of the Art Treasures of the United Kingdom, Collected at Manchester in 1857* (London, 1857), 177.

5 The exhibition of drawings at Marlborough House, together with Ruskin's efforts to make the drawings in the Bequest available and to interpret them for the public, are discussed by Ian Warrell in *Through Switzerland with Turner: Ruskin's First Selection from the Turner Bequest*, exh. cat. (London: Tate Gallery Publications, 1995).

6 *Art Journal*, November 1, 1857, 344–45. The reviewer expressed the hope that the watercolor sketches in the Turner Bequest would provide the core around which a collection of British watercolor art could be formed.

7 When the Sheepshanks collection was put on display in four rooms of the newly opened Museum of Science and Art in South Kensington in 1857, one room was given over to drawings and studies by Wilkie, Cope, Mulready, Landseer, and other artists represented by paintings in the collection. Among these drawings were the one watercolor by Turner and nineteen by James Holland.

8 For the history of the watercolor collection at the South Kensington Museum, see Lionel Lambourne's introduction to Lionel Lambourne and Jean Hamilton, *British Watercolours in the Victoria and Albert Museum* (London: Sotheby Parke Bernet, 1980).

9 *Richard Redgrave: A Memoir Compiled from His Diary*, ed. F. M. Redgrave (London, 1890), 235. Two years earlier he had written: "As yet we have not formed any collection of that purely national art, water-colour. I trust, however, that I have made a beginning at South Kensington Museum, which will in time bear fruit" (May 7, 1859, 214).

10 Holmes, 177.

11 Lewis Johnson discusses the formation of the National Collection of Watercolours as a manifestation of nationalism in his provocative if often confusing and unconvincing introduction to *Prospects, Thresholds, Interiors: Watercolours from the National Collection at the Victoria and Albert Museum*, exh. cat. (Cambridge: Cambridge University Press, 1994).

12 *Art Journal*, July 1, 1861, 200.

13 February 27, 1806: "Mary Smirke heard one of Craig's Lectures at the Institute. – The principal object of it seemed to be to shew the superiority of *water* over *Coloured* painting…She was disgusted at his presumption and folly, but what He said caused

many claps of approbation from the ignorant auditors. – Richard Smirke attended another of his Lectures, which was equally absurd & presumptuous."

March 14, 1806: "Mr. Simmonds mentioned Craig's Lecture at the Royal Institute and Mr. Parsons expressed his approbation of it, being, with Craig, of the opinion that *Water Colour* painting is superior to *oil painting*…Seeing Lysons smile He said 'You think I talk very foolishly.' Lysons replied 'Not very wisely.'"

March 15, 1806: "Craig's Lecture at the Royal Institution was spoken of, in which He represented the advantage of water colour over Oil Painting" — *The Diary of Joseph Farington*, ed. Kathryn Cave (New Haven and London: Yale University Press, 1982), 7:2686, 2691, 2692).

14 William Marshall Craig, *A Course of Lectures on Drawing, Painting, and Engraving, Considered as Branches of Elegant Education* (London, 1821).

15 "Observations on the Rise and Progress of Painting in Water Colours," *The Repository of Arts, Literature, Commerce, Manufactures, Fashions, and Politics* 8 (1812): 257–60, 324–27; 9 (1813): 23–27, 91–94, 146–49, 219–21.

16 Ephraim Hardcastle [William Henry Pyne], "The Rise and Progress of Water-Colour Painting in England," *Somerset House Gazette, and Literary Museum; or, Weekly Miscellany of Fine Arts, Antiquities, and Literary Chit Chat* 1 (1824): 65–67, 81–84, 97–99, 113–14, 129–33, 145–46, 161–63, 177–79, 193–95.

17 *Repository of Arts* 9: 23.

18 John Ruskin, *Essay on Samuel Prout* (first appeared anonymously in the *Art Journal*, March 1849), in *The Works of John Ruskin*, ed. E. T. Cook and Alexander Wedderburn (London: George Allen, 1904), 12:308.

19 December 27, 1862: "The International Exhibition finished for me with the opening. As far as my work went, it was a pronounced success. The pictures, indeed, saved the Exhibition, and prevented a heavy call on the guarantors. Even the artists acknowledged, individually, the great labour of getting together the various works and their general excellence, and also their fair and suitable arrangement. Yet publicly, both the Water-colour Societies protested, because their members were not called in to hang and arrange their works. Their presidents were invited to be present as continuously as they wished; but this was not enough; they said it was entrusted to a person who had no interest in water-colour art. This was hard upon me, as one who had already induced the Department to form a collection (historical) of water-colours, and had written a short account of its rise and progress. When they had seen the arrangement (for which my brother Samuel was principally responsible), even then they did not withdraw their protests as bodies, although as individuals they highly approved" (Redgrave, *Memoir*, 268).

20 Richard and Samuel Redgrave, *A Century of British Painters* (London, 1866), 1:372–73. Lewis Johnson quotes this same passage, making much of the Redgraves' use of Hogarth's term "the black masters," finding in it a "paranoia of racial identity" (*Prospects, Thresholds, Interiors*, 13).

21 Redgrave, *Century*, 1:373–74.

22 Ibid., 375.

23 Leslie wrote of Cozens: "His works, consisting of drawings in water colours only, are confined to the portfolios of a few collectors, and so little, therefore, is he known, that even some artists of the present generation have never seen a landscape by his hand…but his Art made such an impression on Constable, that in a moment of enthusiastic admiration he pronounced John Cozens to be '*the greatest genius that ever touched landscape.*'" Leslie went on to quote Constable's comment that "Cozens was all poetry." Both statements he had included earlier in his *Memoirs of the Life of John*

Constable. While he felt that Constable's estimation of Cozens was extravagant, Leslie nonetheless grouped Cozens with Gainsborough, Wilson, Girtin, Turner, and Constable as the masters of the British school of landscape painting—*A Hand-Book for Young Painters* (London, 1855), 253–79.

24 Redgrave, *Century*, 1:377.

25 Ibid., 400.

26 The introduction concludes: "The use of opaque white grows on the artist, and it would be easy, were it right to do so, to point to those who, beginning to use it delicately and with *finesse*, have ended in revelling in its abuse. It is, therefore, earnestly to be hoped that the art as practised by Turner, Girtin, Cox, and De Wint at his best period, may still find some loving and true followers, and that those who are now using white with taste will treat it with reserve as a dangerous ally or treacherous friend"—Samuel Redgrave, *A Descriptive Catalogue of the Historical Collection of Water-Colour Paintings in the South Kensington Museum* (London, 1877), 67.

27 Alfred William Hunt, "Modern English Landscape-Painting," *The Nineteenth Century* 7 (May 1880): 780, 782–83.

28 Alfred William Hunt, "Turnerian Landscape—An Arrested Art," *The Nineteenth Century* 29 (February 1891): 214–24.

29 *Art Journal*, July 1, 1871, 180.

30 James D. Linton, "The National Art and the National Gallery," *The Magazine of Art* 11 (1888): 150–53.

31 This and the subsequent correspondence on the issue were published as *Light and Water-Colours: A Series of Letters Addressed to the Editor of "The Times"* (London, 1887). In addition, articles on the subject included the following: J. C. Robinson, "Light and Water-Colours," *The Nineteenth Century* 19 (June 1886): 849–60, Frank Dillon, "Light and Water-Colours. A Reply," *The Nineteenth Century* 20 (August 1886): 270–83; Walter Armstrong, "The Permanency of Water Colours," *Art Journal*, August 1886, 253–54; and A. H. Church, "Light and Water-Colours," *The Magazine of Art* 11 (1888): 233–35.

32 Armstrong, "The Permanency of Water Colours," 253.

33 "Art Collections of the Whitworth Institute," *Manchester Guardian*, July 18, 1890.

34 The Guarantors of the Manchester Royal Jubilee Exhibition, under the chairmanship of William Agnew, provided funds for the purchase of forty watercolors. John Edward Taylor, director of the *Manchester Guardian*, gave 154 watercolors from his own collection in 1893. See Francis Hawcroft, *The Whitworth Art Gallery: The First Hundred Years* (Manchester: Whitworth Art Gallery, 1988), 4. Charles Nugent kindly allowed me access to his informative unpublished lecture, "Collecting Watercolours and the History of the Whitworth."

35 James Orrock, *"The English Art," a Lecture Delivered at the Whitworth Institute, Manchester,* October 28, 1891.

36 William Cosmo Monkhouse, *The Earlier English Water-Colour Painters*, 2nd ed. (London, 1897), v.

37 Roget's book was based on material compiled by Joseph John Jenkins, member of the Society of Painters in Water-Colours (Old Water-Colour Society) from 1850 to his death in 1885 and secretary of the Society from 1854 to 1864.

38 Monkhouse, vii.

Notes on Contributors

Maxine Berg is Reader in History at the University of Warwick. She is author of *The Machinery Question and the Making of Political Economy, 1815–1848* (1980), *The Age of Manufactures, 1700–1820: Industry, Innovation and Work in Britain* (1985, new ed. 1994), *A Woman in History: Eileen Power, 1889–1940* (1996), and other works of social and economic history.

Stephen Copley is Lecturer in English at the University of York. His publications include *Literature and the Social Order in Eighteenth-Century England* (1984) and essays on eighteenth-century literature, aesthetics, and polite culture. He is the joint editor of three collections of essays: *Beyond Romanticism* (1992), *The Politics of the Picturesque* (1994), and *Adam Smith's Wealth of Nations: New Interdisciplinary Essays* (1995).

Stephen Daniels is Reader in Landscape and Cultural Geography at the University of Nottingham. He is the author of *Fields of Vision: Landscape Imagery and National Identity in England and the United States* (1993) and a number of other works on the history and theory of landscape and geography. He is presently writing a book on the landscape gardener Humphry Repton.

Elizabeth K. Helsinger is Professor of English Literature and Art History at the University of Chicago and an editor of *Critical Inquiry*. She is the author of *Ruskin and the Art of the Beholder* (1982), *Rural Scenes and National Representation: Britain, 1815–1850* (1997), and other works on nineteenth-century literature, art and culture.

Andrew Hemingway is Reader in History of Art at University College London. He is the author of *Landscape Imagery and Urban Culture in Early Nineteenth-Century Britain* (1992) and of numerous articles and reviews.

Alun Howkins is Reader in History at the University of Sussex. He is the author of *Poor Labouring Men: Rural Radicalism in Norfolk, 1872–1923* (1985), *Reshaping Rural England: A Social History, 1850–1925* (1992). and other works on the social, economic, and cultural history of the British countryside since 1850.

Charlotte Klonk is Research Fellow in the Department of History of Art at the University of Warwick. She is the author of *Science and the Perception of Nature: British Landscape Art in the Late Eighteenth and Early Nineteenth Centuries* (1996).

Kay Dian Kriz is Assistant Professor in the Department of History of Art and Architecture at Brown University. She is the author of *The Idea of the English Landscape Painter: Genius as Alibi in the Early Nineteenth Century* (1997) and is currently working on a book on the visual culture of the slave and sugar trade between Britain and the West Indies.

Christiana Payne is Senior Lecturer in History of Art at Oxford Brookes University. She is the author of *Toil and Plenty: Images of the Agricultural Landscape in England, 1780–1890* (1993).

Ann Pullan teaches eighteenth- and early-nineteenth-century British art. In 1992 she completed her Ph.D. thesis (University of Cambridge), "Fashioning a Public for Art: Ideology, Gender and the Fine Arts in the English Periodical, 1800–1825, and she has published a number of review articles in the *Oxford Art Journal*.

Michael Rosenthal is Senior Lecturer in History of Art at the University of Warwick. His books include *British Landscape Painting* (1982) and *Constable: The Painter and His Landscape* (1983).

Susanne Seymour is Lecturer in Geography at the University of Nottingham. She has published a range of works on the interpretation of estate landscapes in the eighteenth century and is currently researching issues of empire and gender.

Kim Sloan is Assistant Keeper in the Department of Prints and Drawings, British Museum, with responsibility for the British collection. She is the author of *Alexander and John Robert Cozens: The Poetry of Landscape* (1986), *Victorian Painting in the Beaverbrook Art Gallery* (1989), and co-author, with Ian Jenkins, of the exhibition catalogue *Vases and Volcanoes: Sir William Hamilton and His Collection* (1996).

Sam Smiles is a lecturer in the School of Humanities and Cultural Interpretation at the University of Plymouth. He is the author of *The Image of Antiquity: Ancient Britain and the Romantic Imagination* (1994) and *The Perfection of England: Artist Visitors to Devon, 1750–1870* (1995).

Charles Watkins is Senior Lecturer in Geography at the University of Nottingham. His books include *Woodland Management and Conservation* (1990) and *Rights of Way: Policy, Culture and Management* (1996). He is editor (with Stephen Daniels) of *The Picturesque Landscape: Visions of Georgian Herefordshire* (1994).

Scott Wilcox is Associate Curator for Prints and Drawings at the Yale Center for British Art. He is the author of *British Watercolors: Drawings of the 18th and 19th Centuries from the Yale Center for British Art* (1985), co-author, with Christopher Newall, of *Victorian Landscape Watercolors* (1992), and has published other works on British watercolors and panoramas.